Carnegie International

John Caldwell

Curator

Jean-Christophe Ammann

Maria Corral

Kathy Halbreich

John R. Lane

Nicholas Serota

Joan Simon

Advisory Committee

Sarah McFadden

Joan Simon

General Editors

Distributed by Prestel

Carnegie International, November 5, 1988–January 22, 1989

The 1988 Carnegie International is supported by The Hillman Company, the major corporate sponsor, and by grants from the Howard Heinz Endowment, the National Endowment for the Arts, the Pennsylvania Council on the Arts, and by income from the A.W. Mellon Educational and Charitable Trust Endowment Fund for the Pittsburgh International exhibition. This publication received additional support from the James H. Beal Publication Fund of The Carnegie Museum of Art.

Library of Congress Cataloging in Publication Data

Carnegie international

 Catalog of an exhibition held Nov. 5, 1988–Jan. 22, 1989
 1. Art, Modern—20th century-Exhibitions.
I. Caldwell, John. II. McFadden, Sarah. III. Simon, Joan, 1949-
IV. Carnegie Museum of Art.
N6487.P57C3728 1988 707'.4'014886 88-30021
ISBN 0-88039-019-0
(The Carnegie Museum of Art)

ISBN 3-79130-875-0
(Prestel-Verlag, Munich)

Trade edition distributed by Prestel-Verlag, Mandlstrasse 26, D-8000 Munich 40.

Distributed in the USA and Canada by
te Neues Publishing Company
15 East 76 Street, New York, NY 10021

Distributed in the United Kingdom, Ireland and the rest of the world with the exception of continental Europe, USA, Canada and Japan by
Thames and Hudson Limited
30-34 Bloomsbury Street
London WC1B 3 QP, England

Publication Director:
Vicky A. Clark

Production Supervision:
Nancy Robins

Design:
Karen Salsgiver

Editing:
Sarah McFadden and Joan Simon

Typesetting:
Trufont Typographers, Inc.

Cover Photography:
Togashi

Cover Separations and Printing:
Lebanon Valley Offset, Inc.

Text Separations, Printing, and Binding:
Balding + Mansell International Limited

Lenders

Thomas Ammann Fine Art

Siah Armajani

Richard Artschwager

Kunsthalle Bielefeld

Anna and Bernhard Blume

Mary Boone Gallery

Mr. and Mrs. John Garland Bowes

Leo Castelli Gallery

The Carnegie Museum of Art

Paula Cooper Gallery

Douglas S. Cramer

Anthony d'Offay Gallery

Galerie Liliane and Michel Durand-Dessert

Mr. and Mrs. Asher B. Edelman

Gerald S. Elliot

Julia Ernst

Luciano Fabro

Peter Fischli

Günther Förg

Garnatz Collection

Marian Goodman Gallery

Janet Green

Mimi and Peter Haas

Galerie Max Hetzler

Rebecca Horn

Sidney Janis Gallery

Dakis Joannou Collection

Galerie Johnen & Schöttle

Anish Kapoor

Anselm Kiefer

Galerie Bernd Klüser

Jeff Koons

Leonard and Jane Korman

Jannis Kounellis

Galerie Laage Salomon

Wolfgang Laib

Emily Fisher Landau

Galerie Lelong

Sherrie Levine

Lisson Gallery

Luhring, Augustine & Hodes

Helen Marden

Agnes Martin

Bruce Nauman

Oliver-Hoffman Collection

Pace Gallery

Galleria Pieroni

Galerie Philomene Magers

Sigmar Polke

Private Collection

Max Protetch Gallery

Frederick Roos

Susan Rothenberg

Saatchi Collection

San Francisco Museum of Modern Art

Julian Schnabel

Galerie Rüdiger Schöttle

Rita and Toby Schreiber

Joel Shapiro

Sonnabend Gallery

Sperone Westwater Gallery

Galleria Christian Stein

Susana Solano

Monika Sprüth Galerie

Rosemarie Trockel

Cy Twombly

Bill Viola

Walker Art Center

Jeff Wall

Estate of Andy Warhol

Galerie Michael Werner

Michael Werner

David Weiss

Acknowledgements

Sally Adkins
Jean-Christophe Ammann
Giovanni Anselmo
June Batten Arey
Siah Armajani
Richard Armstrong
Richard Artschwager
Roland Augustine
Michael Auping

Helen Baer
David Bancroft
Mary Alice Barnhouse
Irma Barr
Georg Baselitz
Lothar Baumgarten
Douglas Baxter
Martha Bell
Racine Berkow
Carol Berkman
Joseph Beuys
Tessie Binstock
Bruno Bischofberger
Ross Bleckner
Bernard Blistène
Anna Blume
Bernhard Blume
Anna Blümel
Adriana Bond
Mary Boone
Frances Bowes
John Bowes
Ann Boyd
Jeffrey Boyd
Ann Bridges
Don Brill
Ellen Broderick
Gina Broderick
Elizabeth Brown
Michelle Browne
Susan Brundage
Bentley Buran

Tina Calabro
John Caldwell
Dan Cameron
Susan Carabetta
Mildred Cassini
Leo Castelli
Linda Cathcart
Vicky A. Clark
Francesco Clemente
Barbara Coffey
David Cohen
Michael Compton
Lynne Cooke
Paula Cooper
Maria Corral
Nancy Cox
Douglas Cramer
Merle Culley
Richard M. Cyert

I. Michael Danoff
Christine Daulton
Judy Davenport
Guy Dawson
Jole de Sana
Gabrielle Dinman
Rini Dippel
Anthony d'Offay
Jim Dugas
Liliane Durand-Dessert
Michel Durand-Dessert

Asher Edelman
Gerald S. Elliott
Julia Ernst

Luciano Fabro
Trevor Fairbrother
Becky Fine
Milton Fine
Peter Fischli
Edith Fisher
William Florkowski
Jane Flucker
Günther Förg
Howard Fox
Rebeca Frankel
Martin Friedman
Katharina Fritsch
Charles B. Froom
Rudi Fuchs

Jamey Gambrell
Eberhardt Garnatz
Christian Geelhaar
Ruth Gilson
Siegfried Gohr
Susan Goldman
Marge Goldwater
Marian Goodman
Nanette Gordon
Julie Graham
Juliette Grauer
Janet Green
Debra Greenberg
Denise Griffith
Susan Guiser

Peter Haas
Barbara Hagan
Kathy Halbreich
Peter Halley
Daryl Harnisch
Myrleen Harrison
James Hawk
Mary Hendley
Max Hetzler
Elsie Hillman
Henry Hillman

Paul Hoffman
Antonio Homan
Henry Hopkins
Walter Hopps
Rebecca Horn
Frederick Hughes

Rafael Jablonka
Claudia James
Sidney Janis
Carmen Jimenez
Phillip M. Johnston
Kellie Jones

Milena Kalinovska
Joan Kaplan
Anish Kapoor
Wallis Katz
Ruth Kaufmann
Anselm Kiefer
Genie Kiliani
Irene Kilic
Elaine King
Per Kirkeby
Bernd Kluser
John Kohler
Kasper König
Jeff Koons
Leonard Korman
Richard Koshalek
Jannis Kounellis
Hilton Kramer
Ross Kronenbitter

Marjorie Ladley
Wolfgang Laib
John R. Lane
Ernie Lefebvre
Sherrie Levine
Nicholas Logsdail
Barbara London
Genevieve A. Long
Barbara Luderowski
Lawrence Luhring

Table of Contents

Foreword

Undertaking the 1988 *Carnegie International* has been a monumental task. It is an exhibition which devotes approximately 40,000 square feet of space to the work of 39 artists, 18 of whom have made works specifically for this occasion. The staff of The Carnegie Museum of Art is not a large one; so, virtually every member of its staff must be called on to accomplish the myriad details of this endeavor.

My involvement in the development of *Carnegie Internationals* is brief. In 1982, having just joined the museum staff, I witnessed only the final press towards the opening of the 1982 exhibition. Between 1982 and 1985, however, I experienced a full cycle of production, though from somewhat of a distance, since my position as curator of decorative arts did not specifically involve me in it. I admired the museum's recovery from the adverse critical response to the 1982 showing and its thoughtful analysis of how best to fashion the 1985 exhibition, which proved to be a highly praised achievement. John Caldwell describes in his introductory essay the process by which the 1988 *Carnegie International* has come about. When the planning began for the 1988 *International* in 1986, I participated as an interested observer; midway through, in January 1987, when I became acting director of the museum and later—in May 1988—director, my role changed dramatically.

Because I have experienced the making of this exhibition from various points of view, I can ask quite honestly, "Why do we do it?" The effort required is monumental, and the number of people responsible for this exhibition is impressive in being so few. The essays which introduce this catalogue address this question in broader terms. Speaking specifically for The Carnegie Museum of Art, I can answer that first, we do it because in 1896 Andrew Carnegie challenged this museum to focus its attention on the "Old Masters of tomorrow." He envisioned a series of exhibitions of contemporary art which today constitute this country's most important continuing forum for the presentation of new contemporary art. Over nearly a century, through this series of exhibitions, the museum has been able to make significant contributions to 20th-century culture. We also have realized in recent years how central *Internationals* have been to the development of the museum's permanent collection. Approximately a third of the museum's paintings and sculptures have come from these exhibitions.

Tradition and the potential for acquisitions are powerful motivating forces, but they alone are insufficient. Finally, it is the value we set on the personal encounter with works of art that motivates and energizes the museum's production of the *Carnegie International*. We recognize the power of art to order or disrupt, to calm or provoke, to stimulate our minds and excite our emotions. Furthermore, in gathering together the *International*, we not only encounter outstanding new works of art. We also are brought into direct contact with some of the most significant artists at work in Europe and America today. Indeed, at times we are able to engage with them in the creation of a work of art which they have chosen to make specifically for this exhibition. In lectures and symposia, we are able to bring at least some of these artists directly to our audience as well. These factors combine to provide a privileged circumstance for this museum and its audience and one which fosters a degree of commitment to this exhibition which makes its accomplishment possible.

To the artists who have participated in the 1988 *Carnegie International* we owe profound gratitude. Their gallery representatives have been generous with their assistance, for which we thank them. Lenders who have graciously parted with works of art so that they can be included in this exhibition deserve special thanks.

I am deeply grateful to the Advisory Committee who joined with us in planning this exhibition: Jean-Christophe Ammann, director, Kunsthalle Basel and Museum für Moderne Kunst, Frankfurt; Maria Corral, director, Fundación Caja de Pensiones, Madrid; Kathy Halbreich, independent curator, Boston, and former director of the Committee on the Visual Arts, Massachusetts Institute of Technology; John R. Lane, director, San Francisco Museum of Modern Art and former director of The Carnegie Museum of Art; Nicholas Serota, director, the Tate Gallery, London and

former director of the Whitechapel Art Gallery, London; Joan Simon, critic and independent curator, New York, and former director of the Broida Museum, New York. They brought a diversity of well-informed points of view to our deliberations and a belief in the potential for an exhibition like the *Carnegie International*. Although individually they would have chosen a different exhibition and, even as a group would have chosen differently under other circumstances, inevitably, their judgments have informed the exhibition in critical ways. I am personally indebted to the members of this committee for their support of my involvement, first as acting director, and then as director.

John Caldwell, the museum's curator of contemporary art, is curator of the 1988 *Carnegie International*. He co-curated the 1985 *International* with former Carnegie director John R. Lane and initiated plans for the current edition with this same co-curatorship in mind. When Jack Lane left in January 1987 to become director of the San Francisco Museum of Modern Art, John shouldered full curatorship of the exhibition with enthusiasm and has pursued its development with seemingly boundless energy. Most importantly, John took the lead in working with artists to select works for the exhibition. Hence, his distinctive vision is central to this exhibition.

Vicky A. Clark, the museum's curator of education, became acting head of publications in October of 1987. As part of her new responsibilities, Vicky directed the preparation and publication of this catalogue, which documents the 1988 *International*, and the *Artists Guide*, a smaller book about the artists in the exhibition designed for the general public. Her seasoned judgment of contemporary art and criticism and her keen eye for good and imaginative design have proved to be an admirable combination. She has contributed an essay about the works in the exhibition to the catalogue to complement John Caldwell's essay on the organization of the exhibition.

Vicky also coordinated the work of an especially creative team of collaborators in preparing this catalogue. She joins me in thanking Sarah McFadden and Joan Simon, who as general editors solicited the advice of both the advisory committee and the museum staff and then shaped the contents of the book, commissioning three major essays and 39 artist entries by 12 writers and then skillfully edited the entire book. Their understanding of contemporary art produced a book that includes thought-provoking essays as well as short introductions to each artist. We would like to thank Thomas McEvilley, Lynne Cooke, and Milena Kalinovska for their essays and Dan Cameron, Vicky A. Clark, Jole de Sanna, Jamey Gambrell, Kellie Jones, Barbara London, Sarah McFadden, Michael Newman, Linda Norden, Nancy Princenthal, Stephan Schmidt-Wulffen, and Marjorie Welish for their entries. As complex a book as this required the efforts of many people both inside and outside the museum. We thank the many people from art galleries who provided us information and photographs, and our colleagues at other museums who helped with research. And from our staff, we would like to acknowledge in particular the efforts of John Caldwell, Annegreth Nill, Elizabeth Van Dusen, Genevieve Long, Janet Smith, William Stover, William Real, Mary Hendley, and Claudia James.

In the designing of this catalogue, we were extremely pleased to work with Karen Salsgiver, who has crafted a visually compelling publication that complements the quality of the works in the exhibition. Orchestrating the production of the catalogue and the *Artists Guide* was extremely difficult, and we are grateful to Nancy Robins, our production supervisor, whose careful attention to detail was essential to the quality of the book. We were also fortunate for having Lebanon Valley Offset, Inc. to print the covers and accompanying ephemera, and Balding + Mansell International Limited to print the contents of the book. We were heartened by Prestel Verlag's decision to distribute the catalogue again in 1988, and we thank Michael Maegraith in particular.

John Caldwell's leadership in planning the exhibition has been supported in particular by Annegreth Nill, assistant curator of contemporary art, and Lisa Miriello, secretary. John joins me in thanking John R. Lane, former director, and Barbara L. Phillips, former

assistant director for administration, whose contributions to the early development of the 1988 *International* were critical. Cheryl Saunders, registrar, orchestrated the highly complex shipping arrangements necessary to assemble the works selected for the exhibition. Will Real, conservator, has not only been alert to special conservation measures many works in the exhibition required but also planned and directed the major task of storing works of art temporarily removed from display in the museum's Hall of Sculpture and the contemporary gallery in order to give additional space to the exhibition. In these efforts and in the installation of the exhibition, John Vensak, workshop supervisor, and Frank Pietrusinski, Don Brill, Jim Dugas, James Hawk, Jr., Ross Kronenbitter, Ray Sokolowski, and Robert Whitaker provided experienced and dedicated support. David Cohen, who joined the museum in November 1987, became coordinator of the myriad details attendant to the *International*. His organizational skills are amplified by a kinship he shares with artists and a genuine human kindness. Quite simply, we could not have brought the exhibition together without him. Charles Froom, installation designer, provided a restrained environment in which each of the highly diverse works is afforded an appropriate vantage.

I also want to thank Bill Judson, curator of film and video, for his specific involvement with Bill Viola and Fischli/Weiss in their contributions to the exhibition. Ellen Broderick, supervisor of adult programs, planned and coordinated a rich schedule of public programs related to the *International*. Marilyn Miller Russell, docent supervisor, directed with assurance our docent tours of the exhibition. The Museum of Art's docents deserve high praise for the role they play in bringing our public in touch with the works of art in this exhibition. Bay Hallowell Judson, supervisor of children's programs, formulated a stimulating offering of related family programs.

Debra Greenberg of the Kreisberg Group worked with Janet Schwab, director of public programs and services, and Tina Calabro, media relations coordinator for The Carnegie, to enlist publicity for the exhibition. Doris Carson Williams, director of business enterprises for The Carnegie, and Elizabeth Smith deserve our gratitude for special tour arrangements.

The Women's Committee of The Carnegie Museum of Art made certain that the opening celebrations of this exhibition would be marked by a cordial grandeur, in keeping with Pittsburgh hospitality. Our sincere appreciation goes to Carol Sharp, president; Wallis Katz and Ellen Tobin, co-chairmen of the *Carnegie International* Events Committee; and the many members of the Women's Committee who volunteered their efforts.

Funding for the 1988 *Carnegie International* has come from several sources. We are fortunate that in 1980 the A. W. Mellon Educational and Charitable Trust created an endowment to support the *Carnegie International*. Income from this endowment provides approximately half the funds required by the exhibition. Additional funding has come from the Pennsylvania Council on the Arts and from the Howard Heinz Endowment. The National Endowment for the Arts also made a generous grant to this exhibition. The catalogue received specific additional support from the James H. Beal Publication Fund, an endowment fund established in 1987 to support Carnegie Museum of Art publications, that allowed us to publish an all-color book. This is the first use of this fund. A major contribution, by The Hillman Company, headed by Museum of Art trustee, Henry Hillman, made the 1988 *Carnegie International* a reality. The company's appreciation of the importance of this exhibition to the museum and to the city of Pittsburgh underlies its generous sponsorship.

A full listing of the many people who have participated in making the 1988 *Carnegie International* appears at the front of this catalogue. In addition I must add my personal gratitude to Susan Guiser, executive secretary.

Finally, we pay tribute to the Trustees of Carnegie Institute and most especially the members of the Museum of Art Committee whose unflagging dedication to the museum keeps its spirit vibrant.

—*Phillip M. Johnston, Director*

The Making of the 1988 Carnegie International

John Caldwell

To an increasing extent over the last nine years, the *Carnegie International* has simply become part of the fabric of The Carnegie Museum of Art, an integral part of its institutional and professional life. This seems entirely appropriate, given the wish of the museum's founder, Andrew Carnegie, that the exhibition, which he initiated in 1896, be the primary source of the museum's collection as well as a great international exhibition of contemporary art. The *International* is of crucial importance for the people of Pitttsburgh as well. In part because of its regular occurrence over the past 92 years, to many Pittsburghers it has come to be synonymous with the museum itself. Naturally this places a heavy responsibility on the organizers of the exhibition, who are sometimes made to feel a little like the manager (and players as well) of the city's baseball or football team. How, one is constantly asked, is the *International* going?

This particular *International* has been going hard for what seems a very long time. In December 1985, while the last *International* was still on view at the museum, John R. Lane, then director of the museum and co-curator with me of the 1985 *International*, and I made a trip to Europe to begin planning the current exhibition. Our primary purposes were familiarizing ourselves with the art currently being made and shown abroad and seeking our colleagues' opinions of the 1985 exhibition and their ideas on how the 1988 show should be organized. It was the beginning of a process that would continue for almost seven months and was to include three trips around the United States as well as another European journey. As might be expected, we paid particular attention to the responses of the six members of the advisory committee for the 1985 exhibition: Linda L. Cathcart, Rudi Fuchs, Kasper König, Hilton Kramer, Nicholas Serota, and Maurice Tuchman.

There were basically three issues. The first was the organizational principle of the show, whether to continue to select diverse artists for their individual

merits or to focus the exhibition on a particular theme—new talent, for example, or sculpture. The second was to select the artists. And finally, there were the matters of the installation and catalogue.

It seems in retrospect that absolutely everyone who expressed an opinion believed that the show would be best presented on white walls. There was also a consensus on the advantages of having an advisory committee. The question of what kind of catalogue would best serve the exhibition, on the other hand, elicited a wide variety of responses. On the main issue, what sort of exhibition the 1988 *International* should be, a great many opinions were expressed. A number of our colleagues believed that the exhibition should concentrate on particular areas or problems in contemporary art. There were cogent arguments in favor of limiting this year's *International* to artists who had come to the fore in the years since the last exhibition, for example, and on focusing the show on a particular medium that seemed especially vital to the art of the moment. Yet most of our colleagues tended to agree that this exhibition should be done "exactly the same way as last time."

In the end, based on our discussions as well as our experience in 1985, Lane and I decided to continue the *International* as an exhibition of artists chosen on an individual basis by ourselves with the assistance of a carefully selected advisory committee from this country and abroad. This decision reflected a number of factors: the tradition of the *Carnegie International*, established over so many years, was for just such an exhibition. In fact, given the ease of international air travel, the advisory committee could be seen as a logical outgrowth of the practice early in the *International's* history of having commissioners in various European art centers.

Once these basic decisions were made, the next order of business was to select our advisory committee for the 1988 *International*. This process had been underway throughout our travels and discussions with colleagues during the winter and spring of 1986, and it was relatively simple to arrive at the five members,

three Europeans and two Americans, whom we asked in August and September of that year to join us. They were: Jean-Christophe Ammann (Basel), Maria Corral (Madrid), Kathy Halbreich (Boston), Nicholas Serota (London), and Joan Simon (New York).

The first meeting of the committee was set for Pittsburgh in February 1987, but in the meantime an important change had occurred at the museum that had direct consequences for the exhibition. In November 1986, Jack Lane resigned as director of The Carnegie Museum of Art to become director of the San Francisco Museum of Modern Art. Although it was impossible under the circumstances for him to continue as co-curator of the 1988 *International*, he agreed to serve as chairman of the committee's first meeting and subsequently as a sixth member of the advisory committee.

This session began with a discussion of how art had changed and developed since the last *International*, two years before. A number of issues were raised, for example the increased importance of sculpture on both sides of the Atlantic and the growing number of artists, in the United States especially, whose subject included art as a commodity or as a simulacrum. It was during this session that the process of choosing artists for the 1988 exhibition began. During the next three meetings, held in Basel, Pittsburgh, and Madrid, lively and intense discussion and sometimes disagreement about particular artists and the issues raised by their work, continued. By the time our deliberations were completed we had selected a total of 39 artists.

Choosing the works of art to be included in the exhibition was a complex and fascinating process. In a number of cases, there were suggestions by the committee, and these were followed whenever possible. The choice of Joseph Beuys' *Das Ende des 20. Jahrhunderts* (The End of the 20th Century), for example, resulted from a suggestion by Jean-Christophe Ammann. On occasion, an artist was selected with work of a particular sort in mind. From the beginning, discussion of Andy Warhol's works for the show had revolved around his late series of self-portraits. On another occasion, Lothar Baumgarten's already commissioned ceiling for the Hall of Sculpture, the committee was able to approve a project that had been developed previously by the artist working with the staff at the museum. In the vast majority of cases, however, the works in the exhibition were chosen by the artists themselves in consultation with the curator. While the artists' wishes were of primary importance, a number of other factors, also had to be considered. One was the goal of representing an artist with work of a type or in a medium not seen before by audiences in this country. Efforts were made as well to include new work: 18 of the 39 artists are represented by work created specifically for the *International*, in many cases with installations or pieces made for particular spaces. Eight others are presenting work never before exhibited, and 10 others are presenting pieces that have not yet been seen in this country until now. Overall, the work in the 1988 *Carnegie International* represents an extraordinary effort on the part of the artists, either to make work for the exhibition or to include work that in their judgment was the best possible.

The artworks were chosen in the same way as the artists were chosen, one by one on an individual basis. In the exceptional cases in which work was selected without the artist's active participation, the basis for the choice was always the most general one of perceived quality. No conscious attempt was made to advance a particular view of the state of contemporary art, nor were choices made to support a particular idea of where things might be headed. The single, overriding consideration has been to try to present each artist at his or her best—as if there were to be 39 one-person shows. While I assumed full curatorial responsibility for the exhibition, credit for the catalogue belongs to Vicky A. Clark, Sarah McFadden and Joan Simon.

A great deal of care and thought has gone into the installation of this *International*. In addition to the very large temporary exhibition spaces planned for the *Carnegie International* a decade before, when the museum was expanded and remodeled, we decided to use the Hall of Sculpture, an extraordinary space modeled after the interior of the Parthenon. The reason for utilizing this exceptionally generous space, the largest area devoted to the *International* in recent years and perhaps during its entire history, was not only to provide a suitable exhibition area for the large number of artists recommended by the committee, but to serve them well. Though the advisory committee suggested possible placements and many choices were made by the artists themselves, the final layout of the exhibition was the work of a number of people and the result of many factors, chief among them the requirements of the particular works for a certain amount or type of space. Like the selection of artists, the planning of the galleries was the work of a group of people in addition to the curator. Among them were Charles B. Froom, the exhibition's designer, Annegreth Nill, the assistant curator of contemporary art, David Cohen, the exhibition coordinator, Vicky A. Clark, curator of education and acting head of publications, and most important of all, finally, the museum's director, Phillip M. Johnston.

All exhibitions of contemporary art, even the most personal efforts on the part of a single curator, are the work of a collectivity. This one, more than most, is the product of the efforts of a number of people. Like all exhibitions, again, especially exhibitions of contemporary art, it is imperfect. In the nature of things it can only represent a particular moment, and because choices of artists and of their work had to be made, it is by definition incomplete. The 1988 *Carnegie International* is in the end but one story of the many that could have been told. It is nonetheless possible to characterize this exhibition at least in contrast to the 1985 *Carnegie International*. Although 13 artists are represented in both shows, the tone of their work is notably different, lighter, somehow, and more fragile. Then, too, this exhibition has more sculpture and installation pieces than last time, and they are even more unconventional in nature. What has appeared, too, quite unexpectedly, is a certain millenarian cast to the exhibition, rather as if the fin de siècle had begun in the 1980s.

Because of the wholehearted and serious efforts of so many people, one naturally hopes that, at the very least, this exhibition is a good story, no matter how necessarily partial it may be. Until the works of art are actually in place, of course, we cannot really know the exhibition we have made. Nevertheless, our hope is now, as it was at the beginning of the process three years ago, that the 1988 *Carnegie International* contains a part, at least, of the best art of our day.

On the Meaning of Art at the End of the Century

Vicky A. Clark

Three years is an extremely short period of time. We tend to measure our personal lives and shared histories by decades; and as time recedes, we measure it by centuries. Even the art of our time, where new artists and "isms" are introduced at a rate approaching the fashion world's seasonal frenzies, tends to be characterized by major shifts over a decade.

It is somewhat surprising, then, given the mere three-year interval since the last *International* held in 1985, to sense a dramatic shift in the tenor of the art included in the 1988 edition. While the works in the 1985 *International* were aggressive, big and spirited, there is a hushed, muted and almost magical feeling to the 1988 exhibition. It's as if someone turned down the lights to subdue the rambunctious crowd. While in both cases, the curators and the advisory committees chose artists and works based on merit rather than by theme or subgroup, they have managed to define two particular moments. That those particular moments are separated by significant change is immediately evident despite the inclusion of 13 artists from the 1985 show in the present one.

The 1985 exhibition exposed the heady excitement of the early '80s with Anselm Kiefer, Julian Schnabel and Susan Rothenberg reveling in the physical properties of paint and thickly encrusted surfaces. There was delight in the reappearance and acceptance of the figure and narrative in works by Malcolm Morley, John Ahearn and Jörg Immendorff and in the renewal of penetrating realism by Lucian Freud and Eric Fischl. There was a baroque exuberance in the painting of Frank Stella, and almost everywhere there was color, from the density of Brice Marden to the jarring contrasts of Georg Baselitz and the jewel-like intensity of Howard Hodgkin. The exhibition was like a rollicking roller coaster ride with larger-than-life, aggressive, colorful assaults waiting at every turn.

In 1988, the wild ride is over, and the exhibition is quieter and surprisingly subtle and complex. To wit, Richard Serra's esthetics of confrontation embodied in his 1985 *Carnegie*, which towers over the visitor at the entrance to the museum, is now countered by Siah Armajani's contemplations on an ideal democratic state evoked by the quietude of his public reading room; the exuberance of Lüpertz and Stella has shifted to the restrained refinement of Joel Shapiro and Susana Solano.

Obviously the differences between the two exhibitions should not be overstated. It is always problematical to define a moment, particularly when a significant number of the artists offered as exemplars—including Cy Twombly and Richard Artschwager—have steadfastly pursued their singular visions for many years. Agnes Martin and Robert Ryman reflect the continuing vitality of a Minimalist tendency, echoes of which can be found in the work of Günther Förg, Peter Halley, Sherrie Levine, Shapiro and Solano; Giovanni Anselmo, Luciano Fabro, and Jannis Kounellis have sustained their interest in the magical properties of diverse materials; Per Kirkeby is still painting abstract landscapes suffused with northern light; Susan Rothenberg continues her lushly painted figural compositions.

While the figure is still with us, it has taken a more personal turn in Rothenberg's paintings and in the work of a number of other artists. Instead of the bombastic, larger-than-life figures typical of early '80s painting, we now have critiques of contemporary culture by Katharina Fritsch, Rosemarie Trockel and Meyer Vaisman, who make works in diverse mediums that implicate the body/garment/artist in the discrediting of values. Other artists are moving toward a more personal iconography: Baselitz's raw wooden sculptures seem like stand-ins for humanity, confused and weary at the end of the century; Francesco Clemente's personal, highly eroticized images come out of Eastern philosophy and thought; Anna and Bernhard Blumes'

photographic psychodramas feature a world in which inanimate objects come alive to express men and women's innermost fears and thoughts. In this introspective vein, the shattered and reconstructed tables in Elizabeth Murray's luscious paintings become highly personal domestic metaphors. Murray has said "I think art is a mirror of our own conflicts. In some way, artists always paint about themselves whether the result is expressed as fantasy or reality."[1]

Indeed, a major tendency in the late '80s is for art to serve as a mirror that reflects back the artists' personal lives, the art world and the larger world in which we live. Murray has said, ". . . art should not be precious or obscure. Art is communication. You're communicating your feelings and vision."[2] Peter Halley goes one step further: "I believe that art has value only if it engages in a dialogue on intellectual issues beyond art itself. If it doesn't do that, it degenerates into formalist craft."[3]

More and more, communication and dialogue are tied to contemporary events and their effects. The work in the 1988 *International* evinces this tendency as it seems to reflect an end-of-century malaise that has surfaced throughout the world. As Meyer Vaisman said in 1987: "We must be subliminally experiencing the doom given off by the fact that we are not only at the end of the century but also at the end of the millenium. In Western culture the year 2000 has come to typify 'the future.' Now that we're barely thirteen years away from 'the future,' how are we supposed to feel other than alienated? We're all sort of paralyzed."[4]

If any one work in the 1988 *Carnegie International* characterizes this plight, it is Joseph Beuys' *Das Ende des 20. Jahrhunderts* (The End of the 20th Century), 1983–85. At first glance, the Beuys installation looks like a collection of rocks arbitrarily placed in a gallery. Upon closer inspection, the majority of the basalt stones seem to have fallen over while only a few remain standing, reminding one of the ruins of ancient temples or modern buildings destroyed by earthquakes. The solid blocks have been worked;

pieces have been extracted and wrapped with felt before being replaced. (The image, of course, echoes Beuys' own description of how he was saved from near death in World War II by being covered with fat and felt by his rescuers.) This double metaphoric collapse of civilization and its possible salvation gains strength from Beuys' title. The work could easily symbolize the crumbling of meaning and values—as well as the need to restore them—as we approach a new century.

The coarse stones are reminiscent also of prehistoric monuments such as Stonehenge and allude to the magical aspects of these sites. Given Beuys' ardent belief in a social sculpture that would burst through the narrow boundaries of art to effect social, political, and economic revolution, it is hard not to see both hope and despair in this strong and moving piece, which also raises other themes revealed elsewhere in the show: the magical properties of materials, public vs. private art, and of course the meaning of art in today's world. Joseph Beuys, the enigmatic and charismatic artist/performer/agitator continues to cast a large shadow even after his death in 1986.

Andy Warhol, too, was enigmatic and charismatic and of immense importance to younger artists. (The legacies of both Beuys and Warhol can be seen throughout this exhibition.) Warhol seemed preoccupied with death in both his work and his own life. In his last self-portraits, a disembodied, anemic head with its ill-fitting wig floats against a dark background like a skull or a mask. The skeletal face and intensely staring eyes create a ghost-like specter. These works gain significance in the revisionist reading of Warhol's work, which places a premium on appropriation, the devaluation of the image, and the acceptance of art, and especially the artist, himself one of his own best creations, as a commodity. While art as social catalyst might seem the antithesis of art as unblushing commodity, Beuys' and Warhol's ideas relate closely in boldy joining art and life and in questioning the meaning and role of art and artists in our society.

After 40 years of the dominance of personal expression, art for art's sake and formalism, with inroads by conceptually and politically based art, the art of the late '80s seems by and large to have left the ivory tower to engage the world around it. Artists involved in public art—Armajani and Fritsch are examples—have become extraordinarily sensitive about the impact their work may have on a community of viewers. Armajani in particular utilizes art's potential to effect change by explicitly focusing on the way people interact within functional spaces.

Bruce Nauman's carousel is disturbing, transforming a merry-go-round into a nightmare. The mechanical horses have rebelled, but in trying to break from their routine, they have been caught, strung up and sentenced to revolve continually in their imprisoned state, in a visualization of Beckett's or Camus' existential angst. Like Nauman's neon signs, which dazzle with colored light while communicating a serious message, in this piece Nauman has synthesized popular culture and high-art-with-a-message.

Anselm Kiefer has been championed as the savior of German art, which rose phoenix-like from the ashes of post-war Germany. His work, dealing with the Nordic tradition that was tainted by Hitler, delves into the painful recent history of Germany. His scorched landscapes and Nazi architecture are rendered expressionistically as he marries history painting to an Abstract Expressionist surface. Recently his focus has broadened to include other mythologies from Egypt and the Old Testament, and to deal with more universal themes.

Jeff Wall enhances commercial photography's slick effects with a light box display "frame" to tell stories about contemporary life. In *The Agreement* (1987) two people—the one in jeans on foot, the other in a suit in an unmarked car—meet in an empty parking lot to exchange something. They are shown shaking hands while avoiding each other's eyes. The secretiveness of the transaction, familiar to us from B movies and television shows, suggests the trading of illegal substances or information.

Bill Viola's video installation is called *The Sleep of Reason* after an etching by Francesco Goya. Viola uses Goya's title, but he explains that each artist refers to different problems. As Viola has said, "His 'sleep' and its 'monsters' are the result of a lapse of rationality which in his time produced disastrous wars and societal chaos. My 'sleep' is more related to the artifice of the day-to-day world we have constructed around us—the lack of reason (used in the expanded sense of pure knowledge rather than the narrow sense of rational logical thought). I feel that narrow reason has brought us to the brink of environmental and spiritual crisis today. The threatening underworld of demons and monsters [seen here projected on screens in a typical room in a house] is threatening only because the deep psyche—the total individual soul/self—has been ignored in the fragmentation of the self. Materialism represented by the room becomes the legacy of the senses. When the lights go out, it becomes as Holderlein said, 'The setting of the senses is the dawn of truth.'"[5]

Peter Halley employs an abstract vocabulary to reveal the role geometry plays in organizing and controlling our living spaces (he often uses prisons as the extreme example). Attempting social criticism in an abstract language is difficult, but Halley feels that "geometry is an even more powerful language, since it is the language of organization and mass production."[6]

Using a more traditional pictorial language especially prevalent in his native Germany, Baselitz carves figurative sculptures that are equivalent to exposed raw nerves. His rough wooden figures seem to be our century's answer to the anguished soul in Edvard Munch's *The Scream* (1893).

Also reminiscent of the alienation and melancholy of 100 years ago are the shimmering black canvases of Ross Bleckner. Memorials to those who have died of AIDS, these new paintings contain symbolism that has gone beyond the urns, chalices, and gates of earlier works. In these recent paintings,

flickering lights are interspersed with floating hands, kissing birds, and even haloes, suggesting the fantastic and magical aspects of both science fiction and religion. The sparkling stars can be seen as the souls of the dead shining in the night sky, a reading suggested by the punning titles of two works: *Knights in Nights* (1988) and *Two Knights Not Nights* (1988). Bleckner has introduced spirituality into paintings which are neither conventional images of devotion nor abstract meditations in the tradition of Mondrian or Kandinsky, but rather deeply personal reactions that reflect (and contain) aspects of both traditions.

In Julian Schnabel's *St. S.*, an oil and collage on tarpaulin of 1988, the artist introduces an actual religious image, a reproduction of an historical painting of St. Sebastian (a particularly appropriate symbol for the era of AIDS). The framed image of the saint hangs above an ornate piece of fabric which looks like an altar frontal. By returning to a standard iconography and form, Schnabel, like many others, has turned to another time and culture. This work, and his homage to Jean-Michel Basquiat—done after Basquiat's recent death—are restrained and economical works.

The whiter-than-white paintings of Robert Ryman are purist and reductivist in the extreme. Seen singly, they inspire thoughts about absence and the void, but collectively installed, as they are in his *Elliot Room: Charter* (1985–87), they create a meditative environment in a secular setting that is similar in effect to the Rothko Chapel in Houston. Agnes Martin, like Ryman, has adopted the formal means of Minimalism, but has also injected evocative and referential content into her reductivist forms. Her grid paintings are cool and quiet, but they assert themselves despite a barely discernible palette and exquisite surface.

Also meditative are the paintings of Cy Twombly and Brice Marden, both of whom use the equation of drawing and painting developed by Jackson Pollock and Willem de Kooning. (Per Kirkeby also has fused drawing and painting, but somehow his abstract landscapes are more rooted in actuality.) Twombly's work benefits from an immersion in a Mediterranean culture imbued with classical mythology and artifacts, and his works in the *International* take their inspiration from the classical story of the toilet of Venus. Marden's fine webs of lines, evoking human figures and landscapes, are spun over a reworked surface of often muted color. At times the lines suggest an archaeological excavation—inviting comparisons with de Kooning's *Excavation*—and at times they suggest the visualization of an inner, spiritual world.

The resurgence of spirituality seems an alternative, if not always a direct response to, a world increasingly defined by boundaries and separations, and ruled by technology and materialism. That spiritual, almost cosmic and utopian, vision need not come from Western sources only is evident in the work of Anish Kapoor, Bill Viola and Wolfgang Laib. In fact, one of the subthemes of the show could be said to be that of artists looking to other times and cultures (Clemente, Rebecca Horn, and Lothar Baumgarten are examples). Such a tendency is reminiscent of the Nabis and Symbolists at the end of the last century, who mined other cultures for meaning, and of Gauguin, who moved to Tahiti. This flight from Western civilization was aptly described by Annelie Pohlen in 1985; "The deathly fright of the Western world at the sight of the rubble of its own civilized excesses has drawn artists once again to undertake journeys into other types of mental space than logic and analysis, and into exotic regions as well. In particular, primitive cultures and ancient cultures of Asia have served yet again as healing water. The journey has not always been a physical one, but this hasn't hindered artists from mentally exploring mystical spaces where barriers between spirit and matter dissolve. To journey to the 'Other,' if it exists beyond science, we must become empty, completely empty and light, in order to become open and receptive, like a battery that recharges itself with new energy."[7]

This journey to other realms can occur as easily before the paintings of Ryman and Marden as inside the beeswax-lined house of Wolfgang Laib. Laib's golden enclosure, designed for just one person, is like a shrine of silence, perpetually ready for a personal ritual more Eastern than Western. Laib's use of beeswax, like his use of pollen, milk, and grains, fuses the natural, spiritual and ephemeral. In his understated way, Laib has created a meditative chamber that seems out of place, yet welcome, in the busy thoroughfare of a public museum.

The meeting of cultures is at the heart of the work of Lothar Baumgarten. In his installation for the *International*, the culture of the Cherokee Indian is introduced into a room modeled after the Greek Parthenon. In a setting which reflects the melding of the new and the old worlds, Baumgarten has inscribed the Cherokee alphabet (created so that its users could communicate in writing) on the glass paneled ceiling so that the letters float above the marbled hall. The 85 letters of the alphabet are placed among the 189 glass panels, creating a musical rhythm. As in most of his works, Baumgarten combines word (in this case only letters) and image as he facilitates the meeting of two cultures so as to ensure the integrity of both. One, the Cherokee, has been lost, and in reviving it, Baumgarten engages in a ritual of memory which could also be said to characterize the work of his fellow Germans Rebecca Horn and Anselm Kiefer and to some extent Baselitz as well.

Rebecca Horn's work is a complex mixture of reality and fantasy, fathomable mainly through intuition and insight. Horn confronts the viewer with symbols, performances and mechanical devices. In her enclosed room, *Kiss of Snakes for Oscar Wilde* (1988), pairs of mechanical snakes meet above one's head to "kiss". The snakes in their repetitious movement are reminiscent of the constantly striking hammers in Horn's earlier pieces in that they create an ominous feeling of inevitability and even threat.

In much of her work, Horn has explored myths and realities about women, another "Other" that has been brought to attention in the last decade. Elizabeth Murray's choice of tables and cups have obvious female and domestic associations, and the Blumes' photo sequences are based, in part, on roles determined by gender. This feminist subject matter becomes pointed criticism in the work of Sherrie Levine, who attacks the entrenched patriarchy in her appropriations, and Rosemarie Trockel, whose knitted garments—complete with ideological and power symbols—bring so-called women's activities to the arena of art.

The feminist critique is one of many debates challenging the art world—and in fact the world in general—in the late '80s. Opposed to the power of the art market and concerned with the absence or loss of meaning in art, many artists have turned to a spirited questioning of art as they have witnessed the decline of modernism. A group of young artists who have emerged in the last three years has made a practice of pointing out the loss of meaning and value in a world where real objects, meanings, and values have been replaced by signs or symbols. These artists have reacted against the non-referential character of the formalist tradition, as did a transitional Ross Bleckner who wanted to inject meaning into the failed language of Op art. Following Bleckner's example—and also Warhol's appropriations—they have recycled and changed the meanings of previous styles.

Peter Halley's geometric paintings look like earlier geometric abstractions, but in reality, they mock the official tradition with their Day-Glo colors and stucco surfaces. Sherrie Levine's recent geometric paintings, like Halley's, seem familiar but not quite recognizable, leaving the viewer uncomfortably disoriented. Referring to the formalist tradition, these paintings are full of irony; they are empty of meaning

and full of references at the same time. Levine says that she is operating in the three spaces defined by Warhol, who provides the link between Duchamp's Readymades and these younger artists' works: "There are three spaces: the original image, his image, and then a space in between, a sort of Zen emptiness—an oblivion in his work . . ."[8] While Halley refers to the influence of technology in his paintings, Levine feels that hers "evoke a great sense of loss, especially when the source images are about absence and the passage of time."[9]

The work of Rosemarie Trockel also includes familiar elements, but in her case, they are logos: the wool trademark, the hammer and sickle, the playboy bunny. Placed in garments—which refer to the ascendancy of appearances in which fashion masks the real person—they assume equal value and no value simultaneously. As Peter Weibel has argued, Trockel has replaced icons with logos, commenting in the process on the devaluation of ideology and meaning.[10]

Jeff Koons has recently been making sculpture that looks vaguely—and in some cases completely—familiar. In fact, *St. John*, one of several sculptures in the *International*, is based on Leonardo's painting of *St. John* in the Louvre. The familiar, however, has been tainted; the saint is now accompanied by a pig and a penguin with a cross. Koons' reproductions exhibit a wit and humor that can also be seen in the work of Fischli/Weiss, both in their Rube Goldbergian video *The Way Things Go* and in their white plaster cars, utilitarian objects which through a change in scale and material become utterly unuseable—a gesture of planned obsolescence taken to its logical conclusion.

Master punster Meyer Vaisman's paintings/sculptures are witty, multi-layered manifestations of art-as-commodity. To make *In the Vicinity of History* (1988), Vaisman first covered the surface of his canvas with a black-and-white, photographically enlarged image of the weave of the canvas. He then attached oval-shaped canvases, many of them filled with distorted images of ancient and Renaissance coins with the faces of emperors and gods, a pun on the monetary value of art. Vaisman also inserts the face of Sigmund Freud and a caricature of himself, revealing the artist and his personality as the ultimate commodity—a nod to Warhol. In his witty parody of high art, Vaisman seeks to de-mystify and deconstruct the meaning of art. He and his cohorts, many of whose careers he launched at his New York gallery International with Monument, are continuing the tradition of Duchamp and Warhol.

Three other artists of Warhol's generation—Artschwager in the U.S. and Sigmar Polke and Gerhard Richter in Europe—were influenced by the Duchampian tradition and were interested in popular culture, appearances versus reality, and the possibility of working in more than one style at a time.

Sigmar Polke, whose work seems to change every time you see it, has been appropriating images from popular culture and artistic styles since the mid-'60s, and along with Warhol, Jaspar Johns and Robert Rauschenberg formulated an art of equivalence between popular culture and high art. However, whereas Warhol's use of Campbell's soup cans or photographs of electric chairs is fairly direct, Polke has tended to layer his pirated images and styles.

By working in a variety of styles simultaneously, Gerhard Richter has refused to adopt a signature style. His vibrant Abstract Expressionist-looking works are not what they at first seem. In lieu of spontaneity, Richter has relied on his skills at duplicating the look of photographs and diverse styles of painting. Seen in the context of the late '80s, Richter seems to have anticipated the critical topics of originality and uniqueness in art in his probing of the multiplicities of reality and truth.

Richter's ongoing engagement with diverse styles is paralleled in the work of Richard Artschwager. Since the 60's, in both his paintings and sculpture, Artschwager has expressed his interest in the relation between reality and appearances. Using Formica, a synthetic substance often made to look like a material it is not, Artschwager has created some of his most effective pieces—non-functional items of furniture. His ideas have inspired neo-conceptual artists although he insists that his art is more about perception than about the re-definition of art and its role in society: "The subject is that everything is precious. To look at something longer than is usual is to stop and identify it, to identify, I hope, what it truly is. Now, to identify something is to celebrate it, to make it come alive in a way that it's never seemed before. There's no enigma in my final intention. Celebration makes clear my motives: to savor the moment, to make the best of what we have."[11]

Artschwager's optimistic sentiment is at odds with a prevailing fin-de-siècle pessimism and cynicism. Yet the attraction of his work to younger artists is linked to a sense that things as we know them are coming to an end. For many artists there seems to be a feeling of foreboding in the air. Technology, which has advanced to a point of prolonging, and even creating life, has a horrifying, life-threatening capability. Despite economic booms, there is an ever widening gap between the wealthy and the disenfranchised. Between the belief in the inevitability of a world-wide conflagration and the concern for a declining quality of life on an individual basis, there is a growing pessimism and a poignant sense of loss of meaning and value.

It's as if the world is waiting for the explosion, the apocalyptic moment, while not really believing it will happen. It's a mad rush to consume as much as possible, seduced by appearances while denying reality, a conservative holding on to the past when the future threatens to fall apart.

Art reflects this end-of-the-century anxiety; it addresses the repression of the "Other," it explores a painful past and present, it unmasks the superficiality of appearances. Art seems to have taken a critical, even would-be corrective stance. Yet, the art in the 1988 *International*, with all of its serious intent, resounds with Artschwager's celebration. The strong spiritual underpinnings evident in the paintings of Bleckner and the house of Laib cut directly to the heart. Kiefer's increasingly universal statements not only focus on the painful history of 20th-century Germany, but they also are "epic elegies to the human condition."[12] The critically engaged works of Levine, Trockel, Halley, Koons, and Vaisman in very different ways seek to reintroduce meaning and responsibility into art. Indeed, all of the artists in the show continue to create works that marry content and form, that try to be more than just a pretty picture. In this respect, they follow Beuys' example, to differing degrees, of the artist as agitator and as the voice of conscience.

Perhaps the intensified sense of end of decade, end of century, end of millenium is inevitable—a wish for summation, connection, completion, radical re-definition. For some artists it is an imperative to be reckoned with, for others it is but the next dozen years. Most of us look with trepidation to the year 2000, anticipating a "bang" but expecting only a "whimper." No doubt most of us will wake up on January 1, 2000 feeling little different—slightly hung over perhaps—from the day before.

1
Paul Gardner, "Elizabeth Murray Shapes Up," *ARTnews*, September 1984,
reprinted in Elaine A. King, *Elizabeth Murray Drawings 1980–1986*,
(Pittsburgh, 1986), p. 28.
2
Op. cit., p. 23.
3
Lily Wei, "Talking Abstract: Part II," *Art in America*, December 1987,
p. 171.
4
Claudia Hart, "Intuitive Sensitivity," *Artscribe International*, November–
December 1987, p. 37.
5
Claudia James, "Video Art at the International," *Carnegie Magazine*,
November–December, 1988, p. 9.
6
Lily Wei, op. cit., p. 171.
7
Annelie Pohlen, "Cosmic Visions from North and South," *Artforum*, March
1985, pp. 78–79.
8
Jeanne Siegel, "After Sherrie Levine," *Arts Magazine*, June 1985, p. 144.
9
Lily Wei, op. cit., p. 114.
10
Peter Weibel, "From Icon to Logo," *Rosemarie Trockel*, Basel and London
1988.
11
Steven Henry Madoff, "Richard Artschwager's Sleight of Mind," *ARTnews*,
January 1988, p. 118.
12
Mark Rosenthal, *Anselm Kiefer*, Chicago and Philadelphia 1987, p. 155.

The *Carnegie International* is a singular event but not an isolated one. This observation was stated often and in many different ways during the Advisory Committee's discussions, and it was the hope of the committee and the museum staff that this catalogue would focus attention on such general issues as well as on the particular artworks in the exhibition.

The 1988 *International*, a kind of anthology of accomplishments in the visual arts from 1985 to 1988, is the latest "volume" of an encyclopedic survey begun in 1896. While the *Carnegie International* remains the longest running, regularly occurring exhibition of its type in the U.S., a proliferating number of international survey exhibitions of contemporary art have appeared in the last decade and particularly in the three years since the last *International*. The show itself is the result of lengthy deliberations by an advisory committee working with the exhibition's curator, all of whom not only offered suggestions about artists to be considered for this year's show but also raised questions about the meanings and purposes of international exhibitions, why they take place where they do, how to deal with the troubling reality that the term "international" in the context of most of these exhibitions is limited to the territories of Western Europe and North America, and indeed, how much the selection of any group of artists, especially the 39 ultimately chosen for this year's exhibition, inevitably reflects the larger cultural climate.

As "ritual gatherings in the presence of artworks," in the words of Thomas McEvilley, art exhibitions have a complex history and broad philosophical implications. In his essay, McEvilley traces their beginnings to the caves of Lascaux, and follows their progress through time, ending with a detailed account of the almost century-long evolution of the *Carnegie International*. The dialogues among artists, and between artists and a larger public, which occur at international shows are explored separately by Lynne Cooke and Milena Kalinovksa, both of whom present, in a sense, critical "travelogues." Cooke discusses the decade's well-known exhibitions, from *Zeitgeist* to *Skulptur Projekte*; Kalinovska documents international exchanges between East European and Western artists.

The specifics of the 1988 *International* are presented by two of the museum's curators. John Caldwell, curator of contemporary art and director of this exhibition, writes about the logistics of the exhibition's preparation; Vicky A. Clark, curator of education, discusses the works in the show. The anthology is completed with texts on each of the artists by contributors from the U.S. and abroad.

—*Sarah McFadden and Joan Simon*

On the Art Exhibition in History:
The Carnegie International and the Redefinition of the American Self

Thomas McEvilley

The history of the *Carnegie International* chronicles the sometimes painful and difficult process by which America came to terms with modern art. It mirrors a radical redefinition of the American self, through a method that reaches back deep into prehistory. For behind it lies a vastly long record of human gatherings in the midst of art works, a ritualized practice that still functions much as it has for thousands of years. In the earliest art-making societies events not so unlike our international exhibitions took place.

When the paleolithic painted caverns such as the famous ones at Lascaux were opened the paint was as vivid and fresh as the day it was applied, preserved by a sealed environment for tens of thousands of years. It was in part the remote and secretive location of the paintings that preserved them. The famous "galleries" with the heaviest concentrations of paintings are often deep within the earth; to reach some of them one must traverse crawlspaces, climb chimneys, pierce behind waterfalls. The remoteness of the paintings, miles within caverns where air does not move and water does not evaporate, has kept the colors vivid.

It is not that the deep spaces are the largest or the most suitable physically for gatherings of human groups. They were evidently desired precisely because they were deep and difficult of access. This difficulty assured that no one but members of the specific group for which the paintings were made was likely to see them. And even that group would see them only after much deliberate effort, not lightly and casually. The difficult and sometimes dangerous approach, illuminated by flickering torchlight, promoted a special intensity of focus. This heightened feeling, along with the exclusiveness of the rites, tended to merge the participants' identities temporarily, bonding them around a certain definition of life through communal identification with relatively unchanging symbols—for the depicted animal forms, applied in chaotic overlays over thousands of years, show little if any stylistic change.

There, in the resonant galleries deep in the earth, groups of humans gathered before pictures and related to them in a variety of physical ways. The human footprints preserved here and there in the mud are not normal walking or standing imprints, but reveal special pressure placed upon the heel, suggesting a movement not unlike a dance mimetic of the buffalo observed among some Amerindian groups. Most of the prints seem to be those of young adolescents, suggesting that initiation into the tribe, partly through revelation of the hidden pictures, was one function of the rite. Musical accompaniment, on whistles made of such magically potent materials as eagle bone, was played by shamans dancing in animal suits. Marks of spearpoints on some of the painted animal images indicate that the magical preparation of the prey for the hunt was another of the functions these gatherings performed. The whole event had the characteristics of a grand cultural festival combining painting, music, dance and dramatic narrative combined in a symbolic *Gesamtkunstwerk*. Its function was dual: the symbolic definition and bonding of the group and a specific pragmatic purpose to be magically accomplished.

The practice of group bonding through symbolic representations which invite communal identification survived the cave culture. As the state emerged in the ancient Near East around 3,000 B.C., the temple precinct and palace became the symbol-saturated sites of such gatherings. The sound-box of a Sumerian harp from that period depicts a rite that seems closely related to the paleolithic one: it shows performers dressed as animals playing lyre, sistrum and tambourine while another participant dances. In ancient Egypt in the same age, such events involved orchestras of as many as five hundred musicians in settings featuring sculpture, painting and ritual drama. All the arts conjoined to create a sense of the rightness of a

certain culture and a society, by implying that its world view was the world itself.

The function of validating existing power structures was central to artistic practice in feudal societies from the ancient Near East to the Christian Middle Ages. Since art was regarded as having the magical power to either stabilize or destabilize the state, it tended to be closely controlled. Plato says in the *Laws* that in Egypt the only art and music that were legal were those prescribed by the temples, and that no deviation whatever from these established norms was tolerated.

The fact that the artistic professions were inherited rather than chosen in feudal societies reinforced the conventionality of the artistic message. But later, by the 6th century B.C. in ancient Greece, the breakdown of the feudal order led to significant change: the arts found their way beyond the supportive or validating role toward a critical stance. The emergence of a mercantile middle class engaged primarily in foreign trade triggered the promotion of individual effort or merit as an ideal to counter the old aristocracy's emphasis on familially inherited position. Individualism brought subjectivism in its wake. Poets began expressing individual points of view rather than reiterating traditional wisdom and lore; artists began signing their work, emphasizing both self-expressiveness and the new sense of art as a chosen vocation.

In this situation the first art museum arose— that is, the earliest known public building intended exclusively for the display of artworks, as distinct from temples, palaces and other public buildings which contained artworks as accoutrements to their central functions. The Pinakotheke, or Picture Gallery, formed the west wing of the Propylaeum, the entrance-building to the Athenian Acropolis, built in the fifth century B.C. The Pinakotheke consists of a single room with a dado extending horizontally around the wall to facilitate the hanging of portable pictures painted on wooden panels; windows are placed to admit viewing light. The paintings shown there seem to have been on more or less permanent display. Pausanias describes them as depictions of traditional mythological subjects, often violent, with occasional genre scenes and at least one portrait of a controversial statesman, Alcibiades, the presence of which suggests the stimulation of political debate as one function of a newly critical and subjective secular art.

The Erechtheum, inside the sacred precinct of the Acropolis, also had panel paintings hung within it. These, like the artworks in bronze age temples or paleolithic caves, were not presented to a public with the sole or even primary purpose of being contemplated as art, but were experienced as elements of religious practice, with the magic of the fetish-icon still clinging to them. The Picture Gallery was attached to, yet outside the temple complex proper, at the transition point to secular space. It is this partial separation from the ritual precinct which gives a clue to the Picture Gallery's significance. It demonstrates the freeing of art from its ancient matrix in religion and posits the esthetic experience in a modernist sense, as one to be sought for its own sake, alongside the older function of group bonding and defining through ritual.

In this same cultural setting, something close to our modern custom of periodic international exhibitions arose, as Athenian bonding rites were performed before foreigners. In ancient Greece, the seas were closed to ships each year during the stormy winter season, and few foreigners remained in Athens. The annual Festivals of Dionysos, at which the tragic and comic plays were performed, took place after the re-opening of the sea to travel, when Athens was filled with large numbers of wealthy international business visitors. Unlike the secret paleolithic cave rites, these self-defining rites of the Athenians were offered to the outside world as advertisements for a democratic way of life.

The social policies of ancient Athens were less predisposed to preserving a status quo than to constructive use of the forces of change. In this setting art played the role (as it would again in modern times) of criticizing and redefining society rather than of revalidating its inherited structures. Certain of the plays written and performed during that era focused on conflicts between individual rights and the power of the state, such as Sophocles' *Antigone*; others, such as Euripides' *Trojan Women* and Aristophanes' *Acharnians* and *Peace*, were open criticisms of specific governmental policies. If the community was bonded in these events, it was bonded around the principles of criticism and considered change.

The visual arts also reflected a changing sense of what it meant to be a human being participating in a

society. Artists like Polyclitus and Praxiteles made sculptural proposals about the proper role of the citizen, who came to be represented less as enmeshed in a monolithic surrounding structure and more as an observing individual with a detached and sometimes ironic eye.

It is no accident that this same period gave rise to the writing of democratic constitutions and the open experimentation with new forms of statehood. The arts became instruments sensing the winds of change. With their enlarged role, artists could rise from the ranks of artisans to become famous and wealthy public personages. Like the work of philosophers, theirs had a good deal to do with the central questions of humanity's meaning and purpose. At the Dionysian festivals, a process of communal self-defining, criticizing, and redefining took place. When Sophocles' work gave way to Euripides', the people saw themselves anew.

With the decline of Greco-Roman secular humanism, art lost its critical function and was drawn again into the matrix of rite by the monolithic religious culture of the Latin Middle Ages. It was recontextualized as an integrated part of a feudal order, with prescribed subjects and a commitment to maintaining the social structure. The art museum, like the library, vanished; the communal *Gesamtkunstwerk* once again performed its validating function in the cathedral. With the rediscovery of Greco-Roman cultural attitudes in the Renaissance, art emerged again from the religious totality and reclaimed an independent secular status. As in the Hellenistic world, (and even at rare times in the medieval world) the palaces of nobles and wealthy merchants came to house art collections assembled not for ritual function but for esthetic delectation. Toward the end of the Enlightenment, which saw the culmination of the Renaissance revival of Greco-Roman attitudes and mores, the first modern museum—the Louvre—was created in the tradition of the Museum, or home of the Muses, in ancient Alexandria. Liberated by the Revolution, the former palace was filled by Napolean with art.

In the 19th century, the widespread belief in history-as-progress gave the museum collection its chronological or developmental structure and with it a heightened sense of significance: it was seen as constituting a plastic record of a continuous set of successive eras, the visual embodiment of the onrushing force of progress. Related types of cultural exhibitions, such as the World's Fair, also promoted the modernist ideology of progress and thus, unlike premodern or feudal festivals, enshrined change. Again, unlike the bonding rites of tribal groups, but like the ancient Greek festivals of Dionysos, these events tended to address a wide international public.

At the end of the century, several forms of cultural celebration—the World's Fair, the International Exposition, the museum, and the periodic or seasonal festival—were combined in the *Venice Biennale*, the first major recurring international exhibition of art, founded in 1895. The following year, the American industrialist and cultural philanthropist Andrew Carnegie helped found the *Pittsburgh International* as an annual international exhibition of contemporary painting.

At these big international shows, as in primitive rites or feudal religious festivals, large groups of humans gather to perform a bonding rite in the presence of art works which symbolically define and ratify the characteristics of the group. Yet the modern gathering is different in crucial ways from those older types. It is historically linked not with the feudal state but with capitalism and democracy. Its prize-giving orientation reflects the primacy of self-expression, competition of sensibilities, and belief in the social reward for individual accomplishment. Such a reward system dates back to the popular competitive festivals of ancient Greece—to the athletic festivals at Olympia, Delphi, and elsewhere, and to the dramatic festivals at Athens. Even the somewhat peculiar idea of a painting competition has specific classical antecedents recorded in Pliny's anecdotal record of painters such as Apelles.

Still, despite this orientation to individuality, the modern international exhibition is a communal event, and its meanings are communal, though expressed through individual sensibilities. The social function of the major periodic international exhibitions—the *Venice Biennale*, the *Carnegie International* (as it has been called since 1982), *Documenta*, and the *São Paolo Bienal*—involves the reawakened perception that artworks in a post-feudal setting should not only validate, but also define, criticize, and redefine human selfhood and its position in the world and in history. The images of selfhood which art provides change as a culture's sense of what it is changes. Art can thus be seen as the soul of a culture, the representation of its own idea or self.

Art museums serve this soul in two ways. A museum's permanent collection accumulates the soul or self-representation in a layered mass, a great and articulated fantasy or dream of the evolving self and its adventures. It presents a self-definition based on the idea that the self is primarily constituted by memory. Through the collection, the communal self says, in effect, "I have been here and I have been there; I was this and I became that." Such a layered collection (or recollection) shows the self of a culture as changing, and hence incompletely formed. This perception, however, is concealed behind the art-historically generated sense of unity of tradition enshrined in the permanent collection.

The idea of this cumulative, layered, yet still somehow supposedly unitary selfhood is premised on the Hegelian concept that history is moving toward a final culmination and that its different phases represent logical stages of development within an evolving totality. There is a hidden implication that a museum's permanent collection will one day become Total, and the history it commemorates, the selfhood it embodies, be fulfilled and complete. The material analogue of this idea of history is the physical fact that the collection fills up its available space and then has no more room to grow.

The periodic exhibition of contemporary art articulates a communal selfhood in a different way. It commemorates the fleeting moment of the cultural self, like catching glimpses of one's passing image in windows on the street. It articulates a definition that is just emerging, that is acknowledged as still in process. A museum's permanent collection, with its physical limitations, cannot substantially reflect the fleeting present. A museum based on a permanent collection must one day inevitably freeze around that collection. The Louvre is the Louvre forever and articulates forever a certain fixed view of the identity of Western civilization.

The periodic exhibition serves a more immediate need closer to that performed in ancient Athens by the annual competitions of tragic dramas—to define change as it happens, to see the self as always emerging, as an elusive reality that is forever becoming its own future. At the same time, each actual exhibition is a crystallization of a certain moment of the flow, a fly-in-amber preservation of a selfhood that, while new, is already passing or past. The periodic exhibition celebrates the changes of the self; in it, as in a mirror, the old self looks at the new self and,

sometimes with surprise, contemplates its innovations—or lack of them. The unity that is implied is like the unity of Locke's sock which, in John Locke's philosophical parable, receives one patch after another till nothing of the original sock is left and a process of perpetual change has become part of its nature.

The periodic exhibition is like a body taking its own temperature. So there is to this type of exhibition a certain sense of letting go, of welcoming change, of affirming the potential self that the self might change into. Here art is invested with the power of delving directly into the most intimate recesses of the self, publicly and communally. The process was encapsulated in a *New Yorker* cartoon from the late '60s; as two togaed Greeks are leaving the theater, one says to the other, "I don't think Sophocles is sick; I think Sophocles is telling us that we're sick."

The fact that a periodic exhibition of the kind just discussed should be called "International" suggests a sense of cultural identity that ideally transcends nationality to a degree, establishing commonality among various groups. The *Carnegie International* is specifically committed to this: one of the exhibition's purposes stipulated by Andrew Carnegie himself was to "spread goodwill among nations through the international language of art." But the international language of art had by Carnegie's time become modernism and was very soon to become modernist abstraction, and this international language was difficult for the turn-of-the-century American cultural consciousness to learn or to accept. Even New York had trouble with modernism. And the phrase "Pittsburgh International" was almost a contradiction in terms.

The audiences of the early *Internationals* did not want pictorial innovations meddling with their down-to-earth self-image and their naive-realist sense of the known stability of their world. What the history of the exhibitions shows is the gradual and often painful loosening of the concept of American selfhood, the uneasy and epochal opening of a provincial sensibility to a sense of participating in international culture. Consequently, the historic function which the exhibitions have performed has had less, finally, to do with spreading goodwill internationally than with chronicling the opening of the American mind to a history which, while larger than its own, both contains it and somehow is of its essence.

For its first thirty or forty years, the *International* exhibition remained a survey of 19th-century-style painting. The effects of the Armory show of 1913, which essentially introduced European artistic modernism to the United States, were not reflected in the *Internationals* for almost 30 years. Non-representational or non-objective art seemed an affront to the American sense of reality and identity. Impressionism was popular in *Internationals* from their outset, but Post-Impressionism, Fauvism, Cubism, Die Brücke, Der Blaue Reiter, Dadaism, and de Stijl all passed by on the river of history without making a ripple on the shores of Pittsburgh's three rivers. Modern artists easily reconciled with 19th-century viewpoints, such as Bonnard and Vuillard, were shown from 1922 on. Braque was not included till 1928, and Rouault not until 1937. Neither Kandinsky nor Klee was shown until 1939.

Throughout the '20s and '30s (the *Internationals* were suspended in the '40s), the exhibitions provided the occasion for critical battles in which the advance of modernism into America, especially modernist abstraction, was met with fierce resistance in the press. When Braque's *The Yellow Cloth* won first prize in 1937, the *New York Herald Tribune* critic wrote:

> A more purposeless jumble I have never seen, and there is nothing in the smallest degree interesting about it. The composition, as I have indicated, is weak, so is the drawing, and the color has no charm or 'quality' whatever. Why "The Yellow Cloth" received the first prize remains a mystery, unless it is to be explained on the hypothesis that the jury desired to make a gesture toward the left.

The impression that abstract art was a communist menace persisted into the '50s, when America's post-war global involvement forced the crucial transformation which the *Internationals* seem almost to have been awaiting.

The turning point was 1952, the year in which Gordon Bailey Washburn took over directorship of the *Internationals* and opened them more vigorously to European and abstract art. These exhibitions have left us, as symbolic records of this rite, a series of catalogues, each of which embodies its moment in all its tensions and specificities. The cover of the 1950 *International* catalogue, for example, shows a pre-Raphaelitish Nike, or winged goddess of Victory; it heralds the Nike-like entrance of American influence into post-war Europe, with a quaint inability to see emerging American hegemony in a modern guise yet. The first prize that year (worth $2,000) went to Jacques Villon, the second to Lyonel Feininger, the third to Priscilla Roberts. An additional prize was described as follows: "Garden Club Prize, $300 . . . to Leon Devos. Awarded by the jury to the artist painting the best picture of a garden or flowers. Given by the Garden Club of Allegheny County."

In the 1952 catalogue, with its quasi-abstract cover design suggesting a connection with international modernism, Washburn speaks in the voice of a local community that is seeking a way to view itself as part of a great world:

> No city is more occupied than Pittsburgh with the basic materials of twentieth-century life. Our industries produce the coal, iron, steel, aluminum and glass, as well as other materials out of which most of the things that we use are manufactured. Our houses, skyscrapers, bridges, airplanes, machinery, kitchenware, together with hundreds of other structures and objects, depend upon Pittsburgh's brain and brawn. The modern world is our business. We are at the heart of the new industrial civilization. . . .

In an attempt to satisfy the local audience, which may not have seen eye to eye with the more cosmopolitan jury (first prize to Ben Nicholson), each copy of the catalogue contained a blue slip entitled "Popular Prize Ballot." At the bottom was a line reading, "I vote for painting Number . . . ," with the admonition: "Be sure to sign your name below. Otherwise your ballot will not be counted."

The catalogue to the 1955 *International* featured a forthright Abstract Expressionist cover design attributed to "Afro, a member of the 1955 *International* Jury of Award." From that moment the die was cast. The 1955 and 1958 catalogues increasingly distance themselves from locality, addressing instead what in that day seemed universals of esthetic process: "In a sense," Washburn writes in 1958, "human societies delegate to artists, beyond all other members of the community, the duty of full freedom . . . Artists have discarded the old, conventional idea of an objective reality . . ." During the Washburn years, the world view reflected in the exhibition catalogues steadily expanded. In 1952 Washburn wrote about Andrew Carnegie; in 1958 he quoted Werner Heisenberg, Rainer Marie Rilke, Henry Miller's *The Creative Process* and Alan Watts' *The Way of Zen*.

The lists of works included in the shows in these years illustrate the arbitrariness of art history, as an occasional work is picked out to stand as a monument to a historical moment it may ill represent. Most of the artists in the exhibitions were not heard of again in international art discourse. Still, although the majority faded from view, an impressive, quick reading of posterity is provided by the names of those who did not. For the 1955 *International*, Washburn included works by Helen Frankenthaler, Richard Diebenkorn, Jackson Pollock, Ad Reinhardt, Robert Motherwell, Sam Francis, Stuart Davis, Larry Rivers, William Baziotes, Alberto Burri—and Andrew Wyeth. American artists were represented in far greater numbers than artists of any other nationality, yet the extraordinary parenthetical notation, "Sch. P.," which Washburn explains, "signifies that the artist is considered of the School of Paris, though not French-born," was used to characterize many of them.

The crucial 1958 *International* had an especially sensitive finger on the pulse of change and emergence. Marcel Duchamp was a member of the Jury of Award, and a prize was given to Jasper Johns for *Grey Numbers*. Also in the exhibition were works by Joseph Cornell, Robert Rauschenberg, Allan Kaprow, Ellsworth Kelly, and Michael Snow, alongside works by Rothko, Newman, and Reinhardt and, in a still deeper layering, works by Picasso and Ben Shahn, both perennial inclusions in *Internationals*.

Through the '60s, the *International* struggled to pin down an art that was increasingly involved in change. The 1970 exhibition, by eliminating the prize system, tacitly acknowledged the futility of seeking a consistently applicable standard of quality at such a confusing moment. The catalogue text announces that "There will be no guide posts to the 'best' art in the show—as though that were remotely possible!" Still, the same text insists, "Quality is the sole criterion for selection." The confusion intensified in the face of the difficult developments in 1970s art. Neither Minimalism nor Conceptualism was acknowledged to exist. From 1970 until 1982, the *International* exhibitions were replaced by one-person exhibitions of older, established artists—Chillida, Alechinsky, De Kooning. While the museum's intention was to be responsive to the mounting criticism of international exhibitions, the change seemed at the same time an expression of impotence before post-modern pluralism and relativism and their artistic embodiments. The '70s—the decade of the ephemeral, the conceptual, the immaterial, and the site-specific—is invisible in this record of 20th-century art. In 1982, the *International* was revived with a confusing mass of mostly conventional '50s-style painting and sculpture, much of it kitsch-abstract, in an exhibition that was both unfocused and regressive. There was still no hint that Minimalism and Conceptualism had ever existed, or that the '70s ever transpired.

This recognition finally came in 1985 primarily through the exhibition catalogue, which took the form of a critical anthology; here, essays on Conceptual and Minimal art acknowledged for the first time the cognitive element in art. In a sense, the 1985 *International* shows the coming to age of the exhibition after nearly a century of struggling to accept the sometimes difficult and challenging cultural material that entered the American public sphere by way of this channel. In another sense, one might view this coming of age as a loss of self, as the dissolution of a specifically American point of view without which this exhibition becomes less distinguishable from others of its kind in Europe and elsewhere.

Andrew Carnegie's admonition to "spread goodwill through the international language of art" continues to be acted out in this temporary transcendence, or transgression, of clan identity. Differences in local ambience become peripheral to an international guild-like merging of identity. Standing among the pictures and sculptures which show us where we are like coordinates on a map, we regroup and ritually bond. We formalize the sense that here is another marker of a collective journey.

Exhibition Tracking: The Late '80s

Lynne Cooke

What is now called for is the preprogrammed visitor with a desire to learn and not the flaneur who sometimes drifts into a museum.

Veit Loers
Schlaf der Vernunft (The Sleep of Reason)

I regard it as the task of the exhibition curator not only to underline the tendencies that are already creating a furor in our *Zeitgeist*, but also to track down those which exist beneath the surface and which fail or succeed in surfacing according to our capacity to understand them.

Martin Kunz
Edinburgh International

During the three years since the last *Carnegie International*, a terrific number of international exhibitions have taken place. In attempting to provide a diaristic, chronological and critical account of some of the most significant of them, it becomes apparent that there are two opposing tendencies at work: while some of the exhibitions venture out into society, recalling the '60s atmosphere of de-sanctifying the showplaces for art and questioning once again the essential purposes of the art object, still others re-explore the traditional museum setting as the proper framework for much of the art now being made.

The public demand for contemporary art has expanded enormously in recent years, and, encouraged by this vastly enlarged audience, new venues and new museums are constantly springing up. Madrid, Los Angeles, Edinburgh, Athens and Turin, in addition to the more familiar sites of Cologne, London, Venice and Kassel, have all hosted major shows in the past couple of years. Moreover, certain perennial shows have been revived, including Sonsbeek (*Sonsbeek '86*), the Frankfurt Triennale (*Prospect 86*) and the Paris Biennale (*Nouvelle Biennale de Paris 1985*), while the largest of all, *Documenta* and the *Venice Biennale*, continue, notwithstanding much criticism.[1]

In addition to shows dealing exclusively with contemporary art, there have been a number of others which have attempted to situate recent practice in a wider framework: notably, *"Primitivism" in 20th Century Art*; *Arte e Scienza*; *Spuren, Skulpturen und Monumente ihrer präzisen Reise* (Traces, Sculpture and Monuments of Their Exact Journey), all of which bypassed schools and stylistic categories in order to plot thematic trajectories, and in some cases thereby to reinterpret standard histories of 20th-century art.[2]

Also addressing the present through the filter of the past were a number of less focused shows which sought to map the field of post-war art. Among these were *Individuals: A Selected History of Contemporary Art 1945–1986* which launched the Museum of

Contemporary Art in Los Angeles in 1986; *Europa/ Amerika*, which did the same for the Museum Ludwig in Cologne in the same year; and *Transformations in Sculpture: Four Decades of American and European Art* at the Guggenheim in New York.[3] Whether by design or default such shows posited a series of oversimplified oppositions or fabricated a seamless continuity between past and present practice.

As the decade comes to an end, more and more contemporary international shows tend to be issue-based or thematically conceived exhibitions. The great encyclopedic shows that proliferated during the first half of the '80s and that served primarily as a means to inform audiences in widespread locations about new trends in art have apparently fulfilled those ends: *An International Survey of Painting and Sculpture* at the Museum of Modern Art in New York, *Anni Ottanta*, a collaboration by the four north Italian towns of Bologna, Imola, Ravenna and Rimini in 1985, the 1985 *Biennale de Paris*, and *New Art at the Tate* were but four among many.[4] At the same time, the stress on painting, or, more accurately, on a particular mode of painting—figurative expressionism—first heralded in 1981 by *A New Spirit in Painting*, the landmark show that strongly influenced the first half of the decade, has faded.[5]

Despite a marked shift from shows devoted mainly to painting and sculpture to ones which incorporate a wide range of mediums, the much talked-of "neo-post-conceptualism" has not yet been pinned down by a major exhibition. Neo-Geo, the most heavily promoted manifestation of this phenonemon was first extensively examined in *El Arte y Su Doble*, an exhibition organized by Dan Cameron and held in Madrid in 1986. *Cultural Geometry*, a show hosted by the Deste Foundation in Athens, has provided perhaps its most contentious showing to date.[6] Installed by artist Haim Steinbach, one of its noted practitioners, the exhibition juxtaposed this American-bred art with contemporary European works as well as with ancient artifacts from Greece and Cyprus. While the curator, Jeffrey Deitch, presents a persuasive case for the American work, the European parallels are not wholly convincing, nor are those connections to the art of Antiquity which he asserts, but does not demonstrate, in his text.[7] Flawed examples notwithstanding, the idea of establishing a dialectic between the art selected for an exhibition and site has become prevalent in recent years. Achieving this objective very often has entailed reconsidering the audience, targeting the local public as well as the international cultural jogger. Such exhibitions are tending to include a limited number of artists whose work is presented in greater than usual depth.

The larger theoretical issues of modernism and postmodernism, which fueled much of the best critical writing of the early '80s as well as the practice of increasingly diverse groups of artists, are now featured as exhibition themes and as subjects for catalogue texts. In some instances the art serves to advance the theoretical argument; in others it simply illustrates it; and in yet others it is a heterogeneous mixture that does little more than mirror the selectors' taste with the catalogue text serving as a pretext for bringing the works together.

Mostly, individual issues, such as classical revivals or appropriation, rather than the complex nexus of questions encompassed by postmodernism have been selected out for particular attention, as occurred in *Falls the Shadow, Recent British and European Art* (1986); *Edinburgh International: Reason and Emotion in Contemporary Art* (1987); *Similia/Dissimilia* (1987); *Schlaf der Vernunft* (The Sleep of Reason) (1988); *Avant-Garde in the Eighties* (1987); and *L'epoque, la mode, la passion, la morale* (1987).[8] Nonetheless, the latter two failed to present cogent, clearly argued theses and subsided into routine compendia of familiar international names rounded out by a few local stars.

By contrast, *Similia/Dissimilia* and *Falls the Shadow* were both more ambitious and rigorously presented. The organizer of *Similia/Dissimilia*, art historian and curator Rainer Crone, grouped works by a selection of artists who emerged in the '80s with art by a sampling of their elders. The conjunction supported the notion that art provides a counterpart to, not an imitation of, reality. Crone argued that if such work is to refer to something beyond itself, then it must do so by means of metaphor. The notions of reality that are thereby produced are necessarily relativist— shifting models or speculative projections, never absolute truths. As such, they correspond to concepts of reality that inform other areas of experience, notably science and linguistics.

Importantly, Crone's thesis does not seek to establish a historicist reading of the connections between the two groups of works, but neither does it attempt to suggest that the works project a set of

meanings outside a series of framing discourses. Nonetheless, for Crone, linguistic constructs never directly correspond to objects and are never true as such; rather they serve in an enabling capacity.

Crone's stance contrasts with Jon Thompson's and Barry Barker's in their 1986 show, *Falls the Shadow*, an exhibition of works by some 30 European artists. In their polemic against modernist readings and historicist orderings (and, additionally, against American critical practices) they maintained that the works, seductively installed in London's Hayward Gallery, would communicate through poetic means. In the catalogue, they state "the show presents no historical map, furnishes no didactic argument, no theme, and only a deeply hidden critical prognosis."[9] Through an installation that emphasized differences they hoped to set aside those various critical discourses which normally structure discussion of individual works in order to let the works themselves establish dialogues, notwithstanding the substantially different esthetics they might embody.

Thus, for example, works by Richard Deacon, Per Kirkeby and Georg Baselitz were grouped together in one area; elsewhere examples by Christopher LeBrun, Wolfgang Laib, Avis Newman and David Bomberg were assembled together. On the whole the results seemed arbitrary. Other juxtapositions could have proved equally telling. Ultimately, the show paid tribute to the selector's taste rather than to any larger thesis, for their treatment of the museum as a neutral, self-contained space which isolates art from the rest of the world flouts the vehement criticism—which has been mounting for over a decade—of precisely this practice. How work is framed by a show and/or the institution which contains it is now a factor recognized as bearing on the general shape as well as the content of an exhibition from its earliest stages.

Unlike Barker and Thompson, the three selectors of the first *Edinburgh International* (1987)—Michael Compton, Douglas Hall and Martin Kunz—attempted to link their show both to the building which housed it, the Royal Scottish Academy, a Neo-Classical edifice purpose-built as an exhibition venue, and to certain intellectual traditions informing the cultural history of the city. The curators felt the need "to find a starting point for the exhibition in the enlightenment philosophy and architecture of Edinburgh" (once dubbed as the "Athens of the North").[10] The result was an exhibition which surveyed the concept of classicism from four positions, among which "the quotation of traditional classical styles, subjects and images" was only one—and a minor one at that.[11] While the thesis was challenging and the selection of works which fleshed it out provoking, the organizers missed the opportunity to examine the authoritarian values embodied in Neo-Classical architecture: contemporary artists, like Günther Förg for example, who directly confront such issues in their work, were not present.

Relating exhibition theme to local traditions was central to the organization of *The Sleep of Reason* (1988) as well. As in the *Edinburgh International*, the site—Kassel's Museum Fridericianum—was a Neo-Classical building. Originally designed as an encyclopedic museum, the Fridericianum was described by the exhibition's director, Veit Loers, as follows: "The museum's [physical] layout reflects a clear cosmological logic. Above art and nature lie the humanities, philosophy and the natural sciences. At the very top astronomy . . . the pressure of systemization [is] strong. All the collections have to be pressed into the educational scheme of the museum."[12] Yet gradually over time, the function of the building altered, its exhibitions reduced to the contents of a number of display cabinets. Stripped from its encompassing cosmology, the remaining artworks now served merely representational ends.

While the Fridericianum was recently restored, its original function, of course, could not be. Loers argues that in this post-enlightenment age—an age in which reason sleeps—irrationality need not however triumph. An alternative, that is, a different mode—one of "unreason"—may surface, offering new models for understanding.[13] His exhibition linked objects from the former 18th-century collection, such as maps, scientific instruments and mineral samples (installed on a central axis), with recent works by contemporary artists, ranging from Domela, at 88 the oldest, to Jeff Koons, Gerwald Rockenschaub and Gianni Asdrubali, in their early thirties. With a room allocated to each artist, the work of all 26 participants was presented in some depth, yet the demands on the viewer were high. Connecting Loer's thesis to an exhibition conceived as a kind of "thinking model" for eliciting intimations of the ways in which a new mode of nonrational (as distinct from irrational) apprehension of the world might operate, required the spectator to engage in some depth with the issues at stake.

The fact that *The Sleep of Reason* was staged in one of the two principal venues of *Documenta VIII*, held less than a year earlier, also cannot be ignored. In certain respects Loer's approach might be read as a corrective to that inchoate mélange, whose manifold weaknesses sprang above all from the fuzzy conception at its heart. Manfred Schneckenburger, *Documenta VIII*'s director (he was also the principal organizer of *Documenta VI* in 1977), declared the focus to be on art which engaged with society, highlighting "the new social responsibility of art."[14] Several models of the relationship between art and society seemed to be competing with each other: art as reflection, epitomized in the apocalyptic "machines" of Anselm Kiefer, Robert Morris and Robert Longo; and as critique, in the politically oriented statements of Hans Haacke and Barbara Kruger, among others. Yet since, for Schneckenburger, "the way into society does not only depend on iconography and theme, but also with (sic) use and function,"[15] design and architecture were also accorded a place: the former included the work of Andreas Bandolini and Totem, while architecture was presented in the guise of (ideal) plans for museums by such luminaries as Hollein and Ungars. To complete the chaotic miscellany—itself a metaphor for social disorder?—a series of heterogeneous outdoor pieces grappled with their surroundings, though rarely in ways that convincingly tackled the issues inherent in situating contemporary art in public places, serving instead too often to simply decorate or to decorate simply their surroundings.

The double-barreled question of art's social function and its public role surfaced again in what proved to be two of the most lauded shows of the past couple of years: *Chambres d'Amis* ("Guest Rooms") held in Ghent in 1986 and *Skulptur Projekte*, in Münster during summer 1987.[16] For the former, Jan Hoet, the director of the city's Museum for Contemporary Art, invited some 50 artists to make the works in the private homes of local residents. His aims were to bring the audience out into the larger arena of the city and to invite artists to consider the relation between public and private spaces.[17] The variety of artistic solutions—certain artists stripped rooms and used them as museum spaces; others preserved their domestic character but blurred the boundaries between the work and the room; others took on the role of interior decorators rather than object makers per se, etc.—was matched by the wide range of critical reaction to the show. Rudi Fuchs, director of the Haags Gemeentemuseum, for one, argued that there was no need for alternatives to the museum, since it is in that institution's constant spaces that contemporary art finds its proper place for debate.[18] For Fuchs, the museum gallery is a standard—an ongoing public point of reference. Since, he claims, the idealistic alternatives expected in the early '70s from outdoor venues did not materialize, in that they did not finally prove viable or sustainable, what now results from seeking out new situations for art constitutes little more than spectacle and novelty.

This shift in both artistic practice and critical opinion regarding the merits of outdoor installations was underlined by Saskia Bos, curator of *Sonsbeek '86*. First instituted in 1949, this annual sculpture show in the park at Arnhem has lapsed on several occasions. Before '86 it was last held in 1971, when, under the title *Sonsbeek Unlimited* and the direction of Wim Beeren, the exhibition not only occupied the park and adjacent museum, but was dispersed all over Holland. It also expanded the definition of "sculpture" to include performance, film and video. The objects in the show's 1986 edition, were not only confined to the local environs but were housed mainly in several pavilions constructed specifically for the exhibition within the grounds of the park. Bos contended that contemporary sculpture is not at one with the natural world, but rather seeks to divorce itself into specialized environments: "More than ever, today's artworks are artificial products that are not suited to a natural environment, let alone to being involved with it."[19] This point was echoed by Fortuyn/O'Brien, a collaborative duo whose work was included in *Sonsbeek '86*. "A sculpture in the open air, but without any demonstrable context, takes on an illusory character, has the effect of a *fata morgana*, and reveals the doubt about its existence."[20]

Considerations such as these prompted Kasper König and Klaus Bussman to attempt a very different approach in the follow-up to their first show of outdoor sculpture, held in Münster in 1977. König asserted that "the overall guiding spirit of this project (*Skulptur Projekte*, 1987) is a skepticism towards a fashionable notion of public art."[21] On this note, some 60 artists were invited to visit the city to select sites for which they would then propose works. The best of these projects that were realized related to their locations in manifold ways since the artists took the opportunity to

incorporate into the work aspects of the town's socio-cultural milieu and patterns of daily and institutional life. Jeff Koons replaced the *Kiepenkerl*, a statue of a farmer which has become a cherished local talisman and a popular subject for postcards, souvenirs and trinkets, with a stainless steel replica. The solemnity of the unveiling ceremony to inaugurate Koons' version astutely pinpointed the precarious civic position occupied by this public sculpture since it is itself a copy of the original bronze destroyed during World War II. By contrast, Fischli and Weiss exploited the actual rather than the attributed values of their site, a disused parking lot adjacent to a movie theater and snack bar. Here they constructed a small kiosk/model building in an anonymous and banal architectural style designed to harmonize perfectly with the surroundings.

The dialogue between a work and its context not only engaged the local audience in unexpected ways, but required more than usual of the international audience, which has grown accustomed to shows of outdoor art which treat the environment as a kind of safari park, where works are herded into carefully controlled enclosures for tourists to contemplate from a safe distance. As *Skulptur Projekte* demonstrated, genuinely resonant and meaningful connections between site and work are not easily established. They are the result of slow, complex, and often painfully problematic planning and require the audience, the municipal authorities, as well as the artist, to stray from familiar, and therefore preferred, accredited paths.

Nonetheless, for better or worse, the museum is currently generally regarded as the principal site in which art's meaning is constructed and manipulated. "In the visual arts, the era of the early '70s believed itself to be a great flowering of postcapitalist culture. It believed that the commodity and its mind-set would be replaced by performance and by site-specific works . . . The artist would play out the role of the free-subject, creating a model that would be emulated elsewhere in society. But the '70s represented not the flowering of a new consciousness, but rather the last incandescent expression of the old idealism of autonomy. After this . . . no cultural expression would be outside the commodity system."[22] These ideas expressed by Peter Halley have won assent from a broad spectrum of artists. Yet as Halley's own work demonstrates this does not necessitate an art that overtly theorizes its place within the system, for in focusing on the ways in which it acquires meaning, the non-didactic, individual artwork may say as much about what art can mean,

and thus as much about its social meaning, as a work which approaches that question from a polemical perspective. It is still possible to accord autonomous (but not hermetic) art a critical function, as the negation of the instrumentalist, means-ends directed character of daily life, without disavowing the commodity character of the artwork and the key role of the museum in its legitimation.

Yet the fact that most vanguard artists in the '80s choose the site of the museum as the pre-eminent locus for their work and willingly participate in international contemporary shows posits a challenge to curators. Simply paying lip-service to that overworked if much vaunted notion of pluralism constitutes a failure to recognize a distinct number of sub-groups—whether they be Neo-Geo, the New British Sculpture, or a mode of neo-conceptual object-making as found among younger German artists. Not only does the assembling of a plethora of different types of work under one umbrella have a dulling, homogenizing effect, it may become a form of repressive tolerance, further facilitating art's manipulation as spectacle.

As the best, and worst, shows of the past 30 months attest, authoritative curatorial statements are required not only to make sense of the plethora of work currently produced but to engage the audience with significant issues or questions instead of pandering to a desire for entertainment. If the museum/kunsthalle is not only the site where work is most widely perceived and status accredited, but the place where meaning is negotiated, then such shows must operate through their structures and theses as much as through selection and presentation; they must elicit audience involvement by advancing an argument rather than seeking simply to satisfy an appetite. While these approaches seem the right ones for this time, few exhibitions as yet can be said to have fully succeeded—with the notable exception of *Skulptur Projekte* in Münster. But as Veit Loers argues in the statement quoted at the beginning of this article, the onus now lies as much with the audience as with the exhibition curators. Nonetheless, if there is at present more a need for "interpretative" rather than informative shows, this applies only to the art of Western Europe and the United States. Much information is still needed about other places.

1
Other exhibitions outside Europe and the United States, such as the *Biennale of Sydney* and *Bienal de São Paolo* will not be discussed here.

2
"Primitivism" in 20th Century Art, Museum of Modern Art, New York, 1984, curated by William Rubin with Kirk Varnedoe; *The Spiritual in Art: Abstract Painting 1890–1985*, Los Angeles County Museum of Art, 1986, curated by Maurice Tuchman; *Arte e Scienza*, XLII Esposizione Internationale d'Arte, La Biennale di Venezia, 1986; *Spuren, Skulpturen und Monumente ihrer präzisen Reise* (Traces, Sculpture and Monuments of Their Exact Journey), Kunsthaus Zürich, 1985, curated by Harald Szeeman.

3
Individuals: A Selected History of Contemporary Art 1945–1986, The Museum of Contemporary Art, Los Angeles, 1986–88, curated by Julia Brown Turrell; *Europa/Amerika* (subtitled "History of an Artistic Fascination"), Museum Ludwig, Cologne, 1986, curated by Siegfried Gohr and Rafael Jablonka; *Transformations in Sculpture: Four Decades of American and European Art*, Solomon R. Guggenheim Museum, New York, 1985, curated by Diane Waldman.

4
An International Survey of Recent Paintings and Sculpture, Museum of Modern Art, New York, 1984, curated by Kynaston McShine; *Anni Ottanta*, Bologna, Imola, Ravenna, Rimini, 1985, with an organizational commitee of Renato Barilli, Flavio Caroli, Augusto Fanti, Ennio Grassi and Guiseppe Rossi; *Nouvelle Biennale de Paris*, Paris, 1985, President Georges Boudaille; *New Art at the Tate Gallery*, The Tate Gallery, London, 1983, curated by Michael Compton. This spread of information has been greatly aided by the growing number of international art magazines, many of them bilingual. There has also been a rapid increase in the number of art fairs throughout Europe and United States, many of which contain in addition to trade booths contemporary exhibitions selected by noted curators.

5
A New Spirit in Painting, Royal Academy of Arts, London, 1981, curated by Christos M. Joachimides, Norman Rosenthal, and Nicholas Serota. Its thesis was further consolidated in a follow-up, *Zeitgeist*, Martin-Gropius-Bau, West Berlin, 1982, curated by Christos M. Joachimides and Norman Rosenthal.

6
El Arte y Su Doble: Una Perspectiva de Nueva York (Art and Its Double: A New York Perspective), Fundación Caja de Pensiones, Madrid, 1987, curated by Dan Cameron. *Cultural Geometry*, Deste Foundation for Contemporary Art, Athens, 1988, curated by Jeffrey Deitch. Mention should also be made of *NY Art Now*, The Saatchi Collection, London, 1987. Annelie Pohlen identified several sub-groups among younger German artists in *Cross Currents*, Kunstverein Bonn, 1987.

7
For example, Deitch contends, "By studying the new work in the cultural context of Athens, one understands more about how it abstracts the modes of post-industrial society. By studying modern Greece with the perceptual frame of the new art, one understands more about the survival and dissolution of cultural traditions in face of the relentless advance of the new global culture." (op. cit., p. 5).

8
Falls the Shadow, (subtitled "Recent British and European Art"), The Hayward Annual, Hayward Gallery London, 1986, curated by Barry Barker and Jon Thompson; *Edinburgh International: Reason and Emotion in Contemporary Art*, Royal Scottish Academy, Edinburgh, 1987, curated by Michael Compton, Douglas Hall and Martin Kunz; *Similia/Dissimilia*, subtitled "Modes of Abstractions in Painting, Sculpture and Photography Today," Städtische Kunsthalle Düsseldorf, Columbia University, Leo Castelli Gallery, Sonnabend Gallery, New York, 1987–88, curated by Rainer Crone; *Schlaf der Vernunft*, Museum Fridericianum, Kassel, 1988, curated by Veit Loers; *Avant-Garde in the Eighties*, Los Angeles County Museum of Art, 1987, selected by Howard Fox; *L'epoque, la mode, la morale, la passion: Aspects de l'art d'aujourd'hui, 1977–1987*, curated by Bernard Blistène, Catherine David, Alfred Pacquement, Musée National d'Art Moderne, Centre National d'Art et de Culture Georges Pompidou, Paris, 1987. This tendency has been reinforced by many commercial galleries, where dealers now put on thematic anthologies rather than simple group shows and/or invite guest curators to organize exhibitions for their galleries.

9
Falls the Shadow, page 22. See also Andrew Brighton, "The Radicalism of 'Falls the Shadow,'" *Artscribe International*, September–October, 1986, pp. 50–52.

10
James Bustard, Douglas Hall, "Preface," *Edinburgh International: Reason and Emotion in Comtemporary Art*, Edinburgh, 1987, p. 12.

11
The other three positions were: The evocation of the primordial and irrational drives and imagery of which classical styles are the rationalised and culturally conventionalised mask; Classicism as a logical order; Classicism as the standard and compendium of civilised values and practices. "The reinvigoration of the classical tradition and the dialogue with classicism is one of the most notable strains in the art of the past ten years. . . . The exhibitions therefore present classicism, not so much as a source of image and style, as a means of looking at the problems and dilemmas of art in the post-modern climate of recent years." (op. cit., pp. 12–13).

12
Sleep of Reason, p. 180.

13
In his essay, "The Awakening of Postmodernism and Esthetic Reason," Markus Bruderlin writes: "Artistic conceptions are recognized as models of cognition which could offer an alternative to the tautological dynamics of scientific knowledge and its subordination to the fatal mechanisms of a purely instrumental reason. One must keep in mind that art does not always display its reason in the light of rationality and unequivocality . . . ," *The Sleep of Reason*, p. 168.

14
Quoted by Nancy Marmer in one of the best appraisals of the show. ("Documenta VIII: The Social Dimension?", *Art in America*, September 1987, p. 131.)

15
Press release, *Documenta VIII*, 1987.

16
Chambres d'Amis, Museum van Hedendaagse Kunst, Ghent, 1986, curated by Jan Hoet. *Skulptur Projekte*, Westfälischen Landesmuseum für Kunst und Kunstgeschichte in der Städt Münster, 1987, curated by Klaus Bussman and Kasper König. Two exhibitions closely modeled on these were held in Amsterdam in 1987, *Century '87* and *Art About the House*.

17
Hoet claims, "One could see in *Chambres d'Amis* both a city engaging in art and art activating a city, with each proving challenging in a different way from the automatic responses that normally influence the spectator's responses to it . . . Exhibitions like *Chambres d'Amis* and *Skulptur Projekte* are invitations to art to claim a contemporary social function. Getting art outside, into the world, may give birth to some new ideas inside, in our heads." ("Museum Piece: Jan Hoet on Exhibiting Art," *Artforum*, Summer 1987, p. 4).

18
Fuchs, at that time director of the Stedlijk van Abbemuseum, Eindhoven, argues: "The museum is a standard because, among other things, its spatial and architectural structure, developed over decades *in view of* art's necessities, does not push art but simply holds it . . . Art needs the common ground of dialogue and exchange for which, I believe, the museum is the appropriate place." ("Chambres d'Amis," *Artmonthly*, September 1986, p. 6.)

19
Bos quoted by Paul Groot, "What is Today's Sculpture? Three Views," *Artforum*, September 1986, p. 151.

20
Fortuyn/O'Brien, quoted by Martijn van Nieuwenhuyzen, "Sonsbeek '86 at Sonsbeek Park," *Artscribe International*, November–December 1986, p. 83.

21
Quoted in Eleanor Heartney, "Sited in Münster," *Art in America*, September 1987, p. 142.

22
Peter Halley, "Notes on Abstraction," 1987, reprinted in *Cultural Geometry*, (op. cit., p. 77).

Exhibition as Dialogue: The "Other" Europe

Milena Kalinovska

As a concept of cultural history, Eastern Europe is Russia, with its quite specific history anchored in the Byzantine world. Bohemia, Poland, Hungary, just like Austria, have never been part of Eastern Europe. From the very beginning they have taken part in the great adventure of Western civilization, with its Gothic, its Renaissance, its Reformation—a movement which has its cradle precisely in this region. It was here, in Central Europe, that modern culture found its greatest impulses: psychoanalysis, structuralism, dodecaphony, Bartok's music, Kafka's and Musil's new esthetics of the novel. The postwar annexation of Central Europe (or at least its major part) by Russian civilization caused Western culture to lose its vital center of gravity. It is the most significant event in the history of the West in our century, and we cannot dismiss the possibility that the end of Central Europe marked the beginning of the end for Europe as a whole.[1]

Milan Kundera

When are international exhibitions of contemporary art *necessary* and when are they *not* necessary? This was the opening question at the conference "International Exhibitions Now," held at the Riverside Studios in London in 1985.[2] Curators and museum directors from Western Europe and the United States gave their views on why and for whom large-scale international exhibitions are held, and on the aims of international surveys and why they take place in one country and not in another.

Though international exhibitions of contemporary art began proliferating in the late '60s and continued into the '70s, it was not until the '80s that current art from Europe had become a featured component of large group exhibitions. The decade began with *A New Spirit in Painting* (London, 1981) and *Zeitgeist* (Berlin, 1982). Both of these exhibitions brought German and Italian artists as well as an expressionist painterly "international" style to the forefront of critical attention. Moreover, these shows became the models for large-scale multi-national presentations to such a degree that by the mid-'80s exhibitions of this type had begun to look as if done according to a formula. Fresh answers about what constitutes a meaningful international exchange began to be sought.

The consensus of opinion at the Riverside conference was that while new information on individual emerging artists need not always be the focus of a valuable show, basic information on who these artists are, and how to include and interpret their diverse works in an international context were inexorably fundamental, critical and curatorial issues. Furthermore, in addition to gaining access to artists living outside Western Europe and North America, it was felt that alternative organizing structures for exhibitions needed to be explored as well as a curatorial process developed that should include close collaboration with artists, encouraging their active participation in exhibitions, and providing experiences which might enrich their work and its presentation. Another desired alternative was for selecting exhibition sites which have never before served as such, to permit art to

escape a customary institutional context. The absence of Eastern European, non-European, and non-North American artists from major exhibitions held in the West has been questioned with varying intensity for some time. A wide array of reasons is typically used to excuse or defend these omissions: works by such artists "do not fit in," or "are not up to Western standards"; technical difficulties preclude securing the desired work; Western curators are unfamiliar with art being made outside of what they consider their cultural purview. Market and promotional forces also play a part, excluding little-known, commercially uncertain work.

On the other hand, it can be argued that works from non-Western nations should not be uprooted from their environments and sent abroad to serve as cultural ambassadors: such gestures amount to a barely disguised neo-colonialism. It is further believed by some that little is accomplished when non-Western art works are lumped together in national or regional shows exported as packaged entities. In such instances, the possibility for any meaningful international exchange is limited in the extreme.

The cultural dilemma of Eastern Europe hinges on these concerns. Separated from the West by arbitrary and relatively recently drawn political borders, these countries, historically and geographically central to the development of Western culture— including 20th-century modernism—have become as distant and "other" as territories on the opposite side of the globe.

While there may be no way to deal fully with these manifold contradictions in the context of any single exhibition or short essay, there have been several exploratory shows in the past decade that offer new approaches to an East/West exchange—exhibitions that come as revelations, which in one way or another extend the experience of artists, curators, critics and the general public. The following account of a number of those exhibitions constitutes a selected and personal view. It is intended as a beginning, to inform the international audience, indeed the "armchair" traveler, about internationl exhibitions not as familiar as the *Venice Biennale* and *Documenta* nor as well documented or widely discussed as the recent *Chambres d'Amis* and *Skulptur Projekte* in Münster. What follows are descriptions of some exhibitions and related issues that may contribute to an understanding of the needs of artists in the "other" Europe.[3]

A principal aim of most Eastern European artists since the '60s has been to establish contact with the Western art world. Eastern European artists are not generally included in important international exhibitions held in the West, and, due to political and economic factors, such international exchanges rarely, if ever, take place in their own countries. Yet these artists tend to see themselves as belonging to a broad European culture and logically desire to participate in exhibitions and discussions that take place within a Western context. Eastern Europe is, after all, a fairly recent political division of Europe, created after World War II. Writers like George Konrád, Czesław Miłosz and Milan Kundera have argued convincingly that their respective countries should be regarded as Central European; however, the West, in Kundera's opinion "is no longer capable of conceiving of this culture as anything other than an appendage to the political system."[4]

Whatever the argument, the reality is that Eastern European artists' experiences over the past 40 years have been very different in many respects from their Western colleagues'. The art world in which they function has no comparable system of public, independent or private galleries to support advanced work. Public and private collections of contemporary art are either non-existent or very modest. Museums have not yet begun to show contemporary art systematically. Market forces as they are known in the West are substituted, ironically, by political ones. Bureaucrats in these countries' ministries of culture dictate which exhibitions are brought into the country, which allowed out, and finally, which, if any, artists may represent the country in international shows.

Although large, routine exhibitions such as the *Venice Biennale* are admittedly flawed—the sheer number of participants is hardly conducive to creating personal contacts among artists, for example—these exhibitions are among the few international shows in which Eastern European artists are able to take part. The *São Paolo Bienal* and the *Biennale of Sydney* are particularly valued by them, since artists are invited by international selection committees to travel to these exhibitions and participate in various symposia. (Yugoslav sculptor Duba Sambolec, for example, attended the most recent *São Paolo Bienal*.) Occasionally, survey exhibitions provide the same kind of opportunities for artists. Magdalena Jetelová, the only Eastern European artist included in *New Art at the Tate Gallery* (1983), recalls that that exhibition provided a meaningful introduction of her work in the

West. Her rough-hewn architectonic wooden sculpture was placed next to the works of artists, such as Anselm Kiefer, Georg Baselitz and Sigmar Polke, with whom she shared esthetic and stylistic concerns at the time.[5]

Most Western curators admit that they do not have sufficient knowledge, access to information, or opportunities to learn about, much less cooperate with and assist Eastern European artists. Nevertheless, interest in national survey exhibitions has resulted in a few shows, a good example of which was *Presences Polonaises*, held in Paris in 1983. Conceived in 1979 by Pontus Hultén, then director of the Centre Pompidou, and Ryszard Stanisławski, director of the Museum Sztuki in Łódź, the exhibition presented a selection of 20th-century Polish art, including works by 16 contemporary artists.[6] In most cases, however, these national surveys are served up as neat, cultural packages, as in the case of *Russian and Soviet Art: Traditions and Contemporaneity, Works from Six Centuries*, shown in Düsseldorf, Stuttgart and Hanover in 1984/5. The exhibition was organized in the U.S.S.R. by the Ministry of Culture in exchange for Deutsche Bank's *Man and Nature in Contemporary Painting and Graphic Art*, organized expressly for its Moscow and Leningrad showing, in 1983. *Man and Nature*, by comparison, included quite current works (by Richter, Immendorff, Kiefer, Beuys, Baselitz among 33 artists) seen for the first time in the Soviet Union, and was accompanied by a catalogue written by Dr. Ulrich Krempel of the Kunsthalle, Düsseldorf.

There have, though, been a handful of exhibitions in the '80s in which artists from Eastern Europe have taken part as individuals. Among the shows dealing specifically with the ideas of East-West discourse was *Dialog*, organized for Stockholm's Moderna Museet by its director, Olle Granath, in response to what he found to be a nearly universal desire among Polish artists: "a hunger for contact with fellow artists."[7] The show paired works by each of the participating Polish artists with those by a non-Pole he or she had selected. An invitational show in the opposite direction—from the West to the East—was that of Anselm Kiefer, specifically addressed to the Polish people whose country's fate prompted him to do the exhibition. It was held in Warsaw's small, non-commercial back-street Foksal Gallery, established in 1966 by artists and critics for non-conformist artistic and theoretical activities. These exhibitions, and a few others, have offered new solutions—most temporary, others longer lasting—to the participating artists and have grown out of a real need for communication. The following is a brief run down.

Information on the current Western art scene reaches Eastern Europe via art magazines, catalogues, and the rare traveling critic, curator and artist. One of the largest events to provide a forum for actual encounters between artists from East and West was *Konstrukcja w Procesie*, held in 1981 in Łódź, Poland. The organizers were a group of Polish artists headed by Ryszarad Wásko, a video artist and a graduate of the Łódź Theatre, Television and Film School. With the support of the newly formed Solidarity, the now-illegal independent trade union, the artists secured a former factory building and invited 54 artists from the East and West to take part in an exhibition and symposium dedicated to the art of the '70s.

The show's concept—the constructivist aspect of '70s art—was borrowed from the *Pier + Ocean* exhibition held at London's Hayward Gallery and at the Rijksmuseum Kröller-Müller in Otterlo in 1980.[8] A number of Western artists included in that exhibition—Jan Dibbets, Sol LeWitt, Richard Long, and Richard Serra, among others—were invited to Poland to participate along with artists from Hungary, Czechoslovakia, and, of course, others from Poland. Among them were Jozef Robakowski, Ryszard Winiarski, Stanislav Kolíbal, and Tibor Gayor. One of the driving forces behind the event, the likes of which had not taken place in Eastern Europe in three decades, was the organizers' desire to introduce and to show their work alongside work by established Western artists with whom they felt an affinity.

The exhibition was also intended as a reproach to *Westkunst*, the exhibition held in Cologne in 1981, which putatively examined developments in Western art since 1939 without a single example of art from the "other" Europe. The Czech artist Stanislav Kolíbal, wrote in the catalogue to *Construction in Process*:

> More and more we can see that some countries and their artists are being left out, which is something new happening only after the Second World War. Europe doesn't consist of only well-developed industrial countries, although some people think so. Half of a man is still a man . . . At present, there are terms and exhibition like *West*kunst. Thus there appears in culture a term very strange and dangerous. I think that the unity of culture ought to be restored. It is a necessity. It is within the ability of artists, and the artists in Łódź tried it.[9]

While the title "Construction in Process" refers to the actual process of construction (most of the works in the show were executed on site), the title also refers to the economic and political process of re-construction.

The "post-constructivist" tendency in contemporary art is a topic of particular historical relevance to Łódź, the industrial town where Polish Constructivists Władysław Strzemínski, Katarzyna Kobro, Henryk Stazewski, Miecysław Szczuka, and others worked and opened the International Collection of Modern Art in the Town Hall in March 1932. This collection, now part of the Museum Sztuki, included works donated by artists such as Arp, Léger, Van Doesburg, Picasso, Schwitters and Ernst. It became the cornerstone of the second European museum to have a permanent collection of abstract art, and to this day possesses the world's largest holdings of Polish Constructivism.[10] *Construction in Process* can thus be seen as a reprise of the dream by an earlier generation of artists to join advanced art and radical politics.

The exhibition was accompanied by a small-edition, hand-made catalogue entitled *Fabryka* ("factory"). The following year, an American edition of 1500 copies was published in New York by Peter Downsborough, Richard Nonas, and Fred Sandback—who were among the participating artists.[11] *Construction in Process* was reconstituted in somewhat different form as *Process und Konstruktion*, organized by a working committee of 15 artists who took part in the original event, at the Künstlerwerkstätten in Munich in 1985 (funding was provided by the Munich Town Council). In this second manifestation of the exhibition, Eastern Europe was represented by four Polish artists, Ryszard Wásko, who now lives in West Germany, Ryszard Winiarski, Tomasz Konart, and Antoni Mikolajczyk. Among Western artists were Les Levine, who was included in the previous exhibition and, new to the Munich showing, Pat Steir, Michael Witlatschil and Joseph Kosuth.

The Munich exhibition was much more professional in terms of its organization, installation and the quality of its catalogue. But its political impact was negligible, mainly because of the neutral setting whereas in Poland, the show constituted an important, nearly unprecedented event—an international meeting between artists in a society in transition, where new ideas transmitted the excitement of a electrical charge. Of lasting esthetic importance was the donation of works from both exhibitions to public collections after the shows closed. In Łódź, the works became the Solidarity Collection and were given to the Museum Sztuki. In Munich, the collection was given to the Munich Town Council. These collections are not only concrete illustrations of the artists' enthusiasm for both events but provide a living testimony to the cooperative spirit of both ventures.

Held at ARC, Musée d'Art Moderne de la Ville de Paris in 1982, Une *Expérience Muséographique, Échange Entre Artistes 1932–1982, Pologne-USA*, was another show conceived by Polish artists—in this case desiring an exchange with American artists. According to their spokesman Henryk Stażewski, "The contemporary Polish artists feel isolated and do not have enough direct contact with foreign artists and their work. We would like to see our work inserted in a new international context, but this desire does not seem possible, due to existing structures."[12] Critic Anka Ptaszkowska approached Pontus Hultén, then director of the Museum of Contemporary Art, Los Angeles, with the project. Hultén suggested that the exchange take place between artists from two regions, one in Poland, the other in California. The exhibition, co-organized by Ptaszkowska and Hultén, was held somewhat curiously in Paris. A historically significant city for the Poles (it was there that the International Collection of Modern Art, which forms the base of the Museum Sztuki in Łódź was begun by artists), Paris was the choice of contemporary Polish artists for this showing of their work.

When the exhibition at ARC in Paris closed, works by 15 artists working in Poland (Stanisław Drozdz, Koji Kamoji, Tomasz Osinski, Zbigniew Targowski and Ryszard Winiarski, among them) were given to the Museum of Contemporary Art in Los Angeles, very likely making that institution the only major United States museum with a collection of contemporary Polish art. And works by American artists (expanding on the regional theme and including John Baldessari, Sam Francis, Dan Graham, Joel Shapiro, and Lawrence Weiner) were donated to the Museum Sztuki, the only museum in Eastern Europe that consistently attempts to collect contemporary work by Eastern European as well as by Western artists. (It has, for instance, over 1,000 small sculptures, drawings, photographs, notebooks and other documentary material by Joseph Beuys.) What was so exciting about this show is that it actually happened—demonstrating to artists from Eastern Europe that such ambitious ideas as exhibiting with their Western colleagues is possible. The show, with 52 artists each represented by one work, was lively and unorthodox.

The exhibition *Dialog* was conceived by Olle Granath, director of Stockholm's Moderna Museet, during a week of studio visits in Warsaw and Lodz. As he explains, "Everywhere I was faced with the same daring search for unexpected solutions, a feeling that nothing is impossible, that somewhere there is someone capable of understanding and passing on these messages born out of a feeling that the world is boundless, precisely at a moment when the borders seem staked out more tightly than ever."[13] Granath felt the need to communicate and exchange ideas was so prevalent in Poland that it would be best served by an exhibition that might simulate the experience of studio contacts between artists. Thus, eight Polish artists were invited to present their works alongside those by non-Polish artists of their choosing.

The "dialogue" was evidenced in the installation of works by the pairs of artists, Henryk Stażewski, a Constructivist and the oldest artist in the exhibition (he was born in 1894 and died in 1988) selected the French Conceptual artist Daniel Buren. Buren responded by building a special work *pour et avec H. Stazewski*, a room-like construction with four walls, a ceiling and windows from his "Site in Situ" series. Seventeen Stażewski works, dating from 1968 to 1984, were placed within and around Buren's structure in spots Buren specifically designated for them. Buren, who has stated that, once placed in a gallery or a museum, a work of art loses its power, created for Stażewski an environment in keeping with the Constructivist principle of integrating works of art into the spaces in which they are exhibited. Buren both paid homage to the Constructivist concepts and enabled Stażewski's work to speak anew and in an authentic fashion. The works of the two artists together achieved a complementary symbiosis between two kinds of geometries, the structural approach of Buren and the intimate, painterly touch of Stażewski.

Edward Krasiński, who characteristically "connects" his conceptual works to one another and to surrounding objects and architectural details with a painted blue line, chose to show with Swedish sculptor Lars Englund, maker of mathematical/organic spatial structures. Zbigniew Gostomski was interested in seeing what kind of repercussions might occur from the juxtaposition of his *Three Crosses*, paintings of inverted bold black crucifixes on raw canvas, with Barry Flanagan's bronze sculpture *Hare on Ball*. The result was an unexpected lightness cast by the victorious dancing hare on the symbolism of the crosses. Maria Stangret, a painter of commonplace objects such as kitchen sinks and chess boards, took as her "dialog" partner Christian Boltanski and his work dealing with reconstructions of childhood.

The team of Lesław and Wacław Janicki gave six performances of their *A Lesson from Plato*, inspired by Plato's "Lesson." Chosen by the brothers Janicki was another duo, Gilbert and George, who were represented by their film *The World of Gilbert & George* and two photo-pieces. Paintings by Tomasz Tatarczyk and Susan Rothenberg reflected kindred sensibilities and created the most homogeneous interaction in the show. Leon Tarasewicz's minimal landscape paintings were juxtaposed with expressionistically charged photo-oils by the British painter Ian McKeever. McKeever was particularly intrigued by showing with artists not yet known to him.[14] This was, in fact, *Dialog*'s special strength—it contained no particular stylistic or theoretical agenda, but let the artists discover one another.

Mention should also be made of a few independent galleries which have provided Eastern European artists alternate routes of access to international discourse. The Foksal Gallery in Warsaw, Galeria Akumulatory 2 in Poznan, and Matt's Gallery in London are all small, artist-run, not-for-profit operations frequented mainly by artists, critics, curators, students, and teachers. Installations are marked by great attention to presentation; small, concentrated shows organized in close cooperation with the artists are preferred over larger, less personal surveys.[15]

Another way of introducing artists from one country to another has been through subsidized residencies. DAAD, set up in West Berlin to promote an international exchange of artists' experiences and ideas, has attracted particularly high caliber practitioners, including a number of Eastern Europeans. The Berliner Künstlerprogramm (Artists-in-Berlin Program), was initiated in 1963 by the Ford Foundation. In 1965 it was taken over by the Deutscher Akademischer Austauschdienst (DAAD). Each year DAAD invites some 15 internationally known artists—sculptors, painters, writers, composers and filmmakers—for residencies ranging from 6 to 12 months.[16]

The two countries in Eastern Europe that officially support international exchange and dialogue are Yugoslavia and Hungary. Yugoslav artists have been encouraged since the '60s to participate in international exhibitions held both outside and inside Yugoslavia. They have been included on a regular basis in the *Biennale of Sydney*, the *São Paolo Bienal*,

the *Biennale de Jeunes* in Paris and *International Malerwochen* and *Trigon* in Graz. In the '70s Hans Haacke, Jannis Kounellis, Joseph Beuys, Mario Merz, Dan Graham and others had their works presented in Yugoslavia. In the '80s, visiting lecturers there included critic Donald Kuspit at the Museum of Modern Art in Belgrade, the Modern Gallery in Zagreb and Moderna Galerija in Ljubljana, and Harald Szeemann, Achille Bonito Oliva, Germano Celant and others at the Student Cultural Center in Belgrade. On the occasion of the 1984 Jan Dibbets exhibition at Belgrade's MOMA, Rudi Fuchs spoke on the topic of "cultural Europe," which in his opinion extends to Istanbul. (During his talk Fuchs speculated on the ideas of Belgrade's hosting an international event representing this territory.)[17]

Yugoslavia's Ministry of Culture sponsored *Belgrade 77* and *Belgrade 80*, the first two in what was to have been a series of international biennial exhibitions. Unfortunately, a lack of funding led to the demise of the *Belgrade Biennale*, which introduced the works of such Western artists as Bruno Ceccobelli, Enzo Cucchi, Claude Viallat and Richard Long to Yugoslavia.

Budapest's Kunsthalle, Mücsarnok, regularly co-operates with museums in the West, for instance, their 1986 exhibition *Zurück zur Farbe*, which included young Austrian painters and sculptors (among them Erwin Bohatsch, Siegfried Anzinger, Humbert Schmalix), was organized together with Neue Galerie am Landesmuseum Joanneum in Graz. Since 1971 it has had its own triennial entitled *International Small Sculpture Exhibition:* 39 countries participated in the 1987 show. Hungarian artists were introduced to the West in an exhibition *The Construction, Constructivist Tendencies in Contemporary Hungarian Art* held at the Museum Fodor, Amsterdam, in 1987. In this exhibition centered around the tradition and the continuity of Hungarian constructivism, four contemporary artists— Gabor Bachman, Imre Rak, Tator Stalai and Tomas Tromitas showed their work along with paintings by five artists of the older generation including the leading figure of the early 20th-century Hungarian avant-garde Lajos Kassak.

Eastern European artists' frustration at the lack of consistent, serious attention paid to them in the West was clearly voiced at a 10-day event, *Works and Words, International Art Manifestation Amsterdam*, organized by the Fondation de Appel in 1979—the last of its kind to take place in the West. Artists from Holland, Czechoslovakia, Hungary, Poland, and Yugoslavia gathered to take part in lectures, discussions, performances; to present videos, films, photo works; and to create installations. The formation of personal contacts among artists was considered a key objective. Eastern European artists questioned why they had not been invited to international art events organized in Western Europe and the United States and accused the Western art world of arrogance.[18]

The unsatisfactory situation for Eastern European artists has improved only slightly since *Works and Words*, and that change has been linked to the recent cultural liberation within the U.S.S.R.: the increased accessibility and availability of Soviet art has precipitated a growing—and increasingly fashionable—interest in art from outside the West in general.

The popularity in the West of Soviet artists Ilya Kabakov and Eric Bulatov is perhaps indicative. Kabakov was given a solo exhibition at the Kunsthalle in Bern in 1985; a Bulatov show originated this year by the Kunsthaus Zürich is scheduled to travel to the Kunstmuseum in Bonn, Frankfurt's Portikus and the Centre Pompidou. Recent articles in *The New York Times* have featured the competition among New York dealers for Soviet artists as well as major coverage of the first Sotheby's Soviet art auction held in Moscow in summer 1988. The sale included work by 29 contemporary artists and brought more than three times its pre-sale estimate of one million dollars. The artists received 60 per cent of the price, (however, only 10 percent of this amount in hard currency), with 30 per cent going to the Ministry of Culture, 2 per cent to the Soviet Cultural Fund, and 8 per cent to Sotheby's.

After largely ignoring Soviet and East European art for decades, Mikael Gorbachev's *glasnost* and *perestroyka* program has generated sharply increased interest in Soviet art on the part of Western curators, commercial galleries, auction houses, collectors and critics. The motivations of each of these groups for rediscovering Soviet art is different. A few Western curators with some knowledge and interest in Soviet art are taking advantage of the changed climate. They are beginning to organize exhibitions that could not have been done—or justified in economic terms— several years ago and can now be guaranteed solid audiences. One would hope that as more and more curators in the West take interest in the Soviet art scene, they will not promote an image of "uniformity," a nationalist subsuming of differences among artists (as was the case with the earliest exhibitions of the new Germans, Italians, English sculptors of the past

few years). What is required now is original thinking rather than simply following the newest trend.

The motivation for Sotheby's entrance into the Soviet art scene is more complex. A desire to be in on the ground-floor for any future historical multi-million auction sales is a possibility. Sotheby's auction also seems to have coincided with a broader cultural/commercial interest to shake the Soviet art establishment into permitting the creation of some form of art market in the Soviet Union and liberalization of art trade. For some collectors the issue of buying Soviet art is even more closely connected with their commercial interests. (This is certainly the motivation of the Deutsche Bank and Armand Hammer, and is probably also the case with the addition of contemporary Soviet art in recent years to the Ludwig Collection.) If the desire to show and purchase Soviet art is mainly motivated by political and commercial objectives, it is hardly surprising that East European art remains largely overlooked.

The combination of *glasnost/perestroyka*, with the possibility of travel to the U.S.S.R., the fact that the country was closed for such a long time and no information on the art scene was readily available in any direct way, and a certain need for "unknown" new products, all contribute to the current "fashion" from which, one would hope, at least some of the artists will benefit—and not only benefit in the short term. A Czech artist questions the sincerity of this fascination: "This is how they were interested in us 20 years ago and in Polish artists 6 years ago. This is not an interest in art."[19]

Perhaps the only recent exhibition that has attempted to deal with the complexity that is Central Europe was *Expressiv, Central European Art since 1960* organized by the Museum Moderner Kunst/Museum des 20. Jahrhunderts in Vienna in 1987 and shown in a reduced version at the Hirshhorn Museum and Sculpture Garden in 1988. The exhibition was curated by Dieter Ronte, Director of the Museum of Moderner Kunst, Vienna, and Meda Mladek, collector and writer on Czechoslovak art, based in Washington, D.C. The exhibition was in fact financed by the Soros Foundation, New York, and about half of the works came from the Mladek Collection and the Soros Collection, both selected by Mrs. Mladek. It was the first exhibition in which artists from Eastern Europe had the opportunity of exhibiting their works in the context of two important museums in Europe and the United States.

The thesis of the show is that this group of 30 artists working independently of each other in Austria, Czechoslovakia, Hungary, Poland, and Yugoslavia share a similar sensibility—a tendency toward the expressive. By focusing on one aspect of art from five countries, the curatorial approach to the introduction of this work was reminiscent of the exhibitions organized in the eary '80s dealing with neo-expressionist tendencies in art, particularly in Germany. Though the exhibition proposed to deal with art since 1960, the selection of artists resulted in a lack of representation of contemporary work and works by younger artists. Moreover, it did not present current works by older artists. Finally, the Central European issue was linked to the Hapsburg empire, which dissolved at the end of World War I and which has little bearing on the development of contemporary art in the countries concerned. Perhaps a more serious problem was the curators' failure to broach a most pressing question: "What, in fact, does the term Central European now mean?" To what extent is "Central European" a utopian or even nostalgic term, and to what degree has the political division of Eastern Europe affected the culture of the region and the positions of artists working there?

Though the Vienna showing was accompanied by a conference in which Eastern European artists, critics, and academics took part, no seminars or conference with broad participation were organized when the exhibition was shown at the Hirshhorn. Espccially in the United States—where the subject and art from these countries is not well known—such opportunities for discussion were needed to address and critically assess the art works as well as the criteria for selection.

Recent developments in the Soviet Union and some Eastern European countries signal improving prospects for developing for the first time in 40 years (60 in the case of the Soviet Union) a real possibility for a *continuous* dialogue by way of responsibly and intelligently conceived exhibitions, whether individual or group, small or large—not motivated by and limited to issues such as nationalist representation. Nonetheless, showing of Eastern European art in the West will remain a difficult task in the foreseeable future for a number of reasons. The prevailing political view, in spite of *glasnost*'s high profile, is that art is to serve and support the goals of those in power—pragmatism that continues to restrain the forms of esthetic expression and the free flow of works in and out of the countries. (Suzanne Pagé's selection of 8 artists from Czechoslovakia in 1984 for an exhibition at ARC,

Musée d'Art Moderne de la Ville de Paris, was cancelled for these very reasons.) In the absence of an open market, the governments are likely to continue to be the major buyers of art, thus creating financial pressure for artists to conform to official political and esthetic objectives (though this is slowly changing with the creation of freer markets in Poland, Yugoslavia, Hungary, and the Soviet Union.) Among other difficulties that continue to face artists in Eastern Europe, and which have significant bearing on their work and its standing in relation to Western art, are lack of studio space, technical means, exhibiting space, rigid rules controlling entry into art professions, isolation from developments abroad because of limited contact.

Dedicated, enterprising and original curators in the West and their counterparts—ingenious critics, curators, and artists in some Eastern European countries, (in the past most notably in Poland) have already worked together on inventive exhibitions, the best example of which is the Moderna Museet's *Dialog*. It demonstrated that it is not only desirable by artists from both worlds to show together but that above all it is possible. What is required is a particular willingness on the part of Western curators who have access to the means of realizing exhibiting possibilities for Eastern European artists, to address themselves to this issue and see what is the best—not the easiest—way of regaining the "lost" potential of the "other" Europe.

1
"Afterword: A Talk with the Author by Philip Roth," in Milan Kundera, *The Book of Laughter and Forgetting* (New York 1981), p. 230.
2
Paraphrased from an unpublished essay by Jean-Christophe Ammann, "International Exhibitions of Contemporary Art," delivered at the conference "International Exhibitions Now," Riverside Studios, London, 1985.
3
It is hoped that the attitudes and positions of artists working outside Western, advanced capitalist countries will be the subject of future analysis.
4
Alain Finkielkraut, "Milan Kundera Interview," in *Cross Currents, A Yearbook of Central European Culture* (Ann Arbor 1982), p. 17.
5
The author in conversation with Magdalena Jetelová, October 1987. Jetelová subsequently had a solo show of her sculpture at the Museum of Modern Art, New York, 1987 as part of its "Projects" series.
6
Among contemporary Polish artists exhibited at the Centre Pompidou were Jerzy Berés, Wojciech Bruszewski, Stanisław Fijakowski, Roman Opałka, Antoni Starczewski, Krzysztof Wodiczko.
7
Olle Granath in a letter to the author, March 10, 1988.
8
Some of the artists in *Pier + Ocean* were Walter de Maria, Robert Smithson, Hanne Darboven, Mario Merz, Bruce Nauman.
9
Konstrukcja w Procesie (Rindge, New York: Thousand Secretaries Press 1982), p. 79.
10
The first collection of abstract art was established in Hanover in 1926 and was burned in 1933, after Hitler took power. The destruction of the Łódź collection was planned for 1945.
11
The catalogue is in black and white and conveys the documentary nature of the event. All of the photographs were taken during the installation process, and the texts are mainly composed by artists who wrote with affection about their experience in Poland.
12
Quoted from *Une Expérience Muséographique, Échange Entre Artistes, 1931–1982, Pologne-USA*, (ARC/Musée d'Art Moderne de la Ville de Paris, 1982; translation, Museum of Contemporary Art, Los Angeles.)
13
Olle Granath, *Dialog* (Stockholm: Moderna Museet, 1985), p. 9.
14
In conversation with Ian McKeever, February 1988.
15
The Foksal Gallery was established in 1966 by a group of artists and critics and has thrived ever since under the directorship of the critic Wiesław Borowski. Of the 100 exhibitions organized by the gallery as of this writing, 45 have included foreign artists, among them Victor Burgin, Art and Language, Arnulf Rainer, Joseph Beuys and Anselm Kiefer; among contemporary Polish artists showing at the gallery are Krysztof Wodicko and Tadeusz Kantor.
Galeria Akumulatory was founded by artist Jarosław Kozłowski in 1971. It was the intention of the gallery from the start to play a role in the international exchange of ideas—about half the artists showing in the gallery were from abroad. It was Robin Klassnik's experience as a British artist showing at Galeria Akumulatory that led him to set up Matt's Gallery in 1979. He has been inviting Polish artists regularly since 1980.
16
Among the Eastern European artists invited for DAAD residencies have been Braco Dimitrijevic, Yugoslavia; Jarosław Kozłowski, Poland; Stanislav Kolibal, Czechoslovakia; Gyorgy Galantai, Hungary; Ilya Kabakov, Soviet Union.
17
In conversation with and from information supplied by Ljubica Staivuk, former curator of the Museum of Modern Art in Belgrade, and, since 1986, an independent curator based in New York, March-April 1988.
18
Works and Words, International Art Manifestation Amsterdam, 1980, p. 1.
19
Quoted from a letter sent to the author from Czechoslovakia, April 1988.

Catalogue

Giovanni Anselmo

Born 1934, Borgofranco d'Ivrea
Italy

Lives and works in Turin

Identified with Arte Povera since 1967, Anselmo's art is hinged doubly to the principles of physics and the fundamentals of logic. It constitutes an interpretation of reality with respect to certain basic data, such as the fact that reality consists in determining substances, that they have relationships with the terrestrial mass (the force of gravity), the orientation of the earth (north, south, east, west), time, duration and energy.

Until 1969, Anselmo emphasized the value of materials, establishing an elementary, concise interpretation of matter through examinations of various forms of energy (magnetic, electrical) and the life-giving or -threatening situations to which they give rise. In his vegetation-granite assemblage, the contrast between the two materials is so strong that the physical nature of both is accentuated. Cut, size, a taste for the essential—these are the hallmarks of his relationship with the elements.

After 1969, the second structural line of Anselmo's development comes to the forefront: the logical conduction of complex experiences, the mental role of orientation. For example, Anselmo empirically approached the abstract concept of infinity. *Particolare di infinito* (Detail of the Infinite), 1969, consists of a sheet of paper covered with gray pencil marks that make up a detail of the letter "I" in the word "infinito." In *Fotografia dell'infinito attreverso il cielo* (Photograph of the Infinite Through the Sky), 1970, the same issue is addressed, as it is in a 1971 piece in which a slide projector shows a slide of the word "infinito," and in a 1971–73 piece in which a slab of lead has been incised with the word "infinito," but with the "in" portion of the word cut away.

Making an abstract concept visible is equivalent to overturning meaning, which is clearly the point of other of Anselmo's works, such as *Invisibile* (Invisible), 1970–73, *Tutto* (Everything), 1971–73, and *Particolare* (Detail), 1974.

Three 1978 exhibitions concentrate on this aspect, *Un disegno e tre particolari a ovest, trecento milioni di anni a est; Un disegno e un particolare a est, trecento milioni di anni a ovest; Un particolare a sud, trecento milioni di anni a ovest-nord ovest* (A drawing and three details to the west, three hundred million years to the east; A drawing and a detail to the east, three hundred million years to the west; A detail to the south, three hundred million years to the west-north west). Some of his works, like *Trecento milioni di anni* (*Three hundred million years*), made up of a block of anthracite connected to a lamp, are located to the east, west, north, and south with respect to his *Direzione* (Direction) piece that commands the main space. Seen from this vantage, all the previous works as a whole orbit around a central pole determined by the fusion of geographic coordinates and spatial imagination. After 1980, *Oltremare* (Beyond the sea), an archaic version of the "infinite" direction, suggests remote and indefinite locales. It also appears as a table painted in ultramarine blue. *Paesaggio con mano che lo indica mentre verso oltremare i grigi si alleggeriscono* (Landscape with a hand that indicates it while out beyond the sea the grays lighten), 1982, is a spatial installation; on one wall, a drawn hand indicates a direction; high on another wall, blocks of granite grouped in pairs are suspended; standing on the floor level is a table painted ultramarine. The entire environment is part of an expanded thought process, from which rhetoric has been banished. Anselmo presents the infinite as immediate data.

—*Jole de Sanna*
Translated from Italian by Meg Shore

Selected Solo Exhibitions

1987
Galerie Durand-Dessert, Paris. Also 1982, 1978.
1986
Galleria Christian Stein, Turin. Also 1983, 1982.
1985
ARC/Musée d'Art Moderne de la Ville de Paris. Catalogue by Suzanne Pagé and Daniel Soutif.
1984
Marian Goodman Gallery, New York.
1982
Galerie Helen Van der Meij, Amsterdam. Also 1980.
1980
Museum van Hedendaagse Kunst, Ghent, Belgium.
Galleria Sperone, Turin. Also 1977; 1975; 1974; 1971; 1969; 1968 (catalogue by Germano Celant and Maurizio Fagilio).
Stedelijk van Abbemuseum, Eindhoven. Also 1979. Catalogue by Jean-Christophe Ammann and Rudi Fuchs.
Musée de Grenoble. Catalogue by Jean-Christophe Ammann, Rudi Fuchs and Thierry Raspail.
1979
Kunsthalle Basel. Catalogue by Jean-Christophe Ammann and Rudi Fuchs.
1978
Sperone Westwater Fischer, New York.
1975
Kabinett für aktuelle Kunst, Bremerhaven.
1973
Kunstmuseum Luzern. Catalogue by Jean-Christophe Ammann.
1972
John Weber Gallery, New York.
1969
Galerie Sonnabend, Paris.
1968
Musée d'Art et d'Histoire, Geneva.

Selected Group Exhibitions

1987
Skulptur Projekte, Münster. Catalogue.
1986
La Biennale di Venezia. Also 1980, 1978. Catalogues.
Ouverture II, Castello di Rivoli, Turin. Also 1984. Catalogues.
1985
The European Iceberg— Creativity in Germany and Italy Today, Art Gallery of Ontario, Toronto. Catalogue.
The Knot: Arte Povera at P.S. 1, Institute for Art and Urban Resources, Long Island City, New York. Catalogue.
Transformations in Sculpture— Four Decades of American and European Art, The Solomon R. Guggenheim Museum, New York. Catalogue.
1982
Documenta VII, Kassel. Also 1972. Catalogues.
1981
Westkunst—Heute: Zeitgenössische Kunst seit 1939, Museen der Stadt Köln. Catalogue.
1970
Conceptual Art, Arte Povera, Land Art, Museo Civico di Torino, Galleria d'Arte Moderna. Catalogue.
1969
Live in Your Head: When Attitudes Become Form: Works— Concepts— Process— Situations—Information, Kunsthalle Bern. Catalogue.
1967
Arte povera, Universita di Genova.

40

Selected Bibliography

Anselmo, Giovanni. *116 Particolari visibli e misurabli di INFINITO.* Turin 1975.

———. *Leggere.* Turin 1972.

———. "Project: To The Left and To The Right Toward Oversea." *Artforum,* Summer 1987.

Baker, Kenneth. "Giovanni Anselmo at Marian Goodman." *Art in America,* May 1984.

Bandini, Mirella. "Giovanni Anselmo." *Flash Art Roma,* July 1968.

Celant, Germano. *Arte Povera.* Milan 1969.

Kingsley, April. "Giovanni Anselmo." *Artforum,* February 1983.

Magnani, Gregorio. "Giovanni Anselmo." *Flash Art,* Summer 1986.

Oliva, Achille Bonito. *Autocritico automobile/attraverso le avanguardie.* Milan 1977.

———. *Il territorio magico.* Florence 1974.

Poinsot, Jean-Marc. "Anselmo infini." *Art Press,* October 1982.

Trini, Tommaso. "Anselmo, Penone, Zorio e le nuove fonti di energia per il deserto dell'arte." *Data,* 1973.

Zacharopoulos, Denys. "Arte Povera Today." *Flash Art,* March 1984.

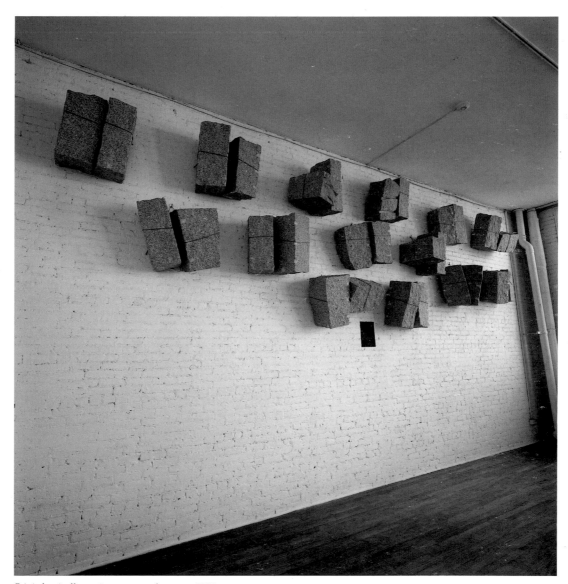

Grigi che si alleggeriscono verso oltremare, 1985
stone, steel cable, and ultramarine blue pigment
variable dimensions
Installation view at P.S. 1, Long Island City, New York
Courtesy of Marian Goodman Gallery, New York

Not in exhibition. Work in exhibition illustrated in supplement.

Siah Armajani

Born 1939, Teheran

Lives and works in St. Paul, Minnesota

It is a partial yet genuine truth that Iran-born Siah Armajani creates sculpture that contemplates architecture. Since 1970 he has brought into being wood and steel structures that are architectural in reference and often in size. Domestic and familiar, his houses and bridges come to us whole or in part to isolate the basic structural elements of doors, windows and stairs.

But Armajani is not content to hand over our vernacular architecture unquestioned. Sometimes he produces functionless architecture or, as in *Red School House for Thomas Paine* (1977–78), turns the structure inside out, compressing or rarefying component parts to their functional limits. Most often, he has simply given himself license to do three-dimensional work defined as sculpture because it entertains a variety of architectural notions.

Both literally and metaphorically, Armajani produces a kind of unhinged architecture. Reading rooms and employee lounges are apt to find both their architectural elements and their furniture dispersed, if not exploded, throughout the available space. Through this dispersal of parts Armajani instructs us to break down social conventions into their component parts and ready them for revitalization. A broad cultural agenda lies behind scattering architectural elements, moreover. Armajani continually addresses the issue of democracy and what structures are appropriate for a society whose stated ideal suggests that its members enjoy equality, freedom of assembly and the access to information. Reading as symbolic of freedom of thought is Armajani's abiding concern, so it is no wonder he has made several different plans for reading rooms and study gardens.

Informed by human behavior and democratic values, Armajani's art has become decidedly functional in recent years. His public art projects for universities and waterfronts revive the belief that an artist can at once question form and affirm use and value.

—*Marjorie Welish*

Selected Solo Exhibitions and Commissions

1988
The Irene Hixon Whitney Bridge, Minneapolis.
1987
Max Protetch Gallery, New York.
Kunsthalle Basel. Traveled. Catalogue by Jean-Christophe Ammann.
Westfälisches Landesmuseum für Kunst und Kulturgeschichte, Münster. Traveled. Catalogue by Klaus Bussman, Kasper König and Ulrich Wilmes.
1985
Dictionary for Building IV, Max Protetch Gallery, New York. Also *III*, 1984; *II*, 1983; *I*, 1981.
Institute of Contemporary Art, University of Pennsylvania, Philadelphia. Catalogue by Janet Kardon and Kate Linker.
1982
The Louis Kahn Lecture Room, Samuel S. Fleisher Art Memorial, Philadelphia.
Grand Rapids Art Museum, Michigan.
1981
Hirshhorn Employee Lounge, Hirshhorn Museum and Sculpture Garden, Washington, D.C.
1980
Reading Garden #3, State University of New York at Purchase.
1979
First Reading Room, Max Protetch Gallery, New York. Traveled.
Reading Room #2, Sullivan Hall Gallery, Ohio State University, Columbus.
1978
Red School House for Thomas Paine, Philadelphia College of Art. Catalogue by Janet Kardon.
1968
A Downtown Renovation, Main Street, Jackson, Minnesota.

Selected Group Exhibitions

1987
Skulptur Projekte, Münster. Catalogue.
Documenta VIII, Kassel. Also *VII*, 1982. Catalogues.
1986
Sonsbeek '86, Arnhem, The Netherlands. Catalogue.
1984
Content: A Contemporary Focus, 1974–1984, Hirshhorn Museum and Sculpture Garden, Washington, D.C. Catalogue.
1983
Beyond the Monument, List Visual Arts Center, MIT, Cambridge, Massachusetts. Traveled. Catalogue.
New Art, The Tate Gallery, London. Catalogue.
1981
Biennial, Whitney Museum of American Art, New York. Catalogue.
Body Language: Figurative Aspects of Recent Art, Hayden Gallery, MIT, Cambridge, Massachusetts. Traveled. Catalogue.
1970
Information, The Museum of Modern Art, New York. Catalogue.
1969
Towers, Museum of Contemporary Art, Chicago. Traveled.

Selected Bibliography

Antin, David. *Poetry Lounge*. Pasadena, California 1982.
Ashbery, John. "Armajani: East Meets Midwest." *Newsweek*, April 1983.
Beardsley, John. *Art in Public Places*. Washington, D.C. 1981.
Berlind, Robert. "Armajani's Open-Ended Structures." *Art in America*, October 1979.
Brenson, Michael. "Siah Armajani." *The New York Times*, 15 November 1985.
Brown, Julia. *Siah Armajani*. New York 1981.
Day, Holliday T. *Siah Armajani: Reading Garden #2*. Omaha, Nebraska 1980.
Friedman, Mildred. "Site: The Meaning of Place in Art and Architecture." *Design Quarterly*, August 1983.
Kind, Joshua. "Statues and Sculpture." *New Art Examiner*, October 1975.
Knight, Christopher. "Little Poetry Lounge on the Prairie." *Los Angeles Herald Examiner*, 1 March 1981.
Lippard, Lucy. *Six Years: The Dematerialization of the Art Object from 1966 to 1972*. New York 1973.
Phillips, Patricia C. "Siah Armajani's Constitution." *Artforum*, December 1985.
———. *Entries (Maximalism)*. New York 1983.
Princenthal, Nancy. "Master Builder." *Art in America*, March 1986.

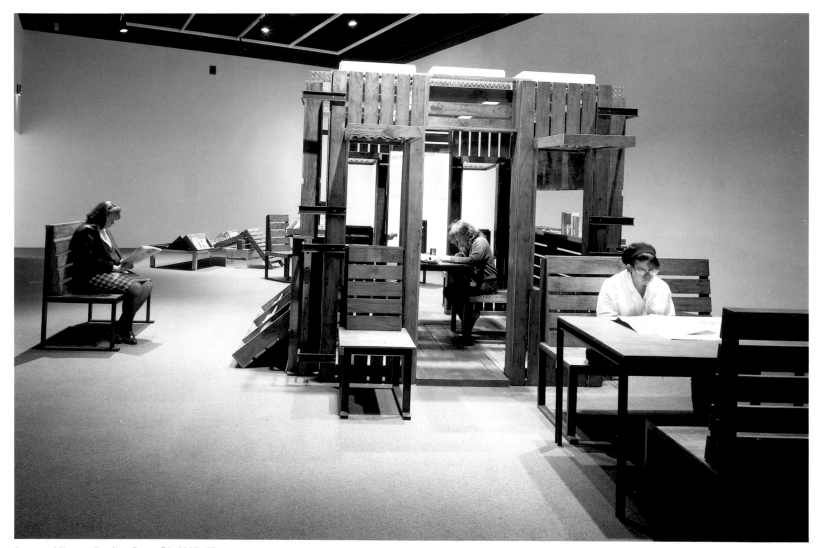

Sacco and Vanzetti Reading Room #2, 1987–88
steel, brick, aluminum, pressure-treated wood, and paint
variable dimensions
Installation view at List Visual Arts Center, M.I.T., Cambridge, Massachusetts
Courtesy of Max Protetch Gallery, New York

Not in exhibition. Work in exhibition illustrated in supplement.

Richard Artschwager

Born 1923, Washington, D.C.
Lives and works in New York

Although Richard Artschwager has recently attracted the attention of a young generation of artists, such as Haim Steinbach, Meyer Vaisman and other producers of conceptual readymades, he has been building his generic, dysfunctional tables, chairs, mirrors and chests of drawers since the 1960s. Artschwager's works of art wittily address the conventions of both sculpture and furniture, disguising their cerebral content by pretending to be goofy ordinary things.

Variations on commonplace objects they may be, but the significance of Artschwager's artworks is that they conflate the notion of essence with that of the received idea. In the early 1960s, Minimal sculptors, seeking an alternative both to the human figure and to the adventurous abstraction of early modern art, derived sculpture from cubes (single or stacked) instantly seen and perceived as volumes. These Minimal sculptors weren't the only ones interested in visual commonplaces, however. Pop artists, off on their own, were also interested as they energetically mined form for all possible cultural and sociological kitsch content. Artschwager was exceptional for bringing together both basic form and Pop content and holding them in provocative tension.

What Artschwager's art serves up are tables looking like nothing more than simple boxes as their pink formica surfaces identify them as flagrant kitchen clichés and mirror constructions presenting unambiguously flat surfaces even as their deep frames refer back to the illusionist space of the Renaissance. In addition, with such objects as a table splayed and hung on the wall, Artschwager argues that by expanding, contracting, reflecting and displacing basic visual conventions, he is able to enrich the meaning of these artifacts in a way that is reminiscent of Magritte's mysterious assertion and denial of the commonplace.

If the 64-year-old Artschwager has become the model for young, sociologically-minded conceptualists, it is partly due to his implicit criticism of the art market, which consumes sculpture as readily as any other "collectible." Yet it is Artschwager's eccentric imagination—not any ideology—that renders his contribution a real challenge to our culture.

—*Marjorie Welish*

Selected Solo Exhibitions

1987
Whitney Museum of American Art, New York. Traveled. Catalogue by Richard Armstrong.
1986
Mary Boone Gallery, New York. Also 1983.
Daniel Weinberg Gallery, Los Angeles. Also 1985, 1983.
1985
Leo Castelli Gallery, New York. Also 1981, 1975, 1973, 1972, 1967, 1965.
Kunsthalle Basel. Traveled. Catalogue by Jean-Christophe Ammann.
1984
University Art Museum, University of California, Berkeley. Traveled. Brochure by Constance Lewallen.
1982
Susanne Hilberry Gallery, Birmingham, Michigan.
1980
Museum of Art, Rhode Island School of Design, Providence.
Daniel Weinberg Gallery, San Francisco. Also 1975, 1974.
1979
Albright-Knox Art Gallery, Buffalo. Traveled. Catalogue by Richard Armstrong, Linda L. Cathcart and Suzanne Delehanty.
1978
The Clocktower, The Institute for Art and Urban Resources, New York.
Kunstverein Hamburg. Traveled.
1974
Galerie Ileana Sonnabend, Geneva. Traveled.
1971
Sonsbeek, Utrecht, The Netherlands. Catalogue by Wouter Kotte.
1959
Art Directions Gallery, New York.

Selected Group Exhibitions

1987
Documenta VIII, Kassel. Also *VII*, 1982; *V*, 1972; *IV*, 1968. Catalogues.
Skulptur Projekte, Münster. Catalogue.
Similia/Dissimilia: Modes of Abstraction in Painting, Sculpture, and Photography Today, Kunsthalle Düsseldorf. Traveled. Catalogue.
1986
In Tandem: The Painter-Sculptor in the Twentieth Century, Whitechapel Art Gallery, London. Catalogue.
1983
New Art, The Tate Gallery, London. Catalogue.
Biennial, Whitney Museum of American Art, New York. Also *Annual* 1972, 1970, 1968, 1966. Catalogues.
1980
La Biennale di Venezia. Traveled. Also 1976. Catalogues.
1974
American Pop Art, Whitney Museum of American Art, New York. Catalogue.
1969
Live in Your Head: When Attitudes Become Form: Works—Concepts—Processes—Situations—Information, Kunsthalle Bern. Catalogue.
Primary Structures, The Jewish Museum, New York. Catalogue.
1964
The New Art, Davison Arts Center, Wesleyan University, Middletown, Connecticut. Catalogue.

Bibliography

Ammann, Jean-Christophe. "Richard Artschwager." *Art of Our Time: The Saatchi Collection*. London 1984.
Artschwager, Richard. "The Hydraulic Door Check." *Arts Magazine*, November 1967.
Artschwager, Richard and Catherine Kord. *Basket Table Door Window Mirror Rug*. New York 1976.
————. *Richard Artschwager/Alan Shields*. Chicago 1973.
Battcock, Gregory, ed. *Minimal Art: A Critical Anthology*. New York, 1968.
Bleckner, Ross. "Transcendent Anti-Fetishism." *Artforum*, March 1979.
Delehanty, Suzanne and Robert Pincus-Witten. *Improbable Furniture*. Philadelphia 1977.
Frank, Peter. "New York Reviews: Richard Artschwager." *ARTnews*, October 1978.
Judd, Donald. "Dick Artschwager and Richard Rutkowski." *ARTnews*, October 1959.
Kuspit, Donald B. "Richard Artschwager." *Artforum*, April 1988.
Lippard, Lucy R. *Six Years: The Dematerialization of the Art Object from 1966 to 1972*. New York 1973.
McDevitt, Jan. "The Object: Still Life, Interviews with the New Object Makers, Richard Artschwager and Claes Oldenburg, on Craftsmanship, Art, and Function," *Craft Horizons*, September–October 1965.
Van Bruggen, Coosje. "Richard Artschwager." *Artforum*, September 1983.
Welish, Marjorie. "The Elastic Vision of Richard Artschwager." *Art in America*, May–June 1978.
Yau, John. "Richard Artschwager's Linear Investigations." *Drawing*, January–February 1985.

44

Dinner, 1987
Formica and acrylic on wood with cloth
51 × 28 × 11⅞ in. (129.5 × 71.1 × 30.2 cm.)
Collection of Janet Green, London

Not in exhibition. Work in exhibition illustrated in supplement.

Georg Baselitz

Born 1938, Deutschbaselitz, Germany

Lives and works in Derneburg, West Germany

As the artist who has generally been given the most credit for having first pushed post-war German painting into an international context, Georg Baselitz ranks as one of the most celebrated artists in the world. His upside-down figure paintings, begun in 1969, are as well-known a symbol of early-'80s painting as Schnabel's plates. Despite this acclaim, however, he remains thoroughly enigmatic and is probably one of the least understood major figures in art today, particularly in the United States. The main reason for this is that Baselitz' contribution is too often considered in strictly formal terms, linked as it is to the revival of figurative and expressionist tendencies in European and American painting during the first half of the 1980s. Whereas any thorough assessment of the complete oeuvre reveals that the state of mind projected by Baselitz' work is much more to the point than what each individual piece looks like.

After a highly visible career as a painter, begun during the mid-1960s, Baselitz turned in 1979 to a series of wooden carvings, producing massive full figures and a number of stylized human heads grazed with a few rough dabs of paint. Each figure is generally presented in the midst of a gesture. Taken together, the works refer stylistically to a variety of possible sources: African, Celtic, Teutonic, Inuit and Etruscan sculpture all seem as much a part of Baselitz' lineage as Picasso's Cubist sculpture and such '20s German sculptors as Wilhelm Lehmbruck and E.L. Kirchner.

Baselitz' three-dimensional work is particularly important because of the detailed manner in which it traces the logic behind his art-making process. As the artist has stated in a recent interview, "Germans in general, and I in particular, need to have a reason for everything we do . . . I am not going to do anything just for fun, or as an experiment." In a quite literal sense, then, Baselitz works in the manner he does because it is a means by which he can demonstrate why he makes art in the first place. Each separate piece becomes a dramatization of the way in which the spirit of invention is checked by the spirit of self-observation, each gesture a ritual of imaginative will undermined by doubt.

At once pathetic and monumental, Baselitz' sculpted figures succeed in trapping the need to justify art-making within a material that is both as raw and as malleable as the first artwork ever made. Implicit in his procedure, though, is Baselitz' longstanding process of self-observation which lends his works their dramatic obstinacy. In this way, the artist has consummated a mortal act in all its breadth and depth, while simultaneously exposing the vulnerable, fragmented nature of the human psyche to the clinical objectivity of historical evaluation. Seen in this light, these works become metaphors for the battered internal life of late 20th-century man, with all his flaws and will to persevere completely intact.

—*Dan Cameron*

Selected Solo Exhibitions

1988
Galerie Michael Werner, Cologne. Also 1984 (catalogue by Hilde Zaloscer); 1983 (catalogue by Andreas Franzke, Rudi Fuchs and Siegfried Gohr); 1982 (catalogue by Herbert Heere); 1981.

1987
Mary Boone Gallery, New York. Catalogue by Trevor Fairbrother. Also 1986, 1984 (catalogue by Klaus Kertess and Norman Rosenthal).
Anthony d'Offay Gallery, London. Catalogue by Jean-Louis Froment and Jean Marc Poinsot. Also 1985 (catalogue by Anthony d'Offay); 1982 (catalogue by Rafael Jablonka).
Kestner-Gesellschaft, Hanover. Catalogue by Carl Haenlein, ed., Stephanie Barron, Eric Darragon, Andreas Franzke, Jean-Louis Froment, Carl Haenlein, A.M. Hamcher and Jean-Marc Poinsot.
Museum Ludwig, Cologne.

1986
Kunstmuseum Winterthur, Switzerland.

1985
Stedelijk van Abbemuseum, Eindhoven. Also 1984 (catalogue by Rudi Fuchs); 1981 (catalogue by Alexander van Grevenstein); 1979 (catalogue by Rudi Fuchs).
Bibliothèque Nationale, Paris. Catalogue by Rainer Michael Mason and François Woimant.

1984
Kunstmuseum Basel and Stedelijk van Abbemuseum, Eindhoven. Traveled. Catalogue by Dieter Koepplin and Rudi Fuchs.

1983
Musée d'Art Contemporain, Bordeaux. Catalogue by Jean-Louis Froment and Jean-Marc Poinsot.
Whitechapel Art Gallery, London. Traveled. Catalogue by Mark Francis and Nicholas Serota, eds., Georg Baselitz and R. Caluocotessi.

1976
Kunsthalle Köln. Catalogue by Siegfried Gohr.

1970
Kunstmuseum Basel. Catalogue by Georg Baselitz and Dieter Koepplin.

1962
Pandämonium, West Berlin. Als 1961.

Selected Group Exhibitions

1987
Berlinart 1961–1987, The Museum of Modern Art, New York. Catalogue.
L'epoque, la mode, la morale, le passion: Aspects de l'art d'aujourd'hui 1977–1987, Musé National d'Art Moderne, Centre National d'Art et de Culture. Georges Pompidou, Paris. Catalogue.

1986
Europa/Amerika—Die Geschich einer künstlerischen Faszination seit 1940, Museum Ludwig, Cologne. Catalogue.
In Tandem: The Painter-Sculptor in the Twentieth Century, Whitechapel Art Gallery, London. Catalogue.

1985
Carnegie International, Museum of Art, Carnegie Institute, Pittsburgh. Catalogue.
The European Iceberg— Creativity in Germany and Italy Today, Art Gallery of Ontario, Toronto. Catalogue.
German Art in the Twentieth Century: Painting and Sculpture 1905–1985, Royal Academy of Arts, London. Traveled. Catalogue.

1984
von hier aus, Messegelände, Düsseldorf. Catalogue.

1982
Documenta VII, Kassel. Also V, 1972. Catalogues.

1975
Bienal de São Paulo. Catalogue.

46

Selected Bibliography

"Collaboration Georg Baselitz."
Parkett, December 1986.
Contributions by Georg Baselitz,
John Caldwell, Eric Darragon,
Remo Guidieri, Dieter Koepplin,
Rainer Michael Mason and
Franz Meyer.

de Sanna, Jole. "Georg Baselitz."
Artforum, September 1987.

Fuchs, Rudi. "Georg Baselitz."
*Art of Our Time: The Saatchi
Collection*. London 1985.

Geldzahler, Henry. "Georg
Baselitz." *Interview*, April 1984.

Goetti, Helmut. "Kullervos
Füsse—Der Maler Georg
Baselitz." *Tendenzen*,
August–September 1968.

Gohr, Siegfried. "In the Absence
of Heroes: The Early Work of
Georg Baselitz." *Artforum*, June 1982.

———. "Georg Baselitz."
Kölner Museums—Bulletin, July 1976.

Gorella, Arwed D. "Der Fall
Baselitz." *Tendenzen*, December 1964.

Kuspit, Donald B. "Le moi
archaique de Georg Baselitz."
Art Press, January 1984.

———. "Pandemonium, The
Root of Georg Baselitz's Imagery."
Arts Magazine, Summer 1986.

Morgan, Stuart. "Georg Baselitz,
Paintings 1966–1969 at Anthony
d'Offay Gallery and Recent
Paintings and Drawings at
Waddington Gallery, London."
Artforum, February 1983.

Pincus-Witten, Robert. "Georg
Baselitz: From Nolde to
Kandinsky to Matisse, A
Speculative History of Recent
German Painting." *Arts
Magazine*, Summer 1986.

Roditi, Edouard. "Le Neo-
Nazisme artistique à Berlin-
Ouest." *L'Arch, Revue du FSJU*,
March 1965.

Schjeldahl, Peter. "Anxiety as a
Rallying Cry." *The Village Voice*,
16 September 1981.

Taylor, Paul. "Cafe Deutschland."
ARTnews, April 1986.

van Graevenitz, Antji. "Baselitz
en de bateke." *Kunstschrift*,
July–August 1982.

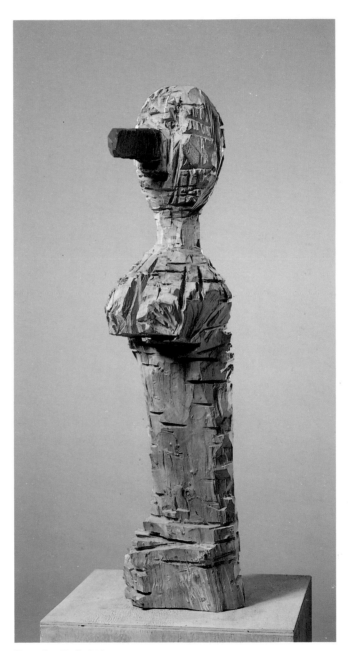

Tragischer Kopf, 1988
painted birch
50 × 12⁹∕₁₀ × 14²∕₅ in. (128.5 × 33 × 37 cm.)
Courtesy of Galerie Michael Werner, Cologne
and Anthony d'Offay Gallery, London

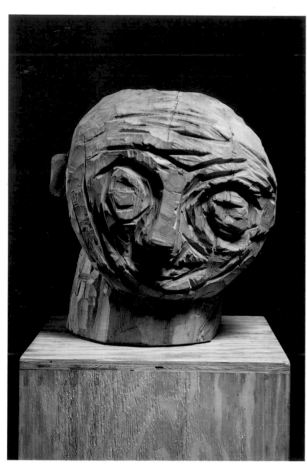

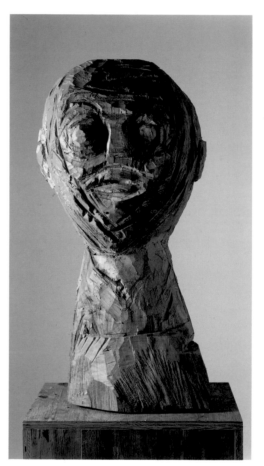

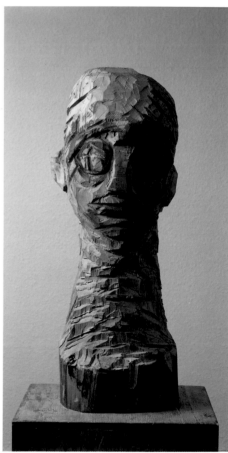

Untitled, 1982
beechwood
19½ × 17⅗ × 17⅗ in. (50 × 45 × 45 cm.)
Private collection, courtesy of Galerie Michael Werner, Cologne

Blauer Kopf, 1983
painted beechwood
31½ × 15⁷⁄₁₀ × 12⅗ in. (80 × 40 × 32 cm.)
Kunsthalle Bielefeld, West Germany

Untitled, 1982
painted poplar wood
33 × 12⅗ × 11⅘ in. (84 × 32 × 30 cm.)
Garnatz Collection, Cologne

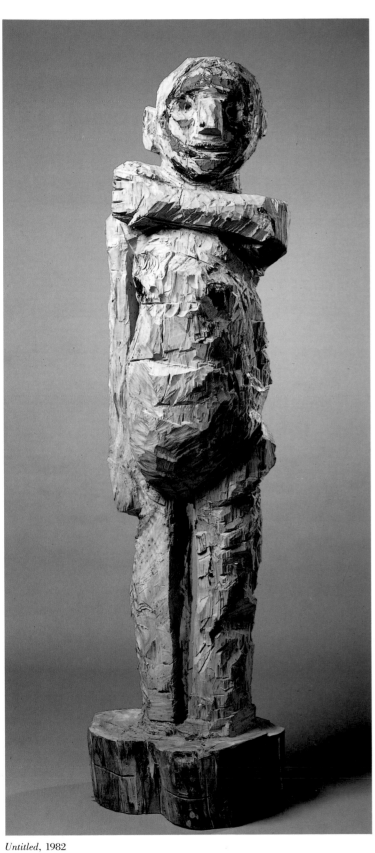

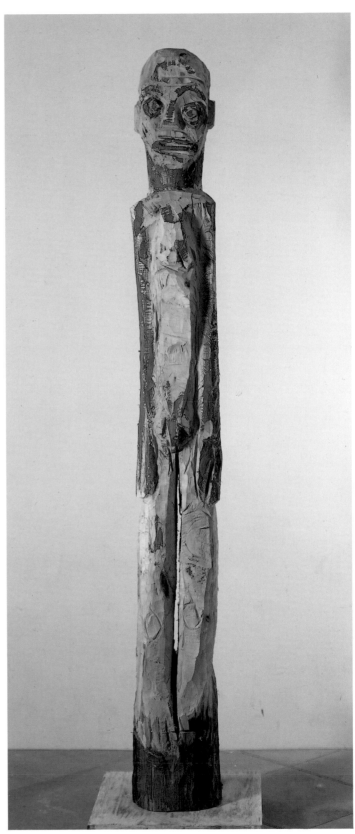

Untitled, 1982
painted wood
98½ × 36 × 24 in. (250.2 × 91.4 × 61 cm.)
Saatchi Collection, London

Untitled, 1983
painted linden wood
97½ × 11⁷⁄₁₀ × 11⁷⁄₁₀ in. (250 × 30 × 30 cm.)
Private collection, courtesy of Galerie Michael Werner, Cologne

Lothar Baumgarten

Born 1944, Rheinsberg, Germany

Travels and works in situ

Because of the close connection between work and text in *The Tongue of the Cherokee*, the museum has chosen to include the artist's text here in lieu of the commissioned entry.

The Talking Leaf

At the beginning of the nineteenth century, Sequoyah (Sik-wa-yi), who called himself George Gist or Guess, discovered the magic of writing. It was a time when the land was still free of missions, and there were no schools. Only occasionally did he and his friends catch glimpses of printed or written papers of the white man. They talked about the mysterious pieces of paper and called them the white man's "talking leaf."

Sequoyah, however, soon discovered that writing had a concrete function, that it was a power and that whoever possessed it, like the white man, was superior. At this time, the Indians had no method for writing down their knowledge, their insights, their beliefs about the cosmos, and their history, in order to pass the wisdom of the elders onto the yet unborn. They lacked any way to preserve it.

Sequoyah dreamt of an Indian "talking leaf." He began to experiment, and his path led to various forms of symbolic accordances: from a simple pictogram of the autochthons to the alphabet of a modern Indian society. Even while on the move, he repeatedly scratched his signs in stones or wrote them in the sand on the banks of the rivers.

"Sequoyah's syllabary, the unaided work of an uneducated Indian reared amidst semi-savage sur-roundings, stands second to none. Twelve years of his life (1809–1821) are said to have been given to his great work. Being entirely without instruction and having no knowledge of the philosophy of language, not even being acquainted with English, his first attempts were, naturally enough, in the direction of the crude Indian pictograph. He set out to devise a symbol for each word of the language, and after several years of experiment, finding this an utterly hopeless task, he threw aside the thousands of characters which he had carved or scratched upon pieces of bark and started anew to study the construction of the language itself. By attentive observation for another long period he finally discovered that the sounds in the words used by the Cherokee in their daily conversation and their public speeches could be analyzed and classified, and that the thousands of possible words were all formed from varying combinations of hardly more than a hundred distinct syllables. Having thoroughly tested his discovery until satisfied of its correctness, he next

Selected Solo Exhibitions

1987
The Carnegie Museum of Art, Pittsburgh. Brochure by Vicky A. Clark.
Marian Goodman Gallery, New York. Also 1985.
Kunsthalle Bern.
1986
ARC/Musée d'Art Moderne de la Ville de Paris. Catalogue.
Museo de Bellas Artes and Jardín Botanico de Caracas, Los Caobos, Venezuela.
Galerie Konrad Fischer, Düsseldorf. Also 1985, 1982, 1976, 1975, 1973, 1972.
1985
Stedelijk Museum, Amsterdam.
Institute of Contemporary Art, Boston. Brochure by Elisabeth Sussman.
1983
Städtisches Museum Abteiberg Mönchengladbach.
1982
Stedelijk van Abbemuseum, Eindhoven.
1976
Kabinett für aktuelle Kunst, Bremerhaven.
1974
Botanical Garden, Cologne. Catalogue.

Selected Group Exhibitions

1988
BiNational: Art of the Late 80s, Museum of Fine Arts and Institute of Contemporary Art, Boston; Städtische Kunsthalle and Kunstsammlung Nordhein-Westfalen, Düsseldorf. Catalogue.
1987
Skulptur Projekte, Münster. Catalogue.
Musée des Arts Africains et Oceaniens, Paris, in conjunction with *L'epoque, la mode, la morale, la passion: Aspects de l'art d'aujourd'hui, 1977–1987*, Musée National d'Art Moderne, Centre National d'Art et de Culture Georges Pompidou, Paris. Catalogue.
1986
Falls the Shadow, Recent British and European Art, Hayward Gallery, London. Catalogue.
1985
The European Iceberg— Creativity in Germany and Italy Today, Art Gallery of Ontario, Toronto. Catalogue.
1984
La Biennale di Venezia. Also 1978. Catalogues.
Ouverture, Castello di Rivoli, Turin. Catalogue.
1982
Documenta VII, Kassel. Catalogue.
1974
Projekt, Kunsthalle Köln. Catalogue.
1970
Jetzt, Kunsthalle Köln. Catalogue.

Selected Bibliography

Baumgarten, Lothar. *Die Namen der Bäume*. Eindhoven 1982.
———. *Land of the Spotted Eagle*. Mönchengladbach 1983.
———. *Makunaíma*. New York 1987.
———. *Señores Naturales*. Venice 1984.
Baumgarten, Lothar and M. Oppitz. *Tě Né Tě*. Düsseldorf 1974.
David, Catherine. "Le Musée National d'Art Moderne." *Parachute*, March 1987.
Foster, Hal. "The 'Primitive' Unconscious of Modern Art." *October*, Fall 1985.
Gale, Peggy. "Lothar Baumgarten's *The Origin of the Night*." *Parachute*, Summer 1986.
Heubach, Friedrich W. "Kultur und Natur oder die Natur ist ziemlich komisch geworden." *Interfunktionen*, September 1972.
Hohmeyer, Jürgen. "Auf dem Amazonas Wandeln." *Der Spiegel*, 23 May 1984.
Metken, Günther. "Der Regenwald—Tanzplatz der Bäume." *Frankfurter Allgemeine Zeitung*, 17 January 1983.
Monk, Philip. "Lothar Baumgarten: Kunsthalle Bern." *Parachute*, December 1987.
Owens, Craig. "Improper Names." *Art in America*, October 1986.
Soutif, Daniel. "Des changements sur la ligne no. 9." *Libération*, 19 January 1987.
Viau, René. "Impressions d'Afrique." *Parachute*, December 1987.
Zacharopoulos, Denys. "The World and its Traditions or the Traditions of the World." *Artforum*, October 1985.

proceeded to formulate a symbol for each syllable. To this purpose he made use of a number of characters which he found in an old English spelling book, picking out capitals, lower-cases, italics, and figures, and placing them right side up or upside down, without any idea of their sound or significance as used in English. Having thus utilized some thirty-five ready-made characters, to which must be added a dozen or more produced by modification of the same originals, he designed from his own imagination as many more as were necessary to his purpose, making eighty-five in all. The complete syllabary, as first elaborated, would have required some one-hundred-and-fifteen characters, but after much hard study over the hissing sound in its various combinations, he hit upon the expedient of representing the sound by means of a distinct character—the exact equivalent to our letter s—whenever it formed the initial of a syllable."[1]

"The alphabet was soon recognized as an invaluable invention for the elevation of the tribe, and in a little over a year thousands of hitherto illiterate Cherokee were able to read and write their own language, teaching each other in cabins or by the roadside. The whole Nation became an academy for the study of the system. Letters were written back and forth between the Cherokees in the East and those who had emigrated to the lands of Arkansas."[2]

In 1827, the Cherokee Council decided to publish a national paper in the Cherokee language. It was decided to cast, in lead, Sequoyah's characters at Messrs. Baker and Green in Boston under the supervision of the young missionary Reverend Samual A. Worcester. Then, in December of the same year, the *Missionary Herald* printed the first verse of Genesis in the new typeface of the Cherokee syllabary. It was the first edition. At the beginning of the following year the modern hand press (of cast iron, with spiral springs to hold up the platen—at that time a new invention) and the typefaces, which came from Boston through Savannah and Augusta, reached the new capital of the Cherokee, New Echota in Georgia.

On Thursday, February 21, 1828, the *Cherokee Phoenix* (Tsa-lagi Tsu-le-hi-ea-nunchi) appeared for the first time. It was the four-page weekly newspaper of the Cherokee Nation, half in Cherokee and half in English and in super-royal format. The printers were two white men, Isaac N. Harris and John F. Wheeler, aided by the Cherokee John Candy. Elias Boudinot (Galagina "the Buck"), an educated Indian, was the first publisher. The *Phoenix* even reached Europe, one of its first subscribers being Baron von Humboldt in Berlin. Neither of the printers understood a word of

Cherokee, and the new letters created much difficulty at first. Paper had not been ordered, and it had to be laboriously brought in from Knoxville, and part of it had become moldy by the time the first edition was printed. Despite all the difficulties, it was the beginning of journalism in the Cherokee Nation.

The Confederation of Cherokee, with more than seventy-five villages, extended over parts of four states: Georgia, North Carolina, Tennessee and Alabama. In 1827, the Cherokee founded the National Constitutional Convention and began to erect a political structure based on the model of the young United States of America. On a rational basis they founded a new value and moral system. Reverend Worcester became their enthusiastic advocate, and they published their new constitution, a bible translation, pamphlet, and their own literature in Sequoyah's letters.

This renaissance did not last long. In Georgia, the authorities were suspicious of the Indians' activities; for a long time the settlers had begrudged their right to arable land. Reprisals against the Cherokee became increasingly frequent. The settlers began to encroach on them, stealing their horses and cattle, in their absence occupying their houses or burning them down, and destroying their crops. Georgia contested the inherited right of the indigenous people to the land of their ancestors and declared all established contracts with the Indians to be null and void. The whites proclaimed more and more new laws and divided the land between themselves, thus depriving the Cherokee of any means of livelihood.

After six years the publication of the *Cherokee Phoenix* was stopped and Reverend Worcester and J. F. Wheeler were thrown into prison. Time and again the American government yielded to the pressure of the speculators and settlers. It proved itself to be incapable of representing the interests of the Indians. There followed the sad and familiar repetition of that which had already occurred elsewhere: wars, broken treaties, expropriation of land, expulsion, rebellion and finally, defeat. The army deported the Nation of Cherokees. On the march to the West, the "trail of tears," twelve thousand people—somewhat less than half of the Cherokee—lost their lives. The rest then tried to survive in the Indian Territory in Oklahoma. Once again a newspaper was printed in Sequoyah's letters, the *Cherokee Advocate*, which appeared in Tehlequah on September 26, 1844, under the auspices of William P. Ross.

52

Sequoyah was born a few years before the American Revolution in the Cherokee village of Tuskegee in Tennessee. His mother was a full-blooded Cherokee. His father, Nathaniel Gist, who was a travelling merchant among the Indians, was probably Dutch. After the father abandoned the family, the young boy was raised by his mother entirely according to the customs and mores of the Indian society. Early in his life, a hunting accident crippled him, and he lost the use of one of his legs. In 1827–1828 he was part of a delegation from his tribe sent to Washington to protest against the attacks of the whites. It was there that the painter Charles Bird King painted his well-known portrait of Sequoyah, showing him with his syllabary. In 1843, when he was more than eighty years old, the patriot undertook a search for some Cherokee who had once headed westward and were not heard of again. He traveled with samples of his writing through Texas to Mexico, and died there in the town of San Fernando in Chihuahua.

Sequoyah is celebrated as the genius of the Cherokee Nation; imaginative and inventive, he taught his people reading and writing in a short period of time. He devised the Cherokee alphabet for them, and he remains the only one in history to develop an alphabet or syllabary completely on his own.

—LB

translated from German by Clara Seneca

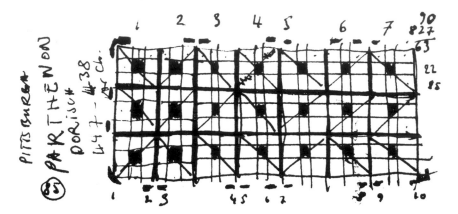

Study for "The Tongue of the Cherokee," 1988
ink and collage on paper
19¾ × 8¹¹⁄₁₆ in. (50.2 × 22.1 cm.)
Courtesy of Marian Goodman Gallery, New York

1
James Mooney, *Myths of the Cherokee*. Bureau of American Ethnology, Annual Report 19, Part I, Washington 1900.
2
As quoted without attribution in Grant Foreman, *Sequoyah*, Norman and London 1938.

Bibliography:

Foster, George E., "Journalism among the Cherokee Indians," *Magazine of American History*, 18, New York 1887.

Gallatin, Albert, *Synopsis of the Indian Tribes . . .*, trans. American Antique Society, II, Cambridge 1836.

Pickering, John, *Über die indianischen Sprachen Amerikas*. Leipzig 1834.

Pilling, James C., *Bibliography of the Iroquoian Languages*. Bureau of Ethnology, Washington 1888.

Starkey, Marion L., *The Cherokee Nation*. New York 1946.

Sketch for "The Tongue of the Cherokee," 1988
ink on paper
2¼ × 4½ in. (5.72 × 11.43 cm.)
Courtesy of Marian Goodman Gallery, New York

The Tongue of the Cherokee

Joseph Beuys

1921–1986, born Cleves, Germany

No less than for Andy Warhol or Gilbert and George, Joseph Beuys' artistic practice is inseparable from his persona. But while Warhol resisted emotional and political engagement so successfully that he made impassivity stylish, and while Gilbert and George took Warhol's opacity and estheticized it, Beuys was a fervent activist and a publicly agonized soul. He was also, somewhat paradoxically, a consummate formalist; indeed, his work bridges Arte Povera and Minimalism, traditional expressionism and Conceptualism. His work also helped bridge Europe and America, serving (when the Vietnam War ended before which he refused to come here) to help renew American interest in art beyond its own borders.

Born in Cleves in 1921, Beuys (like his apparent heir Anselm Kiefer) circled provocatively around the heroism and mysticism of Northern folklore, a lore widely understood to be tainted by association with Nazism. A brief stint in the circus during the '30s can be said to prefigure Beuys' later activities as a performer, an esthetic acrobat part spiritualist and part clown. But his formative experience was as a combat pilot in World War II: in 1943 he was shot down in Crimea and rescued by nomadic Tartars who, he said, covered him in fat and felt to help keep him warm. These two materials, along with beeswax and honey and a few animals—hares, stags, coyotes—appear throughout Beuys' sculpture, tableaux and performances.

Though he made art from the early '50s on, Beuys' first exhibition, of sculptural assemblages, didn't take place until 1965. He was at the time associated with the international Fluxus movement and took part in several of its anarchistic escapades, but his most memorable performances were solo. One of the more potent of these *How to Explain Pictures to a Dead Hare* (1965, Düsseldorf), in which Beuys, his head covered with honey and gold leaf and his shoes encumbered with iron and felt soles, spent three hours silently expounding to a dead hare cradled in his arms. As always with Beuys, the imagery of this event was brutal and sensuous at the same time. Equally legendary is his 1974 New York performance, *Coyote*, a week-long gallery residence with a live coyote. The props included a felt wrap, a hooked walkingstick, gloves, a flashlight and strewn copies of *The Wall Street Journal*.

Beuys was also an accomplished poet of the found object (in which he followed a tradition more Surrealist than Dadaist—unforgettably, he quipped that Duchamp's silence was overrated). The fat-lined bathtub of 1960; the felt covered piano of 1966; the sleds with felt, fat and flashlight, issuing from a Volkswagon minibus, of 1969, are all both culturally and personally evocative. And though such works as the metal and felt *Fonds* (1967–79) are highly reductive, they refer to the structure of a battery and its generative capacity and were, for Beuys, very suggestive. Indeed, he shared the alchemist's belief in all inert matter's spiritual properties.

But it is as an educator—or more properly an agitator—that Beuys (who died in 1986) probably had his greatest impact. He was made a professor of sculpture of the Düsseldorf Academy of Art in 1961 and was dismissed in 1972 for political activism. His subsequent establishment of the Free International University and his promulgation of a "social sculpture" that makes everyone an artist expressed his impatience with the strictures of the art world as much as with the political and economic realities of our time. While Beuys' work is tied to a past both inescapable and unapproachable, his social ideology was radically utopian, and this double pull characterizes his legacy.

—*Nancy Princenthal*

54

Selected Solo Exhibitions

1988
Martin-Gropius-Bau, West Berlin. Traveled. Catalogue by Heiner Bastian, ed.

1986
Städtische Galerie im Lenbachhaus, Munich. Also 1981. Catalogues by Armin Zweite.

1985
Fondazione Amelio, Museo di Capodimonte, Naples.

Anthony d'Offay Gallery, London. Also 1983, 1982, 1981.

1984
Galerie Schellmann & Klüser, Munich. Also 1981, 1980, 1978, 1977, 1976.

1983
Musée Cantonal des Beaux'Arts, Lausanne. Traveled. Catalogue by Céline Bastian, Heiner Bastian, Erika Billeter and Gisela Noack.

Galerie Schmela, Düsseldorf. Also, 1979, 1976, 1972, 1971, 1969, 1965. Catalogues.

1980
City Art Gallery, Leeds, and Victoria and Albert Museum, London. Traveled. Catalogue by Anne Seymour.

1979
The Solomon R. Guggenheim Museum, New York. Catalogue by Caroline Tisdall.

Museum Boymans van Beuningen, Rotterdam. Traveled. Catalogue by Heiner Bastian and Jeannot Simmen.

1977
Nationalgalerie, Staatliche Museum Preussischer Kulturbesitz, West Berlin. Catalogue by Christos M. Joachimides.

Kunstmuseum Basel. Catalogue by Dieter Koepplin and Caroline Tisdall.

1974
Museum of Modern Art, Oxford, England. Catalogue by Caroline Tisdall and Nicholas Serota.

1968
Stedelijk van Abbemuseum, Eindhoven. Catalogue by Otto Mauer.

1967
Städtisches Museum Abteiberg, Mönchengladbach. Catalogue by Johannes Cladders and Hans Strelow.

1966
Galerie René Block, West Berlin. Also 1954.

1961
Städtisches Museum Haus Koekkoet, Cleves. Catalogue.

Selected Group Exhibitions

1988
Zeitlos, West Berlin. Catalogue.

1987
Documenta VIII, Kassel. Also *VII*, 1982; *VI*, 1977; *V*, 1972; *IV*, 1968; *III*, 1964. Catalogues.

Beuys, Klein, Rothko—Transformation and Prophecy, Anthony d'Offay Gallery, London. Traveled. Catalogue.

Warhol/Beuys/Polke, Milwaukee Art Museum. Catalogue.

Brennpunkt, Kunstmuseum Düsseldorf. Traveled. Catalogue.

1986
Qu'est-ce-que la sculpture moderne?, Musée National d'Art Moderne, Centre National d'Art et de Culture Georges Pompidou, Paris. Catalogue.

1985
The European Iceberg—Creativity in Germany and Italy Today, Art Gallery of Ottawa, Toronto. Catalogue.

1984
von hier aus, Messegelände, Düsseldorf. Catalogue.

1982
Zeitgeist, Martin-Gropius-Bau, West Berlin. Catalogue.

Joseph Beuys—Robert Rauschenberg—Cy Twombly—Andy Warhol. Nationalgalerie, Staatliche Museen Preussischer Kulturbesitz, West Berlin and Städtisches Museum Abteiberg, Mönchengladbach. Catalogue.

1974
Art into Society, Society into Art: Duchamp, Warhol, Beuys, Institute of Contemporary Arts, London. Catalogue.

1972
Realität—Realismus—Realität, von der Heydt-Museum, Wuppertal. Traveled. Catalogue.

1971
Métamorphose de l'object: Art et antiart 1910–1970, Palais des Beaux-Arts, Brussels. Traveled. Catalogue.

Selected Bibliography

Adriani, Götz, Winfried Konnertz and Karin Thomas. *Joseph Beuys.* Cologne 1973.

Ammann, Jean-Christophe. "Schweizer Brief: Joseph Beuys; Zeichnungen-kleine Objekte." *Art International,* October 1969.

Bojiscul, W. *Zum Kunstbegriff des Joseph Beuys.* Essen 1985.

Buchloh, Benjamin H. D. "Beuys: The Twilight of the Idol: Preliminary Notes for a Critique." *Artforum,* January 1980.

Burckhardt, Jacqueline, ed. *Ein Gespräch/Una Discussione: Joseph Beuys, Jannis Kounellis, Anselm Kiefer, Enzo Cucchi.* Zurich 1986.

Gespräche mit Beuys, Joseph Beuys in Wien und am Friedrichshof. Klagenfurt 1988.

Harlan, Volker, Rainer Rappmann and Peter Schata, *Soziale Plastik—Materialien zu Joseph Beuys.* Achberg 1976.

Harlan, Volker. *Was ist Kunst? Werkstattgespräche mit Beuys.* Stuttgart 1986.

Herzogenrath, Wulf., ed. *Selbstdarstellung. Künstler über sich.* Düsseldorf 1973.

Morgan, Stuart, "Interview with Joseph Beuys," *Parkett,* January 1986.

Raussmüller-Sauer, Christel, ed. *Joseph Beuys.* Schaffhausen 1988.

Stachelhaus, Heiner. *Joseph Beuys.* Düsseldorf 1987.

Staeck, Klaus and Gerhard Steidl. *Beuys in Amerika.* Heidelberg 1987.

Verspohl, Franz-Joachim. *Joseph Beuys. Das Kapital/Raum 1970–77.* Frankfurt 1984.

Vischer, Theodora. *Beuys und die Romantik.* Cologne 1983.

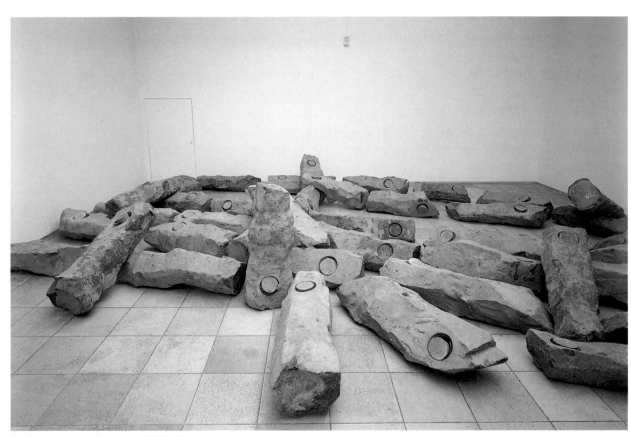

Das Ende des 20. Jahrhunderts, 1983–85
44 basalt stones, clay, and felt
variable dimensions
Installation view at Staatsgalerie Moderner Kunst, Munich
Courtesy of Galerie Bernd Klüser, Munich

Not in exhibition. Work in exhibition illustrated in supplement.

Ross Bleckner

Born 1949, New York

Lives and works in New York

Championed as an abstract painter during the heyday of Neo-Expressionism and subsequently as a mentor to the younger Neo-Geo artists, Ross Bleckner has been cast as a Post-Modernist artist with two distinct styles: one, a revival of Op art; the other, a revival of symbolist painting, rooted in late 19th-century melancholy and alienation. Yet Bleckner is most of all a painter of the '80s, creating allegories which reflect this decade's preoccupations with the horror of AIDS and the threat of nuclear destruction. In his search for a way to express a widespread fear of failure and loss, Bleckner has concentrated on light and perception; ultimately, his paintings are about illumination and insight.

In his large-scale stripe paintings, exhibited for the first time in 1982, Bleckner consciously revived the look of Op art with the hope of injecting emotion into its abstract language. Vertical bands of color dance across his canvases, creating a pulsating, electrical charge. The hypnotic effect is disorienting; the darker bands seem like trees, or even prison bars, denying access to the light-filled space of the paintings which include birds, bows (a pun on the decorative quality of the stripes), or light spots. Just as an image comes into focus, though, it collapses, creating a tension that symbolizes the fragility of perception, and also, perhaps, the fragility of life.

Bleckner's concern with light as it defines objects and creates pictorial space, which is evident even with the distracting kaleidoscopic effect of these paintings, takes center stage in his "atmosphere" paintings of 1983. These small paintings are of nocturnal scenes, in which patches of light emerge from enveloping shadows. With no identifiable imagery or specific source of light, these are as disorienting as his stripe paintings in that they seem to hint at an invisible mystical or spiritual presence as the source of illumination within the work.

These eerie, evocative works bridge the gap between the stripe paintings and the paintings featuring urns, chalices, fading flowers, gates, and chandeliers—emblems of death which hover in a foggy atmosphere—and the more spiritual black paintings which contain spots of light, floating hands, birds, and even haloes. Referring to Symbolist paintings from the turn of the century, Bleckner uses light as the controlling force in these poetic elegies. Capturing the ephemeral reflections of a chandelier or the sparkle of starlight, Bleckner's visionary images gain metaphysical significance. His memorials to those who have died from AIDS can be said to constitute the 20th-century counterpart to the Symbolists' fin-de-siècle picturing of alienation and despair.

—*Vicky A. Clark*

Solo Exhibitions

1987
Waddington Galleries, London.
Catalogue by Peter Schjeldahl.
Mary Boone Gallery, New York.
Also 1987 (catalogue by Rainer
Crone); 1986 (catalogue); 1983;
1981; 1980; 1979.
San Francisco Museum of
Modern Art. Brochure by John
R. Lane.
Galerie Max Hetzler, Cologne.
1987
Margo Leavin Gallery, Los
Angeles.
1986
Mario Diacono Gallery, Boston.
1985
Institute of Contemporary Art,
Boston. Brochure by Elisabeth
Sussman.
1984
Nature Morte Gallery, New York.
1982
Patrick Verelist Galerie,
Antwerp.
Portico Row Gallery,
Philadelphia.
1977
Cunningham Ward Gallery, New
York. Also 1975.
1976
John Doyle Gallery, Chicago.

Selected Group Exhibitions

1988
Biennale of Sydney. Catalogue
1987
*NY Art Now: The Saatchi
Collection*, London. Catalogue
Biennial, Whitney Museum of
American Art, New York.
Catalogue. Also 1975.
Awards in The Visual Arts 6,
organized by Southeastern
Center for Contemporary Art,
Winston-Salem, North Carolina.
Traveled. Catalogue.
Post-Abstract Abstraction, The
Aldrich Museum of
Contemporary Art, Ridgefield,
Connecticut. Catalogue.
1986
*End Game: Reference and
Simulation in Recent Painting
and Sculpture*, Institute of
Contemporary Art, Boston.
Catalogue.
Emerging Artists 1986,
Cleveland Center for
Contemporary Art.
1985
Vernacular Abstraction, Wacoa
Art Center, Tokyo.
1984
The Meditative Surface, The
Renaissance Society, University
of Chicago.
1981
Tenth Anniversary Exhibition,
California Institute of the Arts,
Valencia.
1979
New Painting/New York,
Hayward Gallery, London.

Selected Bibliography

Bleckner, Ross. "Disavowal and Redemption." *Effects Magazine*, July 1983.

Brenson, Michael. "Ross Bleckner." *The New York Times*, 14 February 1986.

Cameron, Dan. "On Ross Bleckner's 'Atmosphere' Paintings." *Arts Magazine*, February 1987.

Halley, Peter. "Ross Bleckner: Painting at the End of History." *Arts Magazine*, May 1982.

Klein, Mason. "Past and Perpetuity in the Recent Paintings of Ross Bleckner." *Arts Magazine*, October 1986.

Mantegna, Gianfranco. "The Ellipse of Reality, Ross Bleckner." *Tema Celeste*, April–May 1987.

Melville, Stephen. "Dark Rooms: Allegory and History in The Paintings of Ross Bleckner." *Arts Magazine*, April 1987.

Mitchell, Raye B. "Ross Bleckner." *New Art Examiner*, April 1976.

Morgan, Stuart. "Strange Days." *Artscribe International*, March 1988.

Owens, Craig. "Back to the Studio." *Art in America*, January 1982.

Pincus-Witten, Robert. "Defenestrations: Robert Longo and Ross Bleckner." *Arts Magazine*, November 1982.

Rankin, Aimee. "Ross Bleckner." *BOMB*, April 1987.

Siegel, Jeanne. "Geometry Resurfacing: Ross Bleckner, Alan Belcher, Ellen Carey, Peter Halley, Sherrie Levine, Philip Taaffe, James Welling." *Arts Magazine*, March 1986.

Smith, Roberta. "Art: In Bleckner Show, an Array of Past Motifs." *The New York Times*, 13 February 1987.

Steir, Pat. "Where the Birds Fly, What the Lines Whisper." *Artforum*, May 1987.

Wei, Lilly. "Talking Abstract: Part One." *Art in America*, July 1987.

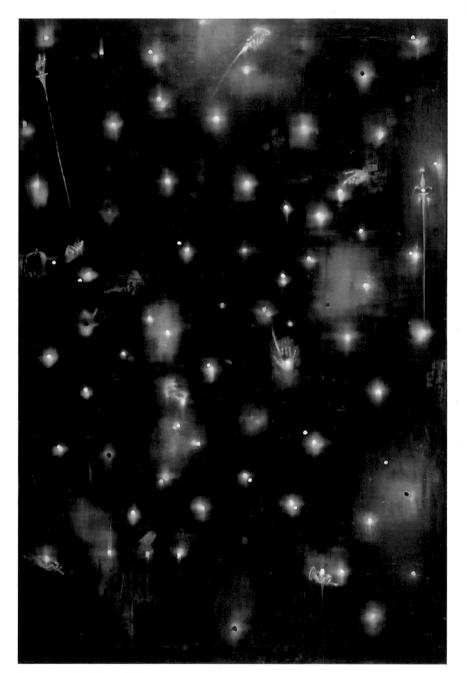

Two Knights Not Nights, 1988
oil on canvas
108 × 72 in. (274.3 × 182.9 cm.)
Collection of Fredrik Roos, Zug, Switzerland

Us Two, 1988
oil on canvas
108 × 60 in. (274.3 × 152.4 cm.)
Courtesy of Mary Boone Gallery, New York

Knights in Nights, 1988
oil on canvas
108 × 72 in. (274.3 × 182.9 cm.)
Collection of Mr. and Mrs. John Garland Bowes, San Francisco

Recover, 1988
oil on canvas
108 × 72 in. (274.3 × 182.9 cm.)
Courtesy of Mary Boone Gallery, New York

Anna and Bernhard Blume

Anna Blume
Born 1937, Bork, Germany
Lives and works in Cologne

Bernhard Johannes Blume
Born 1937, Dortmund, Germany
Lives and works in Cologne

Things are not what they seem in the photo sequences of Anna and Bernhard Blume. Anna Blume has called them photo documents and phototherapy, and the truth lies somewhere in between. Their series of 8-by-4-foot photographs present domestic experiences gone out of control in the rooms of their own house: inanimate objects fly as gravity is defied and normal time and space are suspended. Seemingly innocuous objects—potatoes and plates, for instance—become manifestations of human anxieties.

Collaborators since 1986, each brings something from his/her own work to their joint efforts. Bernhard brings a concern with the conceptual basis of art and its relation to life and creativity, a concern demonstrated in his performance activity (he participated in a Fluxus performance with John Cage in 1964 and has performed since on his own), the use of many mediums including photography and drawing, and even his teaching. Anna brings an interest in a female sensibility and perception which she explored in large drawings from 1975 to 1982. Together they create and star in unusual photo and Polaroid sequences which depict our innermost fears and fantasies.

While these photo sequences are not strictly narrative, resembling recent non-narrative films and non-linear novels, they do have specific content, which concerns the domestic roles traditionally determined by gender. In the kitchen scenes (*Trautes Heim*, 1987, and *Küchen Koller*, 1986–87, for example), the food and dishes overpower the woman (Anna), who is ejected from her kitchen chair/throne. The dishes and potatoes are emblems of the housewife's rage and frustration as they fly through the room. In another sequence (*Vasen-Extasen*, 1987) the living room tilts and shakes like a funhouse: furniture moves, vases fly through the air around the man (Bernhard), who, in one image, is caught inside a pot as if returning to the womb. These psychodramas have much in common with both performance/happenings of the '60s and '70s and, indeed, therapeutic techniques of the same decade. The Blumes' images, like film stills taken out of sequence or the analytic exploration of dream details, accommodate (and create) radical shifts in time, space and meaning.

Instead of using the illusionism of painting to elicit the realms of the subconscious as many of the Surrealists did, the Blumes' use of photography adds an ironic dimension to their staged, if chaotic, encounters. By using photography, the medium long associated with recording facts, the Blumes emphasize that photography is also a tool for exploring the underlying tensions and truths of contemporary life. Their "documentary" photographs condense the multiple realities of seemingly impossible events.

Anna and Bernhard Blume inventively exploit all the technical tricks of the photographers trade to create and record their dramas: time lapse, selective focus, blurred and sandwiched images, multiple exposures, and mirrors. Yet their technical means are never so conspicuous or distracting as to draw attention away from the images themselves and their complex psycho-social interpretations.

—*Vicky A. Clark*

Selected Solo Exhibitions

1987
Portikus, Frankfurt. Traveled. Brochure.
Kunsthalle Basel. Catalogue by Jean-Christophe Ammann, Anna and Bernhard Blume.
Kunst RAI, Amsterdam.
1986
Galerie Magers, Bonn. Also 1976. Catalogue by Horst Walter.
1984
Kunstfonds Bonn.
Künstlerhaus Stuttgart.
1982
Danny Keller Galerie, Munich.
1971
Galerie Jöllenbeck, Cologne.

Selected Group Exhibitions

1987
Een keuze/A Choice, Kunst RAI, Amsterdam.
1986
Behind the Eyes, San Francisco Museum of Modern Art. Catalogue.
1985
Rheingold—40 Künstler aus Köln und Düsseldorf, Turin. Catalogue.
1984
von hier aus, Messegelände, Düsseldorf. Catalogue.
Kunstlandschaft Bundesrepublik, Kunstverein Wilhelmshaven, West Germany.
1982
Mit Fotografie, Museum Ludwig Cologne.
1981
Gegeneinander/Miteinander, Galerie Insam, Vienna.
1980
La Biennale di Venezia. Catalogue.

Selected Bibliography

Blume, Bernhard. *Die Vierte Dimension*. Düsseldorf 1974.

———. *heilig, heilig, heilig*. Munich 1986

———. *Ideoplastie*. Cologne 1970.

———. *Malerei als Medienreflexion*. Bergisch Gladbach 1976.

———. *natürlich*. Munich 1982.

———. *Paraphrase zur Psychopathologie künstlerischer Produktion. Transzendentale Fotografie--Texte zu meinen Fotos und wie sie zustandekommen*. Cologne 1973.

Brock, Bazon. "Wir wollen Gott, basta!" *Heilsgebilde*. Cologne 1983.

Catoir, Barbara. "Bernhard Johannes Blume." *Das Kunstwerk*, 1975.

Grüterich, Marlies. "Bernhard Johannes Blume." *Kunstforum International*, March 1979.

Hamburger, Kurt. *Zu den Ideografien Bernhard Johannes Blume*. Cologne 1977.

Honnef Klaus. "Simulierte Wirklichkeit—Inszenierte Fotografie, Tiel II: Bernhard Blume." *Kunstforum International*, June-July-August 1986.

Iden, Peter. "Bernhard Johannes Blume." *Frankfurter Rundschau*, 1985-86.

Pohlen, Annelie. "Bernhard Johannes Blume." *Kunstforum International*, March 1979.

Schulte, Günther. *Zur Ästhetik der Fotografie, insbesondere der transzendentalen Fotografie Bernhard Johannes Blume's*. Bonn 1976.

Trautes Heim, 1987
24 black and white photographs
86⅗ × 50 in. each (220 × 127 cm. each)
Installation view at Porticus, Frankfurt (detail)
Courtesy of Galerie Philomene Magers, Bonn

Work in exhibition illustrated in supplement.

Francesco Clemente belongs to the generation of artists that began to rock the (New York-oriented) international art world with a "return to figuration" in the late '70s. Born in Naples in 1952, Clemente, who is a self-taught artist, studied architecture in Rome. It was there that he began working as an artist in the late '60s, absorbing the influences of Beuys, Twombly, Boetti and the Arte Povera movement. He had his first exhibition in Rome in the early '70s and had already shown fairly extensively in Europe when he began exhibiting in New York in 1980. For a number of years now Clemente has lived among the cultures of three different continents—he divides his time between New York, Rome and Madras, India—a strategy for living perpetually as an observer of oneself and one's culture that is germane to the concerns of his art.

Initially grouped with other young Italian artists—the "three C's" widely referred to at the time were Clemente, Cucchi and Chia—Clemente soon set himself apart. Among the things that immediately distinguished him from his peers was his deliberately "dilettantish" (a word the artist himself uses comfortably to describe his own art) refusal to adhere to any one format or style. Clemente delighted in variety and change and the influences of non-Western cultures. His work did not appear to be trying to make any all-encompassing statements about the condition of Humanity or the Artist. In addition, his insatiable pictorial appetite—an imagistic willingness to try anything once—and the obsessive force of his discomfitingly sexual subject matter were immediately striking.

Clemente regularly works in a wide variety of two-dimensional mediums: painting, mosaic, fresco, pastels, watercolor, monotype, gouache, etc. He is also one of the few of his generation to treat drawing on a par with his other production. Drawing is in many senses the ideal medium for an artist like Clemente: it is the most private of mediums, the most receptive to idiosyncrasy, and the most portable, suited to the artist's deliberately nomadic existence. Drawing enables art to be a way of life rather than an occupation.

Clemente's art is concerned with metamorphoses of the human body as a mediator between inner and outer worlds. His work has been called decadent, but less superficial critical readings go beyond such tags to investigate the nature of this "decadence" and the transformations the artist describes. The figure most often featured in Clemente's work is his own: his distinctive ascetic visage and clear-eyed gaze stares out as at a mirror, placing the viewer in the sometimes uncomfortable position of voyeur to bizarre scenes of sexual fantasy (too interiorized to be truly erotic) and biological functions run amok. At times the intensity of the gaze is such that the viewer is metaphorically transformed into the narcissistic artist and stares back at an image of his own metamorphosis.

The bodies in Clemente's works are never objects of contemplation: they are always actively involved in (often gruesome) scenarios of mutation and distortion. Body parts seem unanchored by a coherence of self or an integrated anatomy—they roam randomly, with a predatory independence. Decapitated heads, hands and genitals may float in delicately colored grounds, or bleed messily onto the canvas and the bodies to which they were once attached. Gender is not a fixed state of being—men give birth to infants with adult erections; men and women merge in poses drawn equally from the Kama Sutra, Japanese erotic art and horror films. All human orifices gape, porous sites of (quite literally) intercourse with the world; they excrete substances and other bodies and are likewise penetrated by every possible object, animal or human body part. Yet paradoxically, the grotesque is made to serve a metaphysical purpose, and Clemente's disturbed and disturbing bodies hint at a transcendent cycle of death, birth and regeneration.

—Jamey Gambrell

Selected Solo Exhibitions

1987
Kuntsmuseum Basel. Traveled.
Catalogue by Dieter Koepplin.
Fundación Caja de Pensiones,
Madrid. Catalogue by Diego
Cortez, Rainer Crone and Henry
Geldzahler.

1986
Sperone Westwater, New York.
Catalogue. Also 1985 with Leo
Castelli Gallery; 1983 with Mary
Boone Gallery (catalogue); 1981.

1985
John and Mable Ringling
Museum of Art, Sarasota,
Florida. Traveled. Catalogue by
Jean-Christophe Ammann,
Michael Auping and Francesco
Pellizzi.

1984
Nationalgalerie, Staatliche
Museen Preussicher Kulturbesitz,
West Berlin. Traveled. Catalogue
by Rainer Crone, Zdenek Felix,
Lucius Grisebach and Joseph
Leo Koerner.

1983
Whitechapel Art Gallery,
London. Traveled. Catalogue by
Mark Francis, ed.

1981
University Art Museum,
University of California,
Berkeley. Traveled. Brochure by
Mark Rosenthal.

1980
Galleria Gian Enzo Sperone,
Rome. Also 1976, 1975.

Galerie Paul Maenz, Cologne.
Also 1979, 1978.

1979
Galleria Gian Enzo Sperone,
Turin. Catalogue by Achille
Bonito Oliva. Also 1978, 1975.

Galleria Emilio Mazzoli,
Modena. Catalogue by Achille
Bonito Oliva. Also 1978.

1978
Art and Project, Amsterdam.
Catalogue. Also 1978.

Centre d'Art Contemporain,
Geneva.

1974
Galleria Area, Florence.

1971
Galleria Valle Giulia, Rome.

Selected Group Exhibitions

1987
Avant-garde in the Eighties, Los
Angeles County Museum of Art.
Catalogue.

1985
Carnegie International, Museum
of Art, Carnegie Institute,
Pittsburgh. Catalogue.

Ouverture, Castello di Rivoli,
Turin. Catalogue.

Biennale de Paris. Catalogue.

1982
Zeitgeist, Martin-Gropius-Bau,
West Berlin. Catalogue.

Documenta VII, Kassel.
Catalogue.

1981
*Westkunst—Heute:
Zeitgenössische Kunst seit 1939*,
Museen der Stadt Köln.
Catalogue.

1980
7 junge Künstler aus Italien,
Kunsthalle Basel. Traveled.
Catalogue.

1975
Bienal de São Paulo.

1973
Italy Two, Civic Center Museum,
Philadelphia. Catalogue.

Selected Bibliography

Ammann, Jean-Christophe, Paul
Groot, Pieter Heynen and Jan
Zumbrink. "Un altre art?"
Museumjournaal, December
1980.

Bastian, Heiner. "Samtale med
Francesco Clemente." *Louisiana
Revy*, June 1983.

Clemente, Francesco. "A Project
for Artforum." *Artforum*, March
1987.

———. *Chi pinge figura, si non
puo esser lei non la puo porre*.
Adyar, India 1980.

———. *The Pondicherry Pastels*.
London and Madras 1986.

"Collaboration Francesco
Clemente." *Parkett*, June 1986.
Contributions by Francesco
Clemente, Rainer Crone,
Francesco Pellizzi and David
Shapiro.

Crone, Rainer, Zdenek Felix and
Lucius Grisebach. *Francesco
Clemente, Pastelle 1974-1983*.
Munich 1984.

de Ak, Edit. "A Chameleon in a
State of Grace." *Artforum*,
February 1981.

———. "Francesco Clemente."
Interview, April 1982.

Ginsberg, Allen and Francesco
Clemente. *The White Shroud*.
Madras 1984.

Kuspit, Donald B. "Francesco
Clemente: Sperone Westwater."
Artforum, April 1987.

———. "Francesco Clemente:
Kunstmuseum Basel." *Artforum*,
November 1987.

Oliva, Achille Bonito. *La
Transavanguardia Italianna*.
Milan 1980.

Pincus-Witten, Robert. "Entries:
If Even in Fractions." *Arts
Magazine*, September 1980.

Politi, Giancarlo. "Francesco
Clemente." *Flash Art*, April-May
1984.

Ratcliff, Carter. "On
Iconography and Some Italians."
Art in America, September 1982.

Francesco Clemente

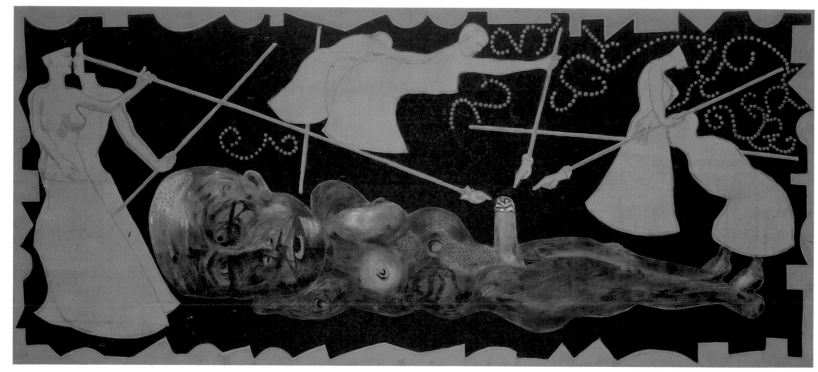

Dreaming the Dreamer, 1987
oil on canvas
84 × 186 in. (213.4 × 472.4 cm.)
Courtesy of Sperone Westwater, New York

Luciano Fabro

Born 1936, Turin

Lives and works in Milan

Luciano Fabro translates every component of experience—be it physical, mental, moral—into art, at times shifting his attention at a very rapid rate. Fabro started in the early '60s with environmental works that stressed both the visual and physical perception of site. Each piece from this period constitutes a theoretical text about space, with the environment as the center of attention. *Buco* (Hole) is a slab of glass which is partially transparent, partially mirrored so that the observer both looks into and sees beyond it. The acts of seeing and perceiving are made conscious—stripped bare—by the visual effort required to relate the two distinct portions of the piece. *Tubo da mettere tra i fiori* (Tube to place among the flowers) is a shiny metal tube strung among bushes in a garden. The shiny surface of the metal, which appears and disappears in the foliage contrasts with and calls attention to the natural setting. *Squadra* (Square rule), *Asta* (Pole), and *Croce* (Cross), all works from 1965 made of tubular metal, have the same revelatory force, but this time applied to an interior space, crossing the space from bottom to top (*Asta*), in four directions (*Croce*), and at the ceiling-wall juncture (*Squadra*).

In-cubo (In-cube, but perhaps also a pun on "incubo," meaning "nightmare" in Italian—trans. note), 1966, is Fabro's first constructed environment. Arms outstretched, the artist determines the size of the environment by holding up its canvas walls. He remains in communication with the surrounding space through the fabric. That the space of *In-cubo* is never closed signified continuity and multiplicity of relationships (body/environment, interior/exterior, etc.).

In 1967, in his *Tautologies*, he obtains the same result through exaggeratedly reduced means: a floor upon which newspapers are placed so that it can be walked upon without the polish being ruined. *Cielo* (Sky), a map of a portion of sky against which the artist is photographed in various orientations (in front, behind, to the right, to the left), straddles the boundary between tautology (things as they are) and space (itself in relationship to things).

In 1968, Fabro's work began to assume more specific forms as he declared the principle of action on the part of the artist with respect to matter. With an array of natural materials before him, he sought the appropriate way to shape, to prepare, to join materials

to each other ("sympathy"). The *Piedi* (Feet), 1968–71, and *Lo Spirato* (The expired one), 1968–73, pieces marked the culmination of this period. In *Piedi*, Fabro displayed a wide range of variously shaped pieces of valuable marble and joined them to columns of silk. In *Lo Spirato* he used a draped sheet just removed from a body to epitomize the state "between the solid and the void without solution of continuity." Indeed, this was the phase during which he sought answers to the void (*Quid nihil nisi minus*, 1969, huge letters on marble) and expressed a moral uneasiness first in the description of his own death according to the text of St. Alfonso (Varese, 1969), then, in *Consideratemi irresponsabile di quanto succede* (Consider me irresponsible for what happens), 1970. At the base of social suffering, Fabro seemed to say, there is the celebration and the defense of life.

In 1975, Fabro addressed the complexity of the image in the *Iconografie* (Iconographies). Dedicated to intellectuals decapitated for their ideas, the *Iconografies* are glass basins full of water that contain a fragment of glass. In the accompanying texts, one reads that the image is not an imitation of natural objects but a fulfillment, a re-creation of nature. In *Io* (I), 1978, a bronze egg scaled to the artist's body in a fetal position, the theme of life takes shape as art. In *Prometeo* (Prometheus), 1986, a broken, unstable geometry links small columns of marble, probing the dissolution of external structure. Here Fabro addressed the crisis of nature following the disaster of Chernobyl. Around 1980 Fabro showed his series of *Habitat* pieces, spaces conceived to contain his work. The most vast and complex of these, the Rotterdam *Habitat* (1981), has walls in alternating perspective. The *Gioielli* (Jewels), light, shiny metal forms suspended in the air, made their debut in this environment. The following year, Fabro introduced a jewel of more conspicuous dimensions in *Enfasi* (Emphasis), a frieze placed against the Friedericianum at *Documenta V*. The later *Effimeri* (Ephemera) metal pieces are echoed in the 1987 group of marbles, *Nude che scendono le scale* (Nude descending the staircase) and *Obelischi* (Obelisks). Simple elements are placed together to emit strokes of light.

—*Jole de Sanna*
Translated from the Italian by Meg Shore

Luciano Fabro

Selected Solo Exhibitions

1988
Galerie Pieroni, Rome.
1987
Le Nouveau Musée, Villeur-banne, France. Catalogue by J. L. Mauban.
The Fruitmarket Gallery, Edinburgh. Catalogue by Mark Francis.
1984
Galerie Paul Maenz, Cologne. Also 1978.
1983
Neue Galerie, Aachen, West Germany.
Logetta Lombardesca, Ravenna, Italy. Catalogue by Jole de Sanna.
1981
Museum Folkwang, Essen and Museum Boymans-van Beuningen, Rotterdam. Catalogue by Zdenek Felix.
1980
Galleria Christian Stein, Turin. Catalogue. Also 1975.
Salvatore Ala Gallery, New York.
1977
Studio Framart, Naples. Catalogue by Luciano Fabro and A. Izzo.
1974
Galleria Notizie, Turin. Also 1971; 1969; 1968 (catalogue by S. Vertone); 1967.
Salle Patino, Geneva.
1973
Galleria Arte Borgogna, Milan.
1965
Vismara Arte Contemporanea, Milan. Catalogue by Luciano Fabro.

Selected Group Shows

1987
Skulptur Projekte, Münster. Catalogue.
1986
Falls the Shadow, Recent British and European Art, Hayward Gallery, London. Catalogue.
1985
Carnegie International, Museum of Art, Carnegie Institute, Pittsburgh. Catalogue.
The Knot Arte: Povera at P.S. 1, Institute for Art and Urban Resources, Long Island City, New York. Catalogue.
The European Iceberg—Creativity in Germany and Italy Today, Art Gallery of Ontario, Toronto. Catalogue.
1984
Ouverture, Castello di Rivoli, Turin. Catalogue.
Skulptur im 20. Jahrhundert, Merianpark, Basel. Catalogue.
1982
Documenta, Kassel. Also *V*, 1972. Catalogues.
1980
La Biennale di Venezia. Also 1978, 1971. Catalogues.
1973
Contemporanea, Parcheggio di Villa Borghese, Rome. Catalogue.
1970
Conceptual Art, Arte Povera, Land Art, Museo Civica di Torino.

Selected Bibliography

Bos, Saskia. "De Statua, Stedelijk van Abbemuseum." *Artforum*, October 1983.

Ceccato, S. "Il problema della nascita delle idee." *Il Giorno*, November 1965.

Celant, Germano. *Arte Povera*. Milan 1969.

———. "Homo Fabro." *Cartabianca*, May 1968.

de Sanna, Jole. "Luciano Fabro, una città di 60 giorni." *Domus*, February 1982.

Fabro, Luciano. *Attaccapanni*. Turin 1978.

Francis, Mark. "A Chart of Life." *Parkett*, January 1987.

Groot, Paul. "Luciano Fabro, Museum Boymans-van Beuningen." *Artforum*, March 1982.

König, Kasper. *Aufhänger*. Cologne 1983.

Lonzi, Carlo. "Intervista con Luciano Fabro—Discorsi." *Marcatré*, April 1966.

Ponti, L. L. "Luciano Fabro: Attaccapanni, bronzi, colori e musiche a Napoli." *Domus*, June 1977.

———. "Tempo tendenze paura dell Arte: Intervista con Luciano Fabro." *Domus*, March 1980.

Risso, B. *Luciano Fabro*. Turin, 1980.

Rogozinski, Luciana. "Luciano Fabro, Galleria Christian Stein." *Artforum*, February 1981.

Soutif, Daniel. "Les riches heures de l'Art Pauvre." *Libération*, September 1987.

Trini, Tommaso. "Luciano Fabro, Galleria Borgogna." *Domus*, June 1971.

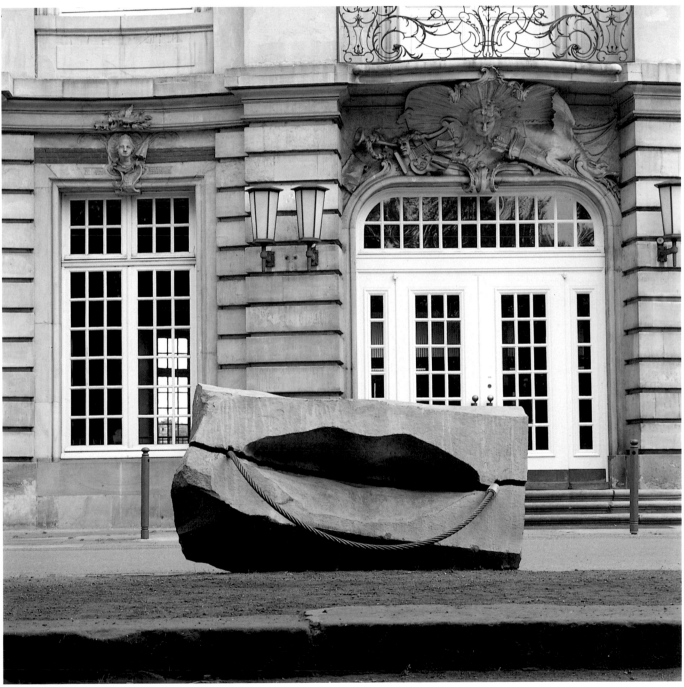

Demeter, 1987
volcanic stone and steel cables
39⅗ × 78⅗ × 27⅗ in. (100 × 200 × 70 cm.)
Installation view at *Skulptur Projekte*, Münster
San Francisco Museum of Modern Art; Gift of Robin Quist in memory of George Quist

Peter Fischli/David Weiss

Peter Fischli
Born 1952, Zurich
Lives and works in Zurich

David Weiss
Born 1946, Zurich
Lives and works in Zurich

Peter Fischli began to work collaboratively with David Weiss in 1979. The decision to forsake individual artistic identity reflects a widespread resistance to the romantic notion of a signature style; Komar and Melamid, Fortuyn/O'Brien, Clegg and Guttman, and Wallace and Donahue are just a few of many similar partnerships. In Fischli and Weiss' work, this resistance is compounded by opposition, also widely shared, to the very notion of a unified sensibility. Their protean sensibility and promiscuous use of materials link them to artists ranging from Sigmar Polke to Bruce Nauman to Annette Lemieux. Moreover Fischli and Weiss transgress treasured national conventions: so thorough is their betrayal (in both senses) of Swiss order and sobriety that their work could be called a model of levity's rainbow.

Among the forms taken by Fischli and Weiss' transgressions are objects that confound function by manipulations of scale: their *Haus* (1987), parked on a busy Münster street, was an otherwise unexceptional, International-style structure built at one-fifth usual size; *Monument* (1986) rebuked its titular aspirations with a modest assemblage of tires and doughy figures. But perhaps Fischli and Weiss' most widely acclaimed works are sculpture/photography hybrids. *Wurstseries*, their first collaboration, consists of ten photographs of frankfurters, baloney and luncheon meat, plus the odd vegetable garnish, arranged to enact such engaging events as a trip to the carpet store. Here, the objects were perishable. In *Stiller Nachmittag* (Quiet Afternoon, also called *Equilibres*, 1985) the objects were physically unstable—precarious assemblages of cutlery, furniture and food held by the camera in a preternatural eternity of top-heavy, asymmetrical balance. And in the 1986–87 film *Der Laufe der Dinge* (The Way Things Go), already a cult classic, chemical instability is added to the contingencies. This hilarious and improbably sustaining almost hour-long movie documents a succession of chemical dissolutions of objects that, falling, dislodge others, sending them down ramps to topple still others in a chain reaction that falters without giving way at every dramatically jerryrigged step. *Der Laufe der Dinge* is a farce on sculptural claims to theatricality and narrative development, on esthetic problems of physical poise and moral problems of reciprocal action; on anthropomorphism and overblown metaphoric programs generally (there are mechanized shoes, for instance, among the broken bottles and styrofoam cups).

Breathtaking ascents from the trivial to the profound—and back again—are in fact Fischli and Weiss' special skill. The 180 tiny, crude, unfired clay sculptures in the 1981 series *Plötzlich diese Übersicht* (Suddenly it All Makes Sense), documented in a book of the same title, embrace the sublime and the ridiculous with equal enthusiasm. Beginnings and endings (*The First Fish Decides to Go on Shore, James Dean's Tragic End*) are favored themes, second only to "Popular Opposites"; man and beast, sweet and sour, theory and practice. Though there is a measure of visual slapstick in these pieces, as there is throughout Fischli and Weiss' work, there is also more mordant humor. Fischli and Weiss' preoccupation with opposing entities may indicate a suspicion on their part that the distinction between what's serious and what's not may be among the many that have recently collapsed.

—*Nancy Princenthal*

Selected Solo Exhibitions

1988
Interim Art, London.
1987
List Visual Arts Center, MIT, Cambridge, Massachusetts. Traveled. Catalogue by Patrick Frey and Karen Marta.
Le Case d'Arte, Milan.
Hewlett Gallery, Carnegie Mellon University, Pittsburgh.
1986
Sonnabend Gallery, New York.
1985
Raum für Kunst, Hamburg.
Centre Culturel Suisse, Paris.
Monika Sprüth Galerie, Cologne. Traveled. Also 1983.
1984
Galerie Crousel-Hussenot, Paris.
1982
St. Galerie, St. Gallen, Switzerland.
1981
Galerie Stahli, Zurich.

Selected Group Exhibitions

1988
The Logic of Display, P.S. 1, Institute for Art and Urban Resources, Long Island City, New York.
Objects in Focus, Nicola Jacobs Gallery, London.
1987
Documenta VIII, Kassel. Catalogue.
Selections From XJ1, Damon Brandt, New York.
Skulptur Projekte, Münster. Catalogue.
1986
Sonsbeek '86, Arnhem, The Netherlands. Catalogue.
1985
Biennale de Paris. Catalogue.
Crosscurrents in Swiss Art, The Serpentine Gallery, London.
1984
Zwischen Plastik und Malerei, Kunstverein Hanover. Traveled.
1982
Swiss Avantgarde, Galeries Nouvelles Images, Cologne.
1980
Saus & Braus, Stadtische Galerie zum Strauhof, Zurich.

68

Selected Bibliography

Collings, Matthew. "The Stumbling Objects of Fischli/ Weiss: An Interview." *Artscribe International*, November-December 1987.

Fischli, Peter and David Weiss. *Drei Geschichten*. Zurich 1974.

————. *Up and Down Town*. Zurich 1974.

————. *Wandlungen*. Zurich 1974.

Fischli, Peter, David Weiss and Urs Luthi. *Sketches*. Bern 1970.

Fischli, Peter, David Weiss, Urs Luthi and E. Kilga. *The Desert is Across The Street*. Zurich 1975.

Grundberg, Andy. "Photographs That Reflect and Confront Cultural Icons." *The New York Times*, 29 January 1988.

Magnani, Gregorio. "New Art & Old Tricks." *Flash Art*, October 1987.

Ratcliff, Carter. "Masters of the Glum 'Eureka!'" *Art in America*, January 1987.

Tazzi, Pier Luigi. "Armleder, Fischli e Weiss: Nostalgia e stile nell'oggetto artistico Europeo." *Vanity*, July-August 1987.

————. "Le Case d'Arte." *Artforum*, Summer 1987.

Wallach, Amei. "Fischli/Weiss: Switzerland's Art Team." *Newsday*, 27 December 1987.

————. "Sculpture In Rubber From Swiss Bad Boys." *Newsday*, January 24 1988.

Cabinet, 1987
black rubber
21½ × 25 × 25 in. (54.6 × 63.5 × 63.5 cm.)
Courtesy of Sonnabend Gallery, New York

Not in exhibition. Work in exhibition illustrated in supplement.

Günther Förg

Born 1952, Fussen, Germany

Lives and works in Cologne and Munich

Günther Förg's art provides a troubling image of late-industrial society, particularly as its interests coincide with the revisionist program of high modernism. The latent criticality in Förg's work strikes a resounding chord across several cultures and periods. Förg alludes directly to numerous 20th-century styles and also to the recognizable styles of particular artists in his works, which run the gamut of black-and-white architectural photographs, room-scale installation sculptures, large wall reliefs of poured lead and "pictures" consisting of rectangular lead sheets sectioned into a few areas and painted over with a matte finish. The grim, unadorned look of his art conveys a clear sense of obdurateness, sternness or even violence held in close check.

Förg's photographs are rooted in both the tradition of German realism, recalling August Sander and the equally penetrating conceptual photography of Bernd and Hilla Becher. Yet Förg's analysis of deteriorated modernist buildings is much more an indictment of social and political myths reflected in the modernist impulse than it is an admonishment of the modern style as such.

In his paintings, Förg pays homage to older German abstract painters such as Blinky Palermo and Imi Knoebel, while also suggesting an affinity with American contemporaries like Peter Halley and Sherrie Levine. The literalness of materials implicit in each of these artists' work presupposes an awareness on the viewer's part of abstraction's emergence in recent years as a form of high-tech camouflage behind which civilization hides its ideological vulnerability. As such, Förg's "abstractions" and lead reliefs become surveys of a cultural terrain dotted by the "ruins" of art.

More than any other atist of his generation, Förg's genius with materials approaches that of the late Joseph Beuys. He works with only the most basic combinations of elements, and yet his finished objects and environments convey a sturdy resoluteness and physicality. Even so, the weighty lead wall reliefs are remarkable for their grace, while both his color-fields and photographs appear as if they could be entered.

Despite its beauty, the art of Günther Förg remains somewhat mute regarding its ultimate intentions, as if to stake a resistance to meaning on the fact that its references are not entirely pure ones. A typical presentation of his work involves an elaborate cross-referencing between different mediums, each pointing to the other within the scope of an expanded tableau. And yet, the deeper underpinnings to his work are visibly apparent in each single piece, since each appears to challenge perceptual and contextual conventions through devices which are ultimately tactile in nature. In this way, Förg effectively collapses meanings that are culturally grounded with those that are based more on the less explicit exchange between viewer and site. Förg's work waits on the periphery, ready to suggest that the march of culture and the race toward manifest destiny are opposite sides of the same, misstruck coin.

—*Dan Cameron*

Selected Solo Exhibitions

1988
Galerie Max Hetzler, Cologne. Also 1985, 1984, 1983. Brochures.
Galerie Pieroni, Rome.
Luhring, Augustine & Hodes, New York.
1987
Museum Haus Lange, Krefeld. Catalogue by Britta Buhlmann and Max Wechsler.
Maison de la Culture et de la Communication, St. Etienne, France. Catalogue by Yves Aupetitallot and Frédéric Migayrou.
1986
Kunsthalle Bern. Catalogue by Ulrich Loock.
Westfälischer Kunstverein, Münster. Catalogue by Paul Groot.
Galerie Grässlin-Ehrhardt, Frankfurt. Catalogue.
1984
Kunstraum München. Catalogue.
1983
Galerie Ursula Schurr, Stuttgart.
1982
Galerie Kubinski, Stuttgart.
1981
Galerie van Krimpen, Amsterdam.
1980
Rüdiger Schöttle, Munich.
1974
Akademie der Bildenden Künste, Munich.

Selected Group Exhibitions

1988
Documenta VIII, Kassel. Catalogue.
1987
Malerei-Wandmalerei, Stadtmuseum Graz mit Museumsapotheke, Austria. Catalogue.
'blow-up' Zeitgeschichte, Wurttembergischer Kunstverein, Stuttgart. Traveled. Catalogue.
1986
Galerie van Krimpen, Amsterdam.
Chambres d'amis, Museum van Hendendaagse Kunst, Ghent, Belgium. Catalogue.
Prospect 86, Frankfurter Kunstverein. Catalogue.
1985
Biennale de Paris. Catalogue.
Medium Photographie, PPS Galerie, Hamburg. Catalogue.
Jeff Wall and Günther Förg: Photoworks, Stedelijk Museum, Amsterdam.
1984
von hier aus, Messegelände, Düsseldorf. Catalogue.
1983
Die göttliche Komödie, Rotterdamse Kunststichting, Rotterdam. Catalogue.
1979
Europa 79, Kunstausstellungen, Stuttgart.

Selected Bibliography

Buck, Matthias and Christian Nagee. *Günther Förg: Verzeichnis der Arbeiten seit 1973.* Munich 1987.

Catoir, Barbara. "Fensterbilder im fensterlosestat Raum." *Frankfurter Allgemeine Zeitung*, 5 June 1986.

————. "Der öffentliche Mensch: Günther Förg in einer Kölner Ausstellung." *Frankfurter Allgemeine Zeitung*, 27 March 1985.

Davvetas, Démosthène. "Günther Förg en themes." *Libération*, September 1987.

"Collaboration Günther Förg: Projekt für Krefeld." *Parkett*, March 1987.

Gookin, Kirby A., "Günther Förg." *Artforum*, Summer 1988.

Groot, Paul. "Günther Förg: Galerie van Krimpen." *Artforum*, January 1986.

————. "Günther Förg: Im Leeren Zentrum der Treppenhäuser." *Wolkenkratzer Art Journal*, July-August 1985.

Hentschel, Martin. "Günther Förg." *Neue Kunst in Europa*, May-June-July 1985.

Inboden, Gudrun. *Junge Kunst aus Westdeutschland '81.* Stuttgart 1981.

Pohlen, Annelie. "Günther Förg: Westfälischer Kunstverein." *Artforum*, October 1986.

Schmidt-Wulffen, Stephan. "Room as Medium." *Flash Art*, December 1986.

Smith, Roberta. "Günther Förg and Reinhard Mucha in Show." *The New York Times*, 28 November 1986.

Ungers, Sophia. *Günther Förg.* Brussels 1986.

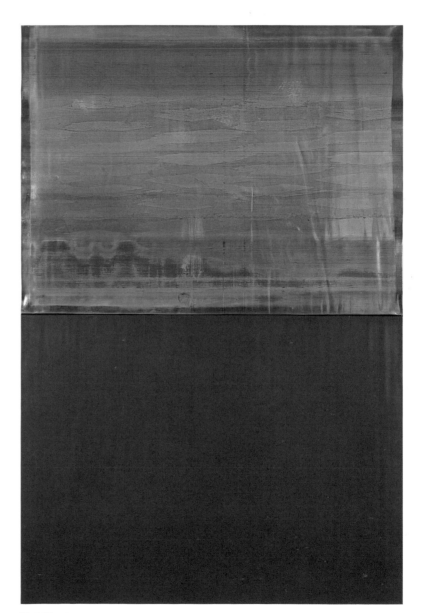

Bleibild 26/88, 1988
acrylic on lead/wood
70⅓ × 47⅓ in. (180 × 120 cm.)
Courtesy of Galleria Pieroni, Rome

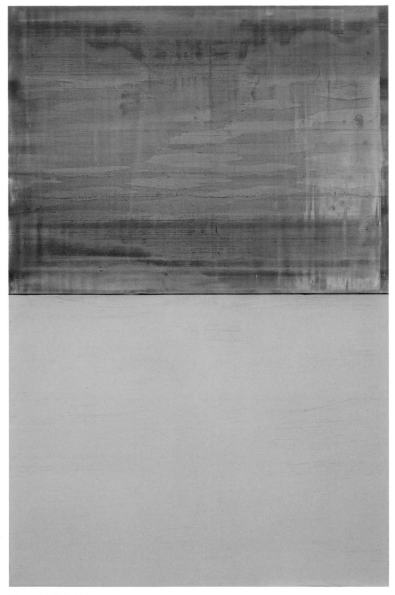

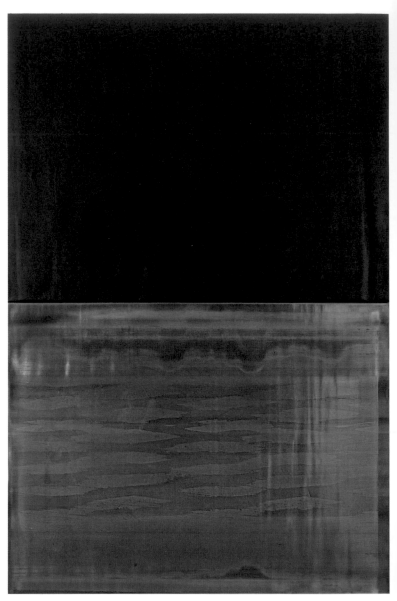

Bleibild 26/88, 1988
acrylic on lead/wood
70⅓ × 47⅓ in. (180 × 120 cm.)
Courtesy of Galleria Pieroni, Rome

Bleibild 26/88, 1988
acrylic on lead/wood
70⅓ × 47⅓ in. (180 × 120 cm.)
Courtesy of Galleria Pieroni, Rome

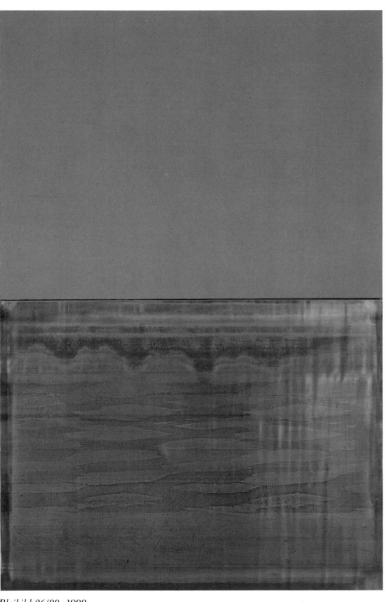

Bleibild 26/88, 1988
acrylic on lead/wood
70⅓ × 47⅓ in. (180 × 120 cm.)
Courtesy of Galleria Pieroni, Rome

Katharina Fritsch

Born 1956, Essen, West Germany

Lives and works in Düsseldorf, West Germany

74

The aura of art works has changed. The devout contemplation once directed at religious pictures has been replaced by a wistful glance similar to the one cast at commodities in shop windows. Katharina Fritsch's art testifies to this change. Her yellow-painted madonna, which first appeared in her repertoire in 1981, is both reminiscent of the religious origins of art and, in its resemblance to cheap devotional objects from pilgrimage sites, refers to art-as-commodity. A tension between awe and desire, between hallowed object and commodity, informs much of today's art. Its morality as well as its autonomy is now being put in question. Until recently, art could be viewed as an antiquated form of production, a relic from the manufacturing age. When Katharina Fritsch designs wallpaper patterns (1980), develops candle holders (1985), or simply brings a postcard with a large edition into mass circulation, she is alluding to the changing understanding of art.

As early as 1980, with her projects in public places (cemeteries, among them), Fritsch tested art's social role. Exposing the public to art on a casual, routine basis was part of a plan to eliminate or reduce the general public's intimidation by the art world. Fritsch also sabotages the autonomy of a work of art by smuggling her pieces into mass circulation. (She even published her own advertising brochure.) While her works appear to be readymades, they are not; they are in appearance so close in their design to utilitarian objects that they could be (or "want to" be) mistaken for store-bought goods. One could even imagine that these unique works are produced in mass. In stripping away the illusions of originality and uniqueness, Fritsch essentially recasts the notion of artistic production, revealing it as profane.

Nevertheless, a common object *does* transmit a unique experience at the moment when its essence is revealed. Sometimes commodities in a shop window also reveal this uniqueness in their pure matter-of-factness. Underlying this phenomenon is the recognition of the soul of things, which Thomas Aquinas called their "whatness." Joyce, too, was on the trail of this epiphany. Fritsch delivers this experience by creating ostensibly everyday objects with imperceptibly modified proportions and colors. Their disruptive force owes largely to the fact that they function as concrete—not just theoretical—assertions of the up-heaval of art's foundations.

—*Stephan Schmidt-Wulffen*
Translated from German by Clara Seneca

Solo Exhibitions

1988
Kunsthalle Basel. Traveled. Catalogue by Jean-Christophe Ammann and Iwona Blazwick.
1987
Kaiser Wilhelm Museum, Krefeld. Catalogue by Julian Heynen.
1985
Johnen & Schöttle, Cologne.
Galerie Schneider, Constance, West Germany.
1984
Galerie Rüdiger Schöttle, Munich.

Selected Group Exhibitions

1988
Cultural Geometry, The Deste Foundation for Contemporary Art, Athens. Catalogue.
BiNational: Art of The Late 80s, Museum of Fine Arts and Institute of Contemporary Art, Boston; Städtische Kunsthalle and Kunstsammlung Nordhein-Westfalen, Düsseldorf. Catalogue.
1987
Anderer Leute Kunst, Museum Haus Lange, Krefeld. Catalogue.
Skulptur Projekte, Münster. Catalogue.
1986
Von Raum zu Raum, Kunstverein Hamburg. Catalogue.
Sonsbeek '86, Arnhem, The Netherlands. Catalogue.
Aus den Anfängen, Kunstfonds, Bonn.
Europa/Amerika—Die Geschichte einer künstlerischen Faszination seit 1940, Museum Ludwig, Cologne. Catalogue.
A Distanced View, The New Museum of Contemporary Art, New York. Catalogue.
1984
von hier aus, Messegelände, Düsseldorf. Catalogue.
1982
Möbel perdu, Museum für Kunst und Gewerbe, Hamburg.

Selected Bibliography

Benway, Mrs. "Schmutz und Reinheit." *SPEX*, April 1987.

Blase, Christoph. "On Katharina Fritsch." *Artscribe International*, March–April 1988.

Fritsch, Katharina. "Friedhöfe." *Kunstforum International*, September 1983.

Gloser, Laszlo. "Katharina Fritsch." *Süddeutsche Zeitung*, 7 June 1987.

———. "Katharina Fritsch." *Werblatt*, Düsseldorf 1981.

Heynen, Julian. "Katharina Fritsch—Elefant." *Katalog Kaiser Wilhelm Museum*, Krefeld 1987.

Hoffman, Jörg. "Was macht der Elefant im Museum?" *Neue Westfälische Zeitung*, 16 March 1987.

Jochimsen, Margarethe. *Junge Rheinische*. Sophia 1986.

Koether, Jutta. "Elefant." *Parkett*, August 1987.

Locker, Ludwig. "Architektonische Aspekte in der Düsseldorfer Gegenwartskunst." *Artefactum*, March–April 1986.

Puvogel, Renate. "Katharina Fritsch—Elefant." *Kunstforum International*, May–June 1987.

Schmidt-Wulffen, Stephan. "Katharina Fritsch." *Kunstforum International*, October–November 1987.

Wulffen, Thomas. "Enzyklopädie der Skulptur." *Kunstforum International*, October–November 1987.

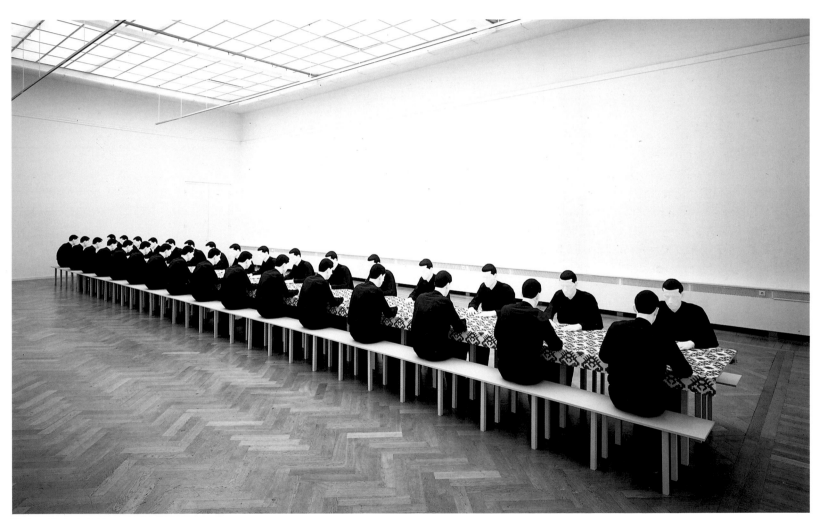

Tischgesellschaft, 1988
polyester, wood, and cotton
55⅒ × 630 × 68⅕ in. (140 × 1600 × 175 cm.)
Installation view at Kunsthalle Basel
Courtesy of Jablonka Galerie, Cologne

Not in exhibition. Work in exhibition illustrated in supplement

Peter Halley

Born 1953, New York

Lives and works in New York

Peter Halley is a prominent member of a mostly younger group of American artists who in recent years have created artworks that provide a new theoretical framework for the role of "high" art within a general sociological context. Halley fabricates his paintings with an idiosyncratic mélange of science fiction, Robert Smithson, French post-structuralist philosophy, and a nostalgia for and resentment of the 1960s. The most explicit rupture which takes place in Halley's art is his refusal to grant iconic status to that most persistent of geometric forms, the square.

According to Halley, the reality of events, objects and values has been largely replaced in late 20th-century Western society by the symbolic order of signs, elements and hierarchies which act as stand-ins or simulations of the things they have set aside. Halley's art, therefore, addresses a condition of suspended belief, in which the artwork is presented as an object of curiosity, an uncertain juncture of perception and desire which manifests a strong ambivalence concerning its own status. A Halley painting superficially adopts the "look" of the "official" lineage of geometric abstraction, while simultaneously mocking that tradition through its use of Day-Glo colors and artificial stucco and by its iconoclastic approach to reductivist form.

It is perhaps the "imagery" in Halley's paintings which is cause for the greatest consternation among his critics. One, two or three large squares, identifiable as cells within a larger system, are positioned against a uniform background. In most paintings, the cells are linked to one another through painted linear arteries or conduits. More than anything else, Halley's canvases resemble cross-section diagrams of the modular spaces which make up the average person's environment for living and working (not to mention viewing art). As emblems or signs, his pictures stand for the location of the artwork within a pseudo-place which is defined not so much by the ideal or the real, as by the hyper-real: a condition in which the symbolic order supercedes empirical order, and all things are reduced to the state of neutral equivalency.

If this description seems to imply that Halley intends for his art to appear as superficial or cynical, such is not the case. However, he is overtly critical of the process of cultural impotency which inevitably takes place once society has dictated that the artist must function as the creator of portable myths. Thus his work should be viewed as synthetic rather than official culture and his theories understood as bearing a similar relationship to philosophy as pop-psychology bears to the real thing. In effect, Halley's art should be understood as proudly tearing away a few outmoded layers of myth from the face of culture, rather than glibly supplying more icons to the grand parade of anxious artifacts. Glowing like thermonuclear cells against a pastoral field, his paintings are a jarring reminder that value in art is a meaningless idea once society has translated the idea of "soul" into a formula for selling soft drinks or luring youthful conscripts into battle.

—*Dan Cameron*

Solo Exhibitions

1988
Rhona Hoffman Gallery, Chicago.
Galerie Bruno Bischofberger, Zurich.
1987
Margo Leavin Gallery, Los Angeles.
Sonnabend Gallery, New York.
1986
Daniel Templon Gallery, Paris.
International With Monument Gallery, New York. Also 1985.
1984
Beulah Land, New York.
1980
P.S. 122, New York.
1979
University of Southwestern Louisiana, School of Art & Architecture, Lafayette.
1978
Contemporary Art Center, New Orleans.

Selected Group Exhibitions

1988
Cultural Geometry, The Deste Foundation for Contemporary Art, Athens. Catalogue.
1987
Terrae Motus, Grand Palais, Paris. Catalogue.
Simulations, New American Conceptualism, Milwaukee Art Museum. Brochure.
NY Art Now: The Saatchi Collection, London. Catalogue.
Generations of Geometry, Whitney Museum of American Art at Equitable Center, New York.
Biennial, Whitney Museum of American Art, New York. Catalogue.
Similia/Dissimilia: Modes of Abstraction in Painting, Sculpture, and Photography Today, Kunsthalle Düsseldorf; Leo Castelli Gallery, New York; Wallach Art Gallery, Columbia University, New York; Sonnabend Gallery, New York. Catalogue.
Documenta VIII, Kassel. Catalogue.
1986
El Arte y Su Doble: Una Perspectiva de Nueva York, Fundación Caja de Pensiones, Madrid. Catalogue.
End Game: Reference and Simulation in Recent Painting and Sculpture, Institute of Contemporary Art, Boston. Catalogue.
1978
Newspace Gallery, New Orleans.

Selected Bibliography

Berger, Maurice. *Political Geometries: On the Meaning of Alienation.* New York, 1986.

Cameron, Dan. "In the Path of Peter Halley." *Arts Magazine,* December 1987.

———. "Transparencies." *Art Criticism,* Fall 1986.

Collins, Tricia and Richard Milazzo. "Tropical Codes." *Kunstforum International,* March–April–May 1986.

Halley, Peter. "Notes on Abstraction." *Arts Magazine,* Summer 1987.

Harris, Susan. "Selections 19." *Arts Magazine,* November 1982.

Kuspit, Donald B. "Young Necrophiliacs, Old Narcissists: Art about the Death of Art." *Artscribe International,* April–May 1986.

Madoff, Steven Henry. "Purgatory's Way." *Arts Magazine,* March 1987.

Mantegna, Gianfranco and Peter Halley. "Technologia transcendentale. Peter Halley." *Tema Celeste,* December–February 1988.

Oliva, Achille Bonito. "Neo-America." *Flash Art,* January–February 1988.

Pincus-Witten, Robert. "Entries: First Nights." *Arts Magazine,* January 1987.

Ratcliff, Carter. "I Like the Free World." *Artforum,* February 1987.

Russell, John. "Bright Young Talents: Six Artists with a Future." *The New York Times,* 18 May 1986.

Siegel, Jeanne. "The Artist Critic of the Eighties: Peter Halley and Stephen Westfall." *Arts Magazine,* September 1985.

Stevens, Mark. "Neo-Geo: Art's Computer Hum." *Newsweek,* 16 November 1987.

Wei, Lilly. "Talking Abstract: Part Two." *Art in America,* December 1987.

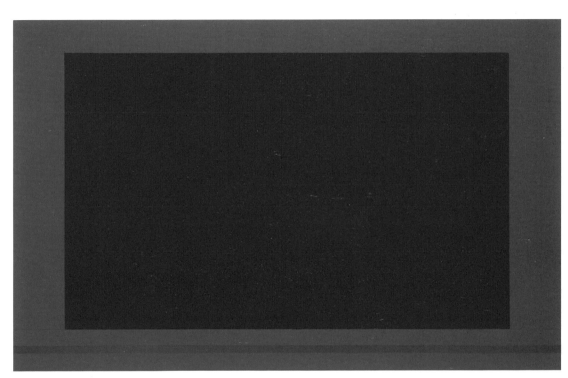

Red Cell with Conduit, 1988
Day-Glo acrylic and Roll-A-Tex on canvas
82 × 127 in. (208.3 × 322.6 cm.)
Courtesy of Sidney Janis Gallery, New York

Two Cells, 1987
Day-Glo acrylic, acrylic, and Roll-A-Tex on canvas
72 × 152¼ in. (182.9 × 386.7 cm.)
The Carnegie Museum of Art, Pittsburgh; Gift Fund for Special Acquisitions, 1987

Weekend, 1988
acrylic on canvas
62 × 192 in. (157.5 × 487.7 cm.)
Collection of Fredrik Roos, Zug, Switzerland

Rebecca Horn

Born 1944, Michelstadt, Germany

Travels and works in situ

Rebecca Horn explores the meanings and effects of solitude and alienation, seduction and power in intuitive works of keen focus and spirited vision. Long interested in mythology and in human interaction with machines, she began in the early '70s to create prosthesis-like apparatuses made of wearable braces supporting such objects as small mirrors, sharpened pencils, a single horn (uni-corn), or feathers. Functioning as costume and/or armor, feathers have decorative or defensive uses, and Horn used them as evocative avian metaphors with mythic invocations. While wearing these unsettling constructions, she and close associates gradually became psychologically involved with them, and in performance would develop means of communication through touch and subtle gestures. Her films and videotapes of these performances captured the tension of these private, somewhat aggressive actions.

Horn's subsequent motorized structures, often comprised of luxuriant, sensual materials, are both inviting and threatening, and profoundly more complex. *Der Eintanzer* (The Dancing Cavalier), 1978, is a simple wooden table that smoothly glides alone through a room to the accompaniment of its own self-contained amplified tango music. In *Small Feather Wheel* (1982), a feathered limb cyclically unfolds, briefly describes a complete circle, then closes back into itself, appearing to be a single linear element, a wing, for several minutes before repeating its cycle. The simple recurring gesture by the vulnerable, seemingly captive free spirit is disturbing. In *Peacock Machine* (1982), a tall, upright fan made of metal rods instead of tail plumage mechanically unfurls and parodies the regal bird's exaggerated strutting, only to fold up and rest temporarily before performing again. Confined in a gallery with these disquieting zoomorphic mechanisms, viewers begin anticipating the forboding but compelling cycles of action. It is as if Horn's mechanized sculptures are carrying out mating dances, silently crying for sexual interaction. When they abruptly withdraw into themselves in momentary stillness, as if in response to danger, the sculptures seem to be concealing their inner spirits, guarding their sources of strength.

Horn's decision to include her sculptures in her narrative films signaled a major development in her work, opening up the possibility for dynamic, temporal tableaux instilled with the sense of an historic past, an oppressive present, and an uneasy future. In *Der Eintanzer* (1978), and *La Ferdinanda—Sonata for a Medici Villa* (1981), she assigned her mechanizations leading roles alongside carefully cast human actors.

Horn inventively continues to probe myth, history, and aspects of the unconscious in both films and installations. In *Lola, a New York Summer* (1987), a paintbrush repeatedly drops from a simple mechanism attached near the ceiling down into a small pot of bright red paint, then jerks backward and splatters pigment all over the wall and down below onto red tap shoes attached to the wall near the floor. The props and gestures are suggestive of painful emotional actions from an earlier time like the tragic heroine Lola Montes or Moira Shearer in the *Red Shoes*. Like Buster Keaton, the subject of her current film, Rebecca Horn searches nature for signs of renewal, finding hope within the disorder of urban landscape.

—*Barbara London*

Selected Solo Exhibitions

1987
Galerie Konrad Fischer, Düsseldorf.
1986
Marian Goodman Gallery, New York.
1984
The Serpentine Gallery, London. Catalogue by Nena Dimitrjevic. Museum of Contemporary Art, Chicago and Kunsthaus Zürich. Traveled. Catalogue by Bice Curiger, Rebecca Horn and Toni Stoos.
1981
Stedelijk Museum, Amsterdam. Brochure.
Staatliche Kunsthalle Baden-Baden. Traveled. Catalogue by Germano Celant and Katharina Schmidt.
1978
Kestner-Gesellschaft, Hanover. Traveled. Catalogue by Marlies Grüterich, Carl A. Haenlein and Roland H. Wiegenstein.
1977
Kunstverein Köln. Traveled. Catalogue by Timothy Baum, Marlies Grüterich and Wulf Herzogenrath.
1973
René Block, Berlin.

Selected Group Exhibitions

1987
Skulptur Projekte, Münster. Catalogue.
1986
Individuals: A Selected History of Contemporary Art 1945–1986. The Museum of Contemporary Art, Los Angeles. Catalogue.
1984
von hier aus, Messegelände, Düsseldorf. Catalogue.
1982
Documenta VII, Kassel. Also *VI*, 1977; *V*, 1972. Catalogues.
1980
Umanesimo, disumanesimo nell'Arte Europe 1890/1980, Palazzo di Parte Guelfa, Florence. Catalogue.
1979
Weich und plastisch—Soft-art, Kunsthaus Zürich. Catalogue.
1977
Neun Bewerber um das Annemarie und Will Grohmann Stipendium, Staatliche Kunsthalle Baden-Baden. Catalogue.
1975
Video Art, Institute of Contemporary Art, University of Pennsylvania, Philadelphia. Catalogue.
Biennale of Paris. Catalogue.
1974
Projekt' 74, Kunstverein Köln.
Projects: Video II, Museum of Modern Art, New York.

Selected Bibliography

Arici, L. "La Ferdinanda—die Villa hat Besuch: zu Objekten von Rebecca Horn." *Du*, May 1983.

Barthelme, Donald. "The Current Cinema: Three Festivals." *The New Yorker*, 8 October 1979.

Baum, Timothy. *Rebeccabook I*. New York 1976.

Bonesteel, M. "The Plumed Machine." *Art in America*, May 1984.

Cameron, Dan. "Horn's Dilemma: The Art of Rebecca Horn." *Arts*, November 1987.

Cassadio, M. "Centro Brera-Milano; mostra." *Flash Art*, March–April 1979.

Celant, Germano. "Rebecca Horn: Dancing on the Egg." *Artforum*, October 1984.

Hoberman, Jim. "Declarations of Independents." *The Village Voice*, 24 September 1979.

Horn, Rebecca. *Dialogo della Vedova Paradisiaca*. Geneva 1976.

"Collaboration Rebecca Horn." *Parkett*, August 1987, with contributions by Bice Curiger, Démosthènes Davvetas, Felix Philipp Ingold, Martin Mosebach and Daniel Soutif.

Neidel, H. "Zeichen als Reise ins Land der besseren Erkenntnis." *Du*, April 1982.

Paoletti, John. "Rebecca Horn at Marian Goodman." *Artscribe International*, April–May 1986.

Pohlen, Annelie. "La Ferdinanda: Kunsthalle, Baden-Baden." *Artforum*, December 1981.

Poser, S. "Horn's Der Eintänzer." *Arts Magazine*, January 1980.

Wechsler, Max. "Paradise Gained." *Artforum*, September 1985.

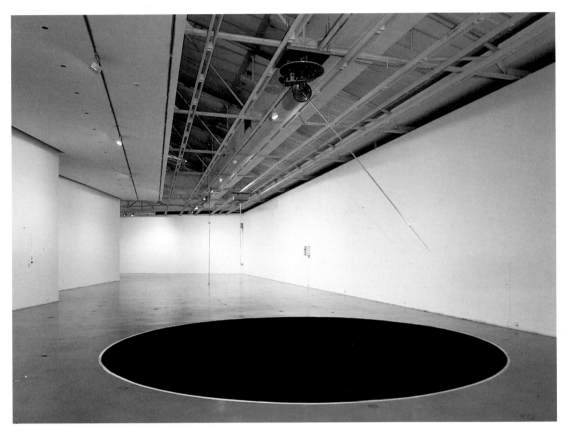

Spiralmaschine, 1986
metal, motor, and pigment
140⅖ in. diameter (360 cm. diameter)
Installation view at ARC/Musée d'Art Moderne de la Ville de Paris
Courtesy of the artist

Not in exhibition. Work in exhibition illustrated in supplement.

Anish Kapoor

Born 1954, Bombay, India

Lives and works in London

Inherent in Anish Kapoor's interest in "making belief" through "making art" is the notion of duality: the pull between the concrete and the illusory, tactility and opticality, physicality and immateriality. And Kapoor encourages several, at times contradictory, readings of his work by instilling a sense of otherworldliness in his objects.

Kapoor's last decade of work was inspired initially by a trip to his native India in 1979 (he has been living in London since the age of 17). There the artist was inspired by Hindu mythology, Indian art and architecture and was particularly intrigued by the mounds of colored powder frequently found outside temples. He began creating geometric forms of chalk or plaster dusted with powdered pigment in primary colors. He sprinkled pigment around the bases of these works as well, forming halos. The pieces—each created for a particular site—seemed to have emerged from or dropped to the ground from another world, their aureoles mediators between the works and the gallery space. Their luminous solid-looking surfaces invited touch while their actual granular fragility prohibited it.

In the early '80s Kapoor abandoned geometric forms in favor of biomorphic ones. These more sensual, complex shapes necessitated a switch in materials: wood, fiberglass or polystyrene covered with mud and cement replaced the more ephemeral chalk and plaster. With these he began creating installations of interrelated works not preconceived as such, but rather deriving from one another in an almost narrative sequence.

Kapoor shares with fellow British sculptors Tony Cragg and Bill Woodrow a fascination with how diverse forms can "come to be seen as a unified ensemble."[1] The interrelationships between components are not strictly formal, however. Kapoor creates drama, emotion and a place of spiritual power.

—*Kellie Jones*

[1] Kenneth Baker, "Anish Kapoor at Barbara Gladstone," *Art In America*, October 1984.

Selected Solo Exhibitions

1988
Lisson Gallery, London. Also 1985, 1983, 1982.
1987
Ray Hughes Gallery, Sydney. Traveled.
1986
Kunsthernes Hus, Oslo. Catalogue by Lynne Cooke and Arne Malmedal.
Barbara Gladstone Gallery, New York. Also 1984.
Albright Knox Gallery, Buffalo. Catalogue by Helen Raye.
University Gallery, University of Massachusetts, Amhurst. Catalogue by Helaine Posner.
1985
Institute of Contemporary Art, Boston. Brochure by David Joselit.
Kunsthalle Basel. Traveled. Catalogue by Jean-Christophe Amman, Ananda Coomaraswamy, and Alexander von Grevenstein.
1983
Galerie 't Venster, Rotterdam. Catalogue by Michael Newman.
Walker Art Gallery, Liverpool. Traveled. Catalogue by Marco Livingstone. Also 1982.
1981
Coracle Press, London.
1980
Patrice Alexandre, Paris.

Selected Group Exhibitions

1987
Viewpoint: British Art of the 1980s, Museum of Modern Art, Brussels. Catalogue.
Similia/Dissimilia: Modes of Abstraction in Painting, Sculpture and Photography Today, Kunsthalle Düsseldorf. Catalogue.
1986
Entre el Objecto y la Imagen, Fundación Caja de Pensiones, Madrid. Catalogue.
1985
The Poetic Object, The Douglas Hyde Gallery. Traveled. Catalogue.
1984
The British Art Show: Old Allegiances and New Directions, 1979–1984, City Museum and Art Gallery, Birmingham. Traveled. Catalogue.
1983
Bienal de São Paulo. Traveled. Catalogue.
New Art at the Tate Gallery, The Tate Gallery, London. Catalogue.
The Sculpture Show, Hayward Gallery and Serpentine Gallery, London. Catalogue.
1982
La Biennale di Venezia. Catalogue.
Englische Plastik Heute, Kunstmuseum Luzerne. Catalogue.
1974
Art in Landscape, Serpentine Gallery, London.

Selected Bibliography

Baker, Kenneth. "Anish Kapoor at Barbara Gladstone." *Art in America*, October 1984.

Cameron, Dan. "Anish Kapoor." *Arts Magazine*, March 1984.

Collier, Caroline. "Anish Kapoor at the Lisson Gallery." *Studio International*, December 1983.

————. "Forms a hole can take . . .: Anish Kapoor, Lisson Gallery, London." *Studio International*, Summer 1985.

Groot, Paul. "Anish Kapoor: 't Venster Gallery." *Flash Art*, May 1983.

Kinmouth, Patrick. "Anish Kapoor's Shadow of Meaning." *Vogue*, August 1983.

Morgan, Stuart. *British Sculpture in the Twentieth Century, Part Two: Symbol and Imagination 1951–80*. London 1981.

Newman, Michael. "Discourse and Desire: Recent British Sculpture." *Flash Art*, January 1984.

————. "Le drame du desir dans la sculpture d'Anish Kapoor." *Art Press*, May 1983.

Oosterhaf, Gosse, and Cees Van der Geer. *Beelden Sculpture 1983*. Rotterdam 1983.

Paparoni, Demetrio. "Spazio di Dio, Spatio della Terra." *Tema Celeste*, June 1985.

Princenthal, Nancy. "Anish Kapoor." *ARTnews*, Summer 1984.

Russell, John. "Bright Young Talents: Six Artists with a Future." *The New York Times*, 18 May 1986.

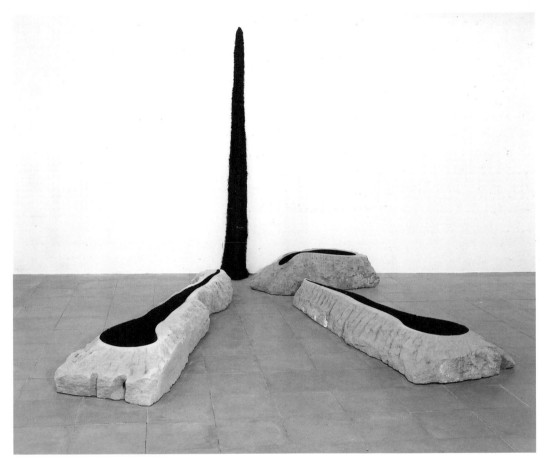

Wound, 1988
limestone and pigment
121⅔ × 170 × 130³⁄₁₀ in. (308 × 432 × 331 cm.)
Weltkunst Foundation, Zurich, courtesy of Lisson Gallery, London

Not in exhibition. Work in exhibition illustrated in supplement.

Anselm Kiefer

Born 1945, Donaueschingen,
Germany

Lives and works in Hornbach,
Odenwald, West Germany

Since the beginning of the 1980s Anselm Kiefer has emerged as one of the most powerful—and controversial—German artists of the younger post-war generation. Kiefer was born in 1945, just months before Germany's final defeat, and his birthdate, like much about his art, is poised on that subtle line demarcating the old and new Germanies. In the mid-'60s Kiefer studied French and law for a short time before switching to art; in the late '60s he attended the art academy in Karlsruhe. Most importantly, in the early '70s he studied with Joseph Beuys in Düsseldorf.

Because Kiefer's works refer, among other things, to the Teutonic mythology popularized by the Nazi party, he has been accused of appealing to the sinister side of German nationalism. Kiefer has not avoided the subject of being a German artist in post-Holocaust Europe. Though clearly aware of the ambiguities of his situation, he has not chosen to unconditionally erase the past or to reject it as subject matter. In a conceptual work of 1969, *Besetzungen* (Occupations), he photographed himself in various places (the beach, the Roman Colosseum, a messy apartment) wearing an ill-fitting, slightly old-fashioned jacket and jodhpurs, his right arm raised in a stiff *Sieg Heil*. It's as if he were saying, "whatever I do and wherever I am, as a German I am inevitably marked by the Nazi past." Here, the artist's balding, disheveled figure is absurd, a parody of German imperialist aspirations. In Kiefer's later paintings, the mythological references—however problematic thay may be—are complex, and the works require a reading which treats formal, esthetic and symbolic issues in the context of the entire oeuvre. What is certain is that the artist has touched on material that is highly sensitive.

Kiefer develops his themes in a number of mediums, most notably painting, altered photographs and artists' books. Over the last two decades, Kiefer's canvases have evolved according to a forceful pictorial logic based on the perspectival play of nature's own geometric forms. The upright pillars of trees in works such as *Man in the Forest*, 1971, and *Resurrexit*, 1973, metamorphose into the grain of wood planks heavily rendered in charcoal in works such as *Germany's Spiritual Heroes*, 1973. These lines resurface, quite literally, in the upturned earth of furrowed fields and roads (signature images for Kiefer) that zoom directly back to the horizon or snake sinuously toward it across rolling slopes. In the early '80s, the lines seeking infinity became the columns, pillars and plaza perspectives of Nazi architecture: *Interior*, for instance, is a direct rendering of Hitler's chancellery, designed by Albert Speer. Most recently, in *Osiris and Isis*, 1985–87, these lines turn up once again, but now in the building-block construction of a stepped pyramid.

Over his images of ordered nature (the fields and forests can seem scruffy armies lined up for review) Kiefer often superimposes images whose formal irregularity and obvious symbolic import mark them as emblematic. An artist's womb-shaped palette, to mention a frequently recurring image, is sometimes equipped with wings, implying the artist's freedom and otherworldly status, as well as the dangers of the occupation. Like the wings of Icarus (another of Kiefer's favored subjects), the artist's wings may prove vulnerable. Words—the names of German cities or the discredited heroes of Germanic myth, and quotes from German poems or songs—also appear, inscribed into the landscape.

Kiefer's works possess an extraordinary physicality. His use of the medium is inventive and violent (and owes a great deal to Abstract Expressionism). Oil and acrylic are mixed with sand and straw and the resulting ridges of clotted or dripping paint describe somber, unquiet landscapes. Kiefer's paint handling is consonant with his subject matter; his canvases *are* the very fields they describe. There is a quality of awesome desolation in many of his works that has led critics to compare him to the 19th-century German Romantic painters. Looking at his "landscapes," it seems that if Kiefer is indeed searching for the sublime, he believes it to dwell in the scorched earth of a 20th-century wasteland.

—*Jamey Gambrell*

Selected Solo Exhibitions

1987
The Art Institute of Chicago and Philadelphia Museum of Art. Traveled. Catalogue by Mark Rosenthal.

Marian Goodman Gallery, New York. Catalogue by John Hallmark Neff. Also 1985, 1982, 1981.

Galeria Foksal, Warsaw.

1986
Galerie Paul Maenz, Cologne. Catalogue by Paul Maenz and Gerd de Vries, eds. and Gudrun Inboden. Also 1984; 1982 (catalogue); 1981.

Stedelijk Museum, Amsterdam. Catalogue by Wim Beeren.

1984
Städtische Kunsthalle, Düsseldorf. Traveled. Catalogue by Rudi Fuchs, Jurgen Harten and Suzanne Pagé.

1983
Anthony d'Offay Gallery, London. Catalogue by Anne Seymour.

Sonja Henie-Niels Onstad Foundations, Oslo.

1981
Museum Folkwang, Essen, and Whitechapel Art Gallery, London. Catalogue by Zdenek Felix and Nicholas Serota.

1979
Stedelijk van Abbemuseum, Eindhoven. Catalogue by Rudi Fuchs.

1978
Kunsthalle Bern. Catalogue by Johannes Gachnang and Marianne Schmidt-Miescher.

1977
Kunstverein Bonn. Catalogue by Anselm Kiefer, Dorothea von Stetten and Evelyn Weiss.

1969
Galerie am Kaiserplatz, Karlsruhe, West Germany.

Selected Group Exhibitions

1987
Documenta VIII, Kassel. Also *VII*, 1982; *VI*, 1977. Catalogues

1986
Beuys, Cucchi, Kiefer, Kounellis, Kunsthalle Basel. Catalogue.

Anselm Kiefer—Richard Serra, The Saatchi Collection, London.

1985
Carnegie International, Museum of Art, Carnegie Institute, Pittsburgh. Catalogue.

Schwarz auf Weiss: Von Manet bis Kiefer, Galerie Beyeler, Basel. Traveled. Catalogue.

German Art in the 20th Century: Painting and Sculpture, 1905–1985, Royal Academy of Arts, London. Traveled. Catalogue.

1945–1985: Kunst in der Bundesrepublik Deutschland, Nationalgalerie, Staatliche Museen Preussischer Kulturbesitz, West Berlin. Catalogue.

1984
von hier aus, Messegelände, Düsseldorf. Catalogue.

1981
Westkunst—Heute: Zeitgenössische Kunst seit 1939, Museen der Stadt Köln. Catalogue.

1980
La Biennale di Venezia. Catalogue.

1973
14 × 14, Staatliche Kunsthalle, Baden-Baden. Catalogue.

84

Selected Bibliography

Bos, Saskia. "Anselm Kiefer, Helen Van der Meij Gallery, Amsterdam." *Artforum*, January 1983.

Fuchs, Rudi. "Chicago Lecture." *Tema Celeste*, March 1985.

———. "Kiefer Schildert." *Museumjournaal*, December 1980.

Gachnang, Johannes. "Anselm Kiefer." *Kunstnachrichten*, Summer 1979.

Kiefer, Anselm. "Besetzungen 1969." *Interfunktion*, December 1969.

———. *Die Donauquelle*. Michael Werner, ed. Cologne 1978.

———. *Hoffman von Fallersleben auf Helgoland*. Groningen 1980.

———. "Gilgamesch und Enkidu im Zedernwalk." *Artforum*, June 1981.

———. *Nothung, ein Schwert verhiess mir der Vater*. Baden-Baden 1983.

———. *Selbstbiographie*. Bonn 1977.

Kramer, Hilton. "The Anselm Kiefer Retrospective." *The New Criterion*, February 1988.

Kuspit, Donald B. "The Night Mind." *Artforum*, September 1982.

Müller, Hans-Joachim. "Anselm Kiefer, Kunsthalle, Bern." *Kunstwerk*, December 1978.

Russell, John. "Anselm Kiefer's Paintings are Inimitably His Own." *The New York Times*, 21 April 1985.

Schjeldahl, Peter. "Anselm Kiefer." *Art of Our Time: The Saatchi Collection*. London 1984.

———. "Anselm Kiefer and The Exodus of the Jews." *Art and Text*, October–December 1985.

Schwartz, Sanford. "Anselm Kiefer, Joseph Beuys and the Ghosts of the Fatherland." *The New Criterion*, March 1983.

Elizabeth von Österreich, 1988
acid-treated lead on photograph with steel and glass
66⁹⁄₁₀ × 51⅓ in. (170 × 130 cm.)
Collection of Mr. and Mrs. David Pincus, Wynnewood, Pennsylvania

Not in exhibition. Work in exhibition illustrated in supplement.

Per Kirkeby

Born 1938, Copenhagen

Lives and works in Copenhagen; Laes, Denmark; and Karlsruhe, West Germany

Kirkeby once defined geology as "the science of the powers behind the forms . . ." Changing careers in the early '60s, Kirkeby the scientist transferred this definition—nearly intact—to art. He considers drawings, sculptures, and paintings as relics which mirror the powers of their creation. Yet art has an advantage over science; every picture can be both an object of study and a theory at the same time—earth's crust and geology.

Kirkeby's works do not encode their message in abstract theories, but rather bear witness to those creative powers which they take as their theme. For Kirkeby, painting documents an event. Whereas with film, a medium in which he also works, associations are strung along in a temporal sequence, continuously imposing new meaning, painting is the sum of layering. Kirkeby keeps these layers transparent. He treats pictorial space as if it were temporal. At the same time, his use of materials recalls the classical tradition, thereby calling up all manner of fleeting associations. The viewer's memory and personal store of knowledge complete the works' meaning.

Kirkeby, in a way, is a conceptualist. His paintings, drawings, brick sculptures, and written texts focus on a process of structures evolving. This process cannot be named categorically. This linguistic hybrid reflects Kirkeby's idea of creation: although working in a spontaneous mode, form and texture develop.

His brick sculptures, produced since 1973, can also be understood as metaphors for the structure underlying every work of art. The idea for the brick sculpture is formed quickly and intuitively by mo-deling plaster. He then "interprets" the resulting form by reconstructing it brick by brick. The creative power which is responsible for the plaster model is the same as for the modular brick sculpture. Process is structure and structure is process. Kirkeby's real topic is the essential combination of spontaneity *and* order. A work of art which can be said to comprise both esthetic object and theory surpasses the common views of creativity, which have historically separated reason and subjectivity. Kirkeby shows that beyond scientific thinking there is a poetical understanding of the world which is not analytical but which has its reasons.

—*Stephan Schmidt-Wulffen*
Translated from German by Clara Seneca

Selected Solo Exhibitions

1988
Galerie Michael Werner, Cologne. Catalogue by Per Kirkeby. Also 1986 (catalogue by Per Kirkeby); 1984 (catalogue by Andreas Franzke); 1983 (catalogue by Per Kirkeby); 1982 (catalogue by A.R. Penck); 1980 (catalogue by Rudi Fuchs, Johannes Gachnang and Per Kirkeby); 1978; 1974.

1987
Centre de Création Contemporain de Tours. Catalogue by Bernard Lamarche-Vadel.

Museum Ludwig, Cologne. Traveled. Catalogue by Troels Anderson, Andreas Franzke, Siegfried Gohr and Peter Schjeldahl.

Museum Boymans-van Beuningen, Rotterdam. Catalogue by Wim Crouwel, Per Kirkeby and Karel Schampers.

1986
Mary Boone Gallery, New York. Catalogue by Peter Schjeldahl.

Städtisches Museum Abteiberg Mönchengladbach. Catalogue by Troels Anderson, Johannes Gachnang, Hannelore Kerstig, Per Kirkeby and Dirk Stemmler.

Whitechapel Art Gallery, London. Catalogue by Tony Godfrey, Per Kirkeby and Nicholas Serota.

1985
The Fruitmarket Gallery, Edinburgh. Traveled. Catalogue by Troels Anderson.

Den Fries Udstillingsbygningen, Copenhagen. Catalogue by Peter Langesen.

1984
Strasbourg Museum. Catalogue by Marie Jeanne Geyer and Per Kirkeby.

1983
DAAD Galerie, West Berlin. Catalogue by Johannes Gachnang.

1982
Stedelijk van Abbemuseum, Eindhoven. Catalogue by Rudi Fuchs, Johannes Gachnang and Per Kirkeby.

1979
Kunsthalle Bern. Catalogue by Johannes Gachnang and Theo Kneubühler.

1978
Kunstraum München. Catalogue by Hermann Kern and Per Kirkeby.

1977
Museum Folkwang, Essen. Catalogue by Zdenek Felix and Troels Anderson.

1964
Hoved-Bibliotek, Copenhagen.

Selected Group Exhibitions

1988
Zeitlos, West Berlin. Catalogue.

1987
Skulptur Projekte, Münster. Catalogue.

1986
Falls the Shadow, Recent British and European Art, Hayward Gallery, London. Catalogue.

Europa/Amerika—Die Geschichte einer künstlerischen Faszination seit 1940, Museum Ludwig, Cologne. Catalogue.

1985
Carnegie International, Museum of Art, Carnegie Institute, Pittsburgh. Catalogue.

1984
von hier aus, Messegelände, Düsseldorf. Catalogue.

1982
Zeitgeist, Martin-Gropius-Bau, West Berlin. Catalogue.

Documenta VII, Kassel. Catalogue.

1981
A New Spirit in Painting, Royal Academy of Arts, London. Catalogue.

1980
La Biennale di Venezia. Catalogue. Also 1976.

1962
Den Eksperimenterende Kunstskole, Copenhagen.

Selected Bibliography

de Waal, Allan, Troels Anderson and Per Hovdenakk. *Per Kirkeby Norge Sverige Danmark 1975/76*. Copenhagen 1975.

Dückers, Alexander. *Erste Konzentration*. Munich 1982.

Gachnang, Johannes. "New German Painting." *Flash Art*, February–March 1982.

———. "Vom Gesicherten zum Wesentlichen-Spaziergange: Gedanken zur Kunst in Dänemark." *Bauen und Wohnen*, December 1981.

Gohr, Siegfried. "The Situation and the Artist." *Flash Art*, February–March 1982.

Horn, Luis and Per Kirkeby. *Per Kirkeby, Übermalungen 1964–1984*. Munich 1984.

Hunov, John. *Per Kirkeby: Ouevre Katalog, 1958–1977*. Copenhagen 1979.

Kirkeby, Per. *Fortgesetzter Text—Hinweise*. Bern-Berlin 1985.

———. *Rodin, la port de l'enfer*. Bern-Berlin 1985.

———. *Selected Essays from Bravura*. Eindhoven 1982.

Kolberg, Gerhard. "Per Kirkeby erste Monumentalskulptur im Museum Ludwig." *Kölner Museums—Bulletin*, 1987.

Malsch, Friedemann. "Per Kirkeby." *Kunstforum International*, October–November 1987.

McGill, Douglas C. "Art People: Per Kirkeby, Danish Artist and Paradox." *The New York Times*, 13 June 1986.

Rein, Ingrid. "Ausstellung: 39, Biennale/Arte visive '80." *Pantheon*, October–December 1980.

Schmidt-Wulffen, Stephan. "Enzyklopädie der Skulptur." *Kunstforum International*, October–November 1987.

Nach der Abnahme, 1987–88
oil on canvas
118¹⁄₁₀ × 137²⁄₅ in. (300 × 350 cm.)
Courtesy of Mary Boone/Michael Werner Gallery, New York

Nature Morte I, 1987
oil on canvas
78⁷⁄₁₀ × 43³⁄₁₀ in. (200 × 110 cm.)
Courtesy of Mary Boone/Michael Werner Gallery, New York

Nature Morte II, 1987
oil on canvas
78⁷⁄₁₀ × 43³⁄₁₀ in. (200 × 110 cm.)
Courtesy of Mary Boone/Michael Werner Gallery, New York

Nature Morte III, 1987
oil on canvas
78⁷⁄₁₀ × 43³⁄₁₀ in. (200 × 110 cm.)
Courtesy of Galerie Laage Salomon, Paris

Jeff Koons

Born 1955, York, Pennsylvania

Lives and works in New York

Until the 1960s, modernist art was seen as the antagonist of kitsch—that mass-produced, debased simulation of authentic culture. With Pop art, the opposition of modernism and kitsch broke down, with the result that the values of the artwork in the gallery and the object in the department store are now understood to derive from a common scale of social coding. This abstraction and equivalence is the central theme of the work of Jeff Koons.

Koons' vacuum cleaners and shampoo polishers placed on or encased in acrylic boxes illuminated by fluorescent lights, 1979–86, equate the idealist purity of art with the newness and desirability of goods on display in a shop window. With its appearance belying its use, the object becomes at the same time familiar and utterly remote, palpably recognizably real, yet phantasmagoric.

Things endure, we do not. The desire for immortality as the loss of the self in the commodity is the desire for one's own repression. In Koons' *Total Equilibrium Tanks*, 1985, basketballs suspended in water evoke the slightly hysterical calm of looking at a fish tank in a dentist's waiting room. The *Equilibrium Tanks* when shown together with Koons' re-presentations of posters promoting Nike sports products and his bronze castings of inflatable life-vests, aqualungs, and a boat, amount to an allegory of a society based on the maxim "sink or swim."

"I don't find any ironic quality in my work at all," Koons has said. "What it does have for me is a sense of the tragic."[1] Irony works in the split between the detached, transcendental subjectivity which thinks and observes and the social objectification of the self. To disclaim irony, Koons disclaims the intention or even the possibility of transcending the given social order. He rationalizes the production of art by functioning like a "creative director" in advertising: he targets his audience and manipulates the viewer according to a programmed formula. For him, the studio is an office; the gallery a showroom; and the production site a factory.

Koons has provided the following information about his works in the 1986 *Luxury and Degradation* exhibition: the water bucket is associated with the proletariat; the Jim Beam train, the liquor bottles and the Model A Ford represent middle class Americana; and the crystal Baccarat set and silver tray signify the upper middle class. Does the sociability of Koons' art result from its collusion in its own assimilation to the status quo? His 1986 stainless steel casts of rococo statuary symbolize upward mobility in our society, which, in terms of polarization, bears comparison to the absolute monarchy of Louis XIV. The egalitarian ideal signified by the equivalence of the reflective objects—"luxury to the proletariat"—is as abstract as exchange value in the money markets. The transcendent norms of style have become wholly immanent to a society based on the codes of prestige. The tragedy is that when transcendence is equated with the perfection of the commodity it has become an "unachievable state of being."

—*Michael Newman*

[1]This and following citations from the interview by Jeanne Siegel, "Jeff Koons: Unachievable States of Being," *Arts Magazine*, October 1986.

90

Solo Exhibitions

1987
Daniel Weinberg Gallery, Los Angeles. Also 1986.
1986
International With Monument Gallery, New York. Also 1985.
1985
Feature Gallery, Chicago.
1980
The New Museum of Contemporary Art, New York.

Selected Group Exhibitions

1988
BiNational: Art of the Late 80s, Museum of Fine Arts and Institute of Contemporary Art, Boston; Städtische Kunsthalle and Kunstsammlung Nordheim-Westfalen, Düsseldorf. Catalogue.
NY Art Now: The Saatchi Collection, London. Also 1987. Catalogue.
New York in View, Kunstverein München.
1987
Simulations, New American Conceptualism, Milwaukee Art Museum.
Skulptur Projekte, Münster. Catalogue.
Biennial, Whitney Museum of American Art, New York. Catalogue.
1986
End Game: Reference and Simulation in Recent Painting and Sculpture, Institute of Contemporary Art, Boston. Catalogue.
Damaged Goods, The New Museum of Contemporary Art, New York.
1985
Affiliations: Recent Sculpture and its Antecedents, Whitney Museum of American Art, Fairfield County, Stamford, Connecticut.
1984
A Decade of New Art, Artists Space, New York. Catalogue.
1980
Art for the Eighties, Galeria Durban, Caracas.

Selected Bibliography

Cameron, Dan. "Art and Its Double: A New York Perspective." *Flash Art*, May 1987.

Deitch, Jeffrey. "Mythologies: Art and the Market." *Artscribe International*, April–May 1986.

Faust, Wolfgang Max. "New New York New." *Wolkenkratzer*, January–February 1988.

Flood, Richard. "Lighting." *Artforum*, March 1981.

Halley, Peter. "The Crisis in Geometry." *Arts Magazine*, Summer 1984.

Jones, Alan. "Jeff Koons." *Arts Magazine*, November 1983.

———. "JEFF KOONS 'Et qui libre?'" *Galeries Magazine*, October–November 1986.

———. "Paravision: An Interview with Tricia Collins and Richard Milazzo." *Galeries Magazine*, Summer 1986.

Koons, Jeff. "'Baptism', A Project for Artforum." *Artforum*, November 1987.

———. "From Criticism to Complicity." *Flash Art*, Summer 1986.

Lawson, Thomas. *Fatal Attraction*. Chicago 1982.

Politi, Giancarlo. "Luxury and Desire: An Interview with Jeff Koons." *Flash Art*, February–March 1987.

Raynor, Vivien. "Art: Objects are Subject of (Damaged Goods)." *The New York Times*, 18 July 1986.

Saltz, Jerry. "The Dark Side of the Rabbit: Notes on a Sculpture by Jeff Koons." *Arts Magazine*, February 1988.

Zimmer, William. "Sculpture at The Whitney." *The New York Times*, 21 July 1985.

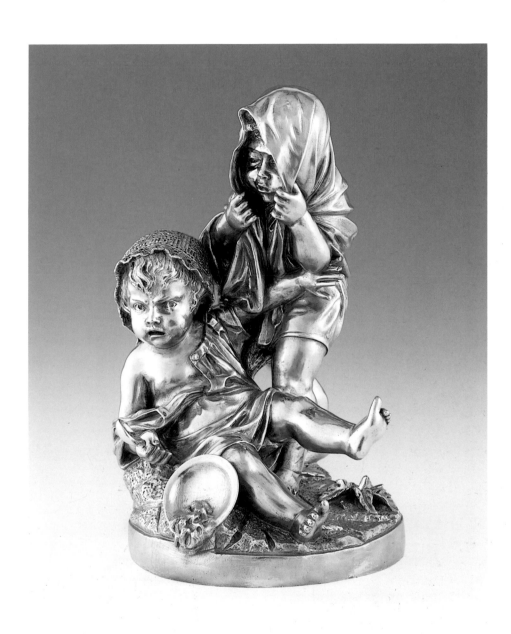

Two Kids, 1986
stainless steel
23 × 14¼ × 14¼ in. (58.4 × 36.2 × 36.2 cm.)
Collection of Donald and Mera Rubell, New York, courtesy of Sonnabend Gallery, New York

Not in exhibition. Work in exhibition illustrated in supplement.

Jannis Kounellis

Born 1936, Pireaus, Greece

Lives and works in Rome

Jannis Kounellis moved to Rome from his native Greece in 1956 at the age of 20 to study art. Among his earliest works, those done in the late '50s and early '60s were random assortments of letters and numbers stenciled in black paint on unprimed canvas. In the mid-'60s Kounellis went through a period of crisis in which he produced nothing. When he emerged from it he had fully rejected painting. At this time Kounellis began to exhibit with other artists who also felt painting was no longer valid and were attempting to articulate an "anti-esthetic," a direct language of ordinary, non-art materials. The Arte Povera artists, as they were called, brought to the visual arts the spirit of social rebellion that characterized Europe and the U.S. in 1968. After a childhood of war, first World War II and then civil war in Greece, it is not surprising that the social/political subtext to most of Kounellis' work has been the death and rebirth of European civilization.

Kounellis has always stressed the literal physical value of his materials and the way in which his objects are constructed. His means have always been simple: rock, steel, lead, wood, coal and burlap, among other raw materials, have formed the mainstay of his art over the last 20 years, along with a small store of objects, most notably fragments of plaster copies of Greek and Roman sculpture. After abandoning painting, Kounellis began exhibiting isolated objects: a stack of burlap sacks; a sack filled with coffee beans; tangled bundles of wool attached to a bed frame; a steel brazier filled with coal. What these pieces had in common, besides their connection to the history of human trade, is that they were presented in terms of specific familiar measures, (sacks, scales, windows, doors, etc.), an important concept in Kounellis' work. Measure for the artist represents that sense of cultural unity necessary for survival that has been lost in the violence of 20th-century Western culture.

Certain symbolic "actions" recur throughout Kounellis' work, of which blocking is the most frequent. He often blocks doors and windows, again, standard human measures, with assemblages of wood fragments and steel beams or panes of lead or rocks piled carefully like a stone fence. It's possible to imagine these pieces as the remnants of performances or rites; and indeed, Kounellis has used his materials in non-narrative performances and tableaux vivants. A number of them done in the '70s are referred to by the artist as "tightrope" acts, and indeed there is an element of metaphysical suspense involved in them. The propane gas torches he had previously installed randomly about galleries reappeared attached to the foot of a woman lying on a bare steel bed spring and covered with a blanket. In one performance, Kounellis placed the torch in his own mouth and stood with his head resting against a shelf joined to a steel panel. In the '80s he began to attach the torches themselves to steel panels, and their function changed to that of elements within a composition rather than as autonomous objects.

Kounellis combines and recombines his elements (and often entire pieces), and their reading frequently changes dramatically depending on the social and political, as well as spatial, context in which they are viewed. Shelves first appeared in Kounellis' work in the late '60s, but during the '80s they have grown larger and their composition more complex. Rather than offering a single item for contemplation, an egg, a braid of human hair or a pile of coffee, as he did in an important 1969 series, Kounellis will often present an entire array of object fragments. These are presented as if they were shards found on some archeological dig, and as if it were the artist's job to place them in order, to discover their relative significance, to reestablish a syntactical sense for secret meanings that had been lost.

—*Jamey Gambrell*

Selected Solo Exhibitions

1988
Galleria Christian Stein, Milan. Also 1987, 1985.
1986
Museum of Contemporary Art, Chicago. Traveled. Catalogue by I. Michael Danoff, Mary Jane Jacob and Thomas McEvilley.
Anthony d'Offay, London.
1985
Städtische Galerie im Lenbachhaus, Munich. Catalogue by Helmut Friedel, Bernd Growe, Jannis Kounellis and Marianne Stockebrand.
Sonnabend Gallery, New York. Also 1984, 1983, 1980, 1974, 1973, 1972.
1984
Museum Haus Esters, Krefeld. Catalogue by Marianne Stockebrand.
1983
Musei Comunali, Rimini, Italy. Catalogue by Germano Celant.
1982
Staatliche Kunsthalle Baden-Baden.
1981
Stedelijk van Abbemuseum, Eindhoven. Traveled. Catalogue by Rudi H. Fuchs.
1979
Museum Folkwang, Essen. Catalogue by Bruno Corà and Zdenek Felix.
1978
Städtisches Museum Abteiberg Mönchengladbach. Catalogue by A. Blok.
Galleria Tartaruga, Rome. Also 1964 (catalogue by Cesare Vivaldi); 1960 (catalogue by Mario Diacono).
1977
Museum Boymans-van Beuningen, Rotterdam. Catalogue by R. Hammacher-van der Brande and Maurizio Calvesi.
1971
Galleria Gian Enzo Sperone, Turin. Also 1968.

Selected Group Exhibitions

1987
Avant-Garde in the Eighties, Los Angeles County Museum of Art. Catalogue.
1985
Carnegie International, Museum of Art, Carnegie Institute, Pittsburgh. Catalogue.
The Knot: Arte Povera, P.S. 1, Institute for Art and Urban Resources, Long Island City. Catalogue.
1984
Ouverture, Castello di Rivoli, Turin. Catalogue.
1982
Documenta VII, Kassel. Also *VI*, 1977; *V*, 1972. Catalogues.
Zeitgeist, Martin-Gropius-Bau, West Berlin. Catalogue.
1981
Westkunst-Heute: Zeitgenössische Kunst seit 1939, Museen der Stadt Köln. Catalogue.
A New Spirit in Painting, Royal Academy of Arts, London. Catalogue.
1980
La Biennale di Venezia. Also 1978, 1974. Catalogues.
1969
Live in Your Head: When Attitudes Become Form: Works—Concepts—Processes—Situations—Information, Kunsthalle Bern. Traveled. Catalogue.
1961
XII Premio Lissone, Lissone, Italy. Catalogue.

Selected Bibliography

Bartolucci, G. and Jannis Kounellis. "Jannis Kounellis: Pensieri e osservazioni (raccolti da G. B.)." *Marcatré*, July–September 1968.

Celant, Germano. *Arte Povera*. Milan, 1969.

———."Collision and the Cry: Jannis Kounellis." *Artforum*, October 1983.

"Collaboration Jannis Kounellis." *Parkett*, September 1985 with contribution by Bruno Corà.

Diacono, Mario. "Jannis Kounellis." *Bit*, March 1967.

Gambrell, Jamey. "Industrial Elegies." *Art in America*, February 1988.

Grüterich, Marlies, "Museum Folkwang Ausstellung: Jannis Kounellis." *Pantheon*, January 1980.

Kounellis, Jannis. "Non per il teatro ma con il teatro." *iparo*, April 1969.

Lonzi, Carlo and Jannis Kounellis. "Interview." *Marcatré*, December 1966.

Oliva, Achille Bonito. *Europe-America: The Divergent Avant-gardes*. Milan, 1976.

Ponti, L.L. "Domus 650 interviews: Jannis Kounellis." *Domus*, May 1984.

Sharp, Willoughby. "Structure and Sensibility: An Interview with Jannis Kounellis." *Avalanche*, Summer 1972.

White, Robin. "Interview at Crown Point Press." *View*, 1979.

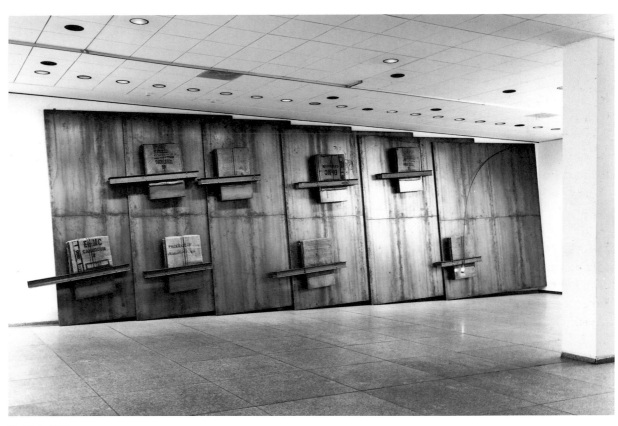

Untitled, 1988
steel plates, iron, burlap, and gas
163⅓ × 492¹⁄₁₀ × 25⅗ in. (415 × 1250 × 65 cm.)
Installation view at Nationalgalerie, Staatliche Museen Preussischer Kulturbesitz, West Berlin
Courtesy of Galleria Christian Stein, Milan and Turin

Not in exhibition. Work in exhibition illustrated in supplement.

Wolfgang Laib

Born 1950, Metzingen, West Germany

Lives and works near Biberach, West Germany

Laib, who was born in 1950, has traveled to India and the Far East and been deeply affected by the teachings of Eastern philosophy and religion. His work reflects his interest in the complex, paradoxical simplicities of Hindu, Buddhist and Zen thought, evoking a meditative, spiritual vision of nature and our place in it. This vision has a timeless aura, owing to Laib's simple vocabulary of natural materials—milk, marble, pollen, rice and wax. They all possess natural symbolism related to nurture, fertility, nourishment, time and seasonality, in addition to innate esthetic—and at times, exquisite—qualities.

The art of Wolfgang Laib is unique among the generation of younger German artists whose vision of the world reflects the influence of Joseph Beuys; it also suggests affinities with transcendentalist American artists such as James Turrell. Laib is unafraid of beauty. As he commented in a recent interview, "Milk or pollen are extremely beautiful—like the sun or the sky. And why be afraid of beauty? Recently [for] so many artists, especially German artists . . . [art] had to be as ugly and as brutal as possible. Beauty was bourgeois—what a strange idea! Maybe it was easier for me since I didn't have to paint a beautiful painting."

Texts on Laib invariably stress that he studied medicine at the University of Tubingen, but that upon finishing his degree in 1974 he chose not to practice and began to devote his time entirely to art. The biographical information is pertinent because the patience, precision and sensitivity required in the study of medicine have survived Laib's vocational transition, though they have been transformed. That transition was one from the transient to the transcendent in nature: from the chaos of the physiological to the order and harmony of the spiritual.

In 1975, Laib made the first in a series of "Milkstones"—rectangular slabs of white marble. Into the slightest breath of an impression in the marble Laib pours milk, and the merging of liquid and stone appears almost total. The stone seems to become liquid and the liquid stone. As Laib has noted, milk is not a white liquid, whiteness is a property of milk; milk is white the way the sky is blue. Different scales or perspectives of time are also introduced and equated as properties of stone and milk alike: over the course of a few hours, the milk sours and evaporates; over millenia stone wears down, crumbles away. The milk and stone are seen as equals in a constant, changeable flow of time.

In 1977 Laib made his first collection of pollens. He lives in a small village and works in a studio surrounded by meadows from which he harvests the pollen of dandelions, hazelnuts, pines, buttercups and other plants that are available. It is, needless to say, a painstaking process, with several weeks of work yielding but a few small jars of pollen. The pollen is exhibited either in these jars, emphasizing its status as specimen; in small piles; or spread in fields of hallucinatory color on the floor.

In 1983 Laib began fashioning small reliquary-shaped structures out of metal and marble. These are his "rice houses." White-grained rice is scattered and arranged in heaps or little "mountains" like votive offerings around the base of these symbolic dwellings. Rice is both a basic food—indeed, the staple of a huge percentage of the world's population—and, like milk, a material with its own inherent esthetic qualities, a translucent yellow-whiteness. Sometimes Laib would place sticks of sealing wax on the floor nearby. He subsequently made entire houses out of deep red or burnt-orange sealing wax (and, most recently, beeswax) finding in their textures and colors a physical intensity and symbolic self-sufficiency consonant with the spirituality of his other materials.

—*Jamey Gambrell*

Selected Solo Exhibitions

1988
Des Moines Art Center. Brochure by Connie Butler. Galerie Lelong, New York. Also 1986.
Galerie Konrad Fischer, Düsseldorf. Also 1983, 1982, 1978.
1987
Galerie Buchmann, Basel. Catalogue.
1986
ARC/Musée d'Art Moderne de la Ville de Paris. Catalogue by Suzanne Pagé and Harald Szeemann.
C.A.P.C., Musée d'Art Contemporain, Bordeaux.
1985
Whitechapel Art Gallery, London. Catalogue by Annelie Pohlen.
1983
Städtisches Museum Abteiberg Mönchengladbach. Catalogue by Johannes Cladders.
1981
Sperone Westwater, New York. Also 1979.
1978
Kunstraum München. Catalogue by Hermann Kern.
1976
Galerie Müller-Roth, Stuttgart.

Selected Group Exhibitions

1988
Zeitlos, West Berlin. Catalogue.
R.O.S.C., Dublin. Catalogue.
1987
Documenta VIII, Kassel. Also *VII*, 1982. Catalogues.
1986
De Sculptura, Vienna. Catalogue.
SkulpturSein, Kunsthalle Düsseldorf. Catalogue.
1985
Spuren, Skulpturen und Monumente ihrer präzisen Reise, Kunsthaus Zürich. Catalogue.
1982
La Biennale di Venezia, German Pavilion. Catalogue.
Kunst wird Material, Nationalgalerie, Staatliche Museen Preussischer Kulturbesitz, West Berlin. Catalogue.
1981
Annemarie und Will Grohman Stipendium, Kunsthalle Baden-Baden. Catalogue.

94

Selected Bibliography

Cladders, Johannes. "Aan de Rijsttafel van Stuifmeel." *Openbaar Kunstbezit*, June 1987.

Couder, Sylvie. "Wolfgang Laib, die vitale Kraft des künstlerischen Aktes." *Artefactum*, April–May 1987.

Davvetas, Démosthènes. "Wolfgang Laib: Interview with the Artist." *New Art*, January 1987.

Ferrari, Corinna. "Wolfgang Laib, una mostra a Milano." *Domus*, April 1978.

Gintz, Claude. "Nature, Culture, Écriture à propos de Wolfgang Laib, Lothar Baumgarten et quelques autres." *Art Press*, October 1986.

Hübl, Michael. "Askese des Abundanten. Wolfgang Laib." *Kunstforum*, March 1985.

Müller, Hans-Joachim. "Sensibilissimus und die Natur." *Die Zeit*, February 1982.

Ottman, Klaus. "The Solid and the Fluid: Bartlett, Laib, Kiefer." *Flash Art*, Summer 1985.

———. "True Pictures." *Flash Art*, February–March 1987.

Pohlen, Annelie. "Cosmic Visions from North and South." *Artforum*, March 1985.

———. "Steinzeit—Endzeit—Meditationszeit, von Laib zu Beuys zu Knoebel mit einem Seitensprung zu Lechner." *Kunstforum International*, July 1983.

Smith, Roberta. "Wolfgang Laib." *The New York Times*, 7 November 1986.

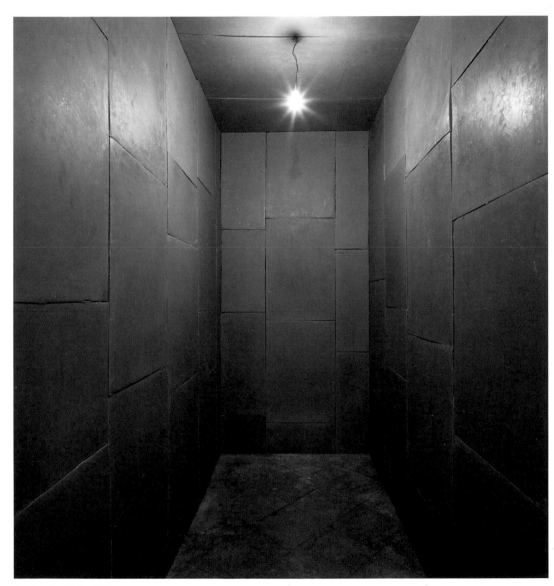

For Another Body, 1988
beeswax, brick, and stucco
interior dimensions: 135⅕ × 63 × 153½ in. (345 × 160 × 390 cm.)
Installation view at *Zeitlos*, West Berlin
Courtesy of the artist

Not in exhibition. Work in exhibition illustrated in supplement.

Born 1947, Hazleton, Pennsylvania

Lives and works in New York

Sherrie Levine seems to have formulated a set of questions for the 1980s just as Andy Warhol posed them in the '70s. While Warhol celebrated banality by obliterating the distinction between high art and popular culture, Levine has attacked the sacrosanct notions of originality, autonomy, ownership and gender. She has taken Warhol's appropriation one step further by expropriating specific works of art as well as general—even generic—styles.

Levine grew up in Saint Louis and attended graduate school in Wisconsin, learning about art through reproductions. Her graduate work in photo-printmaking and commercial art further convinced her that all images are in the public domain and, therefore, useable. In her early work, such as the 36 drawings of *Sons and Lovers* (1976–77), where she juxtaposed silhouettes of presidents Washington, Lincoln, Kennedy, and anonymous faces from ads, Levine presented the iconic and commonplace as interchangeable. However, unlike John Baldessari or David Salle, whose ideas about reclaiming readymade images inspired her, she did not doctor the images she appropriated.

Levine received critical notice, indeed notoriety, in 1981 with her series of photographs entitled "After Edward Weston." By photographing Weston's photographs and exhibiting them as her own (causing threats of lawsuits), Levine confronted a multitude of issues about presentation, re-presentation and representation. Though artists have traditionally made reference to or copies of the work of other artists, what Levine did gave the entire enterprise a rather stunning twist. Levine, explaining her method, often quoted Roland Barthes: "A picture is a tissue of quotations drawn from innumerable centers of culture." Weston's photographs of the nude torso of his son bear a striking resemblance to Greek *kouroi*; Levine's photographs in a parallel way "copied" Weston's work as he had "copied" the Greek sculpture. Yet it is the tension between her direct piracy versus his "influence" that became her real subject matter.

While photographing photographs was perhaps the conceptually purest statement of her critical strategy (she reproduced what was evidently a reproduction), Levine soon turned her attention to re-presenting the work of painters, among them Marc,

Van Gogh, Kirchner, Mondrian and Schiele. Best known were her "Monets," in which she photographed color reproductions of Monet's paintings from art books, retaining the imperfections caused in the printing process. These images, several steps removed from the original, competed with all other reproductions and our memories of the originals (if indeed we had ever seen them). Not only did Levine confiscate an image; she also stole its meaning and subtly rendered it anew. As she stated in 1981, "I am interested in the information in each of the pictures and what it means to us now."

Choosing members of the male pantheon of the art world to expropriate, Levine's calculated choices introduce a feminist critique not only on patriarchy but what we know of as our esthetic patrimony. (Especially revealing in this context are her "self-portraits" after Egon Schiele.) Indeed Levine's scale, which is small, and her technique, especially the watercolors, both of which are traditionally associated with women's work, also play significant parts in her revisionist agenda.

In 1985, Levine began exhibiting representations of abstractions. Her geometric paintings, clearly hand-made, are almost "original"; their references are so generalized that an intimate feeling of *déjà vu* replaces the tactical sang-froid of her earlier work. Nonetheless these paintings, eliciting visions of the work of Brice Marden, Frank Stella, Kenneth Noland, Daniel Buren, and many others, are critically demanding. Painted on lead, the stripes, chevrons, and checkerboard patterns have a physical presence as objects which the photographs never had, and assert the recomplicated relationships the artist brings to the making and meaning of abstraction in our time.

Levine's recent "Knot" paintings—sheets of unpainted plywood with the knot holes painted gold—are perhaps her most trenchant commentary on the displacement of focus, on the validity of reworking readymade abstraction and the role of the artist's intervention in making the apparent evident. If these works are, as the artist says, "about death in a way: the uneasy death of modernism," they are also, like her earlier appropriations, about the definition of new criteria—how to locate a work conceptually and materially vis à vis the history of art as well as the world in which they are made.

—*Vicky A. Clark*

Solo Exhibitions

1988
Hirshhorn Museum and
Sculpture Garden, Washington,
D.C. Traveled. Brochure by
Susan Krane and Phyllis
Rosenzweig.

Galerie Nächst St. Stephan,
Vienna. Catalogue by Sherrie
Levine and Dieter Schwarz.

1987
Donald Young Gallery, Chicago.

Wadsworth Atheneum, Hartford.
Brochure by Andrea Miller-
Keller.

Mary Boone Gallery, New York.
Catalogue by Donald Barthelme.

1986
Daniel Weinberg Gallery, Los
Angeles.

1985
Baskerville and Watson Gallery,
New York. Also 1983.

Mary and Leigh Block Gallery,
Northwestern University,
Evanston, Illinois.

Richard Kuhlenschmidt Gallery,
Los Angeles. Also 1983.

1984
Ace, Montreal.

1981
Metro Pictures, New York.

1979
The Kitchen, New York.

1978
3 Mercer Street, New York. Also
1977.

Hallwalls, Buffalo.

1974
De Saisset Museum, Santa
Clara.

Selected Group Exhibitions

1988
Cultural Geometry, The Deste
Foundation for Contemporary
Art, Athens.

1987
Avant-Garde in The Eighties, Los
Angeles County Museum of Art.
Catalogue.

1986
*Endgame: Reference and
Simulation in Recent Painting
and Sculpture*. Institute of
Contemporary Art, Boston.
Catalogue.

*Europa/Amerika—Die Geschichte
einer künstlerischen Faszination
seit 1940*, Museum Ludwig,
Cologne. Catalogue.

*El Arte y Su Doble: Una
Perspectiva de Nueva York*,
Fundación Caja de Pensiones,
Madrid. Catalogue.

1985
Biennial, Whitney Museum of
American Art, New York.
Catalogue.

1984
Image Scavengers. University of
Pennsylvania, Institute of
Contemporary Art, Philadelphia.
Catalogue.

*Content: A Contemporary Focus,
1974–1984*, Hirshhorn Museum
and Sculpture Garden,
Washington, D.C. Catalogue.

1982
Documenta VII, Kassel.
Catalogue.

1977
Pictures, Artists Space, New
York.

Selected Bibliography

Brenson, Michael. "Sherrie
Levine." *The New York Times*, 29
November 1985.

Buchloh, Benjamin H.D.
"Allegorical Procedures:
Appropriation and Montage in
Contemporary Art." *Artforum*,
September 1982.

Cameron, Dan. "Absence and
Allure: Sherrie Levine's Recent
Work." *Arts Magazine*, December
1983.

Foster, Hal. "The Expressive
Fallacy." *Art in America*, January
1983.

Indiana, Gary. "Endgame." *The
Village Voice*, 6 October 1987.

Krauss, Rosalind. "The
Originality of the Avant-Garde:
A Post-Modernist Repetition."
October, October 1981.

Kuspit, Donald B. "Sherrie
Levine." *Artforum*, December
1987.

Lawson, Thomas. "Last Exit
Painting." *Artforum*, October
1981.

Marzorati, Gerald. "Art in the
(re)Making." *ARTnews*, May
1986.

Morgan, Robert C. "Sherrie
Levine: Language Games." *Arts
Magazine*, December 1987.

Siegel, Jeanne. "After Sherrie
Levine." *Arts Magazine*, June
1985.

Smith, Paul. "Difference in
America." *Art in America*, April
1985.

Smith, Roberta. "It's not Fake
Anything—It's Real Levine."
The Village Voice, 13 December
1983.

Taylor, Paul. "Sherrie Levine
Plays with Paul Taylor." *Flash
Art*, June 1987.

Wei, Lilly. "Talking Abstract:
Part Two." *Art in America*,
December 1987.

Zimmer, William. "Sherrie
Levine." *Soho Weekly News*, 6
October 1977.

"Untitled" (Lead Checks/Lead Chevron:1), 1987
casein on lead
40 × 20 in. (101.6 × 50.8 cm.)
Oliver-Hoffmann Collection, Chicago

"Untitled" (Lead Checks/Lead Chevron:2), 1987
casein on lead
40 × 20 in. (101.6 × 50.8 cm.)
Collection of Leonard and Jane Korman, Fort Washington, Pennsylvania, courtesy
of Mary Boone Gallery, New York

"Untitled" (Lead Checks/Lead Chevron:3), 1988
casein on lead
40 × 20 in. (101.6 × 50.8 cm.)
Courtesy of Mary Boone Gallery, New York

"Untitled" (Lead Checks/Lead Chevron:4), 1988
casein on lead
40 × 20 in. (101.6 × 50.8 cm.)
Collection of Emily Fisher Landau, New York

Brice Marden

Born 1938, Bronxville, New York

Lives and works in New York

Mistaken for a Minimalist in the '60s, Marden was much admired for his densely painted monochromes, in which the flawlessly smooth surfaces, and indeed color itself, was seen to be objectified. Yet the luscious opacity of the works (created by beeswax added to the pigment) and a profusion of tightly woven, energetic brushstrokes gave them a sensuous, ambiguous expressivity that was anathema to the tenets of Minimalism.

While the paintings remained tightly structured with the addition in the '70s of variously colored monochrome panels disposed in orthogonal configurations, they began inviting architectural and metaphysical associations. For the next decade, Marden worked variations on this ostensibly inexhaustible architectonic scheme, with color taking on increasingly arcane symbolic significance. Yet, under the influence of the 1977 commission to design stained-glass windows for Basel Cathedral, his colors were becoming brighter and more luminous, and his drawings, while still securely grid-based, were, by the mid-'80s, showing signs of spontaneous execution (drips, splatters) and loosening gesture. Marden faced the dilemma of having created two separate, apparently unrelated enterprises: the paintings—rigorously, if beautifully programmatic; and the drawings—full of gestural energy, spatial allusion and exquisitely tenuous symmetries.

His solution has been to paint the drawings, or, more accurately, to draw with paint. The result, seen for the first time in a 1987 exhibition which took the majority of his audience by surprise, is a more or less overall linear web—recalling Pollock and Bradley Walker Tomlin, among others—of overlapping calligraphic strokes applied with an extremely long-handled brush which records the hand's slightest tremor. There is much evidence of correction in the paintings—of rubbing out, scraping down and re-working the thinned-down paint, which tinges its linen support with nearly translucent veils and skeins of washed-out color. The linear configurations weave in front of and behind one another, suggesting slight spatial recessions as well as implied grids and emanations of the human figure.

Paradoxically, the new paintings, executed with what, for Marden, amounts to gestural abandon, have less physical presence than the earlier works, in which paint's material substance was practically volumetric. Marden's new pieces, with their intricately plotted networks of angled and sinuous lines, seem in the process of slipping from view. Like dimming memories or escaping thoughts, their verity, while fading, is indelibly present.

—Sarah McFadden

Selected Solo Exhibitions

1988
Mary Boone Gallery, New York. Also 1987 (catalogue by Peter Schjeldahl).
Anthony d'Offay Gallery, London. Catalogue by John Yau.
1984
The Pace Gallery, New York. Also 1982 (catalogue by William Zimmer); 1980; 1978 (catalogue by Jean Claude Lebensztejn).
1981
Stedelijk Museum, Amsterdam. Traveled. Catalogue by Stephen Bann and Roberta Smith.
1980
Galerie Konrad Fischer, Düsseldorf. Also 1975, 1973, 1972, 1971.
1979
Kunstraum München. Traveled. Catalogue by Hermann Kern and Klaus Kertess.
1975
Solomon R. Guggenheim Museum, New York. Catalogue by Linda Shearer.
1974
Bykert Gallery, New York. Also 1973, 1972, 1970, 1969, 1968, 1966.
Contemporary Arts Museum, Houston. Traveled. Catalogue by Dore Ashton.
1973
Galerie Yvon Lambert, Paris. Also 1969.
1963
Wilcox Gallery, Swarthmore College, Pennsylvania.

Selected Group Exhibitions

1988
Contemporary American Art, The Sara Hildenin Taidemuseo Art Museum, Tampere, Finland. Also 1986.
1986
The Spiritual in Art: Abstract Painting 1890–1985, Los Angeles County Museum of Art. Traveled. Catalogue.
1985
Carnegie International, Museum of Art, Carnegie Institute, Pittsburgh. Catalogue.
1981
A New Spirit in Painting, Royal Academy of Arts, London. Catalogue.
1979
Biennial, Whitney Museum of American Art, New York. Also 1977, 1973. Catalogues. Also *Annual*, 1979 (catalogue).
1975
Fundamentele Schilderkunst/ Fundamental Painting, Stedelijk Museum, Amsterdam. Catalogue.
1974
Eight Contemporary Artists, The Museum of Modern Art, New York. Catalogue.
1972
Documenta V, Kassel. Catalogue.
1971
The Structure of Color, Whitney Museum of American Art, New York. Catalogue.
1968
Rejective Art, School of Architecture, Clemson University, South Carolina. Traveled.
1960
The Second Competitive Drawing Exhibition, Lyman Allyn Museum, New London, Connecticut.

Selected Bibliography

Andre, Carl. "New in New York: Line Work." *Arts Magazine*, May 1967.
Bann, Stephen. "Adriatics à propos of Brice Marden." *Twentieth Century Studies*, 1976
de Ak, Edit, et al. "Conversation with Brice Marden." *Art Rite*, Spring 1975.
Lippard, Lucy R. "The Silent Art." *Art in America*, January–February 1967.
Marden, Brice. *Suicide Notes*. Lausanne 1974.
———. "Three Deliberate Grays for Jasper Johns." *Art Now: New York*, March 1971.
Pincus-Witten, Robert. "Ryman, Marden, Manzoni: Theory, Sensibility, Mediation." *Artforum*, June 1972.
Poirier, Maurice. "Color-Coded Mysteries." *ARTnews*, January 1985.
Ratcliff, Carter. "Abstract Painting, Specific Spaces: Novros and Marden in Houston." *Art in America*, September–October 1975.
Schjeldahl, Peter. "Minimalism." *Art of Our Time: The Saatchi Collection*. London 1984.
Smith, Roberta. "Art: New Oil Paintings by Brice Marden at Boone." *The New York Times*, 20 March 1987.
———. "Brice Marden's Paintings." *Arts Magazine*, May–June 1973.
Storr, Robert. "Brice Marden: Double Vision." *Art in America*, March 1985.
Wei, Lilly. "Talking Abstract: Part One." *Art in America*, July 1987.
White, Robin. "Brice Marden Interview." *View*, 1980.

"4" (Bone), 1987–88
oil on linen
84 × 60 in. (213.4 × 152.4 cm.)
Collection of Helen Marden, New York, courtesy of Mary Boone Gallery, New York

"12" (Gray), 1987–88
oil on linen
84 × 60 in. (213.4 × 152.4 cm.)
Collection of Mimi and Peter Haas, San Francisco

Untitled 1, 1986
oil on linen
72 × 58 in. (182.9 × 147.3 cm.)
Courtesy of Thomas Ammann Fine Art, Zurich

Untitled 2, 1986
oil on linen
72 × 58 in. (182.9 × 147.3 cm.)
The Carnegie Museum of Art, Pittsburgh; Edith H. Fisher Fund, 1987

Agnes Martin

Born 1912, Maklin, Saskatchewan, Canada

Lives and works in Santa Fe, New Mexico

Born in the same year as Jackson Pollock, Agnes Martin can be associated by age and temperament with the Abstract Expressionists. Her use of all-over composition conditioned by substantial surface variability and her abiding pursuit of the ineffable, guided in part by Eastern spiritual values, link her to her contemporaries. Along with the reductive but resonant surfaces of her canvases, Martin's written statements, as gnomic as Ad Reinhardt's, suggest the particular strength of her affinity with him. But because Martin's work came to prominence only in the late '50s, and because her signature format is a regular, rectangular grid, she is usually identified with a later artistic generation.

Lawrence Alloway included Martin's work in his 1966 *Systemic Painting* show at the Guggenheim, along with Al Held and Larry Zox; William Seitz found room for it in his 1965 *The Responsive Eye* at the Museum of Modern Art, along with Bridget Riley and Victor Vasarely. Martin's grids were even called feminist, inasmuch as they evoked the patterns and processes of sewing and weaving. As has been clear for some time, these associations obscured (mostly unintentionally) Martin's equal opposition to simply conceptual and optical painting, and belied her indifference to both autobiography and partisan politics.

In 1957, Martin, who had traveled widely, moved to Coenties Slip in lower Manhattan, sharing a community with Robert Indiana, Ellsworth Kelly and James Rosenquist, among others. It was there that Martin arrived at her use of the grid and determined the proportions of its support (generally 6 by 6 feet for paintings and 9 by 9 inches for works on paper—with the exception of a period between 1967 and 1974 when she almost completely stopped producing art, she has remained faithful to this format). The grids on canvas are executed in pencil, oil, or acrylic; the works on paper in pencil or watercolor. Intervals are small, colors muted, lines carefully ruled. Over the years, larger bands of color, sometimes without perpendicular interruption, have appeared, as have, occasionally, unequal intervals, and a sometimes brighter palette of pale blues, peaches, and yellows. These variations elaborate without fundamentally altering her basic program. Yet there is nothing mechanical or formulaic about the work. Very evidently hand-drawn, it is governed by both the exigencies of such execution—lines waver slightly, washes of color pool and ebb—and by shameless, if highly disciplined, lyricism.

The beginning of Martin's painting hiatus coincided with her departure from New York, where her work had achieved considerable critical attention, for a relatively straitened and isolated life in New Mexico. This choice suggests a discipline, a taste for denial, that is central to her sensibility. The significant details of Martin's work exist at the very margins of perceptibility, and its overall impression—even though often linked by title to an experience or a landscape—is mesmerizingly unstable: eluding definitive visual understanding, it defies verbal summary. It is this reticence, perceptual as well as intellectual, that makes Martin's work so important a challenge to today's abstractionists.

—*Nancy Princenthal*

Selected Solo Exhibitions

1986
The Pace Gallery, New York. Also 1985; 1984; 1983; 1981; 1980 (traveled); 1979; 1978; 1977; 1976; 1975.
Garry Anderson Gallery, Sydney.
Waddington Galleries, London. Catalogue.

1985
Margo Leavin Gallery, Los Angeles. Also 1979.

1984
The Mayor Gallery, London. Also 1978.

1979
Museum of Fine Arts, Santa Fe. Catalogue by Agnes Martin.

1978
Galerie Rudolf Zwirner, Cologne.

1977
Hayward Gallery, London and Stedelijk Museum, Amsterdam. Catalogue by Dore Ashton and Agnes Martin.

1976
Robert Elkon Gallery, New York. Also 1972, 1966, 1965, 1964, 1963, 1961.

1973
Kunstraum München. Catalogue by Hermann Kern.

Institute of Contemporary Art, University of Pennsylvania, Philadelphia. Traveled. Catalogue by Lawrence Alloway, Suzanne Delehanty and Ann Wilson.

1971
Visual Arts Center, New York.

1961
Betty Parsons Gallery, New York. Also 1959, 1958.

Selected Group Exhibitions

1986
Individuals: A Selected History of Contemporary Art 1945–1986, The Museum of Contemporary Art, Los Angeles. Catalogue.
The Heroic Sublime, Charles Cowles Gallery, New York.

1981
The 37th Biennial Exhibition of Contemporary Painting, The Corcoran Gallery of Art, Washington, D.C. Catalogue.

1980
La Biennale di Venezia. Also 1976. Catalogues.

1979
The Reductive Object: A Survey of the Minimalist Aesthetic in the 1960s, Institute of Contemporary Art, Boston. Catalogue.

1977
Biennial, Whitney Museum of American Art, New York. Also 1967.

1972
Grids, Institute of Contemporary Art, University of Pennsylvania, Philadelphia. Catalogue.
Documenta V, Kassel. Catalogue.

1966
Systemic Painting, Solomon R. Guggenheim Museum, New York. Catalogue.

1961
Carnegie International, Museum of Art, Carnegie Institute, Pittsburgh. Catalogue.

Selected Bibliography

Alloway, Lawrence. "Agnes Martin." *Artforum*, April 1973.

———. "Formlessness Breaking Down Form: The Paintings of Agnes Martin." *Studio International*, February 1973.

Ashton, Dore. "Premiere Exhibition for Agnes Martin." *The New York Times*, 6 December 1958.

Battcock, Gregory, ed. *Minimal Art: A Critical Anthology*. New York 1968.

Borden, Lizzie. "Cosmologies." *Artforum*, October 1972.

Burton, Scott. "A Different Stripe." *Art and Artists*, October 1966.

Calas, Nicholas and Elena. *Icons and Images*. New York 1971.

Hunter, Sam. *American Art of the 20th Century*. New York 1972.

Judd, Donald. "Exhibition at Robert Elkon." *Arts Magazine*, January 1964.

Kramer, Hilton. "An Art That's Almost Prayer." *The New York Times*, 16 May 1976.

Lippard, Lucy R. "Diversity in Unity: Recent Geometricizing Styles in America." *Art Since Mid-Century*. Jean Leymarie, ed. Greenwich, Connecticut 1971.

McEvilley, Thomas. "Grey Geese Descending: The Art of Agnes Martin." *Artforum*, Summer 1987.

Michelson, Annette. "Agnes Martin." *Artforum*, January 1967.

Ratcliff, Carter. "Agnes Martin and the Artificial Infinite." *ARTnews*, May 1973.

Wilson, Ann. "Agnes Martin: The Essential Form: The Committed Life." *Art International*, December 1974.

———. "Untroubled Mind (Oral and Written Statements by Agnes Martin Given to and Recounted by Ann Wilson)." *Studio International*, February 1973.

Untitled #1, 1988
acrylic and pencil on canvas
72 × 72 in. (182.9 × 182.9 cm.)
Courtesy of The Pace Gallery, New York

Untitled #4, 1987
acrylic and pencil on canvas
72 × 72 in. (182.9 × 182.9 cm.)
Courtesy of The Pace Gallery, New York

Untitled #5, 1988
acrylic and pencil on canvas
72 × 72 in. (182.9 × 182.9 cm.)
Courtesy of The Pace Gallery, New York

Untitled #8, 1988
acrylic and pencil on canvas
72 × 72 in. (182.9 × 182.9 cm.)
Courtesy of The Pace Gallery, New York

Elizabeth Murray

Born 1940, Chicago

Lives and works in New York

Little known abroad, Elizabeth Murray is one of American art's best kept secrets. Murray's brand of figurative abstraction located in wildly skewed constructed canvases resisted neat classification and, therefore, it seems, inclusion on the European exhibition circuit. Yet since the mid-'70s, her paintings have garnered high critical marks in this country for their daring, wit and implicit feminism (qualities which, in painting, were also verboten in the international dialogue).

Ten years ago, Murray's abstract, shaped paintings split apart, then shattered like faulty jigsaw puzzles whose pieces wouldn't interlock but cohered visually by virtue of the continuous images that jumped the gaps between them. The earliest of these images alluded to art-making: brushes, hands, easels. Then cups, goblets and tables—usually on the verge or in the midst of overturning or transforming into something else—worked their way into the increasingly fragmented works whose sections seem to be exploding from rather than hanging on the wall.

By 1982, Murray compounded the paintings' complexity by overlapping their curvaceous canvases, confounding the distinction between actual forms and painted illusion. Little in these works is unambiguous: neither their structure, the identity and symbolic content of their often elusive images, nor the cryptic narratives they describe. They also abhor stasis. Not only do the fractured paintings, which can spread over 15 feet of wall, seem to be coming undone or flying apart, but their images undulate and mutate as if in a dream.

The paintings' formal strength and inventiveness seem sprung from their content, which is autobiographically specific yet generally familiar. The transformation of a table, the site of everyday domestic dramas, into an animate object of comic or ominous appearance, is a nearly cinematic event pitched with such excitement that it cannot be contained by the claustrophobia-inducing space which Murray depicts as its setting. It seems little wonder the paintings came apart.

Within the past few years, Murray has tended to close up her compositions, darken her palette and pare down narrative content. The canvas shapes conform closely to the images themselves, which are now generally scaled up and singular, emblematic rather than anecdotal. Poignancy has infiltrated the work's former zany urgency, and a brooding, self-reflective quality has come over the still-cartoonish forms. Murray's recent paintings of giant, clod-hopperish shoes, for example, which owe something to Van Gogh, Johns, Oldenburg and Guston, are as much excursions into new formal territory as they are probings of an intense emotional tenor.

—*Sarah McFadden*

Selected Solo Exhibitions

1987
University Art Museum, California State University, Long Beach. Traveled. Brochure by Constance Lewallen.
Dallas Museum of Art and List Visual Arts Center, M.I.T., Cambridge, Massachusetts. Traveled. Catalogue by Clifford S. Ackley, Sue Graze, Kathy Halbreich and Roberta Smith.
Paula Cooper, New York. Also 1984, 1983, 1981, 1980, 1976.
1986
Brooke Alexander, New York.
Institute of Contemporary Art, Boston. Brochure by David Joselit.
The Carnegie Mellon University Art Gallery, Pittsburgh. Catalogue by Elaine A. King and Anne Sutherland Harris.
1983
Portland Center for the Visual Arts, Oregon. Brochure by Randal B. Davis.
1982
Hillyer Gallery, Smith College, Northampton, Massachusetts.
Daniel Weinberg Gallery, Los Angeles.
1980
Galerie Mukai, Tokyo.
1978
Ohio State University Gallery, Wexner Center for the Visual Arts, Columbus.
Phyllis Kind Gallery, Chicago.
1974
Jared Sable Gallery, Toronto.

Selected Group Exhibitions

1987
40th Biennial of American Contemporary Painting, The Corcoran Gallery of Art, Washington, D.C. Catalogue.
1986
Individuals: A Selected History of Contemporary Art 1945–1986, The Museum of Contemporary Art, Los Angeles. Catalogue.
An American Renaissance: Painting and Sculpture Since 1940, Museum of Art, Fort Lauderdale. Catalogue.
1985
Biennial, Whitney Museum of American Art, New York. Also 1981, 1979, 1977, 1973. Catalogues. Also *Annual*, 1972. Catalogue.
Correspondences: New York Art Now, Laforet Museum, Harajuka, Tokyo. Traveled. Catalogue.
1984
An International Survey of Painting and Sculpture, The Museum of Modern Art, New York. Catalogue.
Five Painters in New York, The Whitney Museum of American Art, New York. Catalogue.
1983
Directions 1983, Hirshhorn Museum and Sculpture Garden, Washington, D.C. Catalogue.
1982
74th American Exhibition, The Art Institute of Chicago. Catalogue.
1979
New Painting/New York, Hayward Gallery, London. Catalogue.
1974
Continuing Abstraction in American Art, The Whitney Museum of American Art/ Downtown Branch, New York.

Selected Bibliography

Antin, David. "Another Category: 'Eccentric Abstraction.'" *Artforum*, November 1966.

Butterfield, Jan. "Bruce Nauman: The Center of Yourself." *Arts Magazine*, February 1975.

Catoir, Barbara. "Über den Subjektivismus bei Bruce Nauman." *Kunstwerk*, November 1973.

Celant, Germano. "Bruce Nauman." *Casabella*, February 1970.

Danieli, Fidel. "The Art of Bruce Nauman." *Artforum*, December 1967.

"Collaboration Bruce Nauman." *Parkett*. Contributions by Chris Dercon, Patrick Frey, Bruce Nauman, Jeanne Silverthorne, Robert Storr and Rein Wols, July 1986.

Pincus-Witten, Robert. "Bruce Nauman: Another Kind of Reasoning." *Artforum*, February 1976.

Ratcliff, Carter. "Adversary Spaces." *Artforum*, October 1972.

Sauer, Christel. *Dokumentation 1*, Zurich 1978.

Schjeldahl, Peter. "Minimalism." *Art of Our Times: The Saatchi Collection*, London 1985.

Sharp, Willoughby. "Interview with Bruce Nauman." *Arts Magazine*, March 1970.

Smith, Roberta. "Bruce Nauman Retrospective." *The New York Times*, 30 October 1987.

Stiles, Knute. "William Geis and Bruce Nauman." *Artforum*, December 1966.

Tucker, Marcia. "PheNAUMANology." *Artforum*, December 1970.

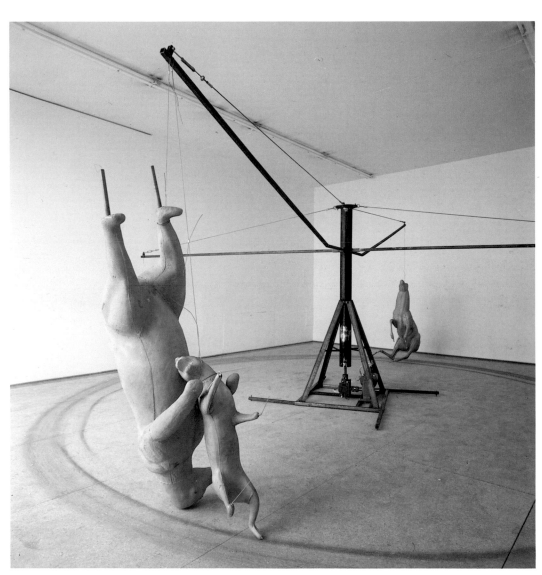

Carousel, 1988
steel and cast aluminum
84 in. high (213.4 cm. high), 214½ in. diameter (545 cm. diameter)
Installation view at Galerie Konrad Fischer, Düsseldorf
Collection of Haags Gemeentemuseum, The Hague

Not in exhibition. Work in exhibition illustrated in supplement.

Sigmar Polke

Born 1941, Oels, Germany

Lives and works in Cologne

Sigmar Polke's work of the '60s and '70s is second only to that of Joseph Beuys in the impact it has made on the current generation of postmodernist artists. Though Polke's work was not widely known in the United States until the mid-'80s (his first New York show was in 1982), it soon became clear that the pictorial liberties he took had significantly influenced a younger generation of American artists. Polke, who was born in 1941 in what is now East Germany, moved to West Germany at the age of twelve. He studied at the Düsseldorf Academy in the late '50s and early '60s, at a time when German art, dominated by Parisian and American abstraction and subsequently by American Pop, had not yet emerged from the devastation and dislocation of World War II. Polke was heavily influenced by American Pop art, but he used its found materials and ironic, distancing strategies to greater parodistic effect and toward a more acute social critique than did Rauschenberg, Johns or even Warhol.

Unlike many of his contemporaries, Polke has never been particularly concerned in his painting with exploring or rescuing from the postwar rubble of Germany's international reputation a German national identity. Instead of trying to resurrect, newly chastened, another version of the archetypal German artist, Polke is interested in the social ideologies inherent in all manner of representational modes. No visual material is exempt from potential appropriation whether it be associated with fascist kitsch, American Minimalism or modernist mysticism. Thus, for example, in a late '60s work, Carl Andre in Delft, Polke parodies the American sculptor with a painting of Netherlandish tiles. In another late '60s series, of "pictures painted according to the commands of Higher Beings," the "Higher Beings" direct the artist alternately to "Paint the Upper Right Corner Black!" (in a spoof on the finicky, picayune irrationality of abstraction), or not to paint "bunches of flowers! Paint flamingos!"

Polke mercilessly scrutinizes the tensions between high and low culture, and the corresponding contradictions for an artist working in a visual realm between the elite, unique object and the cheap, mass-produced throwaway. As Benjamin Buchloh has pointed out, much of Polke's early work makes use of "iconic appropriations from low culture and stylistic appropriations from . . . high culture"; the reverse, however, is sometimes just as true. Polke provokes confrontations between the two vocabularies, as well as revealing the inroads each has made in the other's territory. The results can be surprising: at times lyrical, at others devastatingly skeptical. Interestingly, for all the talk of parody and irony in discussions of Polke's work, humor is rarely mentioned—and Polke is one of the wittiest "serious" artists around (he was, not surprisingly, involved in Fluxus activities in the mid-'60s). After commanding the artist to abandon bunches of flowers for flamingos, he continues, "At first I tried to continue painting. But then I realized that they meant this seriously."

Like his contemporary, the painter Gerhard Richter (with whom he performed as a living sculpture of Capitalism Realism in the '60s), Polke has never succumbed to the temptations of a signature style. But if Richter's work has lately become polarized between two opposite styles, Polke's remains wide open to any and everything. He has continually subverted painting's esthetic conventions by working on tacky, clashing, printed fabrics; over photos, reproducing the imperfections of bad newspaper photographs in meticulous, hand-rendered versions; and slapping layer upon layer of stylistically and contextually discordant images onto canvas. Though Polke's images may appear random, related only by physical proximity, they function together in an astute chaotic unity.

—Jamey Gambrell

114

Selected Solo Exhibitions

1988
Kunstmuseum Bonn. Catalogue by Katharina Schmidt and Günter Schweikhart.
ARC/Museé d'Art Moderne de la Ville de Paris. Catalogue by Bice Curiger and Hagen Liberknecht.
1986
Mary Boone Gallery, New York. Also 1985 (catalogue by Peter Schjeldahl); 1984.
Städtisches Museum Abteiberg Mönchengladbach.
1985
Michael Werner Gallery, Cologne. Also 1983 (catalogue by A. R. Penck); 1974.
Kunsthalle Köln.
Anthony d'Offay Gallery, London.
1984
Marian Goodman Gallery, New York.
Kunsthaus Zürich. Catalogue by Siegfried Gohr, Dietrich Helms, Barbara M. Reise, Reiner Speck and Harald Szeemann.
1983
Museum Boymans-van Beuningen, Rotterdam. Traveled. Catalogue by Wim Beeren, Hagen Lieberknecht, Sigmar Polke and Dierk Stemmler.
1978
InK, Zurich. Catalogue by Christel Sauer.
1976
Städtische Kunsthalle, Düsseldorf. Traveled. Catalogue by Joseph Beuys, Benjamin H. D. Buchloh and Friedrich Wolfram.
1973
Westfälischer Kunstverein, Münster. Catalogue by Jean-Christophe Ammann.
1968
Kunstmuseum Luzern.
René Block, Berlin. Catalogue.

Selected Group Exhibitions

1987
Brennpunkt, Düsseldorf. Catalogue.
Warhol—Beuys—Polke, Milwaukee Art Museum. Traveled. Catalogue.
1986
La Biennale di Venezia. Catalogue.
1985
German Art in the Twentieth Century: Painting and Sculpture, 1905–1985, Royal Academy of Arts, London. Catalogue.
Carnegie International, Museum of Art, Carnegie Institute, Pittsburgh. Catalogue.
1984
von hier aus, Messegelände, Düsseldorf. Catalogue.
1983
Zeitgeist, Martin-Gropius-Bau, West Berlin. Catalogue.
1982
Documenta VII, Kassel. Also VI, 1977; V, 1972. Catalogues.
1981
A New Spirit in Painting, Royal Academy of Arts, London. Catalogue.
Westkunst—Heute: Zeitgenössische Kunst seit 1939, Museen der Stadt Köln. Catalogue.
1963
Demonstration für den kapitalistischen Realismus, Möbelhaus Berges, Düsseldorf.

Selected Bibliography

Ammann, Jean-Christophe. "Raum—Zeit—Wachstum in der aktuellen Kunst." *Kunstjahrbuch*, 1970.

Buchloh, Benjamin H. D. "Parody and Appropriation in Francis Picabia, Pop and Sigmar Polke." *Artforum*, March 1982.

Curiger, Bice. "Das Lachen von Sigmar Polke ist nicht zu töten." *Kunstnachrichten*, September 1977.

Faust, Wolfgang Max and Gerd de Vries. *Hunger nach Bildern: Deutsche Malerei der Gegenwart.* Cologne 1982.

Frey, Patrick. "Sigmar Polke." *Flash Art*, Summer 1984.

Fuchs, Rudi. "Sigmar Polke." *Art of Our Times: The Saatchi Collection*. London 1984.

Gachnang, Johannes. *Sigmar Polke: Zeichnungen 1963–1969.* Berlin 1987.

Groot, Paul and Pieter Heynen. "Wat Bezielt Sigmar Polke: Een Poging tot Analyse van een geliefd Kunstenaar." *Museumjournaal*, May 1983.

Jappe, Georg. "Sigmar Polke." *Frankfurter Allgemeine Zeitung*, 24 December 1970.

———. "Young Artists in Germany." *Studio International*, February 1972.

Kuspit, Donald B. "At the Tomb of the Unknown Picture." *Artscribe International*, March–April 1988.

———. "The Night Mind." *Artforum*, September 1982.

Ohff, Heinz. *Pop und die Folgen*, Düsseldorf, 1968.

———. "Poetry in Contemporary German Art." *Studio International*, December 1964.

Stemmler, Dierk. "Sigmar Polke." *Kunstforum*, October 1974.

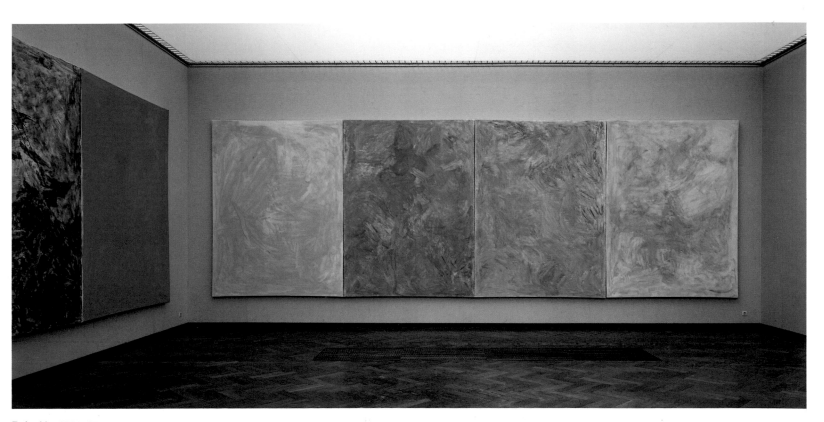

Farbtafeln, 1986–87
mineral pigments and fish glue
7 parts: 118⅒ × 88⅓ in. each (300 × 224 cm. each)
Collection of the Stedelijk Museum, Amsterdam

Not in exhibition. Work in exhibition illustrated in supplement.

Gerhard Richter

Born 1932, Dresden

Lives and works in Cologne

Deeply committed to painting and its traditions, Gerhard Richter has a conceptual agenda that puts him in league with the most radical of contemporary artists. Much discussed since he began showing in his native Germany in 1963, his work is rooted in paradox—formal, material, theoretical and otherwise.

Richter received traditional academic training and a firm grounding in Socialist Realism at Dresden's Kunstakademie in the early '50s. In '61 he moved to Düsseldorf, where he became involved in and was redirected by the anti-art activities of Fluxus. By '64, he was showing paintings based on newsphotos and snapshots—the beginnings of what was to develop into a generally photo-based, stylistically heterogeneous, conceptually cohesive oeuvre.

Initially incorrectly labeled as an exponent of Pop, Richter proceeded to baffle his audiences by producing a smorgasbord of Minimalist-looking monochromes (the "Gray Paintings") and multi-colored grids (the "Color Charts"); realist land- and skyscapes; semi-abstract, gestural land- and cityscapes; portraits of notable 19th-century male contributors to Western culture; abstract-illusionist and -expressionist-looking works; realist still lifes and memento mori.

Few of these separate, stylistic divisions within Richter's oeuvre comprise discrete phases or series, but, rather, have evolved both simultaneously and intermittently, with still-lifes and romantic landscapes currently spelling the artist's now predominantly abstract work. This methodology would seem to support Richter's claim that, for him, the paintings do not essentially differ from one another, but are all fragmentary aspects of an ultimately unknowable reality.

Richter's motive for painting from photographs was to escape the pitfalls of subjectivity—to create paintings bearing no trace of authorship. He found that a photographed image supplied the emotional remove he required from his ostensible subject matter (chosen at first for its apparent banality) and the manner in which it was rendered. This pertained equally to the Realist, Constructivist and, until 1980, to the Abstract paintings—the three principal categories which the artist has designated for his works.

What Richter attempts to reveal is a reality as various as the instruments by which it is perceived and communicated. For him, no single ideological or stylistic view is necessarily truer than another. Therefore, Richter intermingles, across his diverse, prodigious oeuvre as well as within single canvases such established opposites as abstraction and representation; beauty and kitsch; the mechanical and the gestural; the intimate and the grandiose.

Not just the virtuoso, cynical anthologist of style that he was sometimes taken for in the '70s, Richter is also an earnest and perhaps even infatuated seeker of authentic visual experience that transcends style and cultural conventions. Embracing contradiction and inclusiveness as fervently as the majority of his peers (and predecessors, for that matter) have sought clarity and uniqueness, he has set out to undermine preconceived notions about the nature of reality and the possibilities of its presentation in visual art.

Richter has described his own relation to reality in terms that aptly summarize his work: "haziness, insecurity, inconsistency, fragmentary performance, . . ."[1] His painterly phrasing of these terms has the overall look of moral imperative and, perhaps inevitably, self-portraiture.

—*Sarah McFadden*

[1]Quoted in I. Michael Danoff. "An Introduction to the Work of Gerhard Richter," *Gerhard Richter: Paintings*, New York 1988.

Selected Solo Exhibitions

1988
Art Gallery of Ontario, Toronto and Museum of Contemporary Art, Chicago. Traveled. Catalogue by Benjamin H. D. Buchloh, I. Michael Danoff and Roald Nasgaard.
Galerie Durand-Dessert, Paris. Also 1984, 1976.
1987
Museum Overholland, Amsterdam. Catalogue by Christaan Braun and Gerhard Richter.
Marian Goodman Gallery and Sperone Westwater, New York. Catalogue by Benjamin H. D. Buchloh, Anne Rorimer and Denys Zacharopoulos. Also 1985 (catalogue by Benjamin H. D. Buchloh).
1986
Kunsthalle Düsseldorf. Traveled. Catalogue by Jürgen Harten.
1983
Sperone Westwater, New York. Also 1980, 1978.
Galerie Konrad Fischer, Düsseldorf. Also 1977, 1975, 1972, 1970.
1982
Kunsthalle Bielefeld, West Germany. Traveled. Catalogue by Rudi Fuchs and Herbert Heere.
1978
Stedelijk van Abbemuseum, Eindhoven. Traveled. Catalogue by Benjamin H. D. Buchloh and Rudi Fuchs.
1977
Musée d'Art Moderne, Centre National d'Art et de Culture Georges Pompidou, Paris. Catalogue by Benjamin H. D. Buchloh.
1976
Kunsthalle Bremen. Catalogue by Marlies Grüterich and Manfred Schneckenburger.
1974
Städtisches Museum Abteiberg Mönchengladbach. Catalogue by Johannes Cladders.
1973
Städtische Galerie im Lenbachhaus, Munich. Catalogue by Jean-Christophe Ammann.
1972
Kunstmuseum Luzern. Catalogue by Jean-Christophe Ammann.
1971
Kunstverein Düsseldorf. Catalogue by Dietrich Helms.

Selected Group Exhibitions

1988
Biennale of Sydney. Also 1979.
1987
Documenta VIII, Kassel. Also *VII*, 1982; *VI*, 1977; *V*, 1972. Catalogues.
1985
Carnegie International, Museum of Art, Carnegie Institute, Pittsburgh. Catalogue.
German Art in the 20th Century: Painting and Sculpture, 1905–1985, Royal Academy of Arts, London. Traveled. Catalogue.
The European Iceberg—Creativity in Germany and Italy Today, Art Gallery of Ontario, Toronto. Catalogue.
1984
von hier aus, Messegelände, Düsseldorf. Catalogue.
1982
'60–'80: Attitudes/Concepts/Images, Stedelijk Museum, Amsterdam. Catalogue.
1981
Westkunst—Heute: Zeitgenössische Kunst seit 1939, Museen der Stadt Köln. Catalogue.
A New Spirit in Painting, Royal Academy of Arts, London. Catalogue.
1972
La Biennale di Venezia. Catalogue.
1963
Demonstration für den kapitalistischen Realismus, Möbelhaus Berges, Düsseldorf.

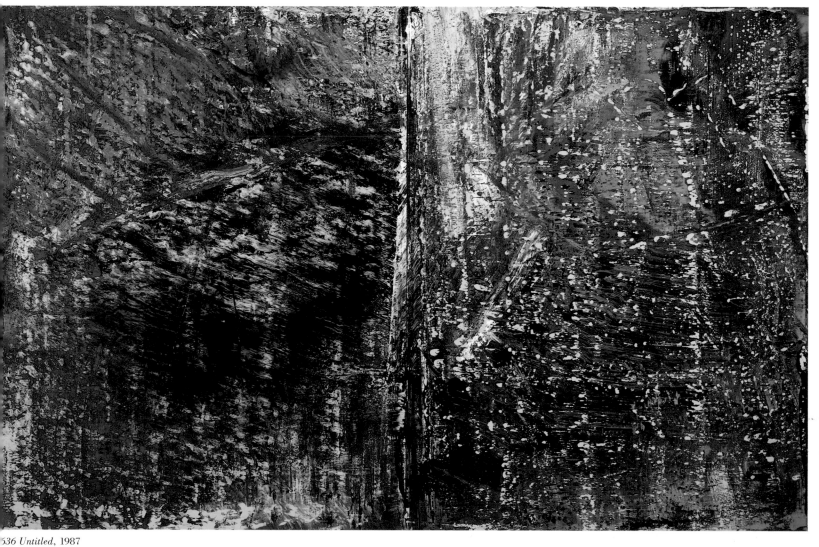

536 *Untitled*, 1987
oil on canvas
102⅖ × 157½ in. (260 × 400 cm.)
Private collection, France, courtesy of Galerie Durand-Dessert, Paris

Susan Rothenberg

Born 1945, Buffalo

Lives and works in New York

Once concerned, as she put it, "to stick to the philosophy of the day—of keeping the painting flat and anti-illusionist,"[1] Susan Rothenberg has come a long way since the mid-'70s, when her now-legendary images of horses broke with Minimalism's taboos against figuration while otherwise heeding its formal agenda. In the intervening years, she has progressively shaken off the need to observe the latest formalist dos and don'ts as she has developed her own voice, as it were, in painting.

This search has entailed a journey back to the human figure and to the age-old challenge of defining it as a three-dimensional form in motion. It has also involved a broadening of subject matter and emotional content, as well as an increased confidence in the powers of intuition and the painting process itself for bringing a particular work into being. Along the way, Rothenberg has shown affinities for diverse predecessors: Monet, Balla, Giacometti, Philip Guston, Jasper Johns. Her recent paintings, heavily worked depictions of spectral figures engaged in repetitive movements (juggling, spinning, cycling), read as metaphors for the physical and psychic energy inscribed in the very act of painting.

Rothenberg's anatomically aberrant horse motifs were not, of course, strictly formal devices. Totem-like, they carried a psychological and emotional charge inconsistent with reductive abstraction. It was this expressive content—a kind of haunting, unfathomable presence—that Rothenberg embraced and has pursued since with ever more impressionistic means. Having dissolved her formerly broad contour lines in a frenzy of agitated, distinct strokes, Rothenberg now interweaves figure and ground so completely—optically and through the physical process of laying down the brush—that they are hardly distinguishable from one another. Form both emerges from and is eroded by the atmosphere surrounding it, so that nothing appears palpable or corporeal but the paint itself.

Swept up in a frenetic rhapsody of movement, light and color, the images are threatened by the prospect of extinction. Should that point be reached, Rothenberg, having to some extent reinvented figurative painting, will have worked her way around to a kind of pure, existential abstraction.

—*Sarah McFadden*

1
Grace Glueck, "Susan Rothenberg: New Outlook for A Visionary Artist," *The New York Times Magazine,* 22 July 1984.

Selected Solo Exhibitions

1988
Galleria Gian Enzo Sperone, Rome.
1987
Sperone Westwater, New York. Catalogue.
1985
Willard Gallery, New York. Also 1983, 1981, 1979, 1977, 1976.
The Phillips Collection, Washington, D.C. Traveled. Catalogue by Eliza Rathbone.
University Art Museum, California State University, Long Beach. Traveled. Brochure by Constance W. Glenn.
1984
Institute of Contemporary Art, Boston. Brochure by Elisabeth Sussman.
1983
Los Angeles County Museum of Art. Traveled. Brochure by Maurice Tuchman.
1982
Stedelijk Museum, Amsterdam. Catalogue by Alexander van Grevenstein.
1981
Akron Art Museum.
1980
James Mayor Gallery, London. Traveled.
1978
Walker Art Center, Minneapolis.
University Art Museum, University of California, Berkeley. Brochure by Mark Rosenthal.
Greenberg Gallery, St. Louis.
1975
112 Greene Street Gallery, New York.

Selected Group Exhibitions

1986
Individuals: A Selected History of Contemporary Art 1945–1986, The Museum of Contemporary Art, Los Angeles. Catalogue.
1985
Carnegie International, Museum of Art, Carnegie Institute, Pittsburgh. Catalogue.
Biennial, Whitney Museum of American Art, New York. Also 1983, 1979. Catalogues.
1983
Back to the USA: Amerikanische Kunst der Siebziger und Achtziger, Kuntsmuseum Luzern. Traveled. Catalogue.
1982
Zeitgeist, Martin-Gropius-Bau, West Berlin. Catalogue.
1981
Schnabel, Rothenberg, Moskowitz, Kunsthalle Basel. Catalogue.
1980
La Biennale di Venezia. Catalogue.
1979
American Painting: The Eighties, A Critical Interpretation, Grey Art Gallery and Study Center, New York University. Traveled. Catalogue.
1978
New Image Painting, Whitney Museum of American Art, New York. Catalogue.
1974
New Talent, A. M. Sachs Gallery, New York.

Selected Bibliography

Flam, Jack. "Art: Bravura Brushwork." *The Wall Street Journal,* 7 October 1985.
Foster, Hal. "Susan Rothenberg, Willard Gallery." *Artforum,* Summer 1981.
Godfrey, Tony. *The New Image—Painting in the 1980s.* New York, 1986.
Herrera, Hayden. "Expressionism Today: An Artist's Symposium." *Art in America,* December 1982.
Hill, Andrea. "Susan Rothenberg at Mayor." *Artscribe International,* April 1980.
Hughes, Robert. "Spectral Light, Anxious Dancers." *Time,* 9 November 1987.
Kramer, Hilton. "Paintings by Susan Rothenberg at the Willard Gallery." *The New York Times,* 24 April 1976.
Nilson, Lisbeth. "Susan Rothenberg: 'Every Brushstroke is a Surprise.'" *ARTnews,* February 1984.
Rose, Barbara. "Robert Moskowitz, Susan Rothenberg, and Julian Schnabel." *Flash Art,* February–March 1982.
Rosenthal, Mark. "Susan Rothenberg." *Art of Our Time: The Saatchi Collection.* London 1984.
———. "From Primary Structures to Primary Imagery." *Arts Magazine,* October 1978.
Russell, John. "Art: 9-Painting Show That's Best of Season." *The New York Times,* 28 January 1983.
Schjeldahl, Peter. "Bravery in Action." *The Village Voice,* 29 April 1981.
———. "Putting Painting Back on Its Feet." *Vanity Fair,* August 1983.
Smith, Roberta. "A Painting Landmark in Retrospect." *The New York Times,* 2 August 1987.
Yau, John. "Susan Rothenberg: Gagosian Gallery." *Artforum,* April 1987.

Night Ride, 1987
oil on canvas
93 × 110¼ in. (236.2 × 280 cm.)
Walker Art Center, Minneapolis; Walker Special Purchase Fund, 1987

Blue Woman with Frog, 1988
oil on canvas
75 × 111½ in. (190.5 × 283.2 cm.)
Collection of Douglas S. Cramer, Los Angeles

Folded Buddha, 1987–88
oil on canvas
91¼ × 111¼ in. (231.8 × 282.6 cm.)
Collection of the artist, courtesy of Sperone Westwater, New York

Robert Ryman

Born 1930, Nashville

Lives and works in New York

"I never considered myself as doing white paintings. When I first began to paint, white was used to eliminate certain images . . . ," recalls Robert Ryman in a recent film. He is talking about the late 1950s, when utilizing white to blot out unwanted passages was a standard technique for both Abstract Expressionists and other artists reacting to the painterly esthetic of that generation. Wiping away the pictorial with a brush heavily loaded with paint, however, Ryman encountered a paradoxical situation. Eliminating the image by filling the field with palpably laid down pigment, he focused our attention on paint as matter.

Ryman's art looks back to the formalism of early modernist painting from the vantage point of the Minimalists' industrial objects. Paint, support and brackets are the material ingredients of his art, much as red, yellow and blue orthogonals preoccupied Mondrian.

An early untitled painting of 1958 lays out in apparently equal parts the brown paper support; white paint slathered across the surface; Ryman's signature written child-like in exaggerated size and deliberateness across the bottom edge of the paper; the red number 58 printed large and positioned sideways on the right margin; and, for balance, a black trefoil on the left margin. Remarkable here is that Ryman ignores the hierarchy of subordination, coordinating all elements so that they draw our attention equally.

Thirty years later a similar work offers a new revelation of the same principle. A steel drawing features grommets attaching the work to the wall and a loopy signature. Yet, despite the change to industrial materials, this work offers a compelling emotional charge. Its chilly intensity—cryptic, inexplicable—is both a straightforward declaration of the medium and an exciting use of formal elements. "Nothing which is visible is indifferent," says Ryman, who indeed shows us the rewards of attentive seeing.

—*Marjorie Welish*

Selected Solo Exhibitions

1988
DIA Art Foundation, New York.
San Francisco Museum of Art.
Brochure by Neal Benezra.
1987
Galerie Konrad Fischer,
Düsseldorf. Also 1980, 1973,
1969, 1968.
The Art Institute of Chicago.
Brochure by Neal Benezra.
1986
Institute of Contemporary Art,
Boston. Brochure by Elisabeth
Sussman.
Leo Castelli Gallery, New York.
Galerie Maeght Lelong, New
York. Also 1984.
1984
Galerie Lelong, Paris. Catalogue
by Jean Frémon.
1981
Musée National d'Art Moderne,
Centre National d'Art et de
Culture Georges Pompidou,
Paris. Traveled. Catalogue by
Yves-Alain Bois and Christel
Sauer.
1980
InK, Zurich. Also 1979.
Catalogues by Christel Sauer.
1977
Whitechapel Art Gallery,
London. Catalogue by Naomi
Spector.
1975
Kunsthalle Basel. Catalogue by
Carlo Huber.
1974
Westfälischer Kunstverein,
Münster. Catalogue by Klaus
Honnef.
Stedelijk Museum, Amsterdam.
Catalogue by Naomi Spector.
1972
Solomon R. Guggenheim
Museum, New York. Catalogue
by Diane Waldman.
1967
Paul Bianchini Gallery, New
York.

Selected Group Exhibitions

1988
Zeitlos, West Berlin. Catalogue.
1987
Whitney Biennial. Whitney
Museum of American Art. Also
1977. Catalogues.
*Similia/Dissimilia: Modes of
Abstraction in Painting,
Sculpture, and Photography
Today*, Kunsthalle Düsseldorf;
Leo Castelli, New York; Wallach
Art Gallery, Columbia
University, New York;
Sonnabend Gallery, New York.
Catalogue.
1985
Carnegie International, Museum
of Art, Carnegie Institute,
Pittsburgh. Catalogue.
1982
Documenta VII, Kassel. Also *VI*
1977; *V*, 1972. Catalogues.
1981
*Westkunst—Heute:
Zeitgenössische Kunst seit 1939*,
Museen der Stadt Köln.
Catalogue.
A New Spirit in Painting, Royal
Academy of Arts, London.
Catalogue.
1980
*Live in Your Head: When
Attitudes Become Form: Works—
Concepts—Processes—
Situations—Information*.
Kunsthalle Bern. Catalogue.
1975
*Fundamentele Schilderkunst/
Fundamental Painting*. Stedelijk
Museum, Amsterdam.
Catalogue.
1966
Systemic Painting, Solomon R.
Guggenheim Museum, New
York. Catalogue.
1964
Eleven Artists, Kaymar Gallery,
New York.

Selected Bibliography

Gilbert-Rolfe, Jeremy. "Appreciating Robert Ryman." *Immanence and Contradiction*, London 1985.

Grimes, Nancy. "Robert Ryman's White Magic." *ARTnews*, Summer 1986.

Kramer, Hilton. "Robert Ryman." *The New York Times*, 22 May 1969.

Kuspit, Donald B. "Ryman, Golub: Two Painters/Two Positions." *Art in America*, July–August 1979.

Pincus-Witten, Robert. "Entries: The White Rectangle, Robert Ryman and Benni Efrat." *Arts Magazine*, April 1977.

Ratcliff, Carter. "Mostly Monochrome." *Art in America*, April 1981.

Reise, Barbara M. "Robert Ryman: Unfinished I (Materials)" and "Robert Ryman: Unfinished II (Procedures)." *Studio International*, February and March 1974.

Rose, Barbara. "ABC Art." *Art in America*, October–November 1965.

"Dossier Ryman." *Macula 3/4*, 1978, with contributions by Christian Bonnefoi, Jean Clay, Barbara Reise, Stephen Rosenthal, Robert Ryman and Naomi Spector.

Sandback, Amy Baker. "Art/On Location." *Artforum*, November 1985.

Schjeldahl, Peter. "Minimalism." *Art of Our Time: The Saatchi Collection*, London 1984.

Storr, Robert. "Interview with Robert Ryman." *Art Press*, 29 March 1987.

————. "Robert Ryman Making Distinctions." *Art in America*, June 1986.

Tuchman, Phyllis. "An Interview with Robert Ryman." *Artforum*, May 1971.

Verstreten, Marian. "Robert Ryman, Le Geste." *+ − 0 Revue d'Art Contemporain*, November 1974.

The Elliott Room: Charter, 1985
oil on aluminum
82 × 31 in. (208.3 × 78.7 cm.)
Collection of Gerald S. Elliott, Chicago

The Elliott Room: Charter II, 1987
acrylic on fiberglass with aluminum
93¾ × 93⅜ in. (238.1 × 237.8 cm.)
Collection of Gerald S. Elliott, Chicago

The Elliott Room: Charter III, 1987
acrylic on fiberglass with aluminum
84¼ × 84 in. (214 × 213.4 cm.)
Collection of Gerald S. Elliott, Chicago

The Elliott Room: Charter IV, 1987
acrylic on fiberglass with aluminum
72⅜ × 72 in. (183.8 × 182.9 cm.)
Collection of Gerald S. Elliott, Chicago

The Elliott Room: Charter V, 1987
acrylic on fiberglass with aluminum
95½ × 95½ in. (242.6 × 242.6 cm.)
Collection of Gerald S. Elliott, Chicago

Julian Schnabel

Born 1951, New York

Lives and works in New York

It could be argued that Julian Schnabel's public life as an artist has been conducted as much in print as in painting. Perhaps more than any other recent living artist Schnabel has been perceived and debated as a phenomenon symbolic of the state of modern art. Controversy has followed his every move. Almost consistently panned by the art press (often with extreme acrimony) when he began to show in New York at the age of 26, Schnabel made good copy for the mass media, which was attracted by this passionate young genius-myth-in-the-making. Here, at long last, was the kind of artist the public could relate to: he painted reasonably recognizable images and spoke in exalted terms of his struggles with the eternal questions of Life, Death and Love.

Schnabel's meteoric (the cliché, in this case, is appropriate) rise to art-world celebrity, with its attendent high prices and waiting lists for paintings, occurred in the late '70s and early '80s, at a time when the art world was undergoing one of its periodic shifts of stylistic balance. Figurative painting was reasserting itself after the relative hegemony of Minimalism and Conceptualism, and "Neo-Expressionism" was soon to appear, rather indiscriminately applied, on everyone's lips. In this context, the ambitions conveyed by Schnabel's rhetoric and the ever increasing scale of his paintings and exhibitions (in 1981 he started something of a fashion by showing his work simultaneously at two prestigious New York galleries), combined with his youth and financial success, made his career paradigmatic of the moment.

Depending on one's point of view, Schnabel epitomized an invigorating return to emotional responsiveness and a direct link to art history or the bankruptcy of art as hype. Some, such as critic Thomas McEvilley in an essay written to accompany the first museum retrospective of Schnabel's work, have seen Schnabel "the phenomenon" as the heroic embodiment of modernism in its apocalyptic struggle with postmodernism. Others, notably *Time* magazine critic Robert Hughes, view Schnabel as the bombastic but flimsy product of a marketing strategy. "How then," as the artist himself has written, "is the viewer supposed to have a direct relationship with a work of art? How to filter out all the distractions, to arrive at its true nature, the mentality, sensibility and history embodied and revealed in the work?"

Schnabel is best known for his "plate" paintings, the first of which was shown in his second New York solo gallery show, in 1979. The inspiration for these came in part from the Catalan architect Gaudi. Sometimes Schnabel used the broken plates as decorative elements, like scattered, overgrown mosaic fragments, their sense of pattern run amok. In other paintings, the artist mixed them with paint in thick, swamplike grounds over which the images traced by his brush trip and stagger like someone trying to run over rocky terrain in the dark.

Schnabel's nonironical use of nontraditional, even kitsch, surfaces also drew attention early on. Many of his paintings from the beginning of the '80s are executed on velvet; recently he has been painting on old, worn tarpaulins and over the readymade landscapes of Japanese Kabuki theater backdrops. He has also experimented with sculpture, producing a number of huge bronzes, some of which quote classical architectural structures while others seem to be actively striving to consolidate, on a monumental scale, the esthetics of Rodin and Beuys.

Schnabel's imagery, like his titles, freely mingles the esoteric with the mundane: thus, images culled from art history are juxtaposed or layered with everyday pop-culture images. Visual quotations come from sources as varied as Caravaggio, Giotto, Max Beckmann, coffee shop paper cups and children's books, but the paintings refuse to privilege any one realm at the expense of another.

—*Jamey Gambrell*

128

Selected Solo Exhibitions

1988
The Israel Museum, Jerusalem.
Catalogue by Suzanne Landau
and Giancarlo Politi.

Galerie Bruno Bischofberger,
Zurich. Also 1985, 1984, 1983,
1982, 1980.

1987
Akira Ikeda, Tokyo. Also 1984,
1983. Catalogues.

Musée National d'Art Moderne,
Centre National d'Art et de
Culture Georges Pompidou,
Paris. Catalogue by Bernard
Blistène, Bernard Ceysson,
Alain Cuef, Wilfried Dickhoff
and Thomas McEvilley.

1986
Whitechapel Art Gallery,
London. Traveled. Catalogue by
Matthew Collings, Thomas
McEvilley and Julian Schnabel.

The Pace Gallery, New York.
Catalogue by Wilfried Dickhoff.
Also 1984 (catalogue by Gert
Schiff).

1985
Waddington Galleries, London.
Catalogue by Donald B. Kuspit.

1982
The Tate Gallery, London.
Catalogue by Richard Francis.

Los Angeles County Museum of
Art. Brochure by Stephanie
Barron.

University Art Museum,
University of California,
Berkeley. Brochure by
Constance Lewallen.

Stedelijk Museum, Amsterdam.
Catalogue by René Ricard and
Alexander van Grevenstein.

Mary Boone Gallery, New York.
Also 1981, 1979.

1981
Anthony d'Offay Gallery,
London.

1976
Contemporary Arts Museum,
Houston.

Selected Group Exhibitions

1987
Biennial, Whitney Museum of
American Art, New York. Also
1983. Catalogues.

1986
*Individuals: A Selected History of
Contemporary Art 1945–1986*,
The Museum of Contemporary
Art, Los Angeles. Catalogue.

1985
Carnegie International, Museum
of Art, Carnegie Institute,
Pittsburgh. Catalogue.

Biennale de Paris. Catalogue.

1984
La Grande Parade, Stedelijk
Museum, Amsterdam.
Catalogue.

1982
La Biennale di Venezia. Also
1980. Catalogues.

1981
*Westkunst—Heute:
Zeitgenössische Kunst seit 1939*,
Museen der Stadt Köln.
Catalogue.

A New Spirit in Painting, Royal
Academy of Arts, London.
Catalogue.

*Schnabel, Rothenberg,
Moskowitz*, Kunsthalle Basel.
Catalogue.

1971
Hidden Houston, University of
Saint Thomas, Houston.

Selected Bibliography

Bleckner, Ross. "Transcendent
Anti-Fetishism." *Artforum*,
March 1979.

Collings, Matthew. "Modern Art/
Julian Schnabel." *Artscribe
International*, September–
October 1986.

Danto, Arthur. "Julian
Schnabel." *The Nation*, 8
December 1984.

de Ak, Edit. "Julian Schnabel."
Art Rite, May 1975.

Joachimides, Christos. "Ein
neurer Geist in der Malerei."
Kunstforum International, May
1981.

Knight, Christopher.
"Descending into the Maelstrom
of a Schnabel Plate Painting."
*The Los Angeles Herald
Examiner*, 18 April 1982.

Kuspit, Donald B. "The Last
Rarefied Romantic." *Artscribe
International*, November–
December 1987.

Kramer, Hilton. "Julian
Schnabel." *Art of Our Time: The
Saatchi Collection*, London
1984.

Nagel, Ivan. "Von Schrecken
und Aufruhr: Julian Schnabels
Gemälde in New Yorker
Gallerien." *Frankfurter
Allgemeine Zeitung*, 16 May
1981.

Perrault, John. "Is Julian
Schnabel that Good?" *Soho
Weekly News*, 22 April 1981.

Pincus-Witten, Robert. "Julian
Schnabel: Blind Faith." *Arts
Magazine*, February 1982.

Plagens, Peter. "The Academy of
the Bad." *Art in America*,
November 1981.

Ratcliff, Carter. "Art to Art:
Julian Schnabel." *Interview*,
October 1980.

————. "Samtale med Julian
Schnabel." *Louisiana Revy*, 2
January 1982.

Schjeldahl, Peter. "Bravery in
Action." *The Village Voice*, 29
April 1981.

Schnabel, Julian. *C.V.J.
Nicknames of Maitre d's and
Other Excerpts from Life*. New
York 1987.

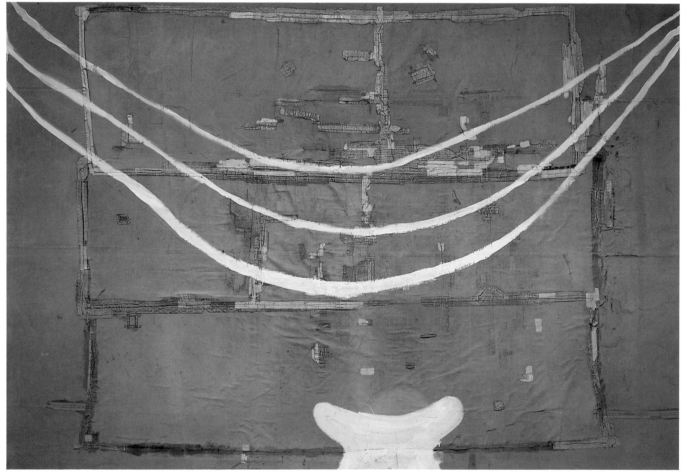

Edge of Victory, 1987
gesso and tape on tarpaulin
136 × 192 in. (345.4 × 487.7 cm.)
Private collection, courtesy of The Pace Gallery, New York

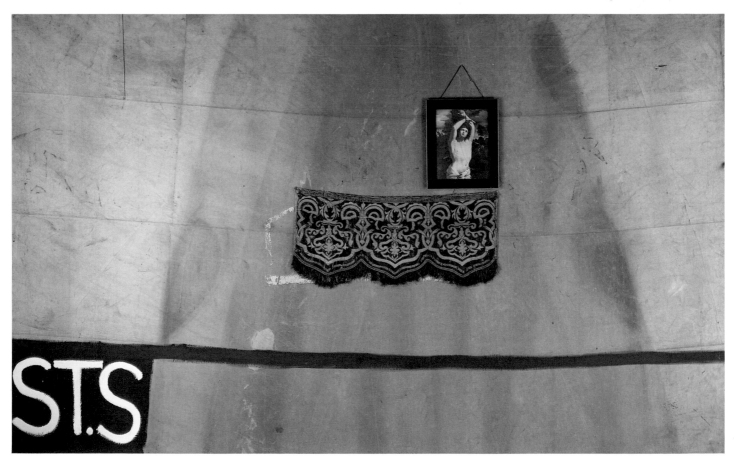

St. S., 1988
oil and collage on tarpaulin
132 × 228 in. (335.3 × 579.1 cm.)
Courtesy of The Pace Gallery, New York

Julian Schnabel

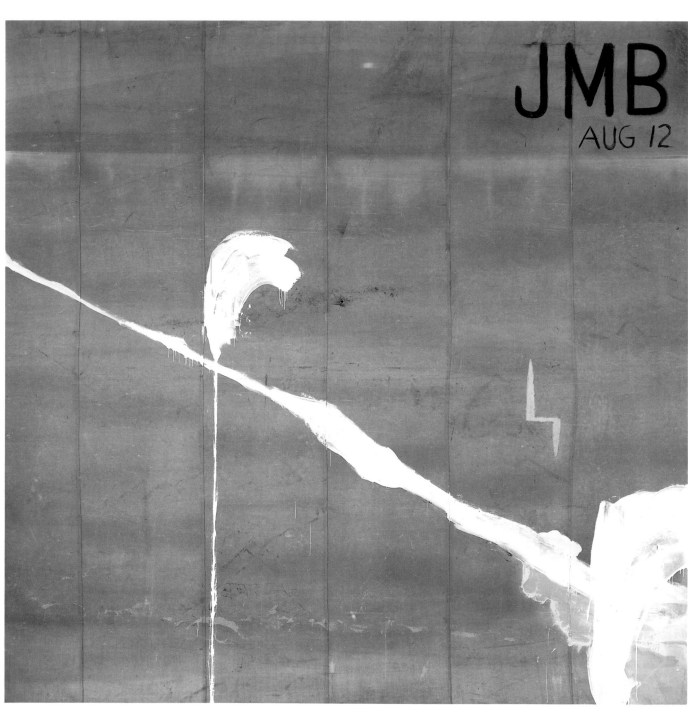

J.M.B., 1988
oil and gesso on tarpaulin
192 × 192 in. (487.7 × 487.7 cm.)
Collection of the artist

Joel Shapiro

Born 1941, New York

Lives and works in New York

"Controlling negative space is a critical issue in sculpture," stated Joel Shapiro in 1982; and it is this concern that has surfaced continually in his work throughout the past 20 years.

Shapiro's process pieces from the early '70s—such as the one in which dozens of clay and pine ovoids were piled on the floor, or *75 Lbs.*, with its equal weights of magnesium and lead juxtaposed, revealing volumes of vastly unequal size—casually played against the spaces they occupied. His works eschewed the monumentalism and exclusive focus on form and material that characterized Minimalism. Instead, the pieces were accessible in both a physical as well as an associational and connotative sense. With the introduction of his very small "representational" sculptures, geometric forms resembling miniature and very generalized chairs, couches, houses, tables, Shapiro began manipulating not just the negative physical space surrounding his works, but also the metaphorical and psychological spaces they opened to the viewer.

Though small, these cast-iron and bronze works paradoxically dominated the architectural spaces in which they were placed. Because diminutive they could be construed as archetypes or symbols and emitted a forceful tension. But while these objects were evocative, their symbolic intent remained obscure. These sculptures used Minimalism's monolithic and unitary qualities in the service of private narrative, without sacrificing either form or meaning.

By 1980, Shapiro's enigmatic objects took on a figural aspect. Additive in a constructivist manner, these substantially larger works command negative space through movement and rhythm, setting up dichotomies and cross references. A central post/torso provides a fulcrum for appendages/limbs which jut out wildly, defying gravity. With no strict vertical or horizontal axes, the works are asymmetrically balanced. The implied movement of their poses gives them a feeling of weightlessness, which is contradicted by their weighty materiality. Perhaps most strikingly the works are equally abstract and figurative. These sculptures' resemblance to frenzied anthropoids also tempts one to see them as metaphors for the chaotic human condition and the depersonalization of the individual in contemporary society.

—*Kellie Jones*

Selected Solo Exhibitions

1988
Paula Cooper, New York. Also 1986, 1984, 1983, 1982, 1980, 1979, 1977, 1976, 1975, 1974, 1972, 1970.
Galerie Mukai, Tokyo. Catalogue by Lynne Cooke. Also 1987, 1981, 1980.
1987
Hirshhorn Museum and Sculpture Garden, Washington, D.C.. Brochure by Ned Rifkin.
1986
John and Mable Ringling Museum of Art, Sarasota, Florida. Catalogue by Mark Ormond.
1985
Stedelijk Museum, Amsterdam. Traveled. Catalogue by Marja Bloem, Karel Schampers and Joel Shapiro.
1982
Whitney Museum of American Art, New York. Traveled. Catalogue by Richard Marshall, Joel Shapiro and Roberta Smith.
1981
The Israel Museum, Jerusalem. Catalogue by Stephanie Rachum.
1980
Whitechapel Art Gallery, London. Traveled. Catalogue by Roberta Smith.
Bell Gallery, Brown University, Providence. Traveled. Catalogue by William Jordy.
1979
Akron Art Museum.
1978
Galerie m, Bochum, West Germany.
1977
Albright-Knox Art Gallery, Buffalo. Catalogue by Linda L. Cathcart.
1976
Museum of Contemporary Art, Chicago. Catalogue by Rosalind Krauss.
1974
Galerie Salvatore Ala, Milan.
1973
The Clocktower, The Institute for Art and Urban Resources, New York.

Selected Group Exhibitions

1988
Philip Guston, Joel Shapiro, Leon Golub, Sigmar Polke, The Saatchi Collection, London
1987
A Century of Modern Sculpture: The Patsy and Raymond Nasher Collection, Dallas Museum of Art. Traveled. Catalogue.
1986
Individuals: A Selected History of Contemporary Art 1945–1986, The Museum of Contemporary Art, Los Angeles. Catalogue.
1985
Transformations in Sculpture: Four Decades of American and European Art, Solomon R. Guggenheim Museum, New York. Catalogue.
1984
An International Survey of Recent Painting and Sculpture, The Museum of Modern Art, New York. Catalogue.
1983
New Art, The Tate Gallery, London. Catalogue.
1982
Documenta VII, Kassel. Also *VI*, 1977. Catalogues.
Correspondencias: 5 Arquitectos, 5 Escultores, Palacio de las Alhajas, Madrid. Traveled. Catalogue.
1980
Skulptur im 20. Jahrhundert, Wekenpark, Riehen, Switzerland. Catalogue.
1976
La Biennale di Venezia. Catalogue.
1969
Anti-Illusion: Procedure/ Material, Whitney Museum of American Art, New York. Catalogue.

Selected Bibliography

Baker, Kenneth. "Shapiro has it Figured Out." *The San Francisco Chronicle*, 21 October 1987.
Bass, Ruth. "Minimalism Made Human." *ARTnews*, March 1987.
Berger, Maurice. "Joel Shapiro: War Games." *Re-Dacti: An Anthology of Art Criticism*. Peter Frank, ed. New York 1983.
Brenson, Michael. "Sculpture Breaks the Mold of Minimalism." *The New York Times*, 23 November 1986.
Cooke, Lynne. "Exhibition Reviews: Joel Shapiro, Sculptures and Drawings at Knoedler, London." *The Burlington Magazine*, September 1985.
Dagen, Philippe. "Joel Shapiro: exercises de sculpture moderne." *Art Press*, December 1986.
Gibson, Eric. "The Minimal and the Magical." *The New Criterion*, January 1985.
Gilbert-Rolfe, Jeremy. *Immanence and Contradiction*. New York 1985.
Isozaki, Arata. "Joel Shapiro at Galerie Mukai." *Yomiuri Shinbum*, May 1980.
Jordy, William H. "The Sculpture of Joel Shapiro." *The New Criterion*, December 1982.
Knight, Christopher. "Joel Shapiro is a master of 'monumental intimacy.'" *Los Angeles Herald Examiner*, 11 December 1983.
Krauss, Rosalind E. "Sculpture in the Expanded Field." *The Originality of the Avant-Garde and Other Myths*. Cambridge 1985.
Kuspit, Donald B. "Manifest Densities." *Art in America*, May 1983.
Ratcliff, Carter. "Joel Shapiro's Drawings." *The Print Collector's Newsletter*, March–April 1978.
Schwartz, Sanford. "Little Big Sculpture." *Artforum*, April 1976.
———. "The Saatchi Collection, or a Generation Comes into Focus." *The New Criterion*, March 1986.

Untitled, 1987–88
bronze
162 × 248½ × 138 in. (411.5 × 631.2 × 350.5 cm.)
Courtesy of Paula Cooper Gallery, New York

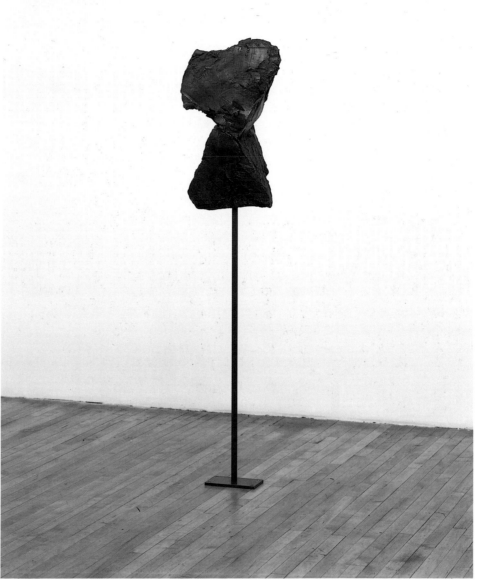

Untitled, c. 1987–88
bronze
72½ × 15½ × 10 in. (184.2 × 39.4 × 25.4 cm.)
Courtesy of Paula Cooper Gallery, New York

Susana Solano

Born 1946, Barcelona

Lives and works in Barcelona

Susana Solano began making sculpture in the late '70s. Her public career as a sculptor, which began in 1980 with a solo show at the Fondació Miró in her hometown of Barcelona, has coincided with the artistic boom of post-Franco Spain. Though currently seen as one of Spain's major artists, Solano remains something of an outsider: she came to sculpture a mature woman in a society that lays particular emphasis on the success of its young men and their entry into the international arena, and has worked as a sculptor of minimalist means and images in a culture that prizes the baroque refinements of a painterly tradition. Solano's relationship and responses to Spain's recent art history are complex and still evolving and should not be overly simplified. Her work possesses a subtle sensuality and sensitivity to poetic metaphor that appear to have been nurtured by the Catalan culture in which she grew up.

Solano's first sculptures were fairly small (i.e., one person can lift and carry them) and were variously executed in canvas, wood and bronze. Soon thereafter the artist began employing iron, which she has both worked in sheet form and used in prefabricated industrial sizes, like beams. Plaster, and most recently, lead and galvanized iron, complete the basic list of her materials. Solano has the occasional help of an assistant in her studio, but does not send out her pieces for fabrication, preferring to work the metal herself. This fact no doubt accounts for the feeling of intimacy her surfaces often convey. Despite the fact that her works have gotten larger and larger, they rarely lose that intimacy or use their scale to melodramatic effect, even when monumental in size.

The intuitive conjuring or delimitation of experienced space runs through Solano's oeuvre, unifying what might otherwise be considered extremely diverse works. ("Space doesn't exist for me," the artist has said; "it is something so ambiguous that I feel the need to delimit it . . . Space [is also] where we are, or what is around me . . . when I am with my daughter in her room and I can hear her breathe. These are spaces that are delimited, defined and, above all, experienced. The void is like closing your eyes, like darkness.") Sculpture thus encompasses intuitions of space and experiences as different as architecture (to which many of her "Fountain" and "Hollow Hills" series refer indirectly) and the volumetric presence of a child's breath in a darkened room or a pool of shadow (a 1983 series was called "Shadow Deposits").

This sense of sculptural volume is nearly palpable in the sensuous surfaces and volumes of the "Fountain" and "Hollow Hills" series, as well as in the more monumental pieces such as *Pervigiles Popinae* (shown at *Documenta VIII*). It is also present, this time by implication, in a work such as the 1987 *Impluvium*, whose severe lines, flat surfaces and precise corners are countered by the near ethereal glare of the galvanized iron "reflecting pool" at its center, which creates an incorporeal volume of light. This is nonmaterial volume made visible. In the project Solano completed for a city-wide outdoor sculpture exhibition in Münster in the summer of '87, she encased a fragment of ruined stone wall projecting out from a medieval tower in a box of iron sheets and beams. Here actual mass was made insubstantial, the heavy presence of the iron made light by the knowledge of the stone inside it.

—*Jamey Gambrell*

Selected Solo Exhibitions

1988
Anthony Reynolds, London.
Catalogue by Teresa Blanch.
Bonnefantenmuseum,
Maastricht, The Netherlands.
Catalogue by Aurora Garcia.
1987
Galeria Giorgio Persano, Turin.
Catalogue by Rosa Queralt.
Galeria des Arènes-Chapelle des
Jésuites, Nîmes. Catalogue by
Aurora Garcia.
Galeria Maeght, Barcelona.
Catalogue by Francisco Calvo
Serraller.
1986
Galeria Fernando Vijande,
Madrid. Catalogue by Teresa
Blanch.
1980
Fundació Joan Miró, Barcelona.
Catalogue by Javier Rubio
Navarro.

Selected Group Exhibitions

1988
La Biennale di Venezia.
Catalogue.
Epoco Nuevo, Cultural Center,
Chicago. Catalogue.
1987
*Christina Iglesias, Juan Muñoz,
Susana Solano*, C.A.P.C., Musée
d'Art Contemporain, Bordeaux.
Catalogue.
*Cinq Siècles d'Art Espagnol—
Dynamiques et Interrogations*,
ARC/Musée d'Art Moderne de la
Ville de Paris. Catalogue.
Bienal de São Paulo. Catalogue.
Skulptur Projekte, Münster.
Catalogue.
Inicis d'una collecció, Fundació
Caixa de Pensiones, Barcelona.
Catalogue.
1986
Correspondence Europe, Stedelijk
Museum, Amsterdam.
Catalogue.
*Three Spanish Contemporary
Artists*, The Serpentine Gallery,
London. Catalogue.
1984
Art Espagnol Actuel, Association
Française d'Action Artistique &
Ministerio de Cultura Español,
Pakais des Arts, Toulouse.
Traveled. Catalogue.
1983
ARCO 83, Galeria Ciento,
Barcelona. Catalogue.
1982
Saló de tardor, Saló del Tinell,
Ajuntament de Barcelona.
Catalogue.

Selected Bibliography

Blanch, Teresa. "La firmeza de vacio." *El Pais*, 29 January 1983.

Combalia, Victoria. "Con luz propia, la escultura de Susana Solano." *El Pais*, May 1987.

Froment, Jean-Louis and Jean-Marc Poinsot. *Susana Solano, sculptures de 1981 à 1987*. Bordeaux 1987.

Gambrell, Jamey. "Five from Spain." *Art in America*, September 1987.

Garcia, Aurora. "Susana Solano—Galeria Vijande." *Artforum*, September 1986.

Koether, Jutta and Diedrich Diederichsen. "Jutta und Diedrich go to Spain." *Artscribe International*, September–October 1986.

Logrono, Miguel. *El templo escultórico de Susana Solano*. Madrid 1987.

Moure, Gloria. "An Encounter with a Secret." *Artforum*, September 1987.

Pilar, Parcerisas. "Susana Solano al Museu Stedelijk en una Selleccio International." *Avui*, 17 September 1986.

Power, Kevin. "Susana Solano—Montenegro." *Flash Art*, Summer 1987.

Queralt, Rosa. *La escultura no es algo al margen de la vida, aunque no pueda explicarse*. Madrid 1987.

Rodriguez-Aguilera, Cesareo. "Susana Solano, juventud y madurez." *Cambio 16*, 25 May 1987.

Serraller, Francisco Calvo. "Musicalidad nocturna." *El Pais*, 2 May 1986.

Spiegel, Olga. "La escultura es un amante celoso y absorbente, pero también compleciente, opina Susana Solano." *La Vanguardia*, 8 April 1987.

Vedrenne, Elisabeth. *Une Sculpture de la solitude*. Paris 1982.

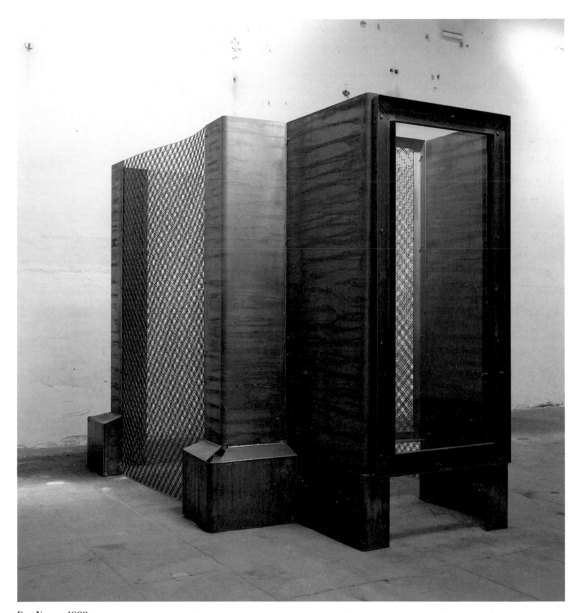

Dos Nones, 1988
iron and polymethyl methacrylate sheeting
95¼ × 84¼ × 122 in. (241.9 × 214 × 310 cm.)
Courtesy of the artist

Rosemarie Trockel

Born 1952, Schwerte, West Germany

Lives and works in Cologne

Rosemarie Trockel's drawings form a world beyond facts and conventions. One image dissolves into another to make us question reality. The drama remains the same, and only the actors change. Whether the subject is an ape or a vase, Trockel's work always deals with the basic elements of existence: life and death, appearance and reality, externality and internality. The value of art amidst truth and illusion is questioned too and animates her play of ciphers. For Trockel, every theme is a metaphor for another. Thus, just as women in the pictures stand for what has been suppressed in human history and mankind is represented by an ape, the use of pictures and language are themselves symptomatic of the morals of society.

Rosemarie Trockel has never wanted to limit her thinking by restricting her art to one medium or material. Quite early in her development she transposed certain motifs from her drawings, into sculptures. In her oil paintings she achieves the spontaneity of her drawings but she gives them the illusory shine of beauty. She knows that, to be convincing, her works must allure the spectator.

In the fine arts, wool had been considered a paltry material, and knitting associated with domesticity and femininity. These associations were the impetus for Trockel's knitted pictures, works that gradually developed into a complex artistic strategy by which the use of signs in post-industrial society becomes illuminated. Trockel finds her patterns in fashion magazines and uses computer-regulated knitting machines to make the work. The unusual material combines art and fashion in a unique way: her audience wears the pictures on their own bodies, and her stretchers become clothed. Because of the mechanical means of reproduction and look of fashion, the claim to originality which is traditionally associated with art is brought into question. When swastikas and playboy bunnies both serve as ornaments, when a hammer and sickle decoration is chic in the same way as the quality sign of pure wool, then the loss of the meaning of such emblems becomes clear. By presenting her knitted pictures as examples of the thoughtless use of such historically significant colophons, Trockel is also pleading for responsible dealing with signs. With her deconstructive method, the artist even gets at complex philosophical correlations. In her works with the "cogito, ergo sum" of Descartes, the idea of subject, so fundamental for the modern understanding of the world, is called into question. Knitted into goods according to Trockel's models, it becomes available as a cipher which can then no longer guarantee the truth of being.

—*Stephan Schmidt-Wulffen*
Translated from German by Clara Seneca

138

Solo Exhibitions

1988
The Museum of Modern Art, New York. Brochure by Jennifer Wells.
Kunsthalle Basel. Travels. Catalogue by Jean-Christophe Ammann, Iwona Blazwick, Wilfried Dickhoff and Peter Weibel.
1987
Galerie Tanit, Munich.
1986
Galerie Friedrich, Bern.
Monika Sprüth Galerie, Cologne. Also 1984, 1983. Catalogue by Wilfried Dickhoff.
1985
Rheinisches Landesmuseum, Bonn. Catalogue by George Condo, Wilfried Dickhoff, Sir Galahad, Klaus Honnef, Jutta Koether, Bettina Semmer and Reiner Speck.
Galerie Skulima, Berlin.
Stampa, Basel.
1983
Galerie Magers, Bonn.

Selected Group Exhibitions

1988
The BiNational: Art of the Late 80s, Museum of Fine Arts and Institute of Contemporary Art, Boston; Städtische Kunsthalle and Kunstsammlung Nordrhein Westfalen, Düsseldorf. Catalogue.
1987
Art from Europe, The Tate Gallery, London. Catalogue.
Similia/Dissimilia: Modes of Abstraction in Painting, Sculpture, and Photography Today, Kunsthalle Düsseldorf. Catalogue.
1986
Sonsbeek '86, Arnhem, The Netherlands. Catalogue.
Biennale of Sydney. Catalogue.
Memento Mori, Centro Cultural Arte Contemporaneo, Mexico. Brochure.
1985
Kunst mit Eigen-Sinn, Museum für Moderne Kunst, Vienna. Catalogue.
Trockel, Semmer, Koether, La Grande Serre, Rouen. Catalogue.
1982
La linea d'ombra, Copparo, Italy. Catalogue.
Bella Figura, Wilhelm Lehmbruck Museum, Duisburg. Traveled. Catalogue.

Selected Bibliography

Beyer, Lucie. "Rosemarie Trockel." *Flash Art*, June 1984.

Haase, Amine. "Umgang mit der Kunstgeschichte." *Köllner Stadtanzeiger*, 8 September 1985.

Koether, Jutta. "Interview with Rosemarie Trockel." *Flash Art*, May 1987.

————. "Pure Invention." *Flash Art*, April 1986.

Leigh, Christian. "Rosemarie Trockel." *Artforum*, Summer 1988.

Nyffeler, Nona. "Rosemarie Trockel's Strickbilder." *Wolkenkratzer*, February 1986.

Pixi, Giacomino. "Rosemarie Trockel." *Juliet*, June 1985.

Pohlen, Annelie. "Rosemarie Trockel." *Kuntsforum*, April 1985.

Schmidt-Wulffen, Stephan. "Rosemarie Trockel." *Flash Art*, February–March 1987.

Speck, Reiner. "Rosemarie Trockel." *Wolkenkratzer*, January 1986.

Spector, Nancy. "Pat Hearn Group Exhibition." *Artscribe International*, January–February 1988.

Cogito, ergo sum, 1988
wool over canvas
85⅕ × 62⅗ in. (220 × 160 cm.)
Courtesy of Monika Sprüth Galerie, Cologne

Not in exhibition. Work in exhibition illustrated in supplement.

Cy Twombly

Born 1928, Lexington, Virginia

Lives and works in Rome

Cy Twombly's characteristic habit of blurring, smudging, veiling and effacing—of almost, but never fully erasing—the contents of his imagery provides an appropriate metaphor for his reticence toward the contemporary art world. He moved to Rome in 1957, leaving New York just as that city achieved primacy as an international art center and has maintained near total silence on the meanings and makings of his art ever since.

From the outset, all of Twombly's art—his drawings, paintings and sculpture—revealed his attention to the mark as the smallest signifying particle of an image and his development of a formal means that fuses and confuses writing and drawing. Twombly has also sustained a poetic, rather than a mimetic, or "picturing," approach to painting, an approach that he once described, in his only published statement, as a resistance to "formalizing," or as "the organization of a 'good painting'" on the basis of purely pictorial relationships between parts and whole. And his images have always been charged with an intense sensuality that ranges from the quiet eroticism suggested by his faint scribblings, stains and multiple erasures to the bombastic sexuality of his more baroque canvases, smeared as they are with thick red, brown and flesh-colored paint.

By 1958, Twombly had begun scrawling legible names and copying fragments of quotations from Classical and Romantic poetry on the surfaces of his drawings and paintings. But even in the early '50s, when his imagery comprised more random marks and lines and more open configurations, Twombly seemed to be engaged in exploring modes of notation and in reconsidering the picture field as an unbounded time-space, open to the possibility of reference. In this sense, Twombly's closest contemporaries are those American artists who emerged in the wake of Abstract Expressionism—Robert Rauschenberg, especially, Jasper Johns, Andy Warhol—artists first celebrated for their obvious breaks with that movement.

Despite their very different approaches to the art-making process, Twombly and his most immediate contemporaries were linked by their willingness to re-open the field of painting to often unorthodox, referential contents and by their resistance to any intellectual or formal agendas. By the mid-'50s, gesture had become just another kind of mark and the painting surface a repository for objects, effects, and the recording of an unpredictable array of experiences and acts. Twombly, in fact, has described his working method as "collage without using the actual technique of collage."

In many ways, Twombly's formal means—from his interest in metamorphoses to his emphasis on touch—as well as his capacity to retrieve seemingly dead aspects of Western culture, reveal a debt to the poet Charles Olson, rector at Black Mountain College during Twombly's attendance there in 1951. It was Olson who rallied against the strictures of formalism by urging poets and artists to "open the field" and who argued the poets' task as "making history available for forms."

Twombly's images—like those of Johns and like Manzoni's *Achromes*, Rauschenberg's combines and Beuys' varied presentations—are at once rife with personal ephemera and highly charged cultural detritus. Twombly's ephemera, fingerprints, signatures and esoteric quotations, read as the faded record of some experience past and remain cryptically inaccessible. These images incite a desire for meaning: we want to read their contents as clues. Yet the desire for meaning often becomes the only meaning offered.

Twombly's surfaces function for us—as they must for him—like the reflecting pool in Narcissus' woodland glade, exacerbating our desire to grasp the persona behind them while forcing us to accept, however reluctantly, the dissolution and metamorphosis of that whole into the fragments Twombly scatters over these canvases and papers.

—*Linda Norden*

Selected Solo Exhibitions

1988
Musée National d'Art Moderne, Centre d'Art et de Culture Georges Pompidou, Paris. Catalogue by Bernard Blistène and Harald Szeemann.

1987
Städtisches Kunstmuseum, Bonn. Catalogue by Gottfried Boehm and Katharina Schmidt.
Kunsthaus Zürich. Traveled. Catalogue by Démosthènes Davvetas, Roberta Smith and Harald Szeemann.

1986
Hirschl & Adler, New York. Catalogue by Roberta Smith. Also 1984. Catalogue.

1984
Staatliche Kunsthalle Baden-Baden. Catalogue by Katharina Schmidt.
C.A.P.C., Musée d'Art Contemporain, Bordeaux
Kunsthalle Baden-Baden. Catalogue by Canzsche Druckerei.

1981
Museum Haus Lange, Krefeld. Also 1965. Catalogue by Paul Wember.
Newport Harbor Art Museum, Newport Beach, California. Traveled. Catalogue by Susan C. Larsen.

1979
Whitney Museum of American Art, New York. Catalogue by Roland Barthes.

1976
ARC/Musée d'Art Moderne de la Ville de Paris. Catalogue by Marcelin Pleynet.

1975
Institute of Contemporary Art, University of Pennsylvania, Philadelphia. Traveled. Catalogue by Heiner Bastian and Suzanne Delehanty.

1973
Kunsthalle Bern. Traveled. Catalogue by Carlo Huber and Michael Petzet.
Kunstmuseum Basel. Catalogue by Heiner Bastian and Franz Meyer.

1966
Stedelijk Museum, Amsterdam. Catalogue by Paul Wember.

1951
Kootz Gallery, New York.

Selected Group Exhibitions

1988
Zeitlos, West Berlin. Catalogue.
La Biennale di Venezia. Also 1964. Catalogues.

1986
In Tandem: The Painter-Sculptor in the Twentieth Century, Whitechapel Art Gallery, London. Catalogue.
Europa/Amerika: Die Geschichte einer künstlerischen Faszination seit 1940, Museum Ludwig, Cologne. Catalogue.

1982
Avangardia Transavangardia, Mura Aureliana, Rome. Catalogue.
Documenta VII, Kassel. Catalogue.
Zeitgeist, Martin-Gropius-Bau, West Berlin. Catalogue.

1981
A New Spirit in Painting, Royal Academy of Arts, London. Catalogue.
Westkunst Heute: Zeitgenössische Kunst seit 1939, Museum der Stadt Köln. Catalogue.

1973
Biennial, Whitney Museum of American Art. Also *Annual* 1970, 1969, 1967. Catalogues.

1953
Rauschenberg: Paintings and Sculpture/Cy Twombly: Paintings and Drawings, Stable Gallery, New York.

Selected Bibliography

Barthes, Roland. *Cy Twombly*. Berlin 1983.

Bastian, Heiner. *Cy Twombly Zeichnungen 1953–1973*. Frankfurt, Berlin and Vienna 1973.

———. *Cy Twombly. Bilder— Paintings 1952–1976*. Frankfurt, Berlin and Vienna 1978.

———. *Cy Twombly. Das Graphische Werk 1953–1984. A Catalogue Raisonné of the Printed Graphic Work*. Munich and New York 1984.

Celant, Germano. *Das Bild einer Geschichte 1956/1976: die Sammlung Panza di Biumo; die Geschichte eines Bildes: action painting, new dada, pop art, minimal art, conceptual environmental art*. Milan 1980.

de Ak, Edit. "Robert Rauschenberg and Cy Twombly at Castelli Downtown." *Art in America*, July–August 1974.

Judd, Donald. "Cy Twombly at Castelli Gallery." *Arts Magazine*, May 1964.

Lambert, Yvon and Roland Barthes. *Cy Twombly. Catalogue raisonné des oeuvres sur papier*. Milan 1979.

Myers, John Bernard. "Marks: Cy Twombly." *Artforum*, April 1982.

Oliva, Achille Bonito. "Cy: una Stanza a Volo Radente." *Carta Bianca*, May 1968.

Pincus-Witten, Robert. "Cy Twombly." *Artforum*, April 1974.

Rosenblum, Robert. "Cy Twombly." *Art of Our Time: The Saatchi Collection*. London 1984.

Szeemann, Harald. *Cy Twombly: Paintings, Works on Paper, Sculpture 1952–1986*. London 1987.

Twombly, Cy. "Signe." *Esperienza Moderna*, 1957.

———. *Fifty Days at Iliam: A Painting in Ten Parts*. Frankfurt 1979.

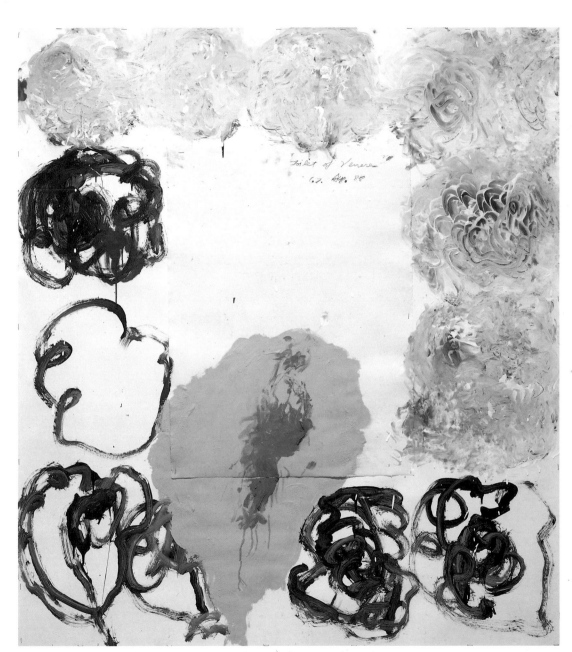

Toilet of Venere, 1988
oil, oil pastel, and gouache on paper mounted on wood
55⅛ × 49½ in. (140 × 126 cm.)
Collection of the artist, courtesy of Sperone Westwater, New York

Not in exhibition. Work in exhibition illustrated in supplement.

Meyer Vaisman

Born 1960, Caracas, Venezuela

Lives and works in New York

Meyer Vaisman sets a standard for precocity which is matched only by the serene detachment that seems to be his stock in trade. Born and raised in Caracas, Venezuela, Vaisman came to New York to study art, deciding soon after his graduation in 1982 to open a storefront gallery in the not-yet-prosperous East Village. The gallery, International with Monument (which recently changed hands, name and location), eventually became the neighborhood's biggest success story (it launched the careers of Peter Halley and Jeff Koons, among others, and by 1986 had provided the young entrepreneur/artist with sufficient means to quit the art business in favor of full-time art-making).

This background would be superfluous were it not for the thematic place occupied by "Meyer Vaisman" in Vaisman's work. Essentially a conceptual prankster in the tradition leading from Marcel Duchamp through Yves Klein, Marcel Broodthaers and Andy Warhol, Vaisman presents his work as a type of art-package suffused by the artist's personality and/or trademark. In his case, this mark consists of a box-like canvas support extended from the wall, on which is printed a simple weave design that is little more than the canvas surface photographically enlarged. Against this apparently neutral background the artist arranges a variety of images and/or objects culled from different sources, all chosen to subtly undermine the object's putatively sober authority as a work of art.

Vaisman's long-term project is to bring art's meaning into sharper focus, to untangle significance from the artist's ego, the culture's need for gratification and history's lust for monuments. Each image in his lexicon provides a clue to his purpose: his early use of human teeth, backwards-running clocks, a child's building blocks and even his own image (drawn by a sidewalk caricaturist) all suggest a renegade post-structuralist suspension, a refusal to grasp at straws for meaning while making up one's mind to have a little laugh at history's expense.

In works from the last two years, Vaisman has become cooler and more complex, still using his own image but also often incorporating objects and signs which stand for the act of art-making in a metaphorical way. These include his accumulations of multicolored blank frames, his superimposition of classical and European coin-faces upon a grid of oval, cameo-like "pictures," and even his series of souvenir heads as collected trophies (these last two groups prominently include Vaisman's own countenance).

Vaisman's overall project is to de-mythify art as a social system, particularly as it relates to the larger-than-life figure of the artist. Taking his cue from other American artists who revel in the artificial extremes of esthetics—Richard Prince and Richard Artschwager among them—Vaisman undertakes this task with considerable humor and insight. By assiduously setting out to uncover the false cult of personality behind art's present-day fetishization, Vaisman seems to be guiding art to the point where it might either uphold certain predetermined illusions or become more real than reality itself.

—*Dan Cameron*

Solo Exhibitions

1988
La Jolla Museum of Contemporary Art, California. Catalogue by Hugh Davies and Trevor Fairbrother.
University Art Museum, University of California, Berkeley. Brochure by Sidra Stich.
Daniel Weinberg Gallery, Los Angeles. Also 1986.
1987
Jay Gorney Modern Art, New York. Also 1986.
Leo Castelli Gallery, New York.
1986
White Columns, New York.

Selected Group Exhibitions

1988
Cultural Geometry, The Deste Foundation for Contemporary Art, Athens. Catalogue.
New York in View, Kunstverein München. Catalogue.
BiNational: Art of the Late 80s, Museum of Fine Arts and Institute of Contemporary Art, Boston; Städtische Kunsthalle and Kunstsammlung Nordrhein-Westfalen, Düsseldorf. Catalogue.
1987
NY Art Now; The Saatchi Collection, London. Catalogue.
Simulations, New American Conceptualism, Milwaukee Art Museum. Brochure.
1986
Rooted Rhetoric, Castel Dell 'Ovo, Naples. Catalogue.
Paravision, Margo Leavin Gallery, Los Angeles.
Ashley Bickerton, Peter Halley, Jeff Koons, Meyer Vaisman, Sonnabend Gallery, New York.
1985
Final Love, Cash/Newhouse Gallery, New York.
1984
The New Capital, White Columns, New York.
Neo York, University Art Museum, University of California, Santa Barbara. Catalogue.

Bibliography

Bankowsky, Jack. "A Spectacle of Capability, Belcher, Taaffe, Vaisman." *Flash Art*, April 1987.

Cameron, Dan. "Who is Meyer Vaisman?" *Arts Magazine*, February 1987.

Collins, Tricia and Richard Milazzo. "The Look of Critique." *C.E.P.A. Journal*, September 1984.

Cotter, Holland. "Meyer Vaisman at Leo Castelli." *Art in America*, January 1988.

Hart, Claudia. "Intuitive Sensitivity: An Interview with Peter Halley and Meyer Vaisman." *Artscribe International*, November–December 1987.

Indiana, Gary. "Funny Ha Ha, Funny Strange." *The Village Voice*, 24 November 1987.

———. "Paravision." *The Village Voice*, 25 May 1985.

Jones, Ronald. "Meyer Vaisman." *Artscribe International*, March–April 1988.

Levin, Kim. "Artwalk." *The Village Voice*, 3 June 1986.

Linker, Kate. "Meyer Vaisman." *Artforum*, February 1982.

Schjeldahl, Peter. "A Visit to the Salon of Autumn." *Art in America*, December 1986.

Smith, Roberta. "Art: 4 Young East Villagers at Sonnabend Gallery." *The New York Times*, 24 October 1986.

———. "Where to See the Newest of the New American Art." *The New York Times*, 1 May 1987.

Self-Portrait with Imaginary Siblings, 1988
process inks and acrylic on canvas
120 × 120 × 8¾ in. (304.8 × 304.8 × 22.2 cm.)
Courtesy of Sonnabend Gallery, New York, and Leo Castelli Gallery, New York

144

In the Vicinity of History, 1988
process inks and acrylic on canvas
96 × 172½ × 8½ in. (243.8 × 438.2 × 21.6 cm.)
Collection of Dakis Joannou, Athens, courtesy of Sonnabend Gallery, New York

Souvenir, 1987
process inks on canvas
84 × 176¼ × 14½ in. (213.4 × 447.7 × 36.8 cm.)
Collection of Mr. and Mrs. Asher B. Edelman, New York

Bill Viola

Born 1951, New York

Lives and works in Long Beach, California

For more than 16 years Bill Viola has used the most contemporary electronic technologies to create provocative, deceptively spare video-and-sound installations and videotapes that pursue an ancient theme: the revelation of the layers of human consciousness. Although based on realistic images, his projects go beyond representation to challenge the viewer's preconditioned expectations and viewing patterns. Deriving from a combination of the highly rational and the deeply intuitive, his work probes many levels of experience. For Viola the image is merely a schematic portrayal of a much larger system, and seeing is a complex process that involves far more than surface recognition. His primary subject is the physical and mental landscape and the connections and interplay between the outer and inner realms. He is also concerned with exploring the interaction of his images with the viewer's memory and with the subconscious and its imagination and dreams.

Viola's environmental installations are symbolic, emotional arenas with components drawn from the everyday world. In them elusive video/sound images seem to assume palpable existence, and tangible objects take on strong mental and emotional associations. Evocative of the deeper, nonverbal areas of consciousness generally associated with sleep and dreams, the installations function as gateways to areas as profound and as challenging as the viewer's receptiveness permits.

Viola gives painstaking attention to his subjects, both natural and man-made, so that the results invariably have a resplendence, depth of spirit, and intensity that make them indisputably his. For many years, he has been drawn to the numinous aspects of nature, subscribing as he does, to Eastern philosophies that place man in the context of nature's ongoing cycle, and that see an infinite, eternal entity embodied in all animate and inanimate things. Having as much esteem for the circulatory system as for the circuit board, Viola is constantly exploring the larger system as it is expressed by the smallest part. Viola takes a straightforward approach to his recorded images: the primary special effects he employs involve slowing down, reversing, or speeding up time. This directness extends to his editing, which is as concise as it is precise: nothing is extraneous and very little is left to chance. Although his works reflect his extraordinary control, during recording he does accept serendipitous events that may take place in front of the camera, thereby heightening the energy of the completed piece. Viola's exceptional technical skill and knowledge enable him to work alone, without technical assistance, so each project remains an exclusive expression of his personal vision.

Working consistently on the fringes of both the fine-art and commercial-art television worlds, Viola has gained international recognition for his beautifully crafted and distinctive work. His interest in the myths of other cultures has led him to explore remote locations revered by native American, Near Eastern, Asian, and Pacific Island peoples, and his themes reflect the cumulative consideration of their diverse but parallel traditions and rituals. Through the rich vocabulary of his highly developed imagery, Viola probes the elusive area between the present and the other world beyond. He seriously follows his poetic vision, continuously searching for greater understanding of our spiritual heritage, and looking beyond individual limitations toward a more collective, universal mind.

—*Barbara London*

Selected Solo Exhibitions

1988
Contemporary Arts Museum, Houston. Catalogue by Deirdre Boyle, Kathy Huffman, Christopher Knight, Michael Nash, Joan Seeman Robinson, Gene Youngblood and Marilyn Zeitlin.

1987
The Museum of Modern Art, New York. Catalogue by Jim Hoberman, Donald Kuspit, Barbara London and Bill Viola. Also 1979.

1985
San Francisco Museum of Modern Art.

The Museum of Contemporary Art, Los Angeles. Catalogue by Julia Brown.

Moderna Museet, Stockholm.

Institute of Contemporary Art, Boston. Brochure by David Ross.

1983
ARC/Musée d'Art Moderne de la Ville de Paris. Catalogue by Dany Bloch, Deirdre Boyle, Anne-Marie Duguet, Kathy Huffman and John Hanhardt.

1982
Whitney Museum of American Art, New York. Brochure by John G. Hanhardt and Bill Viola.

Seibu Museum of Art, Tokyo.

1981
Vancouver Art Gallery.

1980
Long Beach Museum of Art.

1979
Media Study/Buffalo.

1977
The Kitchen, New York. Also 1974.

1975
The Everson Museum of Art, Syracuse. Catalogue by Judson Rosebush. Also 1973.

Selected Group Exhibitions

1988
American Landscape Video: The Electronic Grove, The Carnegie Museum of Art, Pittsburgh. Catalogue.

1987
Biennial, Whitney Museum of American Art, New York. Also 1985, 1983, 1981, 1979, 1977, 1975. Catalogues.

L'epoque, la mode, la morale, la passion: Aspects de l'art d'aujourd'hui 1977–1987, Musée National d'Art Moderne, Centre National d'Art et de Culture Georges Pompidou, Paris. Catalogue.

1986
La Biennale di Venezia. Catalogue.

Où va la Vidéo? La Chartreuse, Villeneuve-les-Avignon. Catalogue.

1984
The Luminous Image, Stedelijk Museum, Amsterdam. Catalogue.

1983
Video as Attitude, Museum of Fine Arts, Santa Fe. Catalogue.

1982
'60–'80: Attitudes/Concepts/Images, Stedelijk Museum, Amsterdam. Catalogue.

1977
Documenta VI, Kassel. Catalogue.

Biennale de Paris. Also 1975. Catalogues.

1974
Projekt '74, Kunstverein Köln. Catalogue.

Selected Bibliography:

Ancona, Victor. "Bill Viola: Video Visions from the Inner Self." *Videography*, December 1982–January 1983.

Bellour, Raymond. "An Interview with Bill Viola." *October*, Fall 1985.

Boyle, Deirdre. "Bill Viola: Womb with a View." *ARTnews*, January 1988.

Duguet, Anne-Marie. "Les vidéos de Bill Viola: une poétique de l'espace temps." *Parachute*, December 1986–February 1987.

Giuliano, Charles. "Visionary Video, The 'Vasari' Diary." *ARTnews*, May 1985.

Grubber, Bettina and Maria Vedder, eds. "Bill Viola." *Kunst und Video*. Cologne 1983.

Hoberman, Jim. "Video." *Omni*, May 1983.

Minkowsky, John. "Bill Viola's Video Vision." *Video 81*, Fall 1981.

Nash, Michael. "Bill Viola's Revisions of Mortality." *High Performance*, Winter 1987.

Ross, David. "The Success of the Failure of Video Art." *Videography*, May 1985.

Shewey, Don. "An Artist Finds Poetry in Videotape." *The New York Times*, 8 November 1987.

Sturken, Marita. "Temporal Interventions." *Afterimage*, Summer 1982.

Viola, Bill. "The European Scene and Other Observations." *Video Art*. Ira Schneider and Beryl Korot, eds. New York, 1976.

———. "History, 10 Years, and the Dreamtime." *Video: A Retrospective, Long Beach Museum of Art, 1974–1984*. Long Beach 1984.

Youngblood, Gene. "Metaphysical Structuralism: The Videotapes of Bill Viola." *Bill Viola: Selected Works*. Los Angeles 1986.

Heaven and Hell, 1985
video/sound installation, living room
248 in. high (629.9 cm. high), 220 in. diameter (558.8 cm. diameter)
Installation view at San Francisco Museum of Modern Art
Collection of the artist

Not in exhibition. Work in exhibition illustrated in supplement.

Jeff Wall

Born 1946, Vancouver

Lives and works in Vancouver

Jeff Wall's backlit Cibachrome transparencies may be compared with stained glass windows radiant with the subliminally flickering energy of fluorescent light; luminescent advertising hoardings in an art gallery; cinema jammed on a single frame; slides projected in the lecture hall. The pictures are programmed like academic machines, serving both as mechanical reproductions of appearance and allegorical emblems from which to decipher social conflict and domination.

Wall, an artist of the city and its environs, lives in Vancouver, Canada which, by contrast with the cultural capitals of the world, is relatively empty and dispersed. With its economy based on the export of raw materials, Vancouver is exposed in an exemplary way to the contradictions of late capitalism. These contradictions surface in those who are marginalized and oppressed: for example, the young working class mothers, tramps, prostitutes, Canadian Native Americans and Asian immigrants who have formed the subjects of many of Wall's pictures, rather like the marginal types chosen by Manet at the beginning of modernism. There are other types and themes: the young hiker in *Backpack*, 1981–82 (after Manet's *The Fifer*, 1866); the adolescent in *The Smoker*, 1986; a middle-class image of authority and desire in *Woman and her Doctor*, 1981–82; male narcissism in *Stereo*, 1982, and the *Double Self-Portrait*, 1979.

While Wall's earlier pictures tended towards the emblematic, a number of his pieces since 1982 have been concerned with the revelation of social relationships through frozen gesture. Compulsive actions bring to light social conflict and contradiction. The turning point with Wall's work was *Mimic*, 1982, where the three characters who advance towards the viewer are caught off-guard to reveal the racial, class and sexual antagonisms which surface in their gestures: a swarthy man, who, with one hand, makes "slant-eyes" toward the better dressed Asiatic beside him who tries to pretend he hasn't noticed, is, with his other hand, dragging along a sullen woman in shorts. The genres of street photography and impressionist instantaneity are coupled in this photographic mimesis.

The Storyteller, 1986, like the essay of that title by Walter Benjamin, contrasts modernization and memory. On one side is the highway rushing away to the vanishing point, on the other trees and grass; the picture is bisected horizontally by lines of cable, perhaps from an electric railway. The linear time of progress is contrasted with the indolent temporality of storytelling. The figures—not exotic but subject themselves to "modernization"—who sit absorbed or recline bored and have time for stories are decentered in the composition on the margins of an empty foreground. The storyteller is a Canadian Native American woman who speaks to two men, one crosslegged and the other sitting in a posture recalling that of the naked woman in Manet's *Le dejeuner sur l'herbe*, 1863. By recalling the Manet, Wall reflects on the relation between modernism and the historical consequences and social effects of modernization, and by means of the sexual role reversal draws critical attention to the voyeuristic gaze that his own photograph necessarily assumes.

—*Michael Newman*

Selected Solo Exhibitions

1988
Le Nouveau Musée, Villeurbanne. Catalogue by Els Barents and Frédéric Migayrou.
Westfälischer Kunstverein, Münster. Catalogue.
1987
Museum für Gegenwartskunst, Basel. Catalogue by Jörg Zutter.
Johnen & Schöttle, Cologne. Also 1986.
Galerie Ghislaine Hussenot, Paris.
1986
The Ydessa Gallery, Toronto.
1984
Institute of Contemporary Arts, London, and Kunsthalle Basel. Catalogue by Ian Wallace.
Galerie Rüdiger Schöttle, Munich.
1983
The Renaissance Society, University of Chicago. Catalogue by Ian Wallace.
1982
David Bellman Gallery, Toronto.
1979
The Art Gallery of Greater Victoria, British Columbia. Catalogue by Willard Holmes and Jeff Wall.
1978
Nova Gallery, Vancouver.

Selected Group Exhibitions

1988
Utopia Post Utopia, Institute of Contemporary Art, Boston. Catalogue.
1987
Zeitgeschichten/Blow-Up, Württembergischer Kunstverein, Stuttgart. Traveled. Catalogue.
L'epoque, la mode, la morale, la passion: Aspects d'art d'aujourd'hui 1977–1987, Musée National d'Art Moderne, Centre National d'Art et de Culture Georges Pompidou, Paris. Catalogue.
Documenta VIII, Kassel. Also *VII*, 1982. Catalogues.
1985
Biennale de Paris. Catalogue.
Jeff Wall and Günther Förg: Photoworks, Stedelijk Museum, Amsterdam.
1981
Directions 1981, Hirshhorn Museum and Sculpture Garden, Washington, D.C. Catalogue.
Westkunst—Heute: Zeitgenössische Kunst seit 1939, Museen der Stadt Köln. Catalogue.
1970
Art in the Mind, Allen Memorial Art Museum, Oberlin College, Ohio. Catalogue.
Information, The Museum of Modern Art, New York. Catalogue.
1969
995,000, Vancouver Art Gallery. Catalogue.

Selected Bibliography

Barents, Els. "Günter Förg en Jeff Wall: Fotowerks." *Bulletin, Stedelijk Museum*, September 1985.

Barry, Judith. "Spiegelbeeld: Notities over de achtergrond van Jeff Walls dubbelzelfportret." *Museumjournaal*, October 1984.

Burnett, David and Marilyn Schiff. *Contemporary Canadian Art*. Edmonton 1983.

Francblin, Catherine. "Jeff Wall: la pose et la vie." *Art Press*, March 1988.

Gale, Peggy. "Outsiders In: Jeff Wall and Ian Wallace." *Canadian Art*, June 1987.

Graham, Dan. "The Destroyed Room of Jeff Wall." *Real Life Magazine*, March 1980.

Honnef, Klaus. "Jeff Wall." *Kunstforum International*, August–September 1986.

Johnen, Jörg and Rüdiger Schöttle. "Jeff Wall." *Kunstforum International*, September 1983.

Kirshner, Judith R. "A Blinding Light." *Real Life Magazine*, Winter 1983–84.

Kuspit, Donald B. "Looking up at Jeff Wall's Modern Appassionamento." *Artforum*, March 1982.

Lippard, Lucy R. *Six Years: The Dematerialization of the Art Object 1966–72*. New York 1973.

Newman, Michael. "Revising Modernism, Representing Postmodernism." *ICA Documents 4*, London 1986.

Wall, Jeff. *Landscape Manual*. Vancouver 1970.

———. "Stereo." *Parachute*, Spring 1981.

Wheeler, Dennis. "The Limits of the Defeatured Landscape: A Review of Four Artists." *Artscanada*, June 1970.

Wood, William. "Three Theses on Jeff Wall." *C Magazine*, Fall 1984.

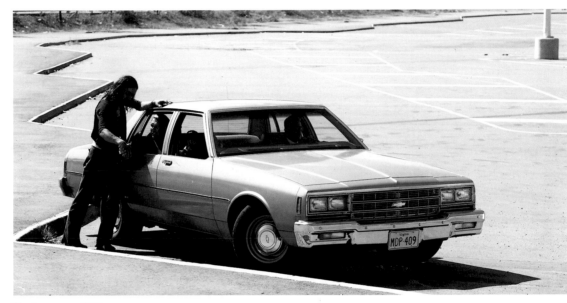

The Agreement, 1987
Cibachrome transparency, fluorescent light, display case
83⁹⁄₁₀ × 154⅖ in. (213 × 392 cm.)
Courtesy of Galerie Rüdiger Schöttle, Munich

Warhol carried the antinomy of modern subjectivity to an extreme. His public face was pure mask; his private life, as revealed after his death by photographs and descriptions of his house on Manhattan's Upper East Side, an all but inaccessible interiority. He even withdrew from the fin-de-siècle splendor of the dining- and drawing-rooms to lie in his magnificent Sheraton four-poster bed and watch videotapes of old movies and eat Teuscher chocolate truffles, perhaps read the devotional book on his bedside, and occasionally stare at himself Narcissus-like in a cheval mirror of monstrous size. He was, after all, a practical metaphysician.

In 1619, the first philosopher of the modern age, René Descartes, discovered that the indubitable ground of his being was his very own thinking self. Among his early writings, Descartes left the following note,

> Actors, taught not to let any embarrassment show on their faces, put on a mask. I will do the same. So far, I have been a spectator in this theatre which is the world, but I am now about to mount the stage, and I come forward masked.[1]

The private self's relation to the world is that of spectator and mask. In the 278th aphorism of *Beyond Good and Evil*, 1886, Nietzsche, who has been called "the last metaphysician of the West," addresses an unknown wanderer who is "walking on his way without scorn, without love, with unfathomable eyes" and asks him what he needs. The reply: "Another mask! A second mask!"

Warhol graduated from the Carnegie Institute of Technology, Pittsburgh, in 1949, as Abstract Expressionism was about to enter its heyday. (During his first summer working as a commercial artist he was commissioned to illustrate an article in *Glamour* magazine called "Success Is a Job in New York.") "To express" means to "press out" an interiority: Abstract Expressionism was the last authentic expressionist movement, and the interiority which it expressed was intended to be an archetypal, collective unconscious. In the '60s, Warhol turned Abstract Expressionism on its head, converting the color field of the painting into a screen for the projection of a collective consciousness: Marilyn, Elvis, Coke, Brando, the *Mona Lisa*, the Statue of Liberty, suicide, disaster, race riots, electric chairs, and Jackie Kennedy became his themes, silkscreened from photographic reproductions in a deadpan repetition which emptied the images of affect. He functioned as a recording machine, a spectator of others in his studio (which came to be known as the Factory), with its mirror walls of tin foil. He extended Duchampian indifference from readymades to people, sex and the Empire State Building in his films, and later to Mao and Lenin in his paintings. And he turned himself into a *persona*, a public self of pure artifice, which Baudelaire, in his mid-19th-century description of dandyism, called, "the last flicker of heroism in the modern age."

Baudelaire knew that the heart of modernity is *mode*, the relentless cycle of fashion, and that the self would become an object, a commodity like any other. It took Warhol to live this logic to the limit, which endowed him with a kind of purity. At the memorial service at St. Patrick's Cathedral he was described as "a recording angel." Warhol's last, spectral self-portraits reveal not only that he had become one of the icons he depicted, but provide yet another mask: he styled himself in camouflage.

—*Michael Newman*

1
The Philosophical Writings of Descartes. Translated by John Cottingham, Robert Stoothoff, Dugald Murdoch. Cambridge, 1985. Vol. I, p. 2.

Selected Solo Exhibitions

1988
Anthony d'Offay, London. Also 1986.
1986
DIA Art Foundation, New York.
1983
Aldrich Museum of Contemporary Art, Ridgefield, Connecticut. Traveled. Brochure.
1981
Kestner-Gesellschaft, Hanover. Traveled. Catalogue.
1980
Stedelijk Museum, Amsterdam.
The Jewish Museum, New York.
1979
Whitney Museum of American Art, New York. Catalogue by Robert Rosenblum.
1978
Kunsthaus Zürich. Catalogue by Erika Billeter, David Bourdon, John Coplans, Hans Heinzholz, Jonas Mekas, Barbara Rose, Helmut Salzinger and Wolfgang Siano.
Louisiana Museum, Humlebaek, The Netherlands.
1976
Württembergischer Kunstverein, Stuttgart. Traveled.
1975
Baltimore Museum of Art. Brochure by Brenda Richardson.
1970
Pasadena Art Museum. Traveled. Catalogue by John Coplans, Jonas Mekas and Calvin Tomkins.
1969
Nationalgalerie, Staatliche Museen Preussischer Kulturbesitz, West Berlin. Catalogue by Werner Hoftmann and E. Roters.
1968
Moderna Museet, Stockholm. Traveled. Catalogue by Olle Granath, Pontus Hultén, Kasper König and Andy Warhol.

1965
Institute of Contemporary Art, University of Pennsylvania, Philadelphia. Catalogue by Samuel Adams Green.
1952
Hugo Gallery, New York.

Selected Group Exhibitions

1987
Made in U.S.A: An Americanization of Modern Art, the 50's and 60's, University Art Museum, University of California, Berkeley. Catalogue.
Warhol/Beuys/Polke, Milwaukee Art Museum. Traveled. Catalogue.
1984
Blam! The Explosion of Pop, Minimal and Performance 1958–1964, Whitney Museum of American Art, New York. Catalogue.
1982
Joseph Beuys, Robert Rauschenberg, Cy Twombly, And Warhol, Nationalgalerie, Staatliche Museen Preussischer Kulturbesitz, West Berlin. Catalogue.
Zeitgeist, Martin-Gropius-Bau, West Berlin. Catalogue.
1976
La Biennale de Venezia. Catalogue.
1974
American Pop Art, Whitney Museum of American Art, New York. Catalogue.
1968
Documenta IV, Kassel. Catalogue.
1967
Pittsburgh International Exhibition of Contemporary Painting and Sculpture, Museum of Art, Carnegie Institute. Catalogue.
1964
Amerikanst Pop-Konst, Moderna Museet, Stockholm. Catalogue.
American Pop Art, Stedelijk Museum, Amsterdam. Catalogue.

Selected Bibliography

Coplans, John. *Andy Warhol.*
New York 1970.

Crone, Rainer. *Andy Warhol.*
New York 1970.

Crone, Rainer and Wilfried
Wiegand. *Die revolutionäre
Ästhetik Andy Warhol's.*
Darmstadt 1972.

Crow, Thomas. "Saturday
Disasters: Trace and Reference
in Early Warhol." *Art in America,*
May 1987.

Feldman, Frayda and Jörg
Schellman. *Andy Warhol Prints,*
New York 1985.

Hughes, Robert. "The Rise of
Andy Warhol," *Art After
Modernism.* Brian Wallis, ed.
New York 1984.

Ratcliff, Carter. *Andy Warhol.*
New York 1983.

Wilcock, John. *The
Autobiography and Sex Life of
Andy Warhol.* New York 1971.

Warhol, Andy. *The Philosophy of
Andy Warhol (A to B and Back
Again).* New York 1975.

Warhol, Andy and Pat Hackett.
POPism: The Warhol Sixties.
New York 1980.

Wünsche, Herman. *Andy
Warhol: Das graphische Werk
1962–1980.* Bonn 1980.

Self Portrait, 1986
acrylic and silkscreen on canvas
80 × 80 in. (203.2 × 203.2 cm.)
Collection of Janet Green, London, courtesy of Anthony d'Offay Gallery, London

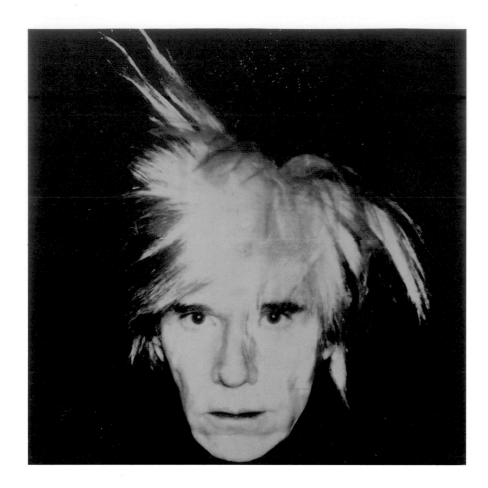

Self Portrait, 1986
acrylic and silkscreen on canvas
80 × 80 in. (203.2 × 203.2 cm.)
Estate of Andy Warhol

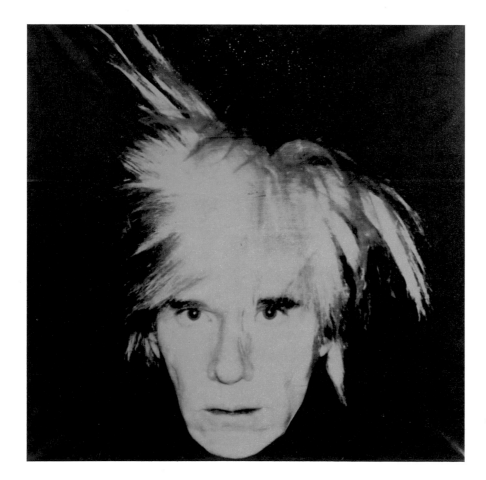

Self Portrait, 1986
acrylic and silkscreen on canvas
80 × 80 in. (203.2 × 203.2 cm.)
Estate of Andy Warhol

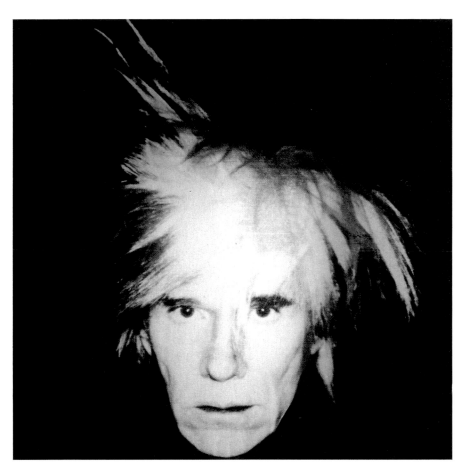

Self Portrait, 1986
acrylic and silkscreen on canvas
80 × 80 in. (203.2 × 203.2 cm.)
The Carnegie Museum of Art; Fellows of the Museum of Art Fund, 1986

Supplement

Giovanni Anselmo

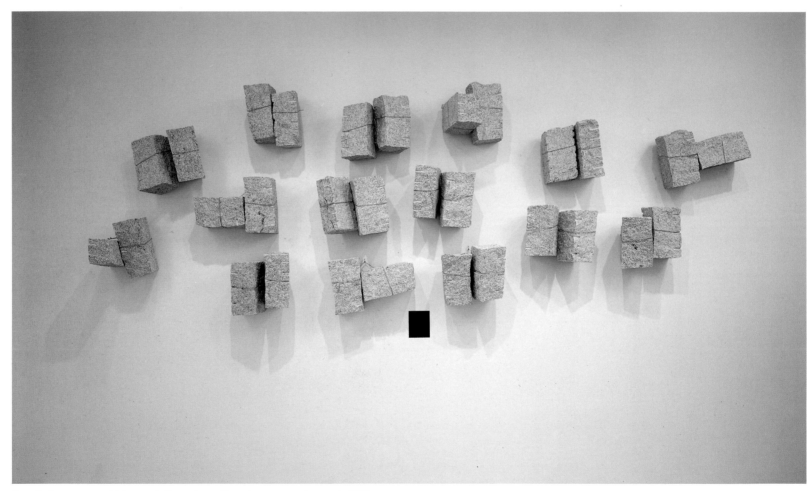

Greys Lightening toward 'oltremare' (Grigi che si alleggeriscono verso oltremare), 1988
stone, steel cable, slipknot, and ultramarine blue pigment
variable dimensions
Collection of the artist, courtesy of Marian Goodman Gallery, New York

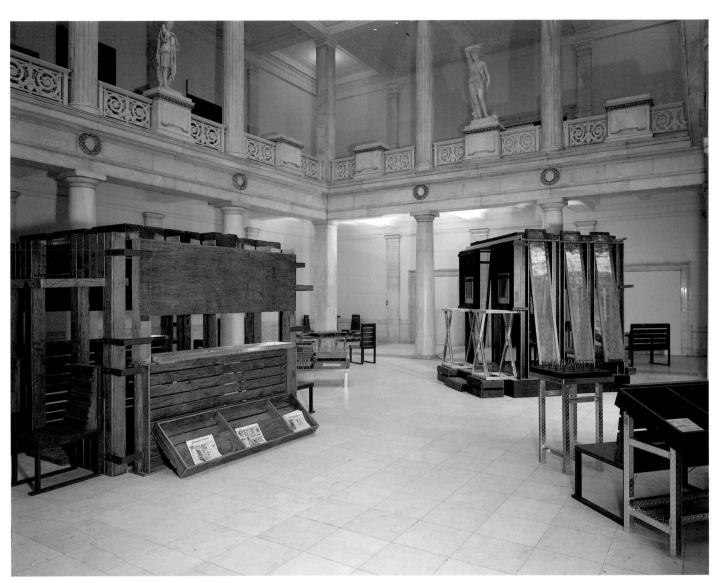

Sacco and Vanzetti Reading Room #3, 1988
diamond plated aluminum, brick, steel, pressure treated lumber, and Minnesota jade
variable dimensions
Courtesy of Max Protetch Gallery, New York

Richard Artschwager

Abstraction, 1987
acrylic on Celotex
47 × 35½ in. (119.4 × 90.2 cm.)
Private collection, courtesy of Donald Young Gallery, Chicago

Diner, 1988
acrylic on Celotex, Formica, and wood
36½ × 104 in. (92.7 × 264.2 cm.)
Collection of Mr. and Mrs. Richard S. Lane, New York

Double Dinner, 1988
paint, wood, Formica, and rubberized hair
27 × 85½ × 35½ in. (68.6 × 217.2 × 90.2 cm.)
Courtesy of Leo Castelli Gallery, New York

Two Dinners, 1988
acrylic on Celotex and wood, mirrors
40⅜ × 48 × 6⅜ in. (102.9 × 121.9 × 16.5 cm.)
Courtesy of Leo Castelli Gallery, New York

162

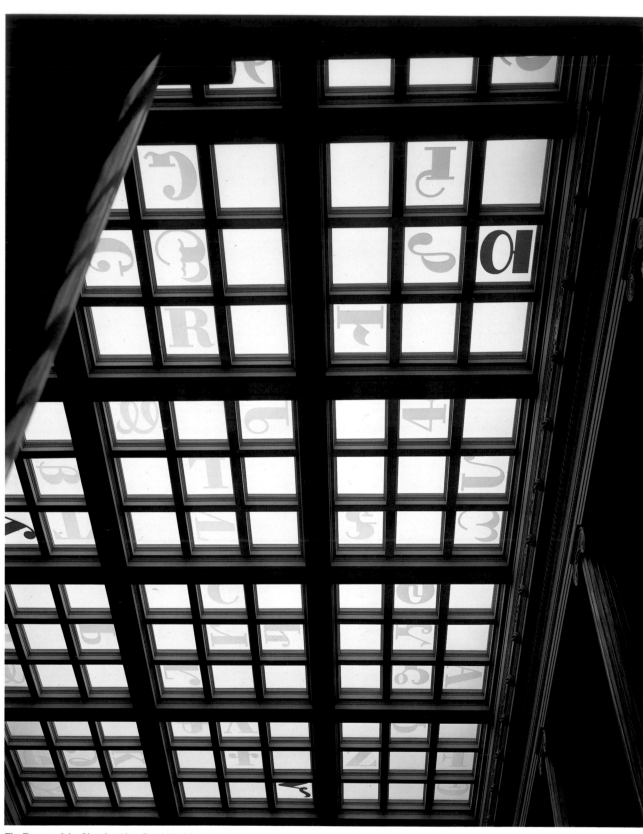

The Tongue of the Cherokee (detail), 1985–88
painted, laminated, and sandblasted glass
100 × 43 ft. (3048 × 1310 cm.)
Courtesy of Marian Goodman Gallery, New York

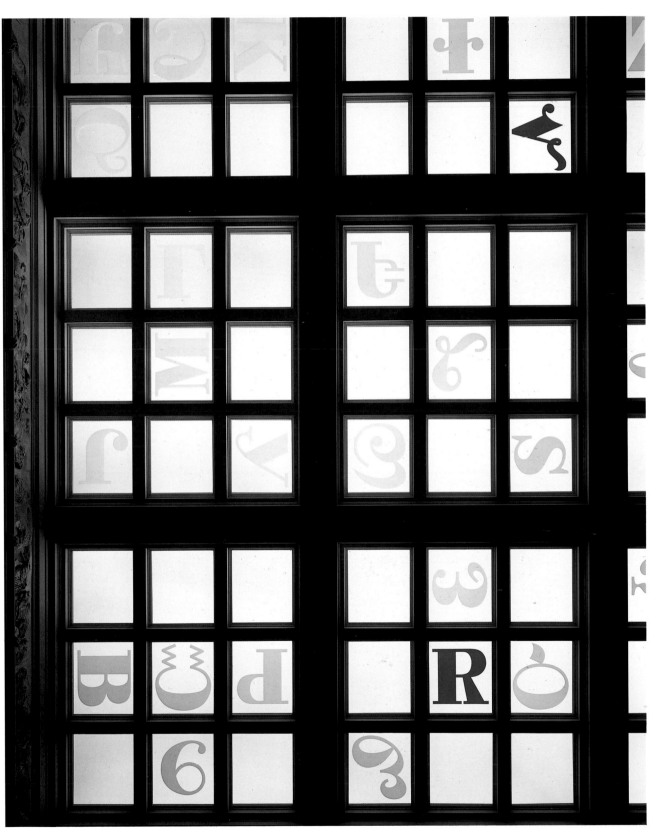

The Tongue of the Cherokee (detail), 1985–88
painted, laminated, and sandblasted glass
100 × 43 ft. (3048 × 1310 cm.)
Courtesy of Marian Goodman Gallery, New York

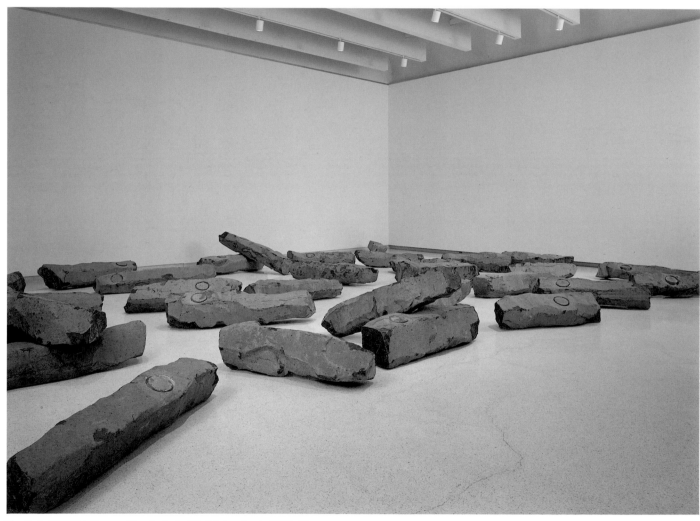

The End of the 20th Century (Das Ende des 20. Jahrhunderts), 1983–85
31 basalt stones, clay, and felt
15¾ × 67 × 15¾ in. each (40 × 170 × 40 cm. each)
Courtesy of Galerie Bernd Klüser, Munich

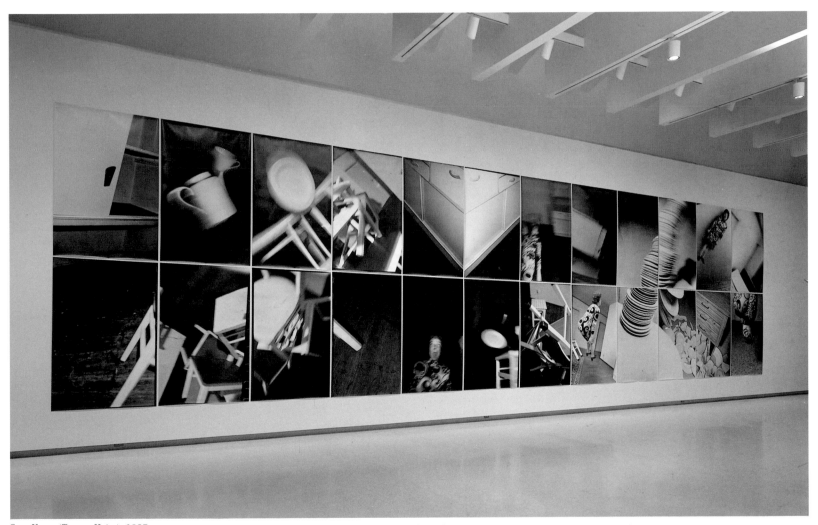

Cosy Home (Trautes Heim), 1987
black and white photographs
86⅗ × 50 in. each (220 × 127 cm. each)
Courtesy of Galerie Philomene Magers, Bonn

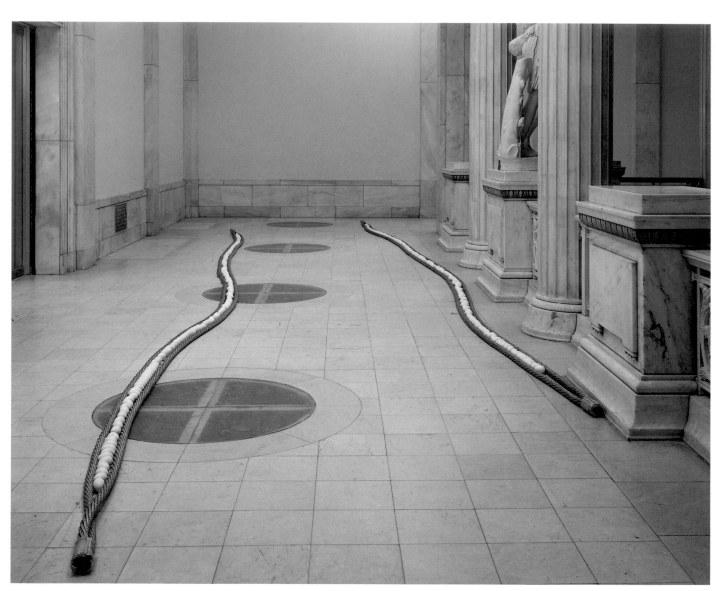

Ovaries (Ovaie), 1988
steel cables and marble
1½ × 7¾ × 393¾ in. each (4 × 20 × 1000 cm. each)
Courtesy of Galleria Christian Stein, Milan and Turin

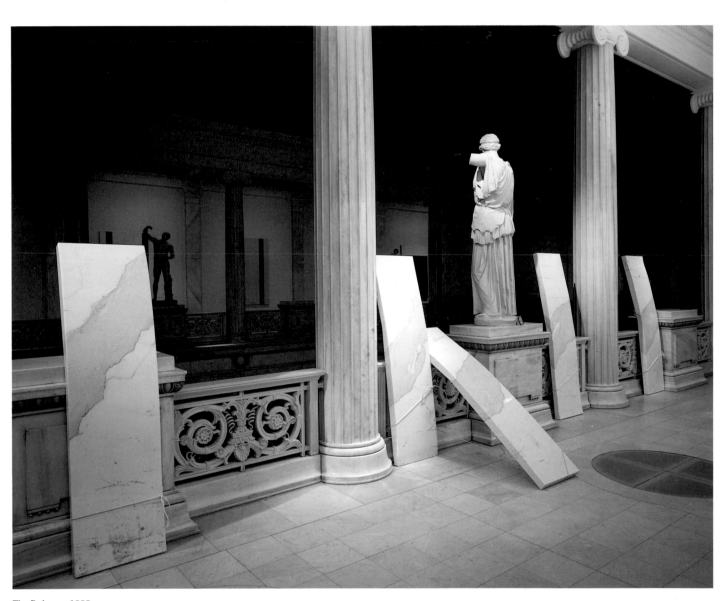

The Balcony, 1988
marble
74¾ × 19½ × 2⅓ in. each (190 × 50 × 6 cm. each)
Courtesy of Galleria Christian Stein, Milan and Turin

Peter Fischli/David Weiss

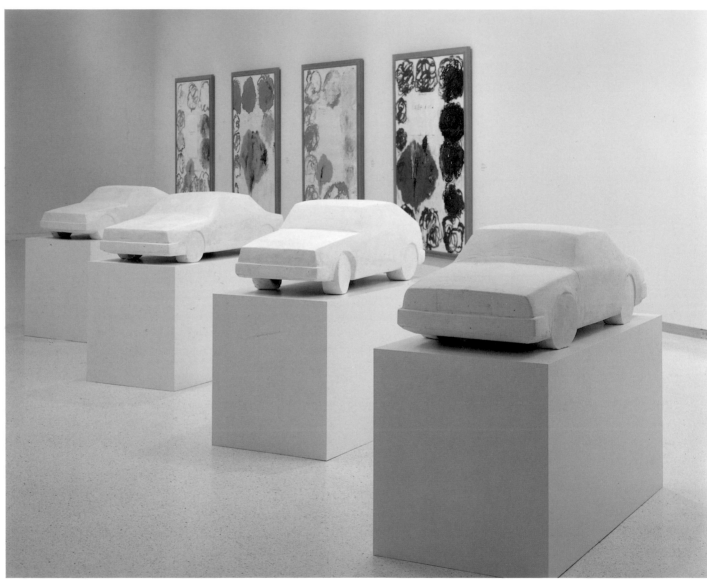

4 Cars, 1988
plaster
19½ × 23½ × 59 in. each (50 × 60 × 150 cm. each)
Collection of the artists, courtesy of Monika
Sprüth Galerie, Cologne, and Sonnabend Gallery, New York

The Way Things Go, 1986–87
¾ in. videotape, 31 minutes, sound,
color, (original in 16 mm film)
Courtesy of Sonnabend Gallery, New York

Günther Förg

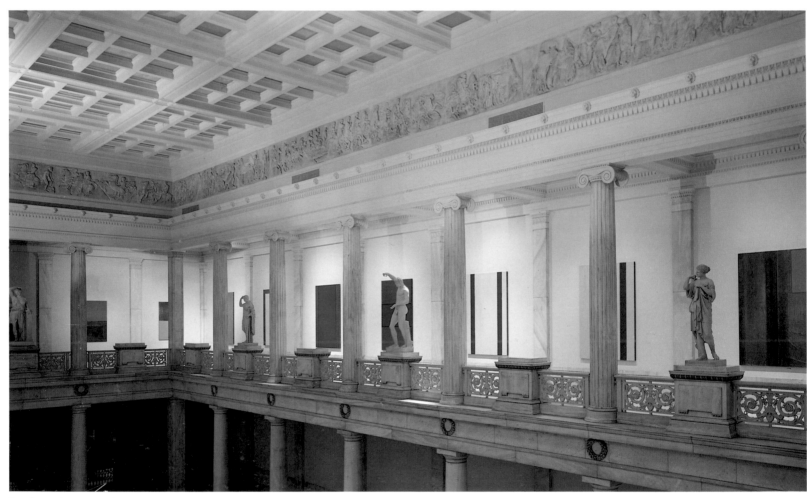

Installation View of *Lead Paintings (Bleibilder)*, 1988

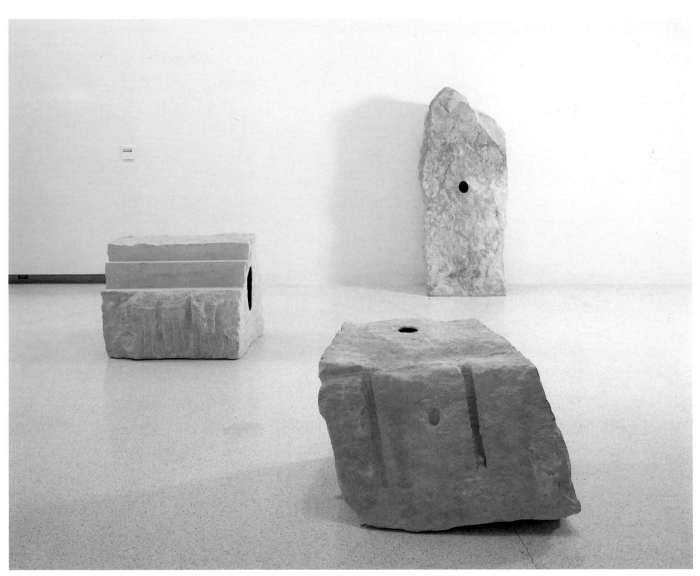

Blood Stone, 1988
limestone and pigment
83 × 33 × 24 in. (211 × 83.8 × 61 cm.), 33 × 35 × 43 in. (83.8 × 89 × 109.2 cm.), and 30 × 40 × 40 in. (76.2 × 101.6 × 101.6 cm.)
Collection of the artist, courtesy of Lisson Gallery, London, and Barbara Gladstone Gallery, New York

Hole, 1988
fiberglass and pigment
84 × 84 × 102 in. (213.3 × 213.3 × 259 cm.)
Courtesy of Lisson Gallery, London, and Barbara Gladstone Gallery, New York

Land between Two Rivers (Zweistromland), 1987–88
oil, acrylic, emulsion, and ash on canvas, lead object (ladder), ballet slippers on treated lead
153½ × 220½ in. (390 × 560 cm.)
Private collection

Anselm Kiefer

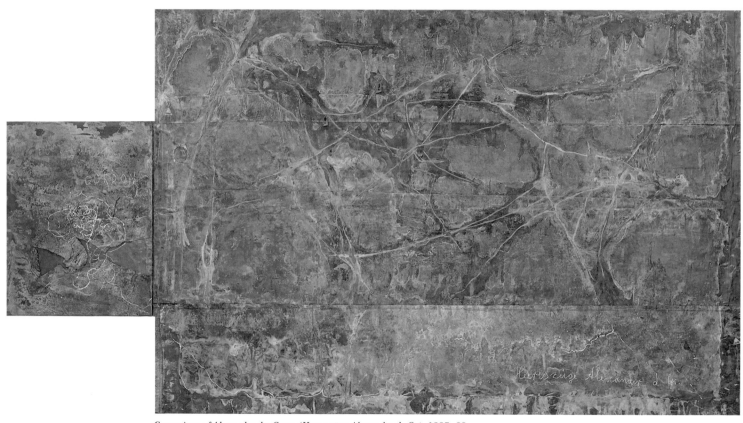

Campaigns of Alexander the Great (Hereszüge Alexander d. Gr.), 1987–88
chalk on treated lead
137¾ × 252 in. (350 × 640 cm.)
Private collection

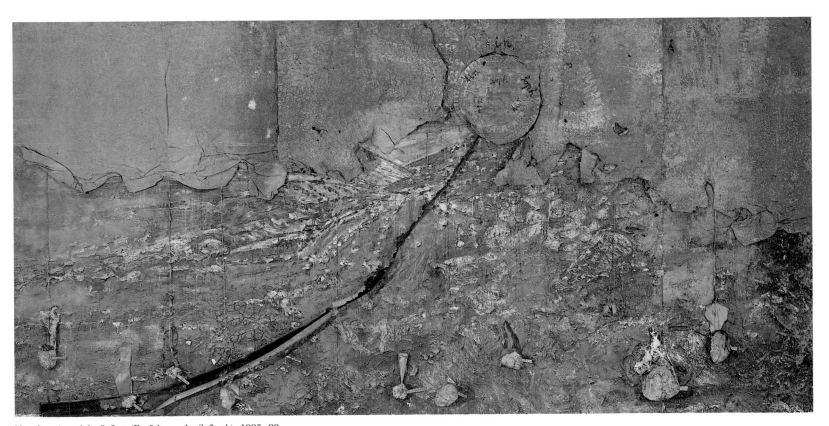

Manifestation of the Sefirot (Entfaltung der Sefiroth), 1985–88
treated lead, lead chunks, lead strips, gutter, photo scraps, cardboard over oil,
acrylic, emulsion, earth, and ash on canvas
134 × 272 in. (340 × 690 cm.)
Private collection

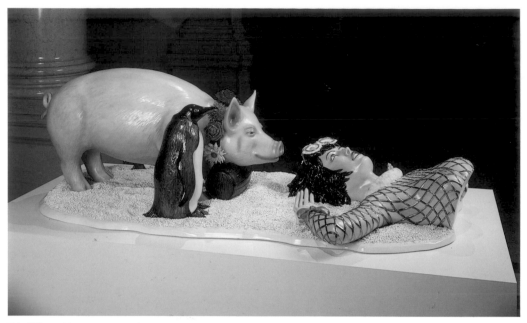

Fait d'Hiver, 1988
porcelain
18 × 30½ × 61 in. (46 × 77.5 × 155 cm.)
Courtesy of Sonnabend Gallery, New York

Ushering in Banality, 1988
painted wood
37 × 32 × 66½ in. (94 × 81 × 169 cm.)
Courtesy of Sonnabend Gallery, New York

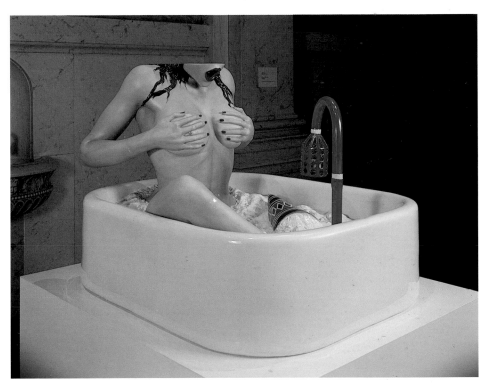

Woman in Tub, 1988
porcelain
25 × 28 × 34 in. (63.5 × 71 × 86 cm.)
Courtesy of Sonnabend Gallery, New York

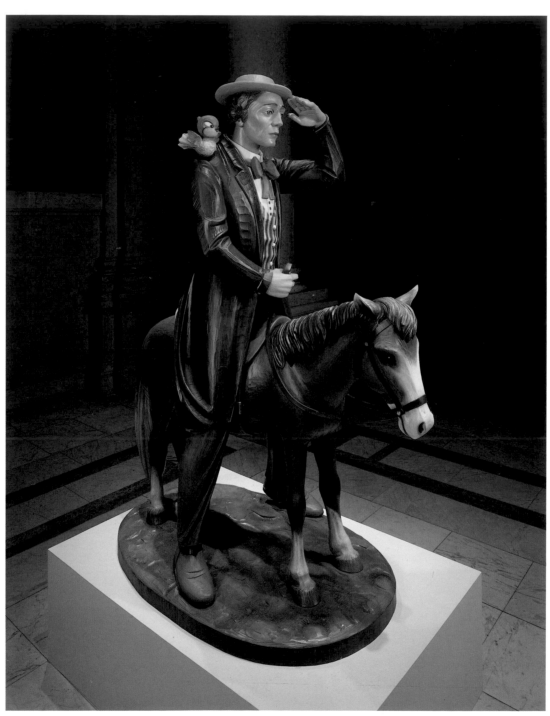

Buster Keaton, 1988
painted wood
65½ × 28 × 50¼ in. (166.4 × 71.1 × 127.6 cm.)
Courtesy of Sonnabend Gallery, New York

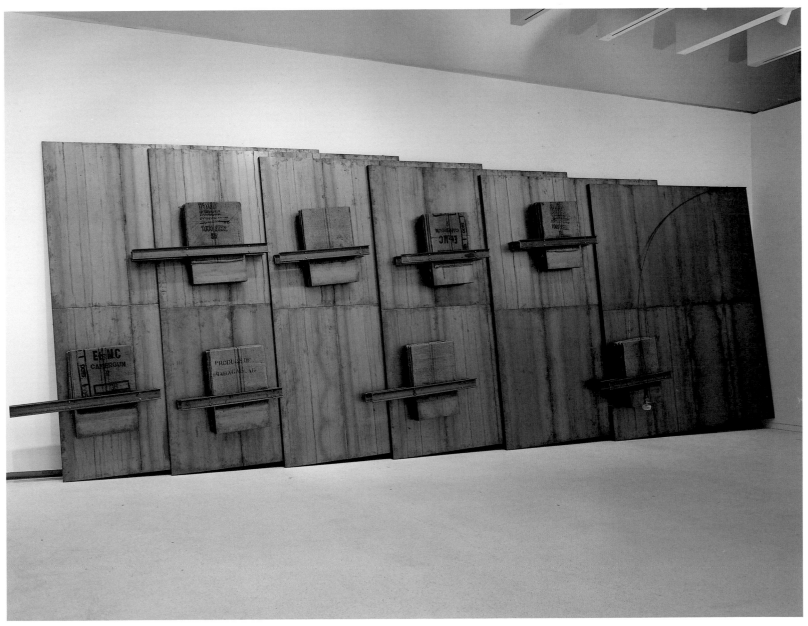

Untitled, 1988
steel panels, iron, burlap, and oil lamp
163½ × 492¼ × 25½ in. (415 × 1250 × 65 cm.)
Courtesy of Galleria Christian Stein, Milan and Turin

Wolfgang Laib

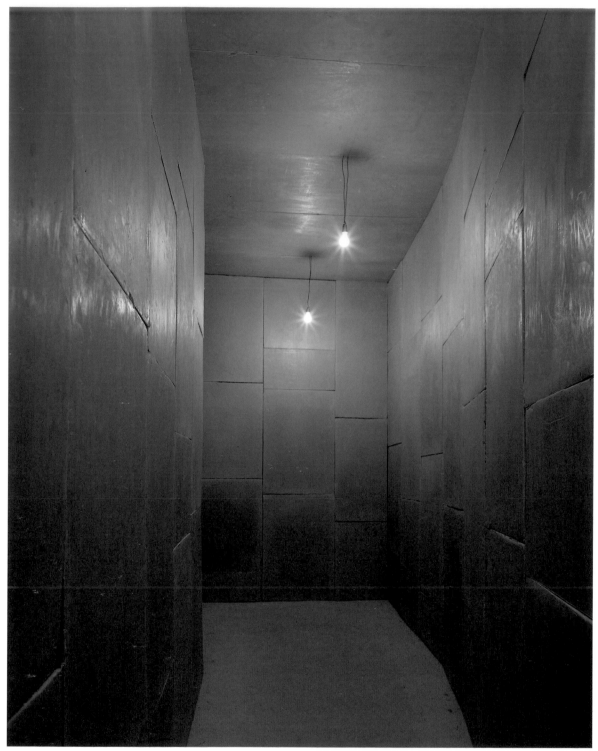

The Passage Way, 1988
beeswax and stucco
outside: 149½ × 106 × 259 in.; inside: 131 × 78 × 245½ in.
(outside: 379.7 × 269.2 × 657.8 cm.; inside: 332.7 × 198.1 × 623.5 cm.)
Collection of the artist, courtesy of Galerie Lelong, New York

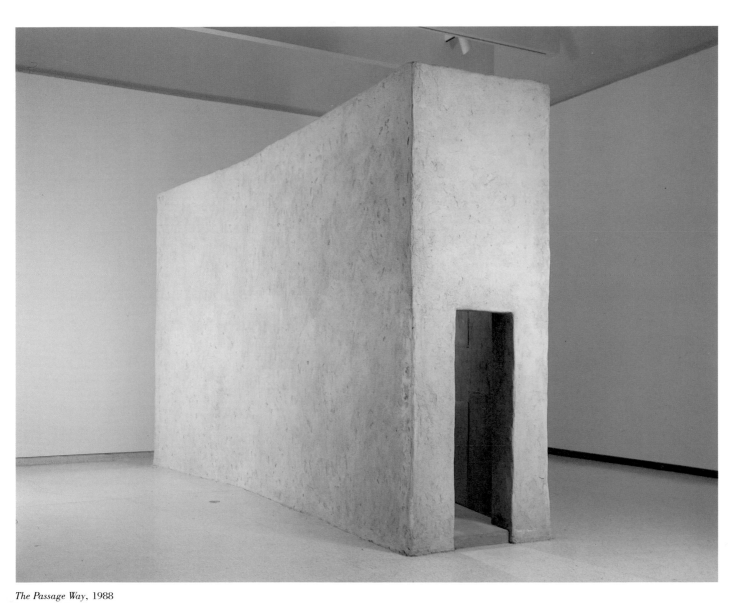

The Passage Way, 1988
beeswax and stucco
outside: 149½ × 106 × 259 in.; inside: 131 × 78 × 245½ in.
(outside: 379.7 × 269.2 × 657.8 cm.; inside: 332.7 × 198.1 × 623.5 cm.)
Collection of the artist, courtesy of Galerie Lelong, New York

Sherrie Levine

Untitled (Lead Checks/Lead Chevron:5), 1988
casein on lead
40 × 20 in. (101.6 × 50.8 cm.)
Courtesy of Mary Boone Gallery, New York

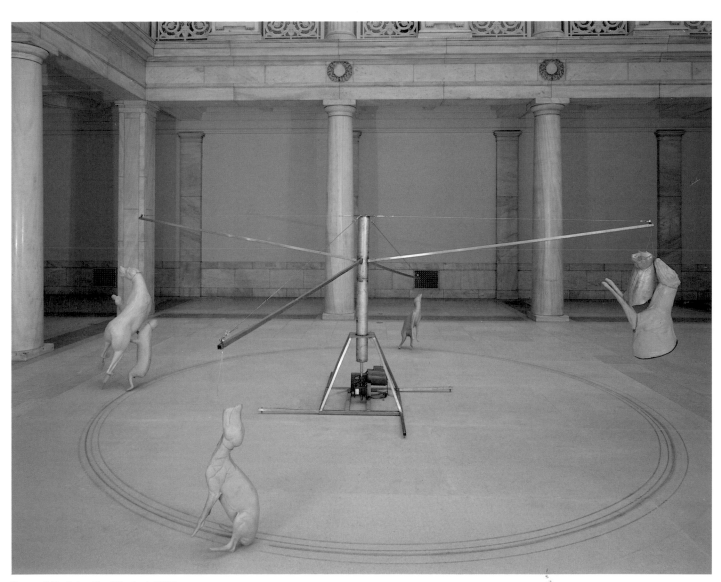

Carousel (Stainless Steel Version), 1988
stainless steel, cast aluminum, and
polyurethane foam
18 feet in diameter (548 cm. in diameter)
Courtesy of Sperone Westwater, New York

Sigmar Polke

The Spirits That Lend Strength Are Invisible I.
Tellurium Terrestrial Material, 1988
tellurium (pure) blown on to artificial resin on canvas
157½ × 118¼ in. (400 × 300 cm.)
Courtesy of Helen van der Meij, London

The Spirits That Lend Strength Are Invisible II.
Meteor Extraterrestrial Material, 1988
1 kg. of meteoric granulate of a 15 kg.
meteor found in 1927 at 22°40′ south and 69°
59′ west of Tocopilla thrown on to artificial resin on canvas
157½ × 118¼ in. (400 × 300 cm.)
Courtesy of Helen van der Meij, London

The Spirits That Lend Strength Are Invisible III.
Nickel (Neusilber), 1988
various layers of nickel incorporated in
artificial resin on canvas
157½ × 118¼ in. (400 × 300 cm.)
Courtesy of Helen van der Meij, London

The Spirits That Lend Strength Are Invisible IV.
Salt of Silver, 1988
silver nitrate painted on invisible, hermetic
structure, artificial resin on canvas
118¼ × 157½ in. (300 × 400 cm.)
Courtesy of Helen van der Meij, London

The Spirits That Lend Strength Are Invisible V.
Otter Creek, 1988
silver leaf and neolithic tools, artificial
resin on canvas
118¼ × 157½ in. (300 × 400 cm.)
Courtesy of Helen van der Meij, London

untitled, 1988
bronze
56 × 60 × 60 in. (142.2 × 152.4 × 152.4 cm.)
Courtesy of Paula Cooper Gallery, New York

Joy (Freude), 1988
wool
82½ × 68¾ in. (210 × 175 cm.)
Collection of Joshua Gessel, Grimaud, France

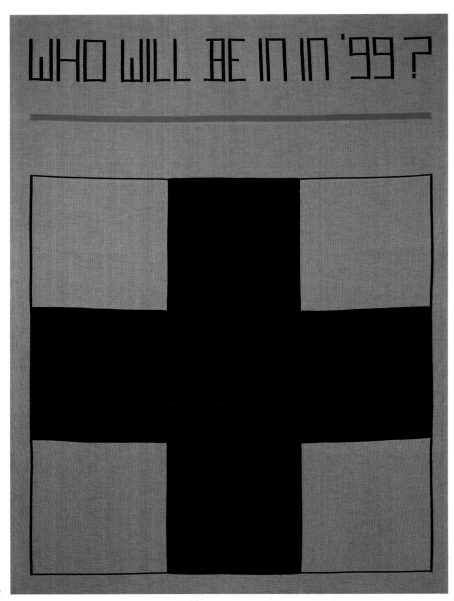

Who will be in in '99?, 1988
wool
82½ × 63 in. (210 × 160 cm.)
Collection of Joshua Gessel, Grimaud, France

Schizo-Pullover, 1988
wool
19½ × 19½ in. (50 × 50 cm.)
Collection of the artist

The Toilet of Venus, 1988
tempera on paper
86½ × 59 in. (220 × 150 cm.)
Private collection

Odalisque (Odalisca), 1988
tempera on paper
86½ × 59 in. (220 × 150 cm.)
Private collection

Odalisque (Odalisca), 1988
tempera on paper
86½ × 59 in. (220 × 150 cm.)
Private collection

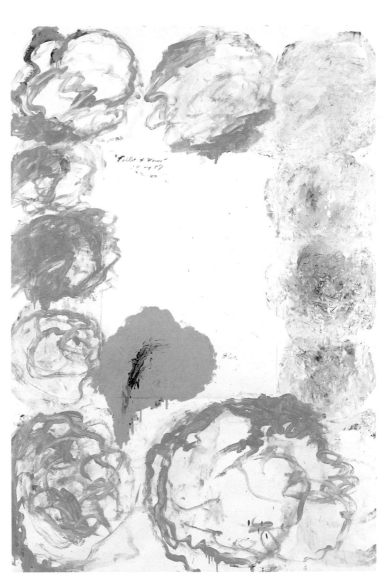

The Toilet of Venus, 1988
tempera on paper
86½ × 59 in. (220 × 150 cm.)
Private collection

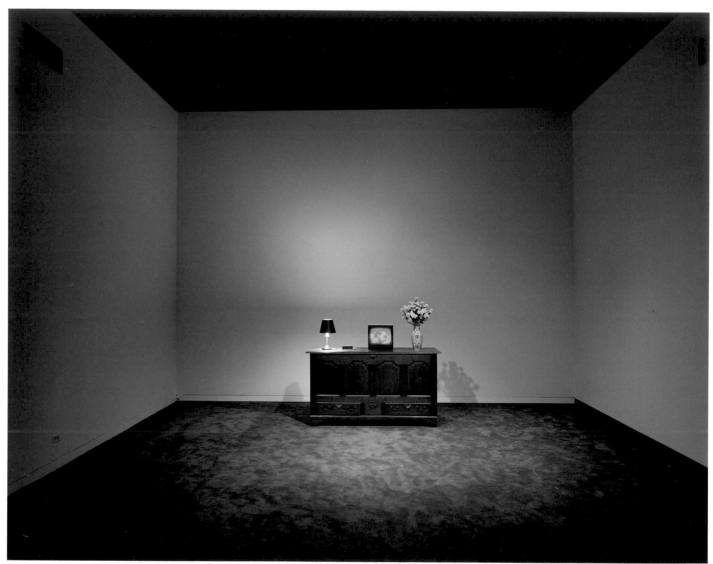

The Sleep of Reason, 1988
video installation: 3 video projectors, 1 monitor, ¾ in. videotape, 2 channels, sound, color, and black and white
169 × 230 × 264 in. (429.2 × 584.2 × 670.5 cm.)
Collection of the artist
Assistance from Sony Corporation, JBL Professional Products, Inc., and Dargate Galleries

Checklist of the Exhibition

This checklist includes information not available when the main body of the catalogue was published, and therefore it is more accurate than the photo captions. In several cases (Anselmo, Beuys, the Blumes, Kounellis, Laib, and Nauman), an artist exhibited a new or different version of a work previously shown and illustrated in the main body of the book.

Giovanni Anselmo

*Greys Lightening toward 'oltremare'
(Grigi che si alleggeriscono
verso oltremare)*, 1988
stone, steel cable, slipknot,
and ultramarine blue pigment
variable dimensions
Collection of the artist, courtesy of
Marian Goodman Gallery, New York

Siah Armajani

Sacco and Vanzetti Reading Room #3, 1988
diamond plated aluminum, brick, steel,
pressure treated lumber, and Minnesota jade
variable dimensions
Courtesy of Max Protetch Gallery, New York

Richard Artschwager

Abstraction, 1987
acrylic on Celotex
47 × 35½ in. (119.4 × 90.2 cm.)
Private collection, courtesy of
Donald Young Gallery, Chicago

Diner, 1988
acrylic on Celotex, Formica, and wood
36½ × 104 in. (92.7 × 264.2 cm.)
Collection of Mr. and Mrs. Richard S. Lane,
New York

Double Dinner, 1988
paint, wood, Formica, and rubberized hair
27 × 85½ × 35½ in.
(68.6 × 217.2 × 90.2 cm.)
Courtesy of Leo Castelli Gallery, New York

Two Dinners, 1988
acrylic on Celotex and wood, mirrors
40⅜ × 48 × 6⅜ in.
(102.9 × 121.9 × 16.5 cm.)
Courtesy of Leo Castelli Gallery, New York

Georg Baselitz

Blue Head (Blauer Kopf), 1983
painted beechwood
31½ × 15⁷⁄₁₀ × 12⅗ in.
(80 × 40 × 32 cm.)
Kunsthalle Bielefeld, West Germany

Tragic Head (Tragischer Kopf), 1988
painted birch
50 × 12⁹⁄₁₀ × 14⅖ in.
(128.5 × 33 × 37 cm.)
Courtesy of Galerie Michael Werner,
Cologne, and Anthony d'Offay Gallery, London

Untitled, 1982
painted wood
98½ × 36 × 24 in.
(250.2 × 91.4 × 61 cm.)
Saatchi Collection, London

Untitled, 1982
beechwood
19½ × 17⅗ × 17⅗ in. (50 × 45 × 45 cm)
Private collection, courtesy of Galerie
Michael Werner, Cologne

Untitled, 1982
painted poplar wood
33 × 12⅗ × 11⅘ in.
(84 × 32 × 30 cm.)
Garnatz Collection, Cologne

Untitled, 1983
painted linden wood
97½ × 11⁷⁄₁₀ × 11⁷⁄₁₀ in.
(250 × 30 × 30 cm.)
Private collection, courtesy of
Galerie Michael Werner, Cologne

Lothar Baumgarten

The Tongue of the Cherokee, 1985–88
painted, laminated, and sandblasted glass
100 × 43 ft.
(3048 × 1310 cm.)
Courtesy of Marian Goodman Gallery,
New York

Joseph Beuys

*The End of the 20th Century
(Das Ende des 20. Jahrhunderts)*, 1983–85
31 basalt stones, clay, and felt
15¾ × 67 × 15¾ in. each
(40 × 170 × 40 cm. each)
Courtesy of Galerie Bernd Klüser, Munich

Ross Bleckner

Knights in Nights, 1988
oil on canvas
108 × 72 in. (274.3 × 182.9 cm.)
Collection of Mr. and Mrs. John Garland
Bowes, San Francisco

Recover, 1988
oil on canvas
108 × 72 in. (274.3 × 182.9 cm.)
Courtesy of Mary Boone Gallery, New York

Two Knights Not Nights, 1988
oil on canvas
108 × 72 in. (274.3 × 182.9 cm.)
Collection of Fredrik Roos,
Zug, Switzerland

Us Two, 1988
oil on canvas
108 × 60 in. (274.3 × 152.4 cm.)
Collection of the Eli Broad
Family Foundation, Los Angeles

Anna and Bernhard Blume

Cosy Home (Trautes Heim), 1987
black and white photographs
86⅗ × 50 in. each (220 × 127 cm. each)
Courtesy of Galerie Philomene Magers, Bonn

Francesco Clemente

Dreaming the Dreamer, 1987
oil on canvas
84 × 186 in. (213.4 × 472.4 cm.)
Courtesy of Sperone Westwater, New York

Luciano Fabro

Demeter, 1987
volcanic stone and steel cables
39⅖ × 78⅗ × 27⅗ in.
(100 × 200 × 70 cm.)
San Francisco Museum of Modern Art;
Gift of Robin Quist in memory
of George Quist

Ovaries (Ovaie), 1988
steel cables and marble
1½ × 7¾ × 393¾ in. each
(4 × 20 × 1000 cm. each)
Courtesy of Galleria Christian Stein,
Milan and Turin

The Balcony, 1988
marble
74¾ × 19½ × 2⅓ in. each
(190 × 50 × 6 cm. each)
Courtesy of Galleria Christian Stein,
Milan and Turin

Peter Fischli/David Weiss

4 Cars, 1988
plaster
19½ × 23½ × 59 in. each
(50 × 60 × 150 cm. each)
Collection of the artists, courtesy of
Monika Sprüth Galerie, Cologne, and
Sonnabend Gallery, New York

The Way Things Go, 1986–87
¾ in. videotape, 31 minutes, sound,
color, (original in 16 mm film)
Courtesy of Sonnabend Gallery, New York

Günther Förg

Lead Picture 26/88 (Bleibild 26/88), 1988
acrylic on lead on wood
70⅘ × 47⅓ in. (180 × 120 cm.)
The Carnegie Museum of Art;
Gift Fund for Special Acquisitions, 1988

Lead Picture 26/88 (Bleibild 26/88), 1988
acrylic on lead on wood
70⅘ × 47⅓ in. (180 × 120 cm.)
The Carnegie Museum of Art;
Gift Fund for Special Acquisitions, 1988

Lead Picture 26/88 (Bleibild 26/88), 1988
acrylic on lead on wood
70⅘ × 47⅓ in. (180 × 120 cm.)
The Carnegie Museum of Art;
Gift Fund for Special Acquisitions, 1988

Lead Picture 26/88 (Bleibild 26/88), 1988
acrylic on lead on wood
70⅘ × 47⅓ in. (180 × 120 cm.)
The Carnegie Museum of Art;
Gift Fund for Special Acquisitions, 1988

Lead Picture 118/88 (Bleibild 118/88), 1988
acrylic on lead on wood
94½ × 62⅞ in. (240 × 160 cm.)
Courtesy of Galerie Max Hetzler, Cologne,
and Luhring, Augustine & Hodes, New York

Lead Picture 119/88 (Bleibild 119/88), 1988
acrylic on lead on wood
94½ × 62⅞ in. (240 × 160 cm.)
Courtesy of Galerie Max Hetzler, Cologne,
and Luhring, Augustine & Hodes, New York

Lead Picture 120/88 (Bleibild 120/88), 1988
acrylic on lead on wood
94½ × 62⅞ in. (240 × 160 cm.)
Courtesy of Galerie Max Hetzler, Cologne,
and Luhring, Augustine & Hodes, New York

Lead Picture 122/88 (Bleibild 122/88), 1988
acrylic on lead on wood
94½ × 62⅞ in. (240 × 160 cm.)
Collection of Milton Fine, Pittsburgh

Lead Picture 123/88 Bleibild 123/88), 1988
acrylic on lead on wood
94½ × 62⅞ in. (240 × 160 cm.)
Collection of Mr. and Mrs.
Stanley R. Gumberg, Pittsburgh

Lead Picture 125/88 (Bleibild 125/88), 1988
acrylic on lead on wood
94½ × 62⅞ in. (240 × 160 cm.)
Courtesy of Galerie Max Hetzler, Cologne,
and Luhring, Augustine & Hodes, New York

Lead Picture 127/88 (Bleibild 127/88), 1988
acrylic on lead on wood
94½ × 62⅞ in. (240 × 160 cm.)
Collection of Dr. and Mrs. Murray Osofsky,
Pittsburgh

Lead Picture 129/88 (Bleibild 129/88), 1988
acrylic on lead on wood
94½ × 62⅞ in. (240 × 160 cm.)
Courtesy of Galerie Max Hetzler, Cologne
and Luhring, Augustine & Hodes, New York

Katharina Fritsch

Ghost and Pool of Blood, 1988
polyester
78¾ × 23½ in. and 21 × 82½ in.
(200 × 60 cm. and 53.2 × 209.4 cm.)
Courtesy of Galerie Johnen and Schöttle,
Cologne

Peter Halley

Red Cell with Conduit, 1988
Day-Glo acrylic and Roll-a-Tex on canvas
82 × 127 in. (208.3 × 322.6 cm.)
Courtesy of Sidney Janis Gallery, New York

Two Cells, 1987
Day-Glo acrylic, acrylic, and Roll-a-Tex
on canvas
72 × 154¼ in. (182.9 × 386.7 cm.)
The Carnegie Museum of Art; Gift Fund for
Special Acquisitions, 1987

Weekend, 1988
acrylic on canvas
62 × 192 in. (157.5 × 487.7 cm.)
Collection of Fredrik Roos,
Zug, Switzerland

Rebecca Horn

The Hydra-Forest, 1988
performing: Oscar Wilde
electrical devices, glass, mercury, shoes
160 × 211 × 450 in.
(406.4 × 535.9 × 1143 cm.)
Courtesy of Marian Goodman Gallery,
New York

Anish Kapoor

Blood Stone, 1988
limestone and pigment
83 × 33 × 24 in. (211 × 83.8 × 61 cm.),
33 × 35 × 43 in.
(83.8 × 89 × 109.2 cm.),
and 30 × 40 × 40 in.
(76.2 × 101.6 × 101.6 cm.)
Collection of the artist, courtesy of
Lisson Gallery, London, and
Barbara Gladstone Gallery, New York

Hole, 1988
fiberglass and pigment
84 × 84 × 102 in.
(213.3 × 213.3 × 259 cm.)
Courtesy of Lisson Gallery, London, and
Barbara Gladstone Gallery, New York

Anselm Kiefer

*Land between Two Rivers
(Zweistromland)*, 1987–88
oil, acrylic, emulsion, and ash on canvas,
lead object (ladder), ballet slippers
on treated lead
153½ × 220½ in. (390 × 560 cm.)
Private collection

*Campaigns of Alexander the Great
(Heereszüge Alexander d. Gr.)*, 1987–88
chalk on treated lead
137¾ × 252 in. (350 × 640 cm.)
Private collection

*Manifestations of the Sefirot
(Entfaltung der Sefiroth)*, 1985–88
treated lead, lead chunks, lead strips,
gutter, photo scraps, cardboard over oil,
acrylic, emulsion, earth, and ash on canvas
134 × 272 in. (340 × 690 cm.)
Private collection

Per Kirkeby

*After the Descent
(Nach der Abnahme)*, 1987–88
oil on canvas
118⅒ × 137⅘ in. (300 × 350 cm.)
Courtesy of Mary Boone/Michael Werner
Gallery, New York

Still Life I (Nature Morte I), 1987
oil on canvas
78⁷⁄₁₀ × 43³⁄₁₀ in. (200 × 110 cm.)
Courtesy of Mary Boone/Michael Werner
Gallery, New York

Still Life II (Nature Morte II), 1987
oil on canvas
78⁷⁄₁₀ × 43³⁄₁₀ in. (200 × 110 cm.)
Courtesy of Mary Boone/Michael Werner
Gallery, New York

Still Life III (Nature Morte III), 1987
oil on canvas
78⁷⁄₁₀ × 43³⁄₁₀ in. (200 × 110 cm.)
Courtesy of Galerie Laage Salomon, Paris

Jeff Koons

Buster Keaton, 1988
painted wood
65½ × 28 × 50¼ in.
(166.4 × 71.1 × 127.6 cm.)
Courtesy of Sonnabend Gallery, New York

Ushering in Banality, 1988
painted wood
37 × 32 × 66½ in. (94 × 81 × 169 cm.)
Courtesy of Sonnabend Gallery, New York

Fait d'Hiver, 1988
porcelain
18 × 30½ × 61 in. (46 × 77.5 × 155 cm.)
Courtesy of Sonnabend Gallery, New York

Woman in Tub, 1988
porcelain
25 × 28 × 34 in. (63.5 × 71 × 86 cm.)
Courtesy of Sonnabend Gallery, New York

Jannis Kounellis

Untitled, 1988
steel panels, iron, burlap, and oil lamp
163½ × 492¼ × 25½ in.
(415 × 1250 × 65 cm.)
Courtesy of Galleria Christian Stein,
Milan and Turin

Wolfgang Laib

The Passage Way, 1988
beeswax and stucco
outside: 149½ × 106 × 259 in.;
inside: 131 × 78 × 245½ in.
(outside: 379.7 × 269.2 × 657.8 cm.;
inside: 332.7 × 198.1 × 632.5 cm.)
Collection of the artist, courtesy of
Galerie Lelong, New York

Sherrie Levine

*"Untitled"
(Lead Checks/Lead Chevron:1)*, 1987
casein on lead
40 × 20 in. (101.6 × 50.8 cm.)
Oliver-Hoffman Collection, Chicago

*"Untitled"
(Lead Checks/Lead Chevron:2)*, 1987
casein on lead
40 × 20 in. (101.6 × 50.8 cm.)
Collection of Leonard and Jane Korman,
Fort Washington, Pennsylvania,
courtesy of Mary Boone Gallery, New York

*"Untitled"
(Lead Checks/Lead Chevron:3)*, 1988
casein on lead
40 × 20 in. (101.6 × 50.8 cm.)
Collection of Milton Fine, Pittsburgh

*"Untitled"
(Lead Checks/Lead Chevron:4)*, 1988
casein on lead
40 × 20 in. (101.6 × 50.8 cm.)
Collection of Emily Fisher Landau,
New York

*"Untitled"
(Lead Checks/Lead Chevron:5)*, 1988
casein on lead
40 × 20 in. (101.6 × 50.8 cm.)
Courtesy of Mary Boone Gallery, New York

Brice Marden

Untitled 1, 1986
oil on linen
72 × 58 in. (182.9 × 147.3 cm.)
Collection of Thomas Ammann, Zurich

Untitled 2, 1986
oil on linen
72 × 58 in. (182.9 × 147.3 cm)
The Carnegie Museum of Art;
Edith H. Fisher Fund, 1987

"4" (Bone), 1987–88
oil on linen
84 × 60 in. (213.4 × 152.4 cm.)
Collection of Helen Marden, New York,
courtesy of Mary Boone Gallery, New York

"12" (Gray), 1987–88
oil on linen
84 × 60 in. (213.4 × 152.4 cm.)
Collection of Mimi and Peter Haas,
San Francisco

Agnes Martin

Untitled #1, 1988
acrylic and pencil on canvas
72 × 72 in. (182.9 × 182.9 cm.)
Courtesy of The Pace Gallery, New York

Untitled #4, 1987
acrylic and pencil on canvas
72 × 72 in. (182.9 × 182.9 cm.)
Courtesy of The Pace Gallery, New York

Untitled #5, 1988
acrylic and pencil on canvas
72 × 72 in. (182.9 × 182.9 cm.)
Courtesy of The Pace Gallery, New York

Untitled #8, 1988
acrylic and pencil on canvas
72 × 72 in. (182.9 × 182.9 cm.)
Courtesy of The Pace Gallery, New York

Elizabeth Murray

Don't Be Cruel, 1985–86
oil on canvas
115 × 116½ × 14 in.
(292.1 × 295.9 × 35.6 cm.)
The Carnegie Museum of Art;
the Henry L. Hillman Fund, 1986

Making It Up, 1986
oil on canvas
136½ × 112 × 16½ in.
(346.7 × 284.5 × 41.9 cm.)
Collection of Rita and Toby Schreiber,
Woodside, California

Things To Come, 1988
oil on canvas
115 × 113 × 27 in.
(292.1 × 287 × 68.6 cm.)
Private collection, San Francisco

Bruce Nauman

Carousel (Stainless Steel Version), 1988
stainless steel, cast aluminum, and
polyurethane foam
18 feet in diameter (548 cm. in diameter)
Courtesy of Sperone Westwater, New York

Sigmar Polke

*The Spirits That Lend Strength Are Invisible I.
Tellurium Terrestrial Material*, 1988
tellurium (pure) blown on to artificial
resin on canvas
157½ × 118¼ in. (400 × 300 cm.)
Courtesy of Helen van der Meij, London

*The Spirits That Lend Strength Are Invisible II.
Meteor Extraterrestrial Material*, 1988
1 kg. of meteoric granulate of a 15 kg.
meteor found in 1927 at 22°40′ south and
69°50′ west of Tocopilla thrown on to
artificial resin on canvas.
157½ × 118¼ in. (400 × 300 cm.)
Courtesy of Helen van der Meij, London

*The Spirits That Lend Strength
Are Invisible III. Nickel (Neusilber)*, 1988
various layers of nickel incorporated in
artificial resin on canvas
157½ × 118¼ in. (400 × 300 cm.)
Courtesy of Helen van der Meij, London

*The Spirits That Lend Strength
Are Invisible IV. Salt of Silver*, 1988
silver nitrate painted on invisible, hermetic
structure, artificial resin on canvas
118¼ × 157½ in. (300 × 400 cm.)
Courtesy of Helen van der Meij, London

*The Spirits That Lend Strength
Are Invisible V. Otter Creek*, 1988
silver leaf and neolithic tools,
artificial resin on canvas
118¼ × 157½ in. (300 × 400 cm.)
Courtesy of Helen van der Meij, London

Gerhard Richter

612-1 Untitled, 1986
oil on canvas
82½ × 73¾ in. (209.6 × 187.3 cm.)
The Carnegie Museum of Art; A. W. Mellon
Acquisition Endowment Fund, 1987

635 Untitled, 1987
oil on canvas
102⅖ × 157½ in. (260 × 400 cm.)
Collection of Galerie Liliane and Michel
Durand-Dessert, Paris

636 Untitled, 1987
oil on canvas
102⅖ × 157½ in. (260 × 400 cm.)
Private collection, France, courtesy of
Galerie Durand-Dessert, Paris

Susan Rothenberg

Night Ride, 1987
oil on canvas
93 × 110¼ in. (236.2 × 280 cm.)
Walker Art Center, Minneapolis; Walker
Special Purchase Fund, 1987

Folded Buddha, 1987–88
oil on canvas
91¼ × 111¼ in. (231.8 × 282.6 cm.)
Collection of the artist, courtesy of
Sperone Westwater, New York

Blue Woman with Frog, 1987
oil on canvas
75 × 111½ in. (190.5 × 283.2 cm.)
Collection of Douglas S. Cramer,
Los Angeles

Robert Ryman

The Elliott Room: Charter, 1985
oil on aluminum
82 × 31 in. (208.3 × 78.7 cm.)
Collection of Gerald S. Elliott, Chicago

The Elliott Room: Charter II, 1987
acrylic on fiberglass with aluminum
93¾ × 93⅜ in. (238.1 × 237.8 cm.)
Collection of Gerald S. Elliott, Chicago

The Elliott Room: Charter III, 1987
acrylic on fiberglass with aluminum
84¼ × 84 in. (214 × 213.4 cm.)
Collection of Gerald S. Elliott, Chicago

The Elliott Room: Charter IV, 1987
acrylic on fiberglass with aluminum
72⅜ × 72 in. (183.8 × 182.9 cm.)
Collection of Gerald S. Elliott, Chicago

The Elliott Room: Charter V, 1987
acrylic on fiberglass with aluminum
95½ × 95½ in. (242.6 × 242.6 cm.)
Collection of Gerald S. Elliott, Chicago

Julian Schnabel

Edge of Victory, 1988
gesso and tape on tarpaulin
136 × 192 in. (345.4 × 487.7 cm.)
Private collection, courtesy of The Pace
Gallery, New York

J.M.B., 1988
oil and gesso on tarpaulin
192 × 192 in. (487.7 × 487.7 cm.)
Collection of the artist, courtesy of
The Pace Gallery, New York

St. S, 1988
oil and collage on tarpaulin
132 × 228 in. (335.3 × 579.1 cm.)
Collection of the Eli Broad
Family Foundation, Los Angeles

Joel Shapiro

untitled, 1987–88
bronze
72½ × 15½ × 10 in.
(184.2 × 39.4 × 25.4 cm.)
Courtesy of Paula Cooper Gallery, New York

untitled, c. 1987–88
bronze
162 × 248½ × 138 in.
(411.5 × 631.2 × 350.5 cm.)
Courtesy of Paula Cooper Gallery, New York

untitled, c. 1987–88
bronze
56 × 60 × 60 in.
(142.2 × 152.4 × 152.4 cm.)
Courtesy of Paula Cooper Gallery, New York

Susana Solano

Two Noes (Dos Nones), 1988
iron and polymethyl methacrylate sheeting
95¼ × 84¼ × 122 in.
(241.9 × 214 × 310 cm.)
Courtesy of Donald Young Gallery, Chicago

Rosemarie Trockel

Cogito, ergo sum, 1988
wool
85⅘ × 62⅘ in.
(220 × 160 cm.)
Collection of Milton Fine, Pittsburgh,
courtesy of Barbara Gladstone Gallery,
New York

Joy (Freude), 1988
wool
82½ × 68¾ in. (210 × 175 cm.)
Collection of Joshua Gessel, Grimaud, France

Schizo-Pullover, 1988
wool
19½ × 19½ in. (50 × 50 cm.)
Collection of the artist

Who will be in in '99?, 1988
wool
82½ × 63 in. (210 × 160 cm.)
Collection of Joshua Gessel, Grimaud, France

Cy Twombly

Odalisque (Odalisca), 1988
tempera on paper
86½ × 59 in. (220 × 150 cm.)
Private collection

Odalisque (Odalisca), 1988
tempera on paper
86½ × 59 in. (220 × 150 cm.)
Private collection

The Toilet of Venus, 1988
tempera on paper
86½ × 59 in. (220 × 150 cm.)
Private collection

The Toilet of Venus, 1988
tempera on paper
86½ × 59 in. (220 × 150 cm.)
Private collection

Meyer Vaisman

In the Vicinity of History, 1988
process inks and acrylic on canvas
96 × 172½ × 8½ in.
(243.8 × 438.2 × 21.6 cm.)
Collection of Dakis Joannou, Athens

*Self-Portrait with Imaginary Siblings for
Richard Prince*, 1988
process inks and acrylic on canvas
120 × 120 × 8¾ in.
(304.8 × 304.8 × 22.2 cm.)
Courtesy of Sonnabend Gallery, New York,
and Leo Castelli Gallery, New York

Souvenir, 1987
process inks on canvas
84 × 176¼ × 14½ in.
(213.4 × 447.7 × 36.8 cm.)
Collection of Mr. and Mrs. Asher B.
Edelman, New York

Bill Viola

The Sleep of Reason, 1988
video installation: 3 video projectors,
1 monitor, ¾ in. videotape, 2 channels,
sound, color, and black and white
169 × 230 × 264 in.
(429.2 × 584.2 × 670.5 cm.)
Collection of the artist
Assistance from Sony Corporation, JBL
Professional Products, Inc., and
Dargate Galleries

Jeff Wall

The Agreement, 1987
Cibachrome transparency, fluorescent
light, display case
83³⁄₁₀ × 154⅖ in. (213 × 392 cm.)
Courtesy of Galerie Rüdiger Schöttle,
Munich

Andy Warhol

Self-Portrait, 1986
acrylic and silkscreen on canvas
80 × 80 in. (203.2 × 203.2 cm.)
The Carnegie Museum of Art;
Fellows of the Museum of Art Fund, 1986

Self-Portrait, 1986
acrylic and silkscreen on canvas
80 × 80 in. (203.2 × 203.2 cm.)
Collection of Janet Green, London, courtesy of
Anthony d'Offay Gallery, London

Self-Portrait, 1986
acrylic and silkscreen on canvas
80 × 80 in. (203.2 × 203.2 cm.)
Estate of Andy Warhol

Self-Portrait, 1986
acrylic and silkscreen on canvas
80 × 80 in. (203.2 × 203.2 cm.)
Estate of Andy Warhol

Acknowledgments

R. H. Billingsley, Jr.
Hasje Boeyen
Eli Broad
John Burke
Ron Diulus
Paul Joseph Dingfelder
John Diveglia
Barbara Gladstone
Marcia Gumberg
Stanley Gumberg
Larry Harding
Richard Knox
Dale Luce
Amerigo Migliorati
Margaret Osofsky
Murray Osofsky
John Reiner
Anna-Chiara Serra
James Shipman
Monika Staiger
Larry Steele
Hansjorg Straub
Walter Uptmoor
Helen van der Meij
Ann D. Weiss
Eddie Wellenstein
Matt Wrbican
Donald Young

Additional Lenders

Giovanni Anselmo
The Eli Broad Family Foundation
Milton Fine
Joshua Gessel
Barbara Gladstone Gallery
Mr. and Mrs. Stanley Gumberg
Galerie Philomene Magers
Dr. and Mrs. Murray Osofsky
Rosemarie Trockel
Helen van der Meij

Photo Credits

The Carnegie Museum of Art would like to thank lenders and galleries for supplying photographs and to credit the following photographers:

Claudio Abate *page 93*
Jon and Anne Abbott *pages 162, 163*
D. James Dee *pages 109–111, 135*
Allen Finkelman *pages 125–127*
Dorothee Fischer *page 113*
Rebecca Horn *page 81*
Nanda Lanfranco *page 67*
Wojtek Naczas *page 134*
Susan Ormerod *page 83*
Kira Perov *page 147*
Paolo Massey Sartor *page 41*
Susana Solano *page 137*
Richard Stoner *pages 52, 53, 156–161, 164–196*
Dorothy Zeidman *pages 121, 123, 143–144*
Werner Zellien *page 95*
Zindman/Fremont *pages 57, 59, 64, 69, 98, 99, 101–103*

Errata

The captions on pages 52 and 53 have been reversed. Both the study and the sketch date from 1985 to 1988.

Cogito, ergo sum by Rosemarie Trockel is in the exhibition.

Cover printed in USA.
Text printed in England.